VISUALIZING
EQUALITY

THE JOHN HOPE FRANKLIN SERIES IN

AFRICAN AMERICAN HISTORY AND CULTURE

Waldo E. Martin Jr. and Patricia Sullivan, editors

VISUALIZING
EQUALITY

African American Rights
and Visual Culture in
the Nineteenth Century

ASTON GONZALEZ

THE UNIVERSITY OF NORTH CAROLINA PRESS

Chapel Hill

This book was published with the assistance of the
John Hope Franklin Fund of the University of North Carolina Press.

© 2020 The University of North Carolina Press

Designed by Jamison Cockerham
Set in Arno, Cutright, Irby, and American Scribe
by Tseng Information Systems, Inc.

Cover illustrations courtesy of the Library Company of Philadelphia
and the Library of Congress Prints and Photographs Division.

Manufactured in the United States of America

The University of North Carolina Press has been a member
of the Green Press Initiative since 2003.

LIBRARY OF CONGRESS CATALOGING-IN-PUBLICATION DATA
Names: Gonzalez, Aston, 1986– author.
Title: Visualizing equality : African American Rights and Visual
Culture in the Nineteenth Century / Aston Gonzalez.
Other titles: John Hope Franklin series in African American history and culture.
Description: Chapel Hill : The University of North Carolina Press,
2020. | Series: The John Hope Franklin series in African American history
and culture | Includes bibliographical references and index.
Identifiers: LCCN 2020007566 | ISBN 9781469659954 (cloth : alk. paper) |
ISBN 9781469659961 (paperback : alk. paper) | ISBN 9781469659978 (ebook)
Subjects: LCSH: African American art — 19th century — Political aspects. |
African American artists — Political activity — 19th century. | African Americans
in art. | Art and race. | African Americans — Civil rights — History — 19th
century. | African Americans — Race identity — History — 19th century. | Politics
in art. | Civil rights movements — United States — History — 19th century.
Classification: LCC N6538.N5 G65 2020 | DDC 709.2/396073 — dc23
LC record available at https://lccn.loc.gov/2020007566

Portions of chapters 1 and 3 originally appeared as Aston Gonzalez,
"The Art of Racial Politics: The Work of Robert Douglass Jr., 1833–46,"
Pennsylvania Magazine of History and Biography 138, no. 1 (January
2014): 5–37, and are printed here by permission of the publisher.

For my mother,

whose passions for reading and adventure

inspired my own

CONTENTS

FIGURES

ACKNOWLEDGMENTS

Instead of imagining this book as a representation of debts, I prefer to think of it as a statement of dividends. There are so many people and institutions to thank for their support and guidance which enabled me to tell the stories within these pages.

First and foremost, Martha S. Jones has been the consummate mentor, both in and out of graduate school. Learning the precision and effects of language over the years that we have worked together has been an exercise in growth and thoughtfulness. Her incisive feedback has broadened the scope of my thinking and made me ask difficult questions of the people and periods about which I write. Like no one else, she has trained me to think expansively, read deeply, and write concisely. Constantly on the lookout for opportunities to enrich my research and nudge me forward in my scholarship, she has shown me to doors that I never knew existed. Thank you, Martha.

I am very grateful for the longstanding support of my three other dissertation committee members who helped shape the foundations of this book. Mary Kelley has always lent her sharp eye and perspicacious mind to my project. Like Martha, she saw me through graduate school from my first semester at the University of Michigan, and I cannot imagine such a rewarding and productive intellectual experience without her. Her joy, energy, and encyclopedic knowledge inspired countless more hours reading in the stacks and archives. Alongside her, Kristin Hass and Kevin Gaines each pushed me to refine my ideas, polish my prose, defend my thoughts, and think long and hard about the framing of my research. Their feedback has been as invaluable to this project as it has changed the way that I have understood people to see, interpret, and respond to the world around them. I thank each of my committee members for their direction and encouragement.

Numerous institutions made this book possible through their generous

financial support. The University of Michigan, Andrew W. Mellon Foundation, Ford Foundation, Woodrow Wilson National Fellowship Foundation, Social Science Research Council, and Salisbury University allowed me to conduct research at far-flung archives. These included the New-York Historical Society, American Antiquarian Society, Library Company of Philadelphia, Historical Society of Pennsylvania, Massachusetts Historical Society, Montana Historical Society, Historic New Orleans Collection, Cincinnati History Library and Archives, William L. Clements Library at the University of Michigan, Boston Public Library, Schomburg Center for Research in Black Culture, Connecticut Historical Society, Emory University, Moorland-Spingarn Research Center at Howard University, Swarthmore College, Haverford College, Cheney University, Presbyterian Historical Society, Smithsonian Institution's National Portrait Gallery, University Archives and Records Center at the University of Pennsylvania, Special Collections at the University of Manchester, the Bodleian Library at the University of Oxford, and Yale University's Beinecke Rare Book and Manuscript Library.

Curators and archivists were very generous with their time and resources. I especially thank Gigi Barnhill and Lauren Hewes, who made my time at the American Antiquarian Society exceptionally rewarding when I was there as a Jay and Deborah Last Fellowship recipient. At the William L. Clements Library, Clayton Lewis was always enthusiastic about my projects and went out of his way to show and discuss with me more materials to aid in my scholarly development, and for that, I am very thankful. At the Library Company of Philadelphia, Phil Lapsansky and Erika Piola kept me busy studying and searching for primary sources while an Albert M. Greenfield Fellow. Phil was incredibly generous with his research notes and set me on the path to research more deeply the art and activism of Robert Douglass Jr. Erika, Krystal Appiah, Rich Newman, and especially Erica Armstrong Dunbar supported my work a few years later as an Andrew W. Mellon Postdoctoral Fellow at the Library Company of Philadelphia's Program in African American History. Erica has always been there to offer advice on this book and to foster my growth as a historian. What's more, she has been a tireless advocate of many other rising and established scholars. The other fellows at the Library Company of Philadelphia, especially Kabria Baumgartner, Emily A. Owens, and Emahunn Raheem Ali Campbell created a productive space for ideas and friendship. Many thanks to the archivists at the Emory University's Manuscript and Rare Book Library for their help guiding me to several of the sources in this book during a short-term fellowship I received

one sweltering Atlanta summer. There, Randall Burkett shared documents and his passion for my project. Ann Shumard was incredibly generous to meet with me and let me view her personal archive of materials at the National Portrait Gallery. She directed me to periodicals unknown to me and helped provide more context from her exhaustive knowledge of early photography. A summer fellowship from Salisbury University also enabled me to explore the connections to England that several of the African American activists in this study forged abroad.

I joined the Department of History at Salisbury University in 2015 and am appreciative of the warmth and friendship I have found in Maryland. I am grateful to my History colleagues and many others across campus who have created a welcoming environment that takes seriously the ways that we can inspire students to improve our world. Passion comes from the heart and there is no shortage of it here.

The generosity of those at Salisbury University allowed me to accept a Ford Foundation Postdoctoral Fellowship. It has brought me in touch with brilliant scholars, challenged me in the best ways, and allowed me the time and space to finish this book. Michele Mitchell's guidance and constant support for me and my research was invaluable during my year working just a few New York City streets away from one of the main subjects in this book. The incredible resources at the Schomburg Center for Research in Black Culture and other New York Public Library locations provided more than just access to manuscripts, periodicals, and prints. The Stephen A. Schwarzman Building became my home away from home. It was an immensely inspirational place to conduct research and write under its gilded ceilings during my year in New York and for many summers and shorter stays before that.

Before graduate school, my mentors and professors at Williams College helped set me on the path to a life of teaching, researching, and writing history. The Mellon Mays Undergraduate Fellowship changed my life and gave me the hope and guidance that I needed to pursue a life in academia. Words cannot fully express my gratitude to Molly Magavern, Charles B. Dew, and Gretchen Long for their unwavering support of me and the passion for research that I developed in college. All should be as fortunate as I have been to know and work with them.

In the early stages of this project, my friends and colleagues at the University of Michigan provided the friendship and academic fellowship that sustained me during graduate school. I am grateful for the ongoing conversations, academic and otherwise, that we have continued over the years. Thank you, Ronit Stahl, Marie Stango, Aaron Boalick, Trevor Hoppe, Rabia Belt,

Joseph Cialdella, Millington Bergeson-Lockwood, Kara French, Cookie Woolner, Katie Rosenblatt, Lissy Reiman, Amanda Hendrix-Komoto, Holly Rapp, Scott de Orio, Maxime Foerster, Liz Papp Kamali, and Frank Kelderman.

Many additional people have offered their feedback on the text and ideas recorded in these pages. Special thanks are in order to Erica Ball, Randy Browne, W. Fitzhugh Brundage, Jasmine Cobb, Kathleen Diffley, Marcy Dinius, Benjamin Fagan, Sara Fanning, P. Gabrielle Foreman, Matthew Fox-Amato, Thavolia Glymph, Shelly Jarenski, Rashauna Johnson, Mitch Kachun, Barbara Krauthamer, Jessica Linker, Kya Mangrum, Mary Niall Mitchell, Richard Newman, Johanna Ortner, Wendy Wick Reaves, Manisha Sinha, Shawn Michelle Smith, Whitney Stewart, Nikki Taylor, Rachel Walker, and Nicholas Wood.

The staff at the University of North Carolina Press who saw this project through to publication helped bring to life the people and their lives on these pages. Chuck Grench, Dylan White, and Mary Carley Caviness deeply invested themselves in this project and kept it on track. Thank you to the manuscript readers who helped me finesse the material into its current form. Laura Jones Dooley, who copyedited the manuscript, was exceptional, simply put. My sincere thanks to you all for making this book a reality.

Thank you to my family members who have encouraged my decision to undertake this project. I aim to make you proud, and your encouragement has motivated me and will continue to do so. Finally, many thanks are due to Yariv Pierce, who has been my fiercest champion and editor. As this project grew, we have grown stronger alongside each other. Thank you.

VISUALIZING
EQUALITY

INTRODUCTION
Pictured Appeals, Social Reformers

In 1846, Abby Kelley Foster, the famed antislavery activist, spoke before audiences — some ardent supporters and others raucous opponents — about her belief in slavery's egregious barbarity. Between lectures in Philadelphia, she visited the daguerreotype studio operated by an African American activist, Robert Douglass Jr., whose deep commitment to expanding opportunities for black people mirrored Foster's. Having founded a literary society for African American men in Philadelphia, participated in antislavery societies, and lectured about and exhibited images he created during a transformative trip to Haiti just a few years earlier, Douglass welcomed the opportunity to work with Foster. Douglass was "anxious to give the world a correct transcript of the features of one so entirely devoted to the interests of humanity," he wrote. So he created a daguerreotype portrait of Foster and commissioned a lithograph to be made in its likeness. The "motive which . . . impelled [him]" to create the image was rooted in Douglass's desire to convince its viewers to support the end of slavery. "If in regarding your portrait a single spirit is encouraged to enter upon the same glorious, although arduous labors," he wrote to Foster, "or excited to action for the advancement of the great and Holy cause [of abolition] in which you are so indefatigably engaged I shall be amply rewarded."[1]

It was a powerful claim to suggest that the image could convert people to the cause of antislavery. Douglass's words testified to his belief in the persuasive power of images during the middle of the nineteenth century. The lithograph commemorated Foster's dedication to the antislavery cause and could motivate antislavery action when members of the public viewed her portrait in the privacy of their homes or for sale in shopwindows. Antislavery organizations had long experimented with strategies to persuade individuals

and governments to end the sale and trafficking of human beings. The use of imagery to advance the antislavery cause was well established by abolitionist organizations in both Europe and the United States.[2] Images could, and did, evoke empathy and compassion for the enslaved while they simultaneously enraged proslavery advocates who castigated images sympathetic to enslaved people and those who sought to liberate them. Douglass and other African American visual artists often worked with antislavery organizations to broadcast their visual arguments to end slavery in the United States. Moreover, these artists supported a wide range of movements to improve the lives of African Americans and created images that documented and broadcast the need to secure black rights. When these black cultural producers controlled visual technologies that portrayed members of their race, they fundamentally altered the corpus of imagery depicting black people.

For the black activists who created these images, the stakes were high. In the decades leading up to the Civil War, free black people throughout the United States understood their demands for safety, security, and equality to be aligned with enslaved people in the United States and abroad. Amid the daily reminders of racial discrimination and violence, they built institutions and established networks of allies that strengthened their communities and took aim at the forces that bound them. For generations, they refined numerous strategies to end slavery and expand rights for free African Americans that included writing petitions, holding public marches, organizing conventions, publishing literature, and producing images. During these struggles, they sustained and enriched communities that constantly confronted laws and social customs developed to maintain rigid racial hierarchies in nearly every realm of life. As the nation geographically expanded south and west, rights for free black people in many places contracted. Alarmed, African American activists and their allies adjusted strategies and adopted visual and print technologies that could aid them in their cause.

This book brings together the visual production and activism of black image-makers who aligned themselves with the process of expanding black rights. *Visualizing Equality* investigates how these understudied and nearly forgotten artists produced images that challenged stereotypes of African Americans. Envisioned as advocacy and designed to sway the hearts, minds, and actions of viewers, these images underscored the brutalities of slavery, promoted black respectability, and celebrated black leadership. These activist producers of visual culture not only intended to change *what* people saw relating to race but also instructed *how* audiences should see it. Technological developments in imaging dramatically changed the very ways that

people viewed and understood their world during the middle decades of the nineteenth century. More specifically, the creation of the daguerreotype, the proliferation of the lithograph, the revival of the moving panorama, the emergence of the illustrated newspaper, and the invention of cartes de visite enabled people in the United States to see and participate in social reform movements in new ways. Each development offered a new tool to produce activist material. Each presented these black activists with broader audiences to persuade. Each provided a different experience for viewers and collectors of these images. The black artists whose lives populate this book quickly seized these technologies and mobilized the popularity, desirability, and unique capabilities of each. They also created visual materials not intended for, or used in the service of, racial equality; this study focuses on their images tied to their racial justice campaigns. They recognized that each visual document circulated in different spaces, reached different audiences, and extended different tactile and other experiential interactions to those who encountered their images. The dynamic range of materials that African American activist artists marshaled in service of campaigns to advance racial equality altered the nation's visual landscape, which was riddled with racial caricatures, satire, and other misrepresentations that empowered and inculcated racism.

Studying the works of these black cultural producers expands our understanding of the arsenal of strategies African Americans drew upon in the service of increasing black rights. Historians have made clear that African American activists played critical roles in campaigns to end slavery and increased the rights of free black people. Numerous historians have broadened the chronology of antislavery activism and detailed the waves of and rifts between African American abolitionists and their contemporaries, yet the role of black artists who adopted visual strategies to realize the freedoms they championed has largely gone unexamined.[3] This study forefronts visual documents created by black activists and expands the scope of black activism in the service of several campaigns to secure rights for African Americans. For example, one of the founders of the Philadelphia Female Anti-Slavery Society, Amy Matilda Cassey, circulated her friendship album among her northern abolitionist friends who inscribed their poems, drawings, calligraphy, and paintings with messages of abolition and female friendship. This source, and the three other known friendship albums belonging to other nineteenth-century African American women, document the networks of friendship that these women sustained. But they also evidence the ideas that bound together many activists—women and men, black and white—

who propelled numerous black and women's rights campaigns forward. The battle for black rights not only took place at marches, political conventions, and benevolent societies but included print and visual culture created and disseminated throughout the United States by African Americans.

Although the wide circulation of images and people accentuates the persuasive power of visual culture, analyses of local conditions illuminate the circumstances that engendered African Americans' artistic production. For example, Patrick Henry Reason's education at the New York African Free School, his participation in benevolent societies, and his activism to expand free black men's suffrage in New York all provide flashpoints to study his political ideas, activist networks, and image production. The vibrant black community in Philadelphia similarly nurtured the development of Robert Douglass Jr., whose connections to prominent antislavery leaders, literary societies, and religious organizations' members supported his visual work. Similarly, James Presley Ball built a thriving photography business in Cincinnati and benefited from the city's meteoric rise as an economic capital of the West. *Visualizing Equality* engages with a deep and broad scholarship that examines African American communities in these locales to widen our understanding of black business, leadership, and political networks.[4] The mutually constitutive political and cultural work undertaken by African American image-makers offers scholars a richer understanding of strategies to secure black freedoms.

While at times intensely local, this is a book about African American visual material that extends nationally and well beyond the United States. Travels to European, African, and Caribbean countries indelibly shaped many artists' activism and visual production. These journeys developed their racial worldview as they entered debates about black emigration and the promises of black freedom that Haiti and Liberia represented. In addition to the religious, governmental, and organizational debates over emigration about which scholars have written, African American artists' images became yet another cultural site upon which dialogues surrounding the promises and pitfalls of black emigration unfolded.[5] Other artists seized the opportunities afforded by international travel to advance their activist networks with prominent antislavery leaders in the United States, England, and Scotland. Still others strove to increase international pressure for, and support of, the end of slavery in the United States. Examining their transnational activities elucidates the triangular relationship between political activism, visual production, and international travel out of which arose various campaigns to end racial inequality.

This book bridges the scholarship of abolitionism and visual culture to show how African Americans themselves crafted images to advance racial equality in the nineteenth century. Scholars have demonstrated the importance of print and visual culture in disseminating antislavery messages to make white Americans question the morality of slavery.[6] Abolitionists in the United States adopted and repurposed images of kneeling slaves used by British abolitionists in the eighteenth century to heighten the visibility of abolitionist sentiments in the United States. The long legacy of these images, as well as the ways in which differing historical contexts changed the meaning of iconic images, demonstrates the evolution of visual culture during the nineteenth century. Furthermore, people viewed more images and understood the world differently as imaging technology changed. Knowing this, black artists seized on these technological shifts and used them in the service of the abolition movement and other campaigns to secure freedoms for African Americans. Recognizing the power that new and reemerging modes of imagery enabled, these black activists adopted these imaging technologies and circulated ideas of people of African descent to larger audiences in ways that clashed with racial stereotypes. These images fundamentally alter our understanding of nineteenth-century black activism because they reveal the cultural-political work that black artists envisioned to engender sweeping reforms.

Visualizing Equality mobilizes scholarship that connects race and visual culture to show how black visual artists embedded political messages that championed black freedoms and countered racial stereotypes. Scholars of the nineteenth century have argued that studying race, images, and performance together can reveal the profound ways that images and performances altered how nineteenth-century white Americans viewed themselves as workers and as people of different races and ethnicities.[7] Scholars have examined the production of racial "knowledge" on the theater stage and in print culture that informed how Americans understood class and racial categories. The phantasmagoric conceptions of blackness generated in these cultural forms shaped broader conceptions of racial belonging and exclusion. Analysis of these negative portrayals of blackness is essential for understanding how the work of African American artists rejected these ideas and proposed alternative visions of African American identities and cultures. Although several white artists created images of black people without an eye toward racial caricature during the mid-nineteenth century, the African American activists whose visual production is examined in this book identified the power of images to influence viewers' understandings of race and

rights in the United States. They created many of these images and worked with others to broadly circulate these views to that end. This project engages other scholars' persuasive studies of visuality, or learned ways of seeing and understanding race, to underscore how black artists envisioned their visual production to revise how people viewed blackness, religion, and politics. The images produced by African American image-makers confronted and subverted these derisive attacks on blackness.

Although uplift ideologies became a centerpiece of some antislavery leaders, the black activist artists examined in this study leveled their charges largely at the institutions and governments that suppressed their rights to freedom.[8] The campaigns that these black activists waged with images, among other strategies to realize racial equality, sought to normalize and commemorate black achievement in the face of immense challenges. They appealed to the morality, religion, patriotism, and democratic ideals of their viewers. Their belief in the moralizing power of images, the ability of images to transform the beliefs and actions of their viewers, was not aimed at the most steadfast of racists; with a few important exceptions, their audiences mostly included white abolitionists, children, free black people, and other spectators at least somewhat sympathetic to their causes. Nothing in their writing or political activism evidenced a belief that the conditions faced by enslaved and free black people resulted from anyone but their oppressors. Augustus Washington and his experience in Liberia is an exception, yet it must be remembered that he left the United States because he believed that racism foreclosed his options. Believing that he could not conquer racial prejudice in this nation, he sought another. Like the waves of antislavery activism in the decades before the Civil War, the fight waged by these black activists was long in duration, uneven in its successes, and punctuated by periods of successive triumphs and setbacks.

Examining African American artistic production during the Civil War and Reconstruction permits a deeper understanding of the campaigns that African American activists supported. Scholars have demonstrated that images of black people became central to how the American public developed ideas about race and citizenship during the Civil War.[9] Left unaddressed, however, is the visual culture produced *by* African Americans *of* African Americans during this era and how black leaders envisioned visual culture produced by African Americans as transforming race relations in the United States. Black photographers such as James Presley Ball of Ohio and Edward Mitchell Bannister of Massachusetts practiced their trade during the

Civil War. They and many of the most prominent African American leaders across the country planned a national exhibition of African American art during the war. Editors of the *Christian Recorder*, the primary periodical of the African Methodist Episcopal (AME) Church, encouraged thousands of readers to take up artistic practices to encourage public recognition of black intellect. Black activist artists partnered with AME Church congregations and leaders during Reconstruction to document the successful acquisition of rights that engendered the election of black politicians. In doing so, they challenged viewers to imagine an increasingly attainable future that enabled and secured black rights. Studying the intentions and uses of African American image production adds significant contours to the scholarship of the visual culture produced during this era.

The social and political milieus of black artists' visual production are the driving force and interpretative frameworks of this book. With an eye to the evolving concepts of race and gender, scholars of visual culture have analyzed visual material as deeply influencing how viewers derived and created meaning in their lives—and the lives of others.[10] Scholars of visual culture have shown that "discourses circulating outside art objects circumscribe their significance."[11] The notion that these discourses—influenced by one's exposure to and engagement with them—affected one's understanding of race, class, gender, and numerous other topics and ideologies powerfully exhibits visual culture scholar Martin Berger's belief that social context fundamentally structures how one views images. A study of the discourses outside and within African American communities is essential for understanding the cultural work of black-authored images during the eras covered in this book. Situating black artists within the debates that they participated in about black voting rights, the abolition of slavery, and the role of black literary societies reveals the strategies that black artists adopted with the hope of securing freedoms and equality for black Americans.

Recent scholarship has examined how images displayed and disseminated nineteenth-century debates concerning African American freedoms.[12] These works demonstrate the growing scholarly recognition that nineteenth-century African Americans understood well the power of images to shape perceptions of race and project aspects of one's racial identity. Though many scholars have written about black *subjects* in early photography, few have written about black *image-makers* in the nineteenth century.[13] *Visualizing Equality* analyzes a broad range of visual forms to study how each served distinctive functions for specific racialized debates and cultural contexts. This

enlarged visual terrain captures more divisive issues that African American cultural producers engaged in their work and allows historians to trace the changing leadership roles embodied by these black artists.

To do this, *Visualizing Equality* marshals a broad variety of sources to gauge and interpret viewers' reception of the images produced by black visual artists during the nineteenth century. I scrutinize exhibition reviews, newspaper articles, diary entries, legal documents, and personal correspondence to re-create the visual world that surrounded the people and communities covered in this study. Historical documents testify to the intricate process by which images contoured the experience of life in the United States at a time when debates over the present and future of free and enslaved African Americans took center stage. Images and responses to them evidence how imagery became central to people's ideas about race, citizenship, and politics. Petitions, editorials, books, advertisements, and pamphlets provide context for discerning black artists' numerous intended audiences and the vehicles through which viewers encountered their work in a variety of spaces. Examining image and text together provides an essential method for determining how black activists and their allies sought to advance numerous campaigns to secure black rights. These diverse sources establish a rich historical context that reveals the intended uses of images as well as the multitude of ways that viewers understood and used them. When analyzing the relation between text and image, these sources point to the process by which black activists aligned their visual production with the racial politics that they practiced in places around the country.

This book begins in Philadelphia with the visual production and antislavery activism of Robert Douglass Jr. as Garrisonian abolitionism grew in power and revulsion. He began to produce images for public and private consumption that aligned with the popular imagery of the growing antislavery movement. Within the context of a culture that valued images as potentially instructive and transformative, Douglass's images and civic activities reveal his connections to many of the influential leaders and organizations of Philadelphia. The Douglass family helped fasten the ties that bound activist Philadelphia together as Robert came of age. There, he transformed his business into one that advocated for the end of slavery. Sketching out the worlds that Douglass moved through, this chapter follows his support for numerous campaigns for black rights. An extended stay in Haiti both inspired him and strengthened his resolve for the possibilities for black people in the United States.

Chapter 2 examines the images created by Patrick Henry Reason of

New York City during the 1830s. He transformed English antislavery symbols to fit the context of slavery in the United States and worked with the American Anti-Slavery Society (AASS) to circulate his images to droves of readers. His engravings of respectable escaped slaves depicted alternative ways to visualize fugitive slaves and people of African descent more generally. Thousands purchased the books that featured his images. Individually and collectively, these representations of black people simultaneously rejected scientific racism and drew upon the tactic of moral suasion—an approach that employed ethical and moral principles, often closely tied with religious teachings and sentimental culture—to encourage viewers to join the cause of abolition. More than that, Reason's images repudiated the broader ideas that circulated widely in derisive images of African Americans. Large numbers of women, men, and children viewed his images featured in antislavery works, and their reception reveals how viewers understood them to advance the antislavery movement.

The third chapter analyzes the process by which Robert Douglass Jr. and Patrick Henry Reason expanded their activist networks through their artistic production during the 1840s. Paralleling the rise in leadership roles for African Americans in antislavery circles, Reason joined the campaign to secure voting rights for free black men in New York, and both he and Douglass protested plans of black emigration. Douglass returned from Haiti and traveled to England, where he strengthened his antislavery networks and developed his artistic skills. The images and lectures resulting from Douglass's Haitian trip celebrated the Caribbean country as a model for black leadership, self-determination, and the building of black cultural institutions in the United States. The images he completed in Haiti communicated the possibilities of realized black rights, leadership, and political organization that might serve as an example for those in the United States. Likewise, Reason created prints of black leaders to highlight domestic black achievement and provide role models who worked to overcome and eradicate racial prejudice. Their adoption of different business strategies and new visual technologies provided avenues to critique and correct racial inequalities.

Chapter 4 moves between the United States and England to analyze the antislavery work exhibited by three black men—James Presley Ball, William Wells Brown, and Henry Box Brown. Following the moving panoramas of slavery that they toured to exhibit the horrors of enslavement and fund antislavery campaigns, this chapter situates the medium of the moving panorama as another popular media form that black activists seized upon to advance their cause. As the visual medium regained popularity in England and the

United States for its landscape views, these black men centered the experiences of enslaved people in their repurposed panoramas for the masses of men, women, and children who viewed them. The reception of these popular panoramas demonstrated the educational and inspirational components to these works. Each of these three moving panorama purveyors implemented different business strategies to attract attendees and convince them of the authenticity and veracity of their antislavery works. Like the African American producers of other visual media, they drew on an established network of activists as they toured towns and cities in the service of the abolitionist cause. Records from these African American exhibitors, advertisements, and attendees reveal the complex process of encouraging viewer expectations, fashioning visual experiences, and interpreting the displayed information. Activists knew that the freedom of millions was at stake.

The fifth chapter explores the life and work of Augustus Washington, who envisioned more rights and freedoms than those available in the United States. Anticipating a future in the United States bound by racial restraints, he packed up his successful photography studio in Hartford, Connecticut, and emigrated to Monrovia, Liberia. Washington worked closely with the American Colonization Society (ACS) to convince black Americans to leave their homeland for Liberia and attempted to provoke viewers of his images to envision the potential of black rights in the United States that he enjoyed in Liberia. Washington's images promulgating black Liberian political leadership and economic promise abroad offered a vision of freedom that belied a hierarchical, and often oppressive, Liberian society. In the wake of the Fugitive Slave Act of 1850, his images brought into focus the debates among African Americans about the uncertain, and perhaps imperiled, future of black people in the United States.

The sixth chapter analyzes the technological revolutions that dominated representations of black people during the Civil War. Illustrated periodicals visually cataloged the war and depicted the trauma and uncertainties experienced by African Americans. At the same time, black photographers advanced their own views and ideas about the possibilities of emancipation and African American military service. Their images documented their lives with visual touchstones common to those that depicted white Union soldiers and subverted racial stereotypes that dominated the visual landscape at the start of the Civil War. The production of these views coincided with numerous black leaders planning a national exhibition of African American art and industry. They proposed an unprecedented display of black artistic and mechanical production to convince people of all races of black intellect

and to improve race relations. The exigencies of and opportunities seized by fugitive slaves and enlisting black men created by the Civil War appeared in the visual production of African American activists.

The final chapter examines how African American activist artists adopted new strategies to realize the promises of Reconstruction and often part-nered with the AME Church leadership to accomplish these. Black image-makers used their reputations and successes to encourage opportunities for, and exercise newly granted rights to, black people after the Civil War. They funded and otherwise advocated black education, supported black Recon-struction politicians, and celebrated constitutional amendments; one even attained political office. They crafted images that revealed their investment in the visual culture of John Brown, black Union veterans, and the future of Cuba. Just as these black activist artists backed the AME Church, so the AME Church leadership repeatedly encouraged its readers to collect, reflect upon, and draw inspiration from their images and the messages that they commu-nicated.

Visualizing Equality expands the terrain on which political arguments took shape, unfolded, and reached audiences during the middle decades of the nineteenth century. By layering analyses of African American activists' images with their racially progressive civic activities, this book elucidates how these individuals tasked themselves with producing and disseminating knowledge about blackness that renounced dominant stereotypes of black people. The artists intended, and diligently worked to achieve, sweeping social change resulting from the internalization of the messages that their images communicated. As questions about Garrisonian antislavery tactics, emigration to Haiti and Liberia, the Fugitive Slave Act, black Civil War mili-tary service, and the growth of the AME Church engaged Americans, black artists used their skills to stake out their positions. With their visual interven-tions in mind, this book encourages us to reimagine the nineteenth-century production and consumption of print and visual culture. Using various methods and enjoying varied success, African Americans made the world they envisioned.

GRAPHIC EXCHANGES
Robert Douglass Jr.'s
Activism in Philadelphia

Robert Douglass Jr.'s mind raced on his journey from the Pennsylvania Academy of the Fine Arts in 1834. As he walked the uneven streets of Philadelphia between freedom and slavery, the stinging personal rejection that he had faced just minutes before proved powerful for the young, gifted, free black artist. His spirits must have soared months before when the prestigious museum and school of fine arts accepted his painting *Portrait of a Gentleman* to be exhibited in the same hallways as some of the greatest European and American master painters and artists.[1] Perhaps it was William Lloyd Garrison, the revered and reviled abolitionist, or maybe James Forten, the wealthy black Philadelphian activist, that Douglass recorded with his paintbrush.[2] Nevertheless, the occasion was momentous; his painting was the first completed by an African American displayed in those hallowed galleries.[3] Yet, as he attempted to visit his exhibited painting, officials prevented him from entering the building. He was a black man who wished to browse its collections with white patrons present.[4] Turned away on account of his race and institutionalized racial segregation, Douglass recalled this experience with racial prejudice for several decades in published letters and advertisements as a means of encouraging patronage of his work. Not one to concede defeat, Douglass only became more involved in campaigns to end racial discrimination throughout his life.[5]

The images created by Robert Douglass Jr. during the 1830s signaled the broad range of antislavery activity facilitated by black men and women. His black-authored images affirmed the dignity of African-descended people in ways that have largely been unexamined by scholars, who have focused their

studies primarily on white-authored visual materials.[6] Scrutinizing Douglass's artistic production and its instrumental role in advancing the abolitionist movement reveals the networks of black and white leadership while also providing a fuller view of African American activism during the 1830s. The cultural milieu that shaped, and in turn was shaped by, Douglass through the technologies of print and visual culture contributed to understandings of race and strengthened the wave of antislavery activism during the 1830s. He applied his broad artistic, political, academic, and international education to his profession as a visual artist and created images that challenged black stereotypes by overlaying visual themes of black respectability, dignity, and intellect. He also intended and designed his images to garner support for the antislavery movement. In doing so, Robert Douglass Jr. created images of black people and white abolitionists that challenged flagrantly racist messages presented to nineteenth-century audiences. This work doubled as a cultural weapon with which black artists like Douglass challenged stereotypes of blackness and produced counternarratives in the service of expanding rights for free and enslaved African Americans. As an activist and cultural producer with stakes in the representation of African Americans, Douglass both expanded and refined discourses of race in the antebellum United States. With Douglass exerting control over the means of visual production and racial representation, the struggle for racial equality in the nineteenth century begins to look different.

<center>THE VISUAL LANDSCAPE OF RACE
IN THE EARLY REPUBLIC</center>

Posted on public streets, collected for viewing at home, pasted to the ceilings of taverns, and printed in periodicals, images increasingly pervaded the lives of people living in the 1830s. Among these were images that perpetuated ideas of blackness as debased, comical, and inferior. Some of the most widely circulated and visible of these derogatory images appeared in the streets and inside parlors. In Boston, for example, several crudely printed images mocked free black Bostonians' annual commemoration of the abolition of the international slave trade in 1808. For decades following, these so-called bobalition prints derided African Americans by presenting them with improper speech, cartoonish bodies, and disproportionate clothing.[7] These images taught and reinforced racist ideology while worrying some African Americans, such as the Reverend Hosea Easton, who lamented:

Cuts and placards descriptive of the negroe's deformity, are every where displayed to the observation of the young, with corresponding broken lingo, the very character of which is marked with design. Many of the popular book stores, in commercial towns and cities, have their show-windows lined with them. The barrooms of the most popular public houses in the country, sometimes have their ceiling literally covered with them. This display of American civility is under the daily observation of every class of society, even in New England. But this kind of education is not only systematized, but legalized.[8]

Such images, "marked with [fabricated and misleading] design," taught the young and the old alike, regardless of class, that the fanciful exterior characteristics of African Americans revealed their allegedly interior, inferior state of mind. More specifically, they encouraged viewers to believe that African Americans were incapable of social graces, intellectually inept, and unworthy of the rights that white Americans enjoyed. These prints ridiculed African Americans' annual celebration that one avenue of slavery—the importation of slaves from abroad—had closed. Theirs was a tradition of individual and collective campaigns to secure the right of freedom, and such public displays were lampooned on parade routes and in print.[9]

The most popular of these derogatory images found in the home were the *Life in Philadelphia* prints created by Philadelphia artist Edward Williams Clay between 1828 and 1830 that mocked white Quakers and free black Philadelphians. Influenced by the people he saw in Philadelphia and the racist caricatures he viewed while in Europe, Clay created prints that communicated a cruel dissonance between African Americans' exterior bourgeois trappings and their interior ability to understand and embody genteel culture. For Clay, these black urbanites merely aspired to, but did not deserve, respect within the United States.[10] One of the figures in his prints, Miss Chloe, says as much (fig. 1.1). When asked how she feels in the hot weather, she responds, "Pretty well I tank you Mr. Cesar only I aspire too much!" Riddled with too many bows and flowers, the enormous hat perched precariously on Miss Chloe's head became an exterior display of her interior mental state. Clay's use of fragmented syntax, disproportionate bodies, oversized clothing, and other caricatured elements signaled to nineteenth-century viewers that black men and women merited a station in life that was less than that which they desired. In adopting the fineries of respectable society, such as the cane that Mr. Cesar holds and the fan and parasol that Miss Chloe clutches, black men and women, argued Clay, brought derision upon themselves because they

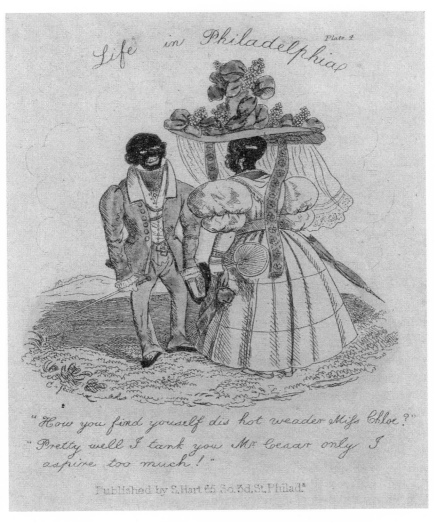

Figure 1.1. Edward Williams Clay, *"How You Find Yourself Dis Hot Weader Miss Chloe?" Life in Philadelphia* series, Philadelphia Set, 1830. *Courtesy of the Library Company of Philadelphia.*

wrongly assumed that they could inhabit the genteel society that such accoutrements denoted. Though they might attempt to replicate it, their failures further marked their status as outsiders from respectable genteel culture.[11]

During the 1830s, members of the public commonly understood images to possess the power to shape the minds and transform the sensibilities of their viewers. In a description published in *Parley's Magazine*, the benefits of engravings seemed endless. With a self-reported subscription base of

twenty thousand customers, the periodical proposed that its pages featured a plethora of images "selected not only with a view to adorn the work, but to improve the taste, cultivate the mind, and raise the affections of the young to appropriate and worthy objects."[12] More specifically, the magazine proposed that its images would transform those who viewed them into "better children, better brothers, better sisters, better pupils, better associates, and, in the end, better citizens."[13] The magazine carefully instructed parents and teachers: "Let children look upon the pictures, not as pictures merely; but let them be taught to study them. What can be more rich in valuable materials for instructive lessons than a good engraving?"[14] Didactic and persuasive, images could be instruments to shape young people into improved members of society. The instructive influence of images was not limited to children; the actions of several abolitionist institutions revealed that the ideas communicated by images could arouse strong reactions in adults as well.

Images proved especially provocative to abolitionists and those whom they hoped to convert to their cause. This included the circulation of antislavery images to stalwart defenders of slavery in the South with the hope of persuading them of slavery's barbarities. Abolitionists wielded images as weapons. They recorded their intentions for antislavery images and the reactions of proslavery supporters in the 1836 Annual Report of the Massachusetts Anti-Slavery Society. A member of the organization wrote that images functioned differently than did text:

> But the pictures! The pictures!! These seem to have been specially offensive. And why, unless it is because they give specially distinct impressions of the horrors of slavery? . . . Pictorial representations have ever been used with success, in making any desirable impression upon the minds of men, the bulk of whom are more immediately and thoroughly affected by a picture, than a verbal description. Why then should they not be used, in the exposure we purpose to make of our national wickedness? If any of them represent what does not exist, let the falsehood be shown and reproved. But with what reason or justice are we called upon to suppress the picture, so long as the original is allowed to defile our land?[15]

Abolitionists knew well that the power of images lay in their ability not merely to engage viewers but also to increase the exposure of the ideas that they contained. Operating with the belief that images could "more immediately and thoroughly" influence people than text, the Massachusetts Anti-Slavery Society attempted to incite abhorrence of slavery with pictures that

showed enslaved people suffering violence at the hands of slave owners. The writer indicated that these images reported the truths of slavery and, confident in their veracity, challenged naysayers to "let the falsehood be shown and reproved." Disproving the ideas conveyed in an image might be more difficult than producing an image that represented contrary views.

Those opposed to abolitionism produced their own images that condemned the idea of abolitionism. One print appearing in Boston around 1833 denounced the "fanaticism" of several antislavery leaders in New York. The foreground depicts three white abolitionists—Arthur Tappan, William Lloyd Garrison, and an unidentified man—who discuss the merits of purchasing linen produced without slave labor as an emancipated slave moves away from the group, dagger in hand, in pursuit of a flying insect labeled "Food." Directly behind the formerly enslaved man is a scene labeled "Insur[r]ection in St. Domingo! Cruelty, Lust, and blood!" that depicts black people using swords, knives, and an ax to murder white men, women, and children. As the text on the print warns, freeing the enslaved would "drench America in blood" as a result of a feared black massacre of white people in the United States.[16] Noting that "several of the principal streets are graced this week with a lithographic caricature of the formation of the New York City Anti-Slavery Society," the *Liberator* understood this caricature to have the unintended effect of aiding the cause of the organization: "It is a miserable affair—not worth the description. But miserable as it is, it will do our cause some work."[17] The malicious image, the *Liberator* implied, baldly revealed the racism of its creator and supporters. Furthermore, the hyperbolic language and alarmist fears that comprised the main thrust of the print's message cast its author and those who shared his ideas as extremist, overly reactive, and dishonest.

Both derogatory and affirmative images depicting African Americans underscored the belief that images could alter the way that people understood the multiple meanings ascribed to the ideas of blackness and abolitionism. As objects that documented the debates over abolitionism and free black people in the United States, these images reveal how their creators used antebellum visual culture to package and deliver ideas about race to audiences. Scholars have mined white-authored images for information about racial attitudes in the United States and in the process have shown how these sources reveal a wealth of information about the lives of enslaved people.[18] Furthermore, scholars have shown how images of African Americans created during the half-century after the American Revolution provide windows into evolving ideas, including colonialism, biological racism, inter-

racial sex, and white superiority.[19] Fewer scholars have studied visual materials created by black men and women during the early nineteenth century. Those who have done so argued that African American artists documented the social history of African Americans and employed religious imagery to stress the benefits of abolition and the altruism of Christian teachings.[20] Images, in short, became a contested terrain on which numerous stakeholders supported their positions because they knew that viewers invested images with the ability to be persuasive, truthful, and educational. They also understood images to be sources of comedy, satire, and caricature prone to exaggeration, distortions, and falsehoods. When adding the variable of race to the visual equation, the politics of these images became exponentially more complex and sometimes explosive. Few Americans knew this better than those who called Philadelphia home.

BLACK PHILADELPHIA

Douglass's expulsion from the premises of the Pennsylvania Academy of the Fine Arts illuminated the circumstances facing black Philadelphians, regardless of their access to capital, in the City of Brotherly Love that had developed over centuries. Enslaved people labored in and around what would become Philadelphia well before William Penn made arrangements to establish the colony of Pennsylvania. Enmeshed in the transatlantic slave trade, Philadelphia's merchants maintained strong links to the Caribbean, Africa, and Europe as a means of supporting the economic success of the colony to the detriment of enslaved Africans and Native Americans increasingly dispossessed of their freedom and land. It did not take long for colonists to establish legal systems that strengthened slavery and weakened abilities to loosen its grip on the colony. A growing black community of free and enslaved people developed in a city that valued black women's domestic work and black men's versatility in positions that exacted other forms of manual labor. The exigencies of city life and the unrelenting demands of slave owners resulted in a minority of enslaved men and women living together as antislavery sentiments took hold in Philadelphia's Quaker community.[21]

The antislavery sentiments that developed within the Society of Friends challenged the institution of slavery well before the American Revolution. More than a hundred years before Robert Douglass Jr.'s birth at the beginning of the nineteenth century, critics such as George Fox and those Quakers who signed the Germantown Petition of 1688 openly criticized slavery. Armed with humanitarian and religious arguments, a minority of Philadel-

phia's Quakers became outspoken detractors of African slavery. Evidence of the controversial nature of slavery included Benjamin Franklin and Hugh Meredith anonymously printing Ralph Sandiford's 1729 book, *A Brief Examination of the Practice of the Times*, that condemned the slave trade with religious and humanitarian reasoning.[22] Members of the Society of Friends collectively recoiled at the more rebellious actions of Benjamin Lay, who complemented his 1737 antislavery harangue, *All Slave-Keepers That Keep the Innocent in Bondage*, with radical theatrics to motivate his fellow Quakers to liberate enslaved people.[23] His contemporary John Woolman took more measured approaches to convince Friends that slavery became the sin of individuals if tacitly or actively supported by any community. In the decades before the American Revolution, Woolman and Anthony Benezet, guided by their antislavery beliefs, opened schools for free black children and helped convince some of Philadelphia's Quakers to formally denounce slavery.[24]

The organization and activism of Philadelphia's antislavery Quakers directly shaped the contours of black freedom in Pennsylvania. The 1775 gathering that formed the organization of what would become known as the Pennsylvania Abolition Society (PAS) counted among its members many Quakers who adopted numerous strategies to end slavery and increase the quality of life of Philadelphia's free black population. After the debates of 1778 that resulted in the contentious, but successful, passage in 1780 of the Act for the Gradual Abolition of Slavery, the PAS challenged slavery in courtrooms, purchased and then liberated enslaved people, petitioned governments to end the international slave trade, and sought to prevent the kidnappings of the growing population of free black Philadelphians.[25] Their numbers grew exponentially with the in-migration of free and fugitive black people from southern states and the Caribbean, manumissions of enslaved people within the state, and the thousands of black Philadelphians born free after the passage of the 1780 gradual emancipation law, which initiated the prolonged death of slavery in Pennsylvania.[26]

The growing free black population contributed to the growth of autonomous and semiautonomous black associations in Philadelphia. Organizations such as the Free African Society aimed to train a growing cadre of black leaders by cultivating the practices deemed to be respectable by broader Philadelphian society.[27] And they succeeded. Members of the Free African Society such as the Reverends Richard Allen and Absalom Jones organized Mother Bethel African Methodist Episcopal Church and the African Episcopal Church of St. Thomas. Black churches, regardless of denomination, formed the bedrock of the city's black religious and cultural insti-

tutions. They provided sanctuaries for worship and from racial prejudice. Their legal incorporation, such as that of Rev. Richard Allen's Mother Bethel African Methodist Episcopal Church, also demonstrated the legal strategies that black Philadelphians and their allies used to protect and build their communities.[28] The legal acumen, knowledge, and connections bespoke the dexterity of Jones's and Allen's leadership. Black churches nurtured congregants' religious faith, but they also served and connected black Philadelphians to education and business. By 1841, black worshipers could select from more than a dozen churches that included a broad range of Protestant denominations to worship and build community.[29]

These religious institutions engendered secular and sacred organizations that aimed to expand the educational and professional opportunities available to free black people. Black women and men formed benevolent, literary, and auxiliary societies under the aegis of, as well as separate from, houses of worship. By 1838, at least eighty benevolent societies supported their black members in financial straits, prevented homelessness, and covered health costs during sickness.[30] Thousands of black Philadelphians claimed membership in and paid regular dues to these organizations, which rapidly increased in number during the 1820s and 1830s. In addition, numerous literary societies served as educational and leadership training grounds for black men and women as Robert Douglass Jr. came of age. In halls, church basements, and private homes, literary and debate societies counted hundreds of black men and women as members as they amassed libraries of books otherwise unavailable to many black Philadelphians.[31] The growth of these associations simultaneously demonstrated the ability of black Philadelphians and their white allies to contribute to their success even as it highlighted the inadequate options elsewhere.

Many of the broader patterns and the institutional revolutions that shaped Philadelphia's black community could be seen in the Douglass household. Barber, perfume seller, and purveyor of personal sundries, Robert Douglass Sr. acquired not a small amount of success after emigrating from the Caribbean island of St. Kitts to Philadelphia.[32] There, he met and married Grace Bustill, the daughter of the wealthy formerly enslaved man Cyrus Bustill, who had become prosperous as a baker and established a reputation as a champion of black opportunity.[33] Alongside Richard Allen and Absalom Jones, Bustill was among the earliest members of the Free African Society, a mutual aid society founded in 1787, and dedicated himself to black education by opening one of Philadelphia's first schools for African Americans. After Robert Sr. and Grace married in the African Episcopal

Church of St. Thomas, which counted among its congregants some of the wealthiest and most influential black Philadelphians, Grace maintained her religious and social ties to the Society of Friends that her parents cultivated. Grace and Robert Sr. raised six children, including the two who became best known in Philadelphia, Robert Douglass Jr. and Sarah Mapps Douglass. Grace and Sarah attended the Arch Street Meeting House, where they confronted racial discrimination but also befriended such powerful Quakers as Lucretia Mott and Sarah and Angelina Grimké.[34] True to Quaker teachings and the goals of numerous mutual aid societies, Grace eschewed the public display of wealth and welcomed the personal improvements of education and moral development.[35]

Grace Bustill and Robert Sr. used their social and economic capital to challenge racial prejudice. Robert Douglass Sr. claimed eight thousand dollars in wealth when the Pennsylvania Abolition Society gathered information about Philadelphia's black communities in its 1838 census.[36] He sat on Philadelphia's Provisional Board for the proposed College for Young Men of Colour along with other elite black Philadelphians Robert Purvis, James Forten, Joseph Cassey, and Frederick A. Hinton. These men, three of them immigrants from the French West Indies, South Carolina, and North Carolina, were also among his closest business associates.[37] Together they raised money for a collegiate school by which "the [African American] sons of the present and future generation may obtain a classical education and the mechanic arts in general."[38] The committee's mention of "the difficult admission of our youths into seminaries of learning, and establishments of mechanism" underscored several of the obstacles facing African Americans in Philadelphia, regardless of economic status.[39] More than a decade before, Robert Sr. helped organize the Augustine Education Society of Pennsylvania and was its treasurer.[40] Around the same time, Grace had partnered with one of the wealthiest black Philadelphians, James Forten, to establish a school for black children.[41] Most private schools in the city did not accept black students and public schools routinely turned away black children, so schools like those run by Grace and black churches' Sabbath schools offered avenues of education for black children and adults.[42] In fact, more black children in Philadelphia attended Sabbath schools in 1838 than common schools, and by the same year, at least ten black teachers operated tuition schools for black students, including Robert Douglass Jr.'s sister, Sarah Mapps Douglass.[43] She and her mother, Grace, extended their service to the black community in which they lived by serving for many years in leadership positions of the Philadelphia Female Anti-Slavery Society.[44] Grace also served as a vice

president at the Anti-Slavery Convention of American Women and aimed to improve black Philadelphians' literary and scientific education when she helped establish the Gilbert Lyceum.[45] This organization composed of black men and women first welcomed both the learned and the unlearned in 1841 for the purpose of educating its members on a range of topics that it sought to supplement with numerous lectures and a collection of minerals.[46]

Education, whether academic or professional, improved black Philadelphians' chances of securing a professional livelihood. Black churches and mutual benefit societies, along with a handful of white Quakers and organizations, educated a small minority of the city's black children and adults and with varying results. Philadelphia's public education for black children arrived years later, and with fewer resources, than the city-funded public white schools.[47] The schools remained racially segregated for generations. Even with this limited education, black Philadelphians faced limited occupational opportunities. Most commonly classified as unskilled laborers, black men in Philadelphia also worked as porters, draymen, coachmen, chimney sweeps, sailors, dockworkers, bricklayers, stonemasons, carpenters, barbers, grocers, confectioners, clothing retailers, and caterers.[48] These skilled positions offered entrance to the middle and elite classes, but the training required for many remained elusive because of employment discrimination. Apprenticeships provided a gateway into the world of skilled work, but racist practices largely excluded black men and women. Some managed to pivot around these obstacles. Black street food vendors plied their foodstuffs around the city, and black women wage earners could be seen throughout the city in domestic service roles.[49] A handful such as Sarah Mapps Douglass became teachers, while others worked with textiles as dressmakers, tailors, and milliners, the last of which Sarah's mother, Grace, claimed as a profession.[50] In these professions, the Douglass women were in close contact with black Philadelphians who patronized their business and educated their children.

Many dimensions of Robert Douglass Jr.'s life such as his family's wealth and manifold connections to black Philadelphians hinted at his exceptional qualities. Yet many social and economic barriers stemming from racial discrimination circumscribed opportunities for black Philadelphians. The benevolent societies and multipronged strategies to increase black education throughout the city existed, in part, because of a lack of resources resulting from prejudicial laws and social practices. Many of the city's black children remained indentured, and their masters did not allow them to be educated.[51] His parents being free, Robert Jr. was not saddled with this burden, and he benefited from an education and his family's social network as he grew older.

His occupation as an artist placed him squarely within the artisan class in which many black Philadelphians worked, though the proportion of black artisans shrank during the 1830s because of white employers' refusal to hire black apprentices.[52] During this decade, the most common occupations for black men included laborers, porters, dockworkers, and mariners.[53] The influx of migrants into Philadelphia inspired more employment discrimination as well as white riots that tore through black neighborhoods during the decade.[54] Douglass's struggles to overcome the obstacles created by racial prejudice, his dedication to black education, and his passion to end slavery became evident in his many activities throughout the city.

Douglass's early visual production outlined his professional trajectory as a young black businessman. His earliest known advertisements promoted his ability to produce signs and ornamentation for local businesses. He specifically publicized his production of smelted and gilded tavern signs in several city wards, but Douglass also welcomed personal business. Those interested in ascertaining his skill in 1830 could pay a visit to his studio at 23 Chestnut Street, in the black neighborhood of Cedar Ward, just a short walk from the Delaware River. There, they could study several examples of his painted landscapes and figures as well as a painting "intended as the head of the 'Roll of the Phoenix Fire Company.'"[55] The next year, he remained at his studio and evidently met with some success, as he called on potential clients to hire his services after assessing his signs hanging outside Philadelphia buildings.[56] His other commissions included painting the Pennsylvania State Seal[57] and a transparency titled *Washington Crossing the Delaware* when the city of Philadelphia hosted festivities marking the one-hundredth anniversary of President George Washington's birth. Displayed on the exterior of Independence Hall with other transparencies in February 1832, Douglass's painting greeted thousands of viewers who passed by the famous building and gathered for celebratory commemoration.[58] It is possible that among the throngs of onlookers, a young Philadelphian by the name of Emanuel Leutze, who would become famous for his painting *Washington Crossing the Delaware*, viewed Douglass's creation.[59] Not long after, Douglass offered for rent the house that he had occupied and moved a few blocks north to the southwest corner of Arch and Front Streets.[60] Moving his business to 54 Arch Street, where he advertised his skills as a portraitist, marked a return home. His parents lived there, a stone's throw from the Delaware River, and this was where his father had dressed hair and sold perfume since at least 1800 and where his mother sold her textile products.[61] Running his business from his parents' home reduced overhead costs and increased potential customers. Those who entered

the building as friends visiting his family members or as patrons looking for a haircut, beard trim, personal toiletries, or hats could find Robert Jr.'s visual production on display. Many of the most economically and socially influential black and white Philadelphians visited the family home that doubled as business headquarters, thus giving Douglass access to professional opportunities.[62] Within this urban and familial backdrop, Robert Jr. dedicated himself to championing the rights of free and enslaved African Americans.

Douglass pursued these goals by producing and disseminating abolitionist images. In 1833, Douglass created his earliest known image related to the antislavery movement, an oil painting of the abolitionist William Lloyd Garrison (fig. 1.2). In keeping with the tradition of oil portraits, Garrison himself almost certainly commissioned Douglass to paint his likeness. The location of the original painting is unknown, but we can envision it through the engraved lithograph of Garrison arranged to be sold at six New York City addresses and two Philadelphia offices. Garrison, a friend of the Douglass family, intimated in a letter written in the spring of 1832 to Robert's sister, Sarah Mapps Douglass, that he expected correspondence from Robert: "I hear nothing from my friend Robert; but I trust he continues to progress in his art, meeting with increased notice and encouragement."[63] Garrison knew well that much of the early support for his new antislavery newspaper, the *Liberator*, came from black households such as the Douglass family. African Americans, primarily northerners, comprised approximately three quarters of early subscribers of the radical periodical and increased subscriptions as agents.[64] Robert Sr.'s published approbation of Garrison's election to the helm of the newly founded American Anti-Slavery Society, the friendship between Robert Jr. and Garrison, and their shared abolitionist sentiments likely factored into Garrison sitting for the portrait, completed in 1833.

Invented at the end of the eighteenth century, lithography provided a visually precise medium by which to reproduce images. Made by drawing an image onto stone or metal with a water-resistant coating, covering the surface in ink, and pressing paper onto the surface to remove the ink from the water-receptive areas, lithographs required considerable time and skill to create, depending on the detail desired. Often created from other artworks that could not be reproduced in print, such as watercolors, oil portraits, and, later, daguerreotypes, lithographs could be reproduced in great numbers depending on the surface (stone or metal) chosen. The greater the number of reproductions, the less detail the resulting lithographs would retain, as the pressure required to impress the ink from the surface into the paper eventually wore away the surface design. Nevertheless, several thou-

Figure 1.2. Robert Douglass Jr., *William Lloyd Garrison*, 1833.
Courtesy of the Historical Society of Pennsylvania.

sand lithographs could be manufactured from the original surface and could be sold for far less money than such labor- and material-intensive mediums as oil paintings. Because of the fastidious skills required to create detailed lithographs, one needed several years of training from a master lithographer to learn the process. It is unclear who taught Douglass how to create lithographs.[65] The purchasing power and respectable reputation of the Douglass family no doubt contributed to young Robert's acquisition of this skill.

Using the lithographic form, Douglass increased not only the visibility of Garrison but also the abolitionist sentiments for which he was increasingly coming to be known.[66] The sympathetic portrayal of Garrison—attired in

respectable middle-class clothing and appearing intelligent with his glasses and high forehead—depicted the abolitionist during the year of the founding of the American Anti-Slavery Society. The production of this print added to the era's visual culture and highlighted the growth of abolitionist sentiments as marked by the dramatic increase in antislavery societies and publications. Douglass used the image of William Lloyd Garrison, whom people knew advocated for the rights of African Americans, as a proxy to support abolitionism and encourage its expansion. The medium of the oil painting, however, did not lend itself to circulation or mass visibility. Douglass's lithographs of Garrison could circulate to a larger audience, strengthen abolitionist sentiment, and earn revenue from multiple patrons.[67]

Douglass made and sold abolitionist images to support himself and the abolitionist cause. Displayed in shopwindows, as was common practice for print establishments during this period, images drew looks from passersby on the street. Exhibiting prints for passing members of the public represented more than a business strategy to attract customers; it engaged in the abolitionist strategy of moral suasion to win over the hearts and minds of the public. Sold for fifty cents in Philadelphia and at six New York City locations, including the AASS office, the print of Garrison included abolitionists among its audience.[68] Douglass advertised his lithograph of Garrison both in the *Emancipator* and in the *Philadelphia Inquirer*, a decidedly less antislavery newspaper.[69] He revealed two audiences he believed to be interested in the image when he addressed his advertisement in the *Emancipator* "[to] the People of Color and Their Friends." Later that month, he made no such appeal in the *Philadelphia Inquirer*, thereby demonstrating his desire for a large and diverse audience. The audience for abolitionist prints could be unexpected. One Mississippi slave owner, curious about abolitionism, purchased several pictures, including the portrait of Garrison, that he carried to the South.[70] Converting supporters of slavery to the cause of antislavery, of course, was one goal of abolitionists. Increasing the acceptance of abolitionist ideologies depended, in part, on heightened levels of visibility, circulation, and persuasive discourse. Douglass's print of William Lloyd Garrison provoked all three.

Douglass linked his visual production with his political interests. For example, he included his signature on an 1836 petition supporting the establishment of the State Anti-Slavery Society of Pennsylvania.[71] The circulation of the printed petition and appeals to gather more signatures reflected the increasing momentum and visibility of the abolitionist movement during the 1830s. In mentioning "the principles which actuated our fathers in 1780,

[that] have still a dwelling place in the bosoms of their descendants," the petition referenced the Pennsylvania legislature's passage in 1780 of the Act for the Gradual Abolition of Slavery. The act called for "every Negro and Mulatto child" born in Pennsylvania after the passage of the act who otherwise would have been a slave to become their master's indentured servant until they reached twenty-eight years of age.[72] Citing the racial prejudice that obscured the aspirations of free black men and women, the petition reminded its free readers to "remember [that] those who are in bonds are bound with them."[73] That Douglass endorsed a petition containing the words "In this present crisis, our cause is identified with theirs" helps pinpoint the causes he championed.[74] He and the other signers demanded immediate emancipation and the fulfillment of rights enumerated in the United States Constitution. Douglass aligned many of the underlying problems facing enslaved African Americans with his own as a free black man relentlessly subjected to the indignities of racism. He and other black Philadelphians endured employment discrimination, mobs terrorizing black neighborhoods, and a multitude of other forms of violence. Most survived these; many did not. Though free from the yoke of slavery, free black people were still burdened with socially and legally sanctioned racial barriers.[75]

Douglass continued his abolitionist involvement by joining the Philadelphia Anti-Slavery Society.[76] Several of its male members' wives, sisters, and mothers had founded the Philadelphia Female Anti-Slavery Society months before, including his mother, Grace Bustill Douglass.[77] Members sponsored speeches, hosted fairs, organized fundraisers, and drafted petitions to the state legislature.[78] An auxiliary of the AASS, the interracial society included members who proclaimed "the inalienable and natural rights" of free African Americans as they attempted to end slavery in the United States, halt the internal slave trade, and prevent the admission of states into the nation that did, or might, harbor slavery.[79] The organization resolved to "represent the enormities of the slave system," which "may be placed so vividly before [the public]" that they would legally remove protections for slavery.[80] In the coming years, Douglass wielded images in this service. These undertakings brought greater visibility to the abolitionist movement in Philadelphia and gave Douglass access to training and patronage that inspired his production of images.

While sustaining his involvement in several abolitionist organizations, Douglass furthered his commitment to African American education in Philadelphia. With Frederick Augustus Hinton, James Cornish, William Whipper, and five other black men, Robert Douglass Jr. founded the Philadelphia Library Company of Colored Persons in 1833. This literary society not only

cultivated knowledge of literature and science but inculcated debating and public speaking skills among its free black male members.[81] Just five years later, more than 150 free black men claimed membership and had collected approximately six hundred volumes for its library.[82] Like many institutions founded by members of the free black elite during this era, the society had a strong moral and social mission to improve aspects of their community deemed undesirable. Many believed that free African Americans in Philadelphia had "progressed in the melioration of their moral and physical condition," as evidenced by societies such as the Philadelphia Library Company of Colored Persons.[83] As one visitor described these debating clubs, "The discussions were conducted with a degree of spirit and propriety, and displayed a cogency and acuteness of reasoning and an elevation and elegance of language for which he was little prepared."[84] This and similar societies provided communal training that challenged widespread assumptions about black intellectual capacity. The visitor also reported that "the subjects of discussion generally relate to their own rights and interests, and frequently result in decisions from which the prejudiced mind of the white man would startle with apprehension. A change is rapidly coming over this people. They are now numerous, united, and bitterly conscious of their degradation and their power."[85] The three academic components that supported the Philadelphia Library Company of Colored Persons—"an adequate library, a reading room, and a debating society"—provided opportunities for Douglass to develop his ideas concerning black rights and extend these opportunities to other black Philadelphians.[86]

Like his training at the Philadelphia Library Company of Colored Persons, Douglass built upon a long history of abolitionist imagery. In 1787, Englishman Josiah Wedgwood designed a seal for the Society for Effecting the Abolition of the Slave Trade that prominently featured a supplicant slave with uplifted, shackled hands clasped together in prayer below the inscription "Am I Not a Man and a Brother?" The next year, Wedgwood sent several reproductions of this work to Benjamin Franklin, then president of the Pennsylvania Society for Promoting the Abolition of Slavery.[87] British abolitionists marshaled numerous iterations of Wedgwood's image to rally people for the cause of abolition from the late 1780s until slavery was declared illegal throughout the British Empire in 1833. Henry Thomson's 1827 oil painting *The Booroom Slave*, which depicted a kneeling woman of African descent clasping her hands in prayer and looking skyward, bore a striking resemblance to Wedgwood's seal.[88] Lithographs of *The Booroom Slave* circulated in the United States, and in 1833, the abolitionist author Lydia

Maria Child used it as the frontispiece of her book *An Appeal in Favor of That Class of Americans Called Africans.* The transatlantic movement of visual documents reveals how abolitionists in the United States adopted British abolitionist imagery to fit the context of slavery in the United States. Robert Douglass Jr. seized the opportunity.

Douglass drew inspiration from other artists and publishers to increase the visibility of abolitionism and the sufferings of enslaved African Americans. In 1834, he completed an ink wash drawing of a supplicant black woman in the friendship album of another black Philadelphian, Mary Anne Dickerson (fig. 1.3). Mary Anne and her sister Martina each owned a friendship album that they circulated to their closest friends and colleagues living in cities along the East Coast. Their friends wrote notes, painted flowers and figures, and embossed the pages of these manuscripts with messages of sentimental friendship, religious fervor, and political activism. These albums highlight the various networks among black and white people of both genders.[89] A member of the Dickerson family believed that Robert Douglass Jr. should have the honor of writing the friendship album's introductory poem. The location and content of his image was critical: his rendition of a kneeling slave would be seen and studied by later recipients of, and contributors to, the album in the coming years of Mary Anne's life. Leaving one's mark in a friendship album, especially at the beginning of the bound keepsake, bespoke close ties and mutual respect.[90]

Douglass's image challenged the existence of slavery on moral and religious grounds by means of moral suasion. He strategically drew upon antislavery imagery and poetry to accomplish this. Douglass appears to have completed the ink wash drawing with either the frontispiece of Lydia Maria Child's *Appeal* or a reproduction of Thomson's painting close at hand, given the identical subject matter and position of the figure. Douglass included four lines of calligraphic text under the image. They read:

When the grim lion urged his cruel chace,
When the stern panther sought his midnight prey,
What fate reserved me for this Christian race?
A race more polished, more severe than they![91]

Taken from a longer poem composed in 1744 by an Englishman, William Shenstone, this excerpt addressed the violence of slavery and its advocates.[92] The pairing of the poem with the image chastised Christians who either owned slaves themselves or tacitly supported the institution of slavery by allowing its existence. Though Douglass wrote beneath the verses that he

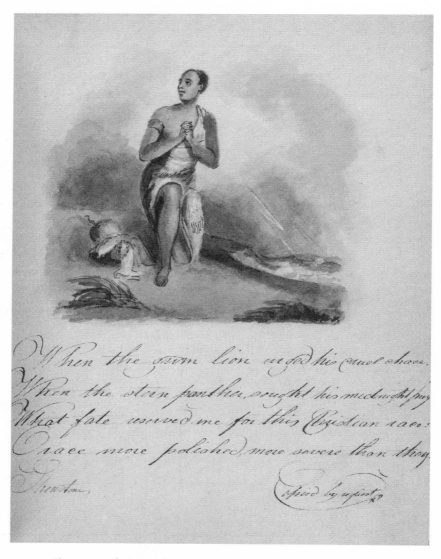

Figure 1.3. Robert Douglass Jr., *The Booroom Slave*, ca. 1834, Mary Anne Dickerson Album. *Courtesy of the Library Company of Philadelphia.*

had reproduced the image and poem "by request," he shared their attacks on slavery.[93] The poem, and Douglass's reproduction of this select stanza, highlighted the incongruity of Christianity as practiced by supporters of slavery. The kneeling enslaved woman laments the fate of her life at the hands of Christians and points to a paradox from which she and all other enslaved people suffer: the "polished" and professed morality of Christians, yet their

Graphic Exchanges

ability to allow and support the "severe" institution of slavery. As men and women active in the abolitionist movement, those who viewed Douglass's entry in Mary Anne Dickerson's friendship album readily understood the plight of enslaved African Americans. For free African Americans, Douglass's image of the innocent and persecuted African woman paralleled their existence as marginally free people who often fled violent white mobs and battled legal incursions on black rights.

The inscriptions in Mary Anne Dickerson's friendship album demonstrated the power of print and visual culture to connect activists across long distances. Many prominent activists in Philadelphia, New York City, and Boston, including William Cooper Nell, Charlotte Forten, Ada Hinton, Sarah Mapps Douglass, and Arnold Buffum, inscribed their messages in Dickerson's album. Poems such as Robert Burns's "Rights of Woman" appeared alongside detailed flower watercolors as friends and family members left their mark in her friendship album over several decades. Douglass penned an original poem introducing the album to its future viewers and contributors as well as producing the kneeling slave image popular in antislavery visual culture. His multiple entries at the beginning of the friendship album's life indicated a close friendship with Dickerson or her immediate family members. Her father, Martin, had freed himself from slavery and worked as a nurse in Philadelphia until his death a few years after Douglass notated the friendship album.[94] Her mother, Adelia, worked at the Locust Street Theatre.[95] Approximately twelve years old at the time Douglass added to her friendship album, Dickerson may have encountered the poem in the classroom of her teacher, Sarah Mapps Douglass, who was well versed in abolitionist literature. Dickerson probably saw the image of *The Booroom Slave* and the text of the poem in one of the many copies of the popular Lydia Maria Child book *An Appeal in Favor of That Class of Americans Called Africans* published the previous year. Though Douglass does not reveal who requested the image of *The Booroom Slave* and the copy of the Shenstone stanza, it was probably Dickerson because she owned the friendship album. The request demonstrates a previous knowledge of both the poem and the image. Robert Douglass Jr.'s introduction, wishing that "no misfortune . . . Befall thy Lady" and hoping that those who would write in the album would take up "the pen of Genius . . . [to] compliment" Mary Anne, reveals that Douglass wished for Mary Anne to become better known within the networks of prominent individuals through her album.

Douglass used Mary Anne's friendship album as a platform to reach various networks linking elite free black men and women in populous east-

ern cities. Knowing that other contributors to the friendship album would later see the messages of abolition that she requested, Douglass's art spread the message of abolition to her friends and colleagues, not all of whom were ardent abolitionists. Douglass communicated the racial and religious politics in *The Booroom Slave* to individuals—Amy Matilda Cassey, William Cooper Nell, Ada Hinton, and Sarah Mapps Douglass, among others—who later received Dickerson's album for perusal and inscription. Through his abolitionist art, Douglass aligned himself with other prominent Philadelphians who believed deeply in the cause of abolition and the rights of free black people. For example, Amy Matilda Cassey and Sarah Mapps Douglass served on the committee of the Philadelphia Female Anti-Slavery Society together. Born into an elite New York family, Amy Matilda married the wealthy black businessman Joseph Cassey a few years before he and Robert Douglass Sr. sat together on the Philadelphia Provisional Board in 1831 to plan a manual labor collegiate school for African American youth. Another inscriber, Ada Hinton, also had ties to the Douglass family. Her father, Frederick Augustus Hinton, had served on Philadelphia's Provisional Board with Robert Douglass Sr. Frederick Augustus Hinton and Robert Jr. had also founded the Philadelphia Library Company of Colored Persons the year before Robert Jr. painted *The Booroom Slave* in Mary Anne Dickerson's friendship album. Artistic production and racialized political engagement interlaced Robert Jr.'s world.

The 1837 publication of a poem about Douglass's portraits of abolitionists testified to the provocative power of his images related to abolition and the artistic skill he wielded to achieve such ends. That year, two antislavery newspapers published the poem "On Seeing the Portraits of Abolitionists Painted by R. Douglass Jr." In the poem, the author, "L.A.," detailed the moving experience of viewing Douglass's portrait of Elizabeth Margaret Chandler, the Quaker abolitionist author active in Philadelphia before she moved to Michigan in 1830. There, Chandler established the Logan Anti-Slavery Society before dying three years before the publication of the poem. Its sentimental lines read, in part:

Who can believe the limner's art
Can catch such motion of the heart?
But see where Genius' power confess'd
Portrays the feelings of the breast;
Gives thrilling language to the eye;
And to the parted lip—a sigh![96]

The poem applauds the portrait and conveys the emotions elicited by its execution. Though only the portrait of Chandler is specifically referenced (an asterisk identifies her as the "pure sainted spirit" celebrated in verse), the poem's title makes clear that Douglass had painted several images of abolitionists. On a much larger scale than the friendship albums maintained by Philadelphia's black women, these newspapers circulated the news of Douglass's abolitionist work within and beyond his home city.

DOUGLASS AND THE PROMISE OF HAITI

No fewer than two weeks after the poem celebrating Chandler appeared in the *Constitutional Advocate of Universal Liberty,* Robert Douglass Jr. announced his plans to travel to Haiti, the first black republic in the Western Hemisphere. There, he hoped to gain artistic inspiration and patronage. Just four days before Douglass set sail for Port au Prince, Sarah Grimké sent his sister, Sarah Mapps Douglass, a letter that read in part: "I hear Robt is going to Hayti to reside. I hope his parents can cordially approve it. What is he going to do there?"[97] The temporary condition of traveling to Haiti stood in stark contrast to the more permanent intention to "reside" in Haiti during the 1830s, especially for a free black man. The colonization movement had attracted scores of followers and detractors, both black and white, since well before the founding of the American Colonization Society in 1816.[98] Leaders on both sides of the Atlantic discussed colonization of African Americans to Sierra Leone and Haiti as a means of ridding the United States of slavery. Robert Douglass Jr. was not among the colonizationists; the people with whom he collaborated and the organizations in which he participated either rejected the notion of colonization or said nothing of it.

Douglass believed Haiti to be a country of promise, that is, one that held the possibility of recognizing his artistic talent without finding fault in his race. Black Philadelphians knew well the conflicting reports about Haiti and the people living there, and they knew also that whatever the difficulties were in living there, antiblack racism would not constrict every facet of their lives. In this place, Douglass hoped to find more people to sponsor his artwork. Departing the port of Philadelphia on the afternoon of November 27, 1837, Douglass traveled with two fellow abolitionists, Lewis Gunn and Charles Burleigh.[99] According to the black newspaper the *Colored American,* the three traveled to Haiti for the purpose of "collecting and imparting such information as may be alike, useful to the natives, and to the friends of humanity in this country."[100] Debates about African American emigration to

Haiti had raged in the decades before Douglass arrived in the Haitian capital of Port au Prince. Believed by many African American leaders to be an escape from the racism in the United States, Haiti became home to thousands of black emigrants from the United States. By 1830, support for Haitian emigration had diminished considerably among many early advocates owing to the country's environmental challenges, economic difficulties, and governmental disorganization, as well as strengthened activism to achieve freedom and equality in the United States.[101] After arriving in Port au Prince, Douglass mailed a letter to the *Liberator*, which published it alongside an editorial note that lent greater insight into his purpose for visiting the black republic. The newspaper described him as "a colored artist of great promise . . . hoping to find that patronage which was denied to him in this land of Christian prejudice, republican slavery, and democratic lynch law."[102] Black Philadelphians knew these to be true all too well after experiencing violent waves of white riots in the 1830s that destroyed black Philadelphians' homes, businesses, and institutions, and lives.

In contrast, Haiti provided Douglass with a variety of subjects for painting the opportunities accessible to black people. In the letter reprinted in the *Liberator*, Douglass recounted the extraordinary celebration of Haiti's independence day on January 1, 1838. His prose vividly communicates the joyous scene in which "people applauded," "trumpets flourished," and "artillery thundered" in an impressive display of black leadership and church spectacle in front of the Haitian Government House.[103] Fortunate to secure a prime viewing position in the orchestra, Douglass documented the activities of the military personnel and paid close attention to the clothing, decorations, and symbols featured in the ceremony. Douglass conveyed his deep impressions of the achievements of black people in Haiti. To his eye, "Every thing was conducted in the most perfect order—no drunkenness or fighting, as with us on the 4th of July. I had never seen so many soldiers, and the perfect regularity of their movements amazed me. They were well armed, and, with few exceptions, well equipped, and the appearance of the 'Garde National' or military horse and foot, was truly splendid."[104]

Douglass's laudatory words about the conduct and appearance of the Haitians subverted the negative conceptions of Haitians in popular culture. Especially during and after the Haitian Revolution, trumped up stories of Haitians' cannibalism and political incapacity made their way to the United States.[105] For example, upon learning that Douglass, Gunn, and Burleigh traveled to Haiti, one Charleston, South Carolina, newspaper wrote of their trip as a "silly errand" because "that fine Island is a sorry commentary on

abolitionism—*a complete waste and desert*, as all the world knows, since it has fallen into the hands of the free negroes."[106] Despite others' preconceptions, Haiti made an enduring and positive impression on Douglass. As he conveyed to his abolitionist readers in the *Liberator*: "What I have seen to-day, I shall not soon forget; for although too much of a peace man to approve of a military government, yet the height of what these people have arisen to, from the most abject servitude, caused in my bosom a feeling of exultation, which I could not repress."[107] Douglass assumed that many of those gathered with him were formerly enslaved people and had achieved a life that offered freedom, rights, and opportunities previously unknown on such a scale.

Though permanent patronage eluded him in Haiti, Douglass created nearly a dozen paintings that served him well after his return. His traveling companions, Gunn and Burleigh, left Port au Prince on April 17, 1838, and arrived in Baltimore on May 4.[108] Douglass stayed longer in Haiti and arrived back in Philadelphia from Port au Prince on July 1, 1839. The ship manifest for his vessel, the *Brig Finance*, listed his occupation as "portrait painter," and the paintings he brought back indicated as much.[109] If Sarah Grimké was correct, Robert Douglass likely stayed in Haiti to seek out artistic commissions and scenes and people to paint. During his stay, he visited many places, met with many of Haitians, and practiced the French language that he spoke and translated later in life. Once back in Pennsylvania, he displayed these paintings to audiences to educate them about black Haitian leadership and the black cultural institutions it engendered.

The Philadelphia to which Douglass returned, however, was a troubled place. Less than two months before his return, construction crews completed the massive Pennsylvania Hall, a structure funded by abolitionists to host "public discussions on all subjects that are not of an immoral and improper tendency." Contributions poured in from Philadelphia and beyond to purchase two thousand shares at twenty dollars each to complete a building wherein people could discuss pressing social issues. The topic of abolition stood above all others. Philadelphia newspapers praised the completion and intended purposes of the building, noted its interior specifications, and documented that its largest room could accommodate nearly three thousand people.[110] For a few short days, several abolitionists lectured to large crowds inside the neoclassical building's auditorium, including the two men who traveled with Douglass in Haiti: Lewis Gunn and Charles Burleigh. Delivering speeches on "Free Discussion" and "Indian Wrongs," Gunn and Burleigh joined William Lloyd Garrison, Lucretia Mott, Abby Kelley, and several others during the hall's opening ceremonies in speaking about many topics,

including abolitionism.[111] In the days leading up to Pennsylvania Hall's completion, whispers about the building constructed to harbor mixed-gender audiences and interracial relationships circulated throughout the city.[112] A boisterous crowd gathered near its front steps on the night of May 17, 1838, as Angelina Grimké Weld addressed the massive audience gathered for the Female Anti-Slavery Society meeting inside. Anticipating trouble, Philadelphia's mayor addressed the crowd as it grew in size and disorderliness. His words proved impotent. The mob burst into the hall, destroyed and pilfered its contents, and set it aflame. The fire destroyed the building. For the next few days, crowds harassed black Philadelphians, set fire to a black orphanage, damaged the African Methodist Episcopal Church, and threatened the existence of the *Public Ledger*, which printed articles denouncing the mob violence.[113]

The political disenfranchisement of black men throughout Pennsylvania marked another attack on the livelihood of African Americans. Momentum for the removal of black men's right to vote accelerated at the state constitutional convention in May 1837. Having returned from summer recess, constitutional delegates belonging to the Reform Convention met in October but had not decided to preserve free black male voting rights by the time Robert Douglass Jr. left in December. Vigorous activism by African Americans in Pittsburgh and Philadelphia in the form of petitions and the circulation of printed arguments to maintain black suffrage proved ineffective. Despite numerous appeals presented to the members of the Reform Convention, the option to disenfranchise all black men in Pennsylvania came before the people. On October 9, 1838, just three months after Robert's return, little more than a thousand-vote majority removed black men's ability to vote in Pennsylvania's public elections.[114] The new ban directly affected Robert Douglass Jr.'s family as well as their friends, business associates, and fellow church congregants. Two years before, Douglass signed a petition in support of the establishment of the State Anti-Slavery Society of Pennsylvania that read, in part, "In this present crisis, our cause is identified with theirs."[115] With the new state constitution enacted in 1838, the crises facing free black people in Pennsylvania more closely mirrored those faced by the enslaved people for whom they zealously fought.

PICTURING BLACK FUGITIVITY
AND RESPECTABILITY
IN NEW YORK CITY

Just two weeks before their May 14, 1838, nuptials, the radical abolitionists Angelina Grimké and Theodore Weld sent out invitations to scores of their closest family, friends, and colleagues (fig. 2.1). Marrying their antislavery politics and their commitment to each other, the couple selected as the letterhead of their wedding invitation an image of a kneeling slave engraved by the free black New Yorker Patrick Henry Reason. The recipients of their invitation were likely aware of the symbol and its artist because the letterhead had been in circulation among white and black activists since 1835 and the letterhead image had appeared widely in antislavery visual and material culture. Directly beneath the image read the description: "Engraved by P. Reason, A Colored Young Man of the City of New York. 1835." Held in Philadelphia on the same day of the dedication of Pennsylvania Hall before its destruction by a mob three days later, the Grimké-Weld ceremony included many prominent white and black abolitionists. Black Philadelphian artist Robert Douglass Jr. did not attend, but his Quaker sister and mother joined the gathering, which included William Lloyd Garrison, Lewis Tappan, and Maria Weston Chapman.[1] Gathered to witness their activist friends devote themselves to marriage, attendees knew well that the kneeling slave at the top of the wedding invitation graphically and textually demonstrated Grimké's and Weld's commitment to the antislavery cause. Several other artists had produced images of a kneeling slave since the English ceramicist and antislavery advocate Josiah Wedgwood made it popular beginning in 1787, yet Grimké and Weld selected an image that demonstrated support for a young black artist.

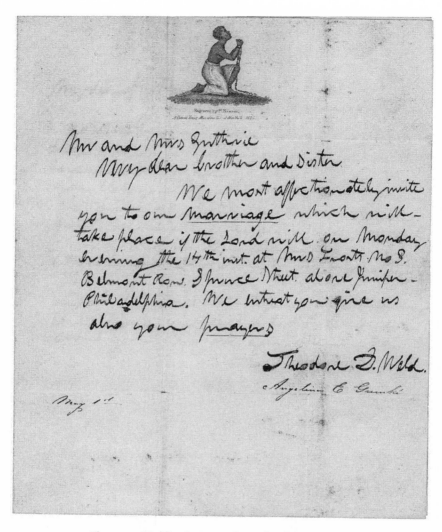

Figure 2.1. Wedding invitation from Theodore Weld and
Angelina Grimké, May 1, 1838, Weld-Grimké Family Papers.
Courtesy of the William L. Clements Library, University of Michigan.

The wedding invitation letterhead exhibited Patrick Henry Reason's
connections to the antislavery movement during the 1830s.[2] Reason contrib-
uted to the massive growth of antislavery literature and imagery produced
during this decade by creating numerous images of escaped slaves that anti-
slavery organizations published in books and periodicals. Seen by thousands
of men, women, and children, these images challenged racial stereotypes
that circulated broadly in newspapers, books, almanacs, and common con-

Picturing Black Fugitivity and Respectability

versation. Using art as advocacy, Reason believed fervently in the power of images to enable the moral and mental development of their viewers. He fashioned portraits of escaped slaves that projected black respectability and invoked religious arguments that subverted antiblack sentiments. Reason, and the antislavery organizations with which he partnered, hoped to expand and strengthen the abolitionist movement to engender the dismantling of slavery in the United States. The technologies and uses of print and visual culture that circulated Reason's images intensified the wave of antislavery activism of the 1830s.

BUILDING BLOCKS OF FREEDOM
IN EARLY NEW YORK CITY

Like nearly all northern states during the period of the early republic, slavery was a defining characteristic of New York when Patrick Henry Reason was born on the island of Manhattan in 1816. For nearly two hundred years, slave owners and their supporters deeply embedded the institution of slavery in the social, political, and economic development of the land that became New York.[3] Less than two decades before Reason's birth, New York passed its first gradual abolition law that produced similar tiers of slavery and freedom for African Americans that black people in other northern states experienced. Enslaved men and women toiled in every county of the state in 1800. In New York City just ten years later, the free black population more than doubled to nearly 7,500, so that the city's total black population of more than 8,900 people constituted nearly 10 percent of the city's populace.[4] Due in large part to black in-migration similar to that experienced in Philadelphia and perhaps an increased birthrate, the growing black population provided opportunities to build and strengthen institutions that served black New Yorkers.

Religious institutions formed the foundations for black communities in New York. Free and enslaved people had long worshipped at prominent Anglican and Episcopal churches in Lower Manhattan, and with the growth of Methodism closer to the outset of the American Revolution, slavery became a divisive subject. Methodism had been comparatively more attractive to colonial black New Yorkers than Anglicanism because of Methodist leaders' disapproval of slavery.[5] The 1780s and 1790s witnessed the growth of New York City's free black population and the rise of institutions that increasingly sought independence from white benefactors and leaders. The revolutionary spirit moved black leaders and congregants, but their finan-

cial and hierarchical ties to these powerful churches proved difficult to sever. Regardless of the denomination or church, black congregants found themselves relegated to lesser leadership positions and inferior spaces to worship in these white-controlled congregations. Tensions among church leaders proved numerous. By 1796, black New Yorkers founded African Methodist Episcopal Zion Church, and other black ministers soon helmed churches of the Presbyterian, Episcopalian, and Methodist Episcopal denominations. In most cases, the process that resulted in this leadership was long, difficult, and tenuous but eventually provided solid grounding for the growth of black institutions.[6]

Social reform campaigns and organizations benefiting New York City's black population sprang from these religious institutions. Numerous Episcopalians worked with Quakers to establish the New York Manumission Society, which helped secure the passage in 1799 of the Act for the Gradual Abolition of Slavery. In addition to pressuring state officials to end slavery, the society provided legal aid to black New Yorkers, advocated policies that increased slave manumissions, and organized boycotts of proslavery businesses. Mutual aid societies such as the African Marine Fund, the Benevolent Daughters of Zion, Wilberforce Philanthropic Society, and New-York African Clarkson Association strengthened community and social causes within the city's growing free black population. The act passed by the state legislature in 1810 to incorporate the New York African Society of Mutual Relief also demonstrated the legal knowledge and allies that black New Yorkers had cultivated. The society's ability to provide for the well-being of black New Yorkers in financial straits echoed one of the goals of the New York Manumission Society, which permanently established the first of several African Free Schools in 1787 to educate the city's free and enslaved black youth. These institutions provided a stepping-stone to skilled jobs for many black children who maneuvered around discriminatory employment practices.[7]

Employment discrimination and the long shadow of slavery limited the occupational options of black New Yorkers. As in Philadelphia, a small minority of black New Yorkers had accumulated or inherited wealth, but the vast majority of the city's black population worked in occupations that prevented them from accumulating substantial capital. Most black women labored as domestics, and by the beginning of the nineteenth century, many black people of both sexes lived in the homes of white New Yorkers. Black men commonly toiled as unskilled laborers and in the service trades. By the first decade of the nineteenth century, city directories listed only a small handful of black men holding various artisan occupations.[8] In addition, many black

men and women established themselves as caterers, seamstresses, food peddlers, master chimney sweeps, oyster purveyors, and a variety of other service occupations.[9] At least one avenue to remedy the economic disadvantages that black New Yorkers faced became considerably more difficult to navigate when New York increased property requirements for black men to qualify as voters while eliminating them altogether for white men in 1821.

Despite a multitude of legally and socially sanctioned inequalities, black New Yorkers fashioned a rich and vibrant community. Black people from southern states, the Caribbean, and Africa infused numerous cultural practices into the public life of the city. Large and colorful parades through the streets of Lower Manhattan became regular occurrences that displayed networks within black communities.[10] African Americans convened in New York and Philadelphia to discuss emigration to Africa, the Caribbean, and South America and began building the foundations of an emergent black nationalism.[11] While the public space of the city, religious institutions, and organizations linked black New Yorkers, Samuel Cornish and John Russwurm provided another medium for community building when they began publishing the nation's first black newspaper, *Freedom's Journal*. The timing of the periodical's inception, just a few months before slavery ended for most enslaved New Yorkers in 1827, was fortuitous, as the new editors made clear on the first page of the newspaper's first issue: "The civil rights of a people being of the greatest value, it shall ever be our duty to vindicate our brethren, when oppressed, and to lay the case before the publick."[12] African American activists including New Yorker William Yates claimed numerous rights, some of which flowed from claims of birthright citizenship and others of which derived from the language of natural rights circulating since the colonial era.[13] Armed with the resources, audience, and intellectual history of their struggle, the new editors of *Freedom's Journal* entered a flourishing and sometimes treacherous print culture in part because "from the press and the pulpit we have suffered much by being incorrectly represented." The periodical's editors made clear that African Americans "wish to plead our own cause. Too long have others spoken for us." As with the protracted end of slavery in Pennsylvania, indentured servitude and enslavement continued in New York for decades after the first gradual emancipation law in 1799. Degrees of freedom existed for black New Yorkers, but the ideologically, religiously, culturally, and economically diverse black population of New York City maintained and protected robust cultural institutions in the face of legal and customary race prejudice. It was within these expanding and contracting freedoms that Patrick Henry Reason came of age.

Patrick Henry Reason benefited from the groundwork of black education and activism established more than a generation before his birth. After his parents, Michel[14] and Elizabeth Reason, immigrated to New York City from Guadeloupe and Saint-Domingue, they baptized him in St. Peter's Roman Catholic Church in April 1816.[15] Many black and mixed-race Haitians emigrated during and after the Haitian Revolution, settling in such large port cities as New Orleans, Charleston, Baltimore, Philadelphia, and New York. As historian Julius Scott has argued, these had long been locations of exchange among people of African descent where Haitian immigrants established communities, and as the eighteenth century "drew to a close, blacks continued to apply to their local conditions the ideas of self-determination and antislavery which the Haitian Revolution unleashed."[16] Young Reason moved within one such community. Almost certainly raised Catholic, given his baptism and the likelihood of his parents' Catholic background, Reason received a secular education at the African Free School.

Established under the auspices of the New York Manumission Society, the African Free School grew to include several separate schools that provided an education to free, enslaved, and indentured black youth in Manhattan. Its schoolhouses quickly filled with eager young "children of color of all classes" whose white and black teachers instructed them in spelling, reading, writing, arithmetic, grammar, geography, map drawing, navigation, and elocution.[17] The names of hundreds of children filled the schools' registers during the decades that New York experienced the gradual abolition of slavery before its legal termination in 1827. The schools expanded opportunities for black children to acquire skills that could be useful after graduation, if employers lacking the racial discrimination rife in the city would hire their alumni. One way to raise funds and make public the African American students' inculcation of the administration's goals to provide "moral and intellectual improvement" took place regularly on examination days. These publicized events "had a tendency to try the public sentiment, whether it were favorable or otherwise, to the cause of educating these long neglected children."[18] As one set of proceedings described one African Free School's public exams, "The performances in writing were neat, and in many instances, highly ornamental." At this public exam, "a very numerous assemblage of spectators, who appeared to take a deep interest in the evident success and prosperity of this institution" attended the proceedings.[19] Spectacle notwith-

standing, the public display of black children's knowledge of the same school subjects white students studied in nearby schools offered valuable lessons to white viewers skeptical of black intelligence. They also provided public visibility of the most gifted and promising students to those New Yorkers who may not have otherwise taken notice.

Reason's schooling and talents prepared him to be an engraver. He excelled in the map drawing instruction offered at the African Free School. Displayed at the American Convention held in Baltimore in November 1828, his drawing entitled *A Map of Turkey in Europe, with a View of the Seraglio at Constantinople* testified to the youth's visual and artistic training and aptitude at just twelve years old. An essay written by Patrick's brother, Elwer, also appeared at the convention, as did an imagined journal of a voyage from Boston to Madeira by their schoolmate and later prominent doctor, orator, and activist James McCune Smith.[20] The African Free Schools provided training to hundreds of black youth, many of whom, like Patrick Henry Reason, James McCune Smith, Henry Highland Garnet, George Downing, Samuel Ringgold Ward, and Alexander Crummell, developed successful careers and led prominent lives of activism.[21] Just two years after the exhibition of Reason's map, his drawing of the African Free School No. 2 became the engraved frontispiece for a book that detailed the history of the African Free Schools and the New York Manumission Society. Given the tradition of replicating images, the engraving likely matched Reason's drawing closely. The image demonstrated Reason's able knowledge of perspective, scale, geometry, and attention to detail (fig. 2.2).

In March 1833, a few years after a lithographer took Reason's drawing, lithographed it, and published it as the frontispiece in a book cataloging the history and mission of the African Free School, Reason began a four-year engraving apprenticeship. Training under the tutelage of a white British engraver living in New York City named Steven Gimber, the young Reason received "meat, drink, clothes washing, and lodging" from his mother while Gimber paid her three dollars a week for young Reason's work.[22] The indenture contract records that Reason's father was deceased, so by entering into the contract, Elizabeth Reason gained some income, Patrick gained a trade, and Gimber gained a worker. Listed as an engraver in New York City directories beginning in 1829, Gimber would have built upon the skills that young Reason had cultivated at the African Free School. If remaining at his residential address for several years indicated economic stability, Gimber enjoyed at least a reasonable amount of permanence during the years immediately before Reason produced an image of a kneeling slave in 1835.[23] Numerous

NEW-YORK AFRICAN FREE-SCHOOL, No. 2.
Engraved from a drawing taken by P. Reason, a pupil, aged 13 years.

Figure 2.2. *New-York African Free-School, No. 2*, frontispiece from Charles Andrews, *The History of the New-York African Free-Schools*, 1830. *Courtesy of the American Antiquarian Society.*

engravers operated in Lower Manhattan, and it is unknown how the white British engraver took on the black teenager as his apprentice. It is possible that the principal of the African Free School or one of Reason's map drawing teachers recognized his talents and searched for an engraver who would offer a black youth an engraving apprenticeship that would last several years. These men would have possessed the social connections to locate and secure a position for Reason. Entering the skilled trades proved exceedingly difficult for most free people of color in New York City on account of employers' and their employees' racial prejudices. As one student of the African Free School lamented in his 1819 valedictory address:

Picturing Black Fugitivity and Respectability

Why should I strive hard, and acquire all the constituents of a man, if the prevailing genius of the land admit me not as such, or but in an inferior degree! Pardon me if I feel insignificant and weak. Pardon me if I feel discouragement to oppress me to the very earth. Am I arrived at the end of my education, just on the eve of setting out into the world, of commencing some honest pursuit, by which to earn a comfortable subsistence? What are my prospects? To what shall I turn my hand? Shall I be a mechanic? No one will employ me; white boys won't work with me. Shall I be a merchant? No one will have me in his office; white clerks won't work with me.[24]

Unlike many of his schoolmates, Reason acquired engraving skills and training as an adolescent and young adult that gave him a foundation to operate independently. The timing and acquired skillset proved fortuitous; as Reason became an adult, a growing wave of antislavery activity churned out more than a million antislavery prints by the middle of the 1830s, and many of these featured images to make more strident demands to end slavery.[25] Antislavery activists recognized the persuasive potential of images that worked in conjunction with, and sometimes independently of, text. They capitalized on numerous strategies to effect the demise of slavery, including the mass production of images to trouble the mind and sway the hearts of viewers. Artists who possessed these skills in visual production were in demand.

Soon after his apprenticeship ended in 1837, Reason entered into a year-long employment contract with Gimber and Thomas W. Whittey, of Patterson, New Jersey. Offered between six and ten dollars a week for the duration of his contract, Reason agreed to work for their engraving, lithography, and painting business. Gimber and Whittey tasked Reason with grinding and mixing pigments for landscape, portrait, and sign painting.[26] When Reason struck out on his own, he maintained a business at 148 Church Street in Lower Manhattan, a short walk south from his residence on Thompson Street, which became his place of business as well.[27] He advertised his business in the *Colored American*, a black newspaper scarcely a year old, which detailed the events of the black community in New York City. Reason advertised his skills as an engraver of historical, portrait, and landscape scenes as well as a draftsman and lithographer. Such skills displayed a range of abilities and dexterity with several visual technologies that appealed more to commercial business. But in an additional nod to his expansive business model, Reason also invited those who might walk in off the street desiring address, visiting, and business cards or certificates for organizations or special events.

He even advertised that he engraved jewelry, thus indicating that his clientele possessed some, or considerable, means.[28] If none of the populations Reason solicited earlier in his advertisement took notice, he encouraged individuals and groups wishing to learn the "scientific method of drawing" to attend his evening classes.[29] His multiple appeals signaled the business acumen that he had developed by his early twenties. Such varied services pointed both to Reason's skills and to his attempts to mitigate the racial discrimination that he, a black man trying to attract clients, would have experienced in a city where many other established white men with similar image-making skills could be hired in the 1830s. Soon after he struck out on his own, Reason partnered with the some of the most prominent members of the American Anti-Slavery Society. These connections enabled him to create images viewed by thousands of men, women, and children. These images encouraged diverse audiences to think critically about African Americans' rights and the role that white allies played in helping to secure their freedoms.

HUMANE IMAGES, RADICAL IDEAS

Patrick Henry Reason's participation in black benevolent societies revealed how he envisioned his art as performing the work of abolitionism. Long having been involved in the black Phoenixonian Literary Society, even acting as its president in 1837, Reason worked on the Phoenixonian Literary Society's Committee of Lectures to arrange for a dozen African American speakers from as far away as Boston to educate listeners on a range of topics including natural history, music's influence on society, astronomy, phrenology, blood circulation, oratory, and the patriots of the American Revolution.[30] Free and open to the public, these lectures given in venues throughout Lower Manhattan offered black and white members of the public the ability to witness the studied intelligence of black speakers and their implicit rebuke of the racial stereotypes of the era.[31] Reason himself gave a well-reviewed anniversary oration on "The Philosophy of the Fine Arts" at that society's fourth anniversary exercises.[32] A long, glowing review praised his speech on the same topic two years later as "profound in thought, pure and chaste in diction, and novel in some of the ideas, it was a composition of no ordinary merit."[33] Reason lectured that "the Fine Arts . . . draw us from the immoderate gratification of corporeal pleasures, and sensual appetites." Furthermore, "the benefits and delight resulting from a study of these subjects, particularly of painting, upon which the gentleman dwelt with much force, was strongly and strikingly exhibited, and powerfully urged upon the individuals

present" so that they might be rewarded with "true permanent intellectual pleasure."[34] That Reason focused his speech on visual artistry is no surprise. The fine art of engraving, in which he had been long engaged, apart from being pleasurable to the eye, he believed, possessed the ability to deliver its viewers from "corporeal pleasures" and cultivate the moral and mental improvements of its viewers.[35] As such, Reason underscored the importance of studying specimens of the fine arts for the purpose of "true permanent intellectual pleasure." Reason's engravings of escaped slaves fit squarely within this realm. If Reason's "Anniversary Oration" was any indication, he encouraged viewers of his engravings of fugitive slaves to scrutinize his work for the purpose of deriving from them the moral and religious wrongs of slavery and engaging more fully with the debates surrounding slavery and its abolition. In doing so, viewers of these images would simultaneously avert "the immoderate gratification of corporeal pleasures and sensual appetites" surrounding them in popular culture.[36] Boycotts of goods produced with enslaved labor such as sugar and cotton textiles had motivated antislavery critics for decades.[37] Reason's speech suggested that visual culture could be a vehicle to refocus viewers' attention to sophisticated pursuits and avoid self-indulgent inclinations.

Reason's known commercial engraving career began with his production in 1835 of a common symbol of the antislavery movement on both sides of the Atlantic: the kneeling slave. Like many artists before him, Reason created an image that resembled the supplicant slave created in 1787 by Josiah Wedgwood. The Wedgwood design quickly became part of the material culture of abolition, appearing on sugar bowls, plates, pins, purses, medallions, and jewelry worn by antislavery supporters in Britain who proclaimed their politics with this image that communicated a plea for freedom.[38] It became part of a culture of moral suasion meant to advance the antislavery cause with moral and emotional appeals. Upon the receipt of a number of these Wedgwood medallions, former slave owner and president of the Pennsylvania Abolition Society Benjamin Franklin wrote that the "Figure of the Supplicant [Slave] . . . may have an Effect equal to that of the best written pamphlet, in procuring Favour to those oppressed people."[39] Antislavery activists in Philadelphia, New York City, and beyond breathed new life into the iconic figure when they altered its details and paired it with religious, gendered, and racialized text. The image of the kneeling slave appeared with variations of the following questions: "Am I Not a Woman and a Sister?" and "Am I Not a Man and a Brother?" These questions, at their foundation, recognized enslaved people as part of the human family and challenged viewers to substan-

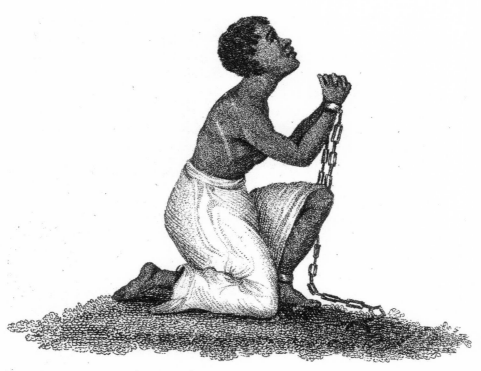

Engraved by P. Reason,

A Colored Young Man of the City of New York. 1835.

Figure 2.3. Patrick Henry Reason, [*Supplicant Slave*], frontispiece
from Lydia Maria Child, *The Fountain for Every Day in the Year*, 1836.
Courtesy of the American Antiquarian Society.

tiate this in their thoughts and actions. The repurposing of the supplicant
slave image by abolitionists in the United States like Patrick Henry Reason
spoke to the growing tide of visual material marshaled for the antislavery
cause and an attempt to identify activist strategies that would result in its
success.

One strategy included the publication of antislavery images within reli-
gious texts. In 1836, Reason's image of a supplicant slave appeared in a prayer
book that fit in the palm of its reader. Published as the frontispiece in *The
Fountain for Every Day in the Year,* written by the ardent antislavery activist
Lydia Maria Child, the image presented viewers with a kneeling slave whose
clasped hands and left leg were chained together (fig. 2.3). As its title sug-
gested, the book encouraged readers to pray over and contemplate the hor-

Picturing Black Fugitivity and Respectability

rors of slavery every day. Select lines from the poems and speeches of female and male antislavery advocates urged the end of slavery. Its size encouraged its portability. Only three inches tall and marketed as a pocket manual, the book could be easily slipped into one's pockets while owners conducted errands and engaged in leisurely activities in Boston, New York, Philadelphia, and several other cities where it was sold with Reason's engraving between its pages. Its price varied from nineteen cents to twenty-nine cents in the shops of numerous print sellers as far north as Vermont and as far west as Ohio.[40] Printed by the American Anti-Slavery Society in New York City, the book aimed to use religious ideas as a vehicle for the inculcation and circulation of abolitionist ideas. The embrace of religion as a strategy to end slavery had deep roots by the 1830s, when Child published many of her antislavery works.[41] The proceeds from the sale of the book, which appeared in at least three editions, also raised money for the increasing costs of operating the society and its auxiliary groups.[42]

Reason's artistic prowess formed part of the marketed allure of Child's book. A January 1836 advertisement in the *Liberator* for *The Fountain for Every Day in the Year* praised Reason as the creator of the "elegant engraving" within the book's pages.[43] Mentioning Reason by name and by race, and identifying him as a New Yorker, the text directly under the frontispiece and the description of Reason communicated black accomplishment. In essence, the AASS both advocated for the end of slavery and advertised the skill of a free black engraver. The specificity of the information describing Reason contrasts with the unnamed enslaved figure of uncertain gender, location, and age. The race of white engravers did not accompany the frontispieces they created, so the inclusion of Reason's race, location, and age range with his image highlighted black artistic achievement. Furthermore, the information validated his profession as an engraver. From a business perspective, it also marketed Reason's skills to anyone who viewed the image. Those who carried the book learned Reason's name and his location. Much like calligraphic signatures that often resided under a lithographed portrait as a symbol verifying the accuracy of the image, the biographical text beneath the kneeling slave authenticated Reason's skill. The addition of the positive value judgment of Reason's work — "elegant engraving" — endorsed the visual product of an African American artist to the expansive readership of the publication.

The American Anti-Slavery Society used Reason's image of the supplicant slave to teach children the wrongs of slavery. Youth who subscribed to or read the AASS children's periodical that began publication in the sum-

mer of 1835, *The Slave's Friend*, encountered praise of Reason's frontispiece in *The Fountain for Every Day in the Year.* Such encouragement to read more antislavery material evidenced the interlinked and self-reinforcing nature of antislavery print culture. Children read that Reason's image of the supplicant slave brought pleasure to one viewer who described it as a "handsome engraving [of] a kneeling slave."[44] The children's periodical encouraged antislavery sentiments in language accessible to very young readers and cost one cent per issue, or eighty cents for 100 copies for those wishing to spread antislavery ideas widely.[45] The AASS Executive Committee tallied 140,150 published copies of the *Slave's Friend* in 1836.[46] The following year, 130,150 copies of the *Slave's Friend* ran hot off the presses.[47] Numerous woodcut images appeared in each issue and frequently depicted the barbarity of slavery in graphic terms. Each issue inculcated lessons of black people's humanity and the African slave trade with short stories, poems, and reprinted conversations between individuals. Immediately following the approving description of Reason's "handsome engraving," the periodical urged its readers: "Children! Go ask your fathers to go to Mr. John S. Taylor's Bookstore . . . of the Anti-Slavery Office, and buy The Fountain."[48] This demonstrated the power of intergenerational antislavery ideology transmitted from adults to children as well as from children to adults. The description of the image and short excerpts of Child's book aimed to persuade readers to purchase the slim volume with the celebrated image created by Patrick Henry Reason as a key motivator.

The intended readership of Child's book moves us closer to understanding how the image encouraged its viewers to react. With the knowledge that the sale of *The Fountain for Every Day in the Year* raised funds for the AASS, it is likely that those who purchased the book at antislavery offices along the East Coast already shared the abolitionist beliefs of the author.[49] By 1836, thousands of members had joined AASS chapters throughout the midwestern, New England, and Middle Atlantic states. By 1838, approximately one hundred thousand claimed membership in the radical organization and its auxiliaries alone.[50] Of all classes, black and white, men and women, abolitionist supporters who subscribed to the *Liberator* received notice of the imminent publication of Child's book.[51] African Americans comprised approximately three quarters of the antislavery newspaper's early subscribers and many of its agents.[52] Furthermore, the advertisement in *The Slave's Friend* signaled the AASS leadership's desire for children not only to purchase and read the book but also to persuade their parents to adopt antislavery sentiments.

The ambiguous elements of Reason's kneeling enslaved figure broad-

Picturing Black Fugitivity and Respectability

ened the appeal of the image. The kneeling enslaved figure whose arms extend perpendicularly from the body and bend upward at the elbows with hands clasped encouraged viewers to believe that the enslaved figure was deep in prayer. The figure's upturned head and raised eyes borrowed the common religious symbolism that signaled supplication before a religious presence. Bound hands and legs implied that the figure prayed to be saved from slavery. Ambiguous in gender, the figure thus allowed children and adults to imagine the person to stand in for both enslaved men and women.[53] Some may have understood the figure to be an enslaved woman because of the long clothing worn, but Reason made the gender of the figure more ambiguous by not reproducing the well-known "Am I Not a Woman and a Sister?" and "Am I Not a Man and a Brother?" text. In its place are Reason's name, race, and location. Like the ambiguous gender, the figure's indiscernible age allowed viewers to imagine someone who embodied a range of age and life experience. The lack of a background isolates the enslaved figure on a small patch of earth, creating an image that is not geographically identifiable or suggestive. When taken together, these indeterminate characteristics of Reason's image — ambiguous gender, age, and location — allowed the viewer to interpret the figure with an identity and living circumstances that varied widely. It provided an example of how Reason's artistry encouraged viewers to construct meaning from an image in the service of the antislavery movement. It opened possibilities for viewers to see who and what they wanted to see in Reason's supplicant figure. The image could thus be readily understood as representing most enslaved people in the United States. The most important characteristics of the image, however, were certain: slavery bound the figure who wished for freedom.

Reason's image became a personal appeal to the viewer of the image to aid in the cause of abolition. The practice of reading prayers encouraged sustained religious reflection and introspection, and Child purposefully interwove antislavery ideas throughout this experience. As such, the supplicant slave image functioned on several emotional registers. By purchasing the book, the buyer actively contributed to the antislavery effort by raising money for a growing abolitionist organization. Reason's image of desired redemption paired with text that encouraged personal improvement and worked to provoke a range of emotions — sympathy, sadness, anger, and perhaps shame — over the existence of slavery. Furthermore, given the biblical passages and abolitionist sentiments adorning the book's pages, many of the buyers consumed religious and antislavery messages.[54] Child's book supplied an enslaved face and body to which readers could ascribe their spiritual

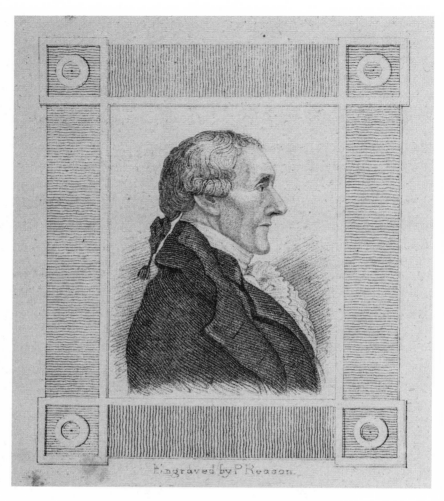

Figure 2.4. Patrick Henry Reason, *Granville Sharp, Esq.*,
frontispiece from Charles Stuart, *A Memoir of Granville Sharp*, 1836.
Courtesy of the American Antiquarian Society.

petitions. Viewers could envision the kneeling slave as imploring, not God,
but themselves the readers, to put their anger or shame into action and re-
lease them from bondage.

Reason's production of antislavery images included renderings of white
abolitionist trailblazers. In 1836, the same year that Reason's image of a sup-
plicant slave was published in Child's book, a biography of Granville Sharp
featured a frontispiece by Reason (fig. 2.4).[55] Beneath the portrait read the
words "Engraved by P Reason," "Granville Sharp, Esqr.," and "Philanthro-

Picturing Black Fugitivity and Respectability

pist." The book detailed Sharp's role as an abolitionist lawyer in England and contained two essays he penned to persuade readers of the religious and moral transgressions of slavery. The choice to describe Sharp as a "philanthropist" rather than an abolitionist speaks to his greater vision to eliminate human injustice because "philanthropist" still retained its eighteenth-century meaning of "lover of mankind."[56] Given this definition and Sharp's passionate antislavery activism, the word "philanthropist" recognized Sharp's belief in the humanity of African-descended people.

The visual characteristics of Reason's image create the impression of Sharp as a noble and moral man. Its border is architectural in style and influenced by classical European design. The border's precise vertical and horizontal lines connect its geometrical edges. Sharp wears a distinguished coat and a frilled cravat often worn by elite Englishmen. By using the artistic technique of pointillism—that is, a multitude of dots spaced at different distances from one another to form an image—Reason rendered Sharp's clothing with fine detail, and several resulting reviews described the image as "beautiful," "a beautiful copperplate likeness," "handsomely engraved," and "an accurate likeness."[57] Distinguished clothing, complemented by Sharp's erect posture and powdered wig, conveyed Sharp's propriety and reinforced the respectable label of "philanthropist." Reason's highly detailed representation of Sharp's face and clothing allowed viewers of the image to scrutinize the countenance of a man held in high moral regard by other abolitionists. His regal appearance and the classically ornamental elements of the portrait coupled with text—his name, title, and label as "philanthropist"—encouraged viewers to understand these exterior elements as representative of his interior moral and intellectual might. Such a heightened level of physical information allowed viewers a more intimate visual connection with Granville Sharp, and by extension his teachings, despite his death long before the American Anti-Slavery Society published this biography, which sold more than two thousand copies by May 1836.[58] Offered for sale in Connecticut, New York, Massachusetts, Ohio, and Pennsylvania, the book offered Sharp as a model for antislavery activists after his death, and Reason's reproduction of his portrait helped accomplish this.[59]

In 1838, Reason engraved the first of several frontispieces depicting escaped slaves that heightened the visibility of the antislavery movement. Published by the AASS, the Narrative of James Williams detailed the horrors of slavery endured by James Williams, who fled the Alabama plantation where he acted as a slave driver to escape a severe whipping before arriving in New York City (fig. 2.5). The frontispiece of the narrative depicts Williams after

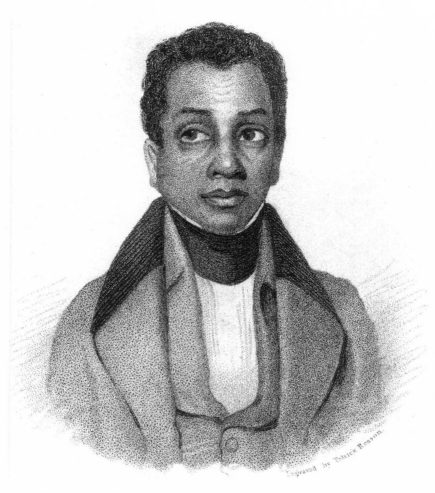

Figure 2.5. Patrick Henry Reason, *James Williams*, frontispiece from *Narrative of James Williams, an American Slave*, 1838. *Courtesy of the New-York Historical Society.*

his escape. The pointillist portrait engraving produces a highly detailed representation of Williams's clothing and face.

Reason's engraving of Williams communicated the escaped slave's worthiness to be recognized as a respectable person and not a piece of property. In contrast to the ambiguity of Reason's image of supplicant slave, Williams squarely faces the viewer as a specific, identifiable person. Reason engraved highlights and shadows on Williams's wrinkled brow, the tip of his nose, and beneath his chin to suggest the presence of a light source illuminating Williams from above. Such a technique was common in portrait oil painting, a medium of art often associated with respectable sitters. Furthermore, the

Picturing Black Fugitivity and Respectability

attire worn by Williams—his layered waistcoat, vest, shirt, and cravat—readily communicated middle- or upper-class status to viewers because of the money required to purchase such clothing. Such a proper image of a black man, and especially a black man who had until very recently been enslaved, clashed with cultural forms claiming to represent blackness in the 1830s.[60] His clothing, noncaricatured facial features, proper posture, and lighthearted facial expression stand out against the derogatory images depicting African Americans common during this era.

Furthermore, in contrast to the black dialect that had long been used to ridicule African Americans, those who picked up James Williams's tale of escape read a book written in the first person that is free of black vernacular. The book's preface makes clear the importance of language: "The Editor is fully aware that he has not been able to present this affecting narrative in the simplicity and vivid freshness with which it fell from the lips of the narrator. He has, however, as closely as possible, copied his manner, and in many instances his precise language. THE SLAVE HAS SPOKEN FOR HIMSELF."[61] Such language more forcefully echoed the editors of *Freedom's Journal*, who wrote in the nation's first black newspaper more than a decade earlier: "We wish to plead our own cause. Too long have others spoken for us."[62] This preoccupation with orality simultaneously highlighted the deprivation of academic education under slavery and the oral self-representation of Williams himself. It also distinguished Williams from the derogatory visual and print cultures that intentionally mocked African Americans by attributing to them improper diction and syntax. The image and the text worked together by presenting James Williams, a newly free man, as an individual not meant to be the entertainment found in blackface minstrelsy and caricatured prints. Instead, his image demonstrated to readers that the end of slavery could result in finely dressed, thoughtful, and educated black men and women. Reason's image offered evidence of the inner respectability of a formerly enslaved man. Image and language worked together to demonstrate how even the most challenging of life's circumstances experienced by enslaved people could not suppress the respectability of an African American man. If this could be true of Williams, as evidenced by exterior characteristics—his refined attire and his proper language—it could be true of other enslaved people.

A controversy over Williams's narrative illustrated the powerful potential for an image to confirm or repudiate the authenticity of one's enslavement. Advertised mostly in Massachusetts and New York,[63] Williams's narrative proved very popular, with the first printing of ten thousand copies

selling out in two days.[64] When southern newspaper editors acquired the popular book and researched its claims, they openly disputed the veracity of Williams's account. The abolitionist newspaper the *Emancipator* responded to their skepticism: "The portrait [created by Reason] also is a very perfect likeness of the man, and may help confirm or refute his story."[65] The frontispiece itself, imagined the *Emancipator* journalist, could aid in settling the authenticity of James Williams's entire life story.[66] The writer's words also pointed to the conflation of an image and the sum of one's past. As such, Reason's frontispiece of Williams stood in for his experience of slavery. The journalist contended that Reason's image of Williams could simultaneously evidence the claims of abolitionists and proslavery advocates alike. On one hand, his portrait validated not merely his story but his very existence. On the other hand, if no one identified Williams as having been an enslaved man using Reason's "very perfect likeness," the image could destroy the veracity of the escaped slave narrative.

How could an image confirm or refute a story? In the case of James Williams, the answer depended on the image's ability to confirm or contradict the viewer's own assumptions about James Williams. Was the image of James Williams believable? In other words, given the totality of his appearance — including his clothes and demeanor — did viewers believe that this could really be a formerly enslaved man? Some, like one reader whose reaction to James Williams's frontispiece the *Liberator* published, trusted that Reason's image of Williams accurately represented a formerly enslaved man. As scholar Lara Langer Cohen has argued, readers of the narrative initially believed his tale in part because they erroneously conflated the written text and the physical bodies of escaped slaves.[67] In this case, Reason's image of Williams gave life to the idea of Williams's purported enslavement. As one viewer wrote, "James Williams is a reality. That fine portrait, bearing on it the sad impress of soul-conquering slavery, is the picture of a real MAN."[68] Reason's image of Williams prompted the writer in the *Liberator* to identify Williams not as property but as human. The viewer's words testify to the firm belief that the portrait authenticates both Williams's humanity and his formerly enslaved status. This viewer believed that the image validated not only Williams's story but his very existence. Furthermore, the reader claimed to see beyond the genteel clothing and demeanor donned by Williams into the "soul-conquering slavery" of his past. This process demonstrates that even despite the markers of freedom from slavery such as Williams's clothing, viewers crafted their own beliefs about the identity and interiority of those depicted in images. That they did so reveals how viewers interacted with

Picturing Black Fugitivity and Respectability

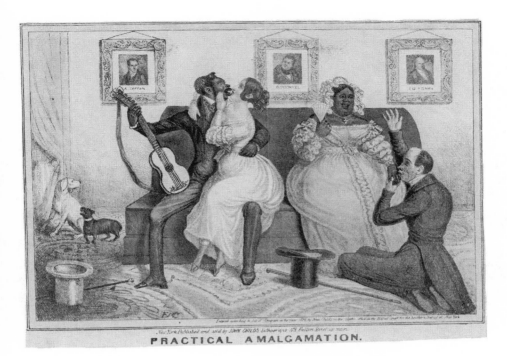

Figure 2.6. Edward Williams Clay, *Practical Amalgamation*, ca. 1839.
Courtesy of the Library Company of Philadelphia.

images and how they derived and structured meaning from them. The written words of the viewer of Williams's image elucidated how the image factored into the process of racialized meaning-making.

The ideas of black humanity, black respectability, and antislavery conveyed in Reason's portrait of James Williams clashed with derogatory visual material depicting African Americans during this era. In 1839, one year after the publication of the *Narrative of James Williams*, Edward Williams Clay created his *Practical Amalgamation* series (fig. 2.6). One of the seven prints in this series, the eponymous *Practical Amalgamation* depicts two interracial couples kissing on a bench while portraits of three detractors of slavery — Arthur Tappan, Daniel O'Connell, and John Quincy Adams — hang on the parlor wall behind them. They look down from the wall with the effect of condoning the interracial sexuality on display below. Each of the images in the *Practical Amalgamation* series foreshadows or depicts the alleged results of interracial sex. The logic of the print assumes that the abolition of slavery would result in sexual relations across the color line. The outcome would be, in one of the crudest words of the era, the "mongrelization" of the human

species, as symbolized in the print by the intermingling of the two animals in its lower left corner. In communicating this sexual fear, the print functioned on visual registers that evoked a common cultural practice that mocked African Americans: blackface minstrelsy. The banjo held by the black man in the print at once referenced the banjos with which blackface minstrels regaled their audiences and also acted as a metaphorical phallus, given Clay's placement of the instrument near the black man's lap.[69] Clay's *Practical Amalgamation* cast African Americans as lecherous and grotesquely bestial while Reason spurned these visual invectives and portrayed escaped slaves as respectable people worthy of the freedom that they had achieved with self-emancipation.

In 1839, a New York printer published another image of an escaped slave engraved by Reason that encouraged close study of his face. The frontispiece depicts a man named Peter Wheeler and accompanies his story of slavery and escape, entitled *Chains and Freedom; or, The Life and Adventures of Peter Wheeler*. Unlike the averted eyes of James Williams, Wheeler is shown looking directly at the viewer (fig. 2.7). The level of detail in the portrait decreases as the viewer moves his or her eye from the top to the bottom of the image, suggesting that Reason spent more time and effort engraving Wheeler's head and face than the clothes he wears. This can be seen in the meticulous pointillist rendering of the wrinkles in Wheeler's forehead, his tightly curled hair, his facial features, and even the tuft of hair beneath his lip. Turned so that he almost squarely faces the viewer, Wheeler wears a partially unbuttoned coat that sports a high collar. His engaged eye contact with the viewer, the heightened level of facial detail, and Wheeler's comparatively lighter-complexioned skin framed from above and below with contrasting dark hair and a dark jacket further encouraged readers to study his face.[70]

In contrast to the caricatured and stereotyped images of black people in circulation, Reason pictured Wheeler and Williams with unique faces particular to their person and their life histories. By the time of their publication, numerous scientists, philosophers, and anatomists had long obsessed over the facial and cranial structures of primates, especially humans and apes. These scientists "substantiate[d] the perception that whites, blacks, and nonhuman primates are in a hierarchical relationship to one another."[71] Contemporary scholars, as well as nineteenth-century critics, have shown how "blacks were repeatedly drawn in profile by *scientists and artists* alike with what are now recognized to be exaggerated facial angles in order to make the point that blacks are related to nonhuman primates."[72] One of these critics, Frederick Douglass, wrote about scientific racism and the im-

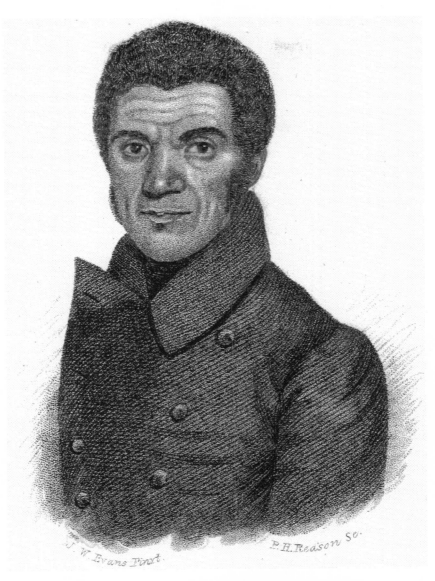

Figure 2.7. Patrick Henry Reason, *Peter Wheeler*, frontispiece from *Chains and Freedom; or, The Life and Adventures of Peter Wheeler*, 1839. *General Collections, Library of Congress.*

portance that images had long held in shaping viewers' conceptions of race. He lamented: "It seems to us next to impossible for white men to take likenesses of black men, without most grossly exaggerating their distinctive features."[73] To him, the "reason [was] obvious"—namely, that "artists, like all other white persons have adopted a theory respecting the distinctive features of negro physio[g]nomy."[74] Douglass argued that the racial prejudice held by white artists acted as a strong "temptation to make the likeness of the *negro*, rather than of the *man*."[75] Douglass's distinction between *negro* and *man* signaled that he believed that white artists implemented a visual vocabulary of race reliant on racial stereotypes when depicting people of African descent. As such, Douglass deplored the practice of white artists picturing black people as subhuman and therefore deficient in work ethic, morality, and intelligence. Well before Douglass penned these thoughts, scientific racism had influenced the ways in which many white people imagined and represented black people.[76]

Wheeler's and Williams's portraits rejected another premise visible in many derogatory images of African Americans: that people of African descent resembled apes. By accentuating the amount of detail in the faces of both escaped slaves, Reason enhanced their individuality. They were not interchangeable. In other words, he made Wheeler and Williams visually distinct from the caricatured, stereotyped images of black people circulating in U.S. culture with unique faces particular to their person and life experiences. While neither the engravings of Williams or Wheeler showed the two sitters from a profile view, neither man bears the facial or cranial attributes that practitioners or believers of scientific racism used to justify racial hierarchies. Soon after the circulation of diagrams displaying African-descended people with exaggerated facial angles corresponding to those of primates, scientists and artists mirrored the trend in their images and writings.[77] Reason's representations of these men rejected such depictions of black people. Reason's images of Wheeler and Williams thus ran counter to the images of black people and exalted them as gentleman in appearance. Their portraits perform the opposite function of the pictures of caricatured African Americans and diagrams of scientific racism—that is, they display and affirm the humanity and individuality of these two escaped slaves to their readers.

Though individuality could prove powerful for expressing black humanity, the American Anti-Slavery Society used anonymity to educate young minds about black masculinity and national belonging. Also published in 1839, the same year as Wheeler's *Chains and Freedom* and a year after Williams's *Narrative*, a small periodical for children featured a wood-

cut print clearly modeled after Reason's frontispiece of Williams (fig. 2.8). When an unknown artist copied the image from the *Narrative of James Williams,* he or she copied Reason's portrait and created a mirror image of the original after pressing the inked woodblock to paper. Whereas the AASS had praised Reason's frontispiece to Child's *Fountain for Every Day in the Year* in the *Slave's Friend,* now a different image based on Reason's portrait of Williams appeared in the children's periodical. Williams goes unnamed in the text, but the periodical used his image to show young readers the appearance of a "free colored American." Much like the unnamed supplicant slave image that greeted readers in 1836, the anonymous image of Williams enabled a range of expectations and stories to percolate in the minds of the thousands of young readers of the *Slave's Friend.* Unidentified, Williams could stand in for all African American men; his anonymity could be representative. As such, Williams became a symbol of blackness — masculine blackness — that extended to each African American man who resembled him.

The *Slave's Friend* specifically identified visual examination as a method to educate children about the connections between race, masculinity, and national belonging. Two references in the text specifically encouraged young readers to scrutinize the image of the unnamed Williams. The first, "This is a picture of a freeman!" displayed accessible diction and excitedly identified the figure as free, while noting that "he breathes the sweet air of liberty, and looks like a MAN." Romantic language notwithstanding, the text celebrated the possibilities of freedom in the United States for a person of African descent. The text corrected any young reader who might assume that a black man was an African, not an American; rather, it specifically identified the pictured man as "one of those Americans *called* Africans." The text below the portrait of Williams reinforced this idea by labeling him "A Free Colored American." Working together, the text and image are explicitly instructive. First, the text provided children with the genealogical background of who constituted a "freeman." Second, it argued that a black man looked like a "MAN," and the text's repetition of the word "man" intended to convince readers that black men possessed the ideal characteristics belonging to free men — honesty, morality, and independence among them — which countered the notion that slavery sapped the manliness from the enslaved and, as evidenced in the *Slave's Friend,* their descendants.

Proslavery forces reacted quickly and defiantly to these ideas and specifically to the text and images that communicated them. In the late summer of 1835, a mob of officials and lay citizens in Charleston, South Carolina, confiscated and burned approximately one thousand issues of the *Slave's*

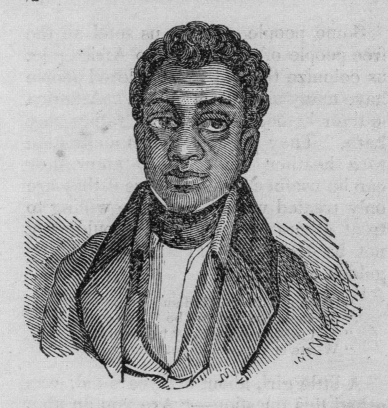

A FREE COLORED AMERICAN.

This is a picture of a freeman ! He is not an African, but one of those Americans *called* Africans. Either he or his forefathers were once slaves. He now breathes the sweet air of liberty, and looks like a MAN.

Figure 2.8. Woodcut in *The Slave's Friend*, no. 5, 1839.
Courtesy of the American Antiquarian Society.

Friend and several editions of the antislavery newspapers the *Emancipator* and the *Anti-Slavery Record*.[78] Appalled by both the content and the method of circulating antislavery ideas, one southerner wrote that "it is a monstrous abuse of the privilege of the public mail, to use it as the vehicle for conveying and scattering in every direction over the South and West the moral poison with which these publications are drugged."[79] Many South Carolinians assumed that abolitionists intended enslaved populations in slaveholding states to catch wind of their efforts. With the memory of Nat Turner's deadly rebellion fresh on their minds, southerners interpreted the transportation of these antislavery tracts down South as an attempt to foment slave insurrections. The publishing agent for the American Anti-Slavery Society, R. G. Williams, quickly defended the organization and wrote that the periodicals were not "designed to excite insurrection among the Southern Slaves. They address not the Slave, but his Master."[80] More specifically, the abolitionist materials were "directed to professional and distinguished citizens, and in no instance, to our knowledge, to any slave or even free colored man."[81] Proslavery southerners likely dismissed such claims outright and feared the worst: slave insurrection.

The hysteria following the confiscation of antislavery literature in Philadelphia bore many of the same markers of the earlier Charleston uproar. Another group of individuals bent on curtailing the spread of antislavery print and visual culture confiscated and destroyed a shipment of antislavery tracts in Philadelphia. This time, the group confiscated more than two thousand antislavery publications, including the *Slave's Friend*, spirited "them to the middle of the Delaware [River], and there tore them into ten thousand pieces, and scattered them upon the waters."[82] The rationale for such actions derived from the images and text contained therein that again, defenders of slavery speculated, could engender a slave rebellion. The antislavery publications "are of the most incendiary and inflammatory character, some of them being embellished with cuts of various kinds, calculated to excite and inflame the mind of the slave, — and to poison his already embittered feeling against his master."[83] Just a few years later, in 1838, a mob would burn Pennsylvania Hall, the newly opened meeting place for activists championing many causes, in a similar attack on racially progressive issues. The intent attributed to antislavery publishers as well as their intended audiences, correctly or not, factored into the condemnation of these antislavery tracts. To their detractors, children's antislavery periodicals posed no less of a threat and received the same treatment as printed material aimed at adult readers. Supporters of slavery understood the provocative potential of antislavery images and

texts, especially those advocating for the recognition of African Americans' humanity and freedom.

As the confiscation and destruction of abolitionist material in South Carolina and Pennsylvania made clear, the abolitionist images of Patrick Henry Reason were radical, controversial, and provocative. His depictions of escaped slaves and antislavery advocates during the 1830s aimed to protect and expand the rights of African Americans—namely, the right to freedom and the rights that flowed from it. Reason benefited from the growth and business demands of the AASS, which directly shaped the development and strategies of the antislavery movement in the United States. Reason's visual production demonstrated knowledge of previous abolitionist imagery and an immersion in the visually didactic tactics embraced by the antislavery movement during the 1830s. He marshaled his talents to viewers and readers of abolitionist literature with images of African Americans that displayed and celebrated their humanity while subverting common racial stereotypes. In doing so, Reason waged a cultural war on stereotypical images of black people in the service of black rights during the 1830s. His work presented audiences with oppositional visual forms of blackness in contrast to those displayed in the city's streets, taverns, and parlors, as well as on the minstrel stage. Black men rarely wielded control over depictions of black people during the 1830s. His work expands our understanding of what constitutes the struggle for racial equality in the nineteenth century. Reason's images showed thousands of men, women, and children an uncommon vision of blackness defined by achievement, respectability, and national belonging. The struggle for abolition and racial equality took place not only in the courtrooms and polling places; it took place in the realm of visual culture that Americans consumed every day. The 1840s ushered in an era when both Patrick Henry Reason and Robert Douglass Jr. expanded their strategies to secure the rights of free and enslaved African Americans.

3

COMPOSITIONS OF NO ORDINARY
MERIT AND THE STRUGGLE
FOR BLACK RIGHTS

The church pews formerly inside St. Philip's Episcopal Church burned brightly in the streets of New York City on the night of July 11, 1834. The white mob had destroyed the sacred possessions of the black house of worship, defaced its exterior, and ravaged what it could of the church that increasingly represented the success, wealth, and autonomy of one of Manhattan's robust black congregations. In due time, its stained-glass windows would be replaced and its worshipers would return to their prayers. But, just like the church, its leader, the Reverend Peter Williams Jr., would never quite be the same. A little more than half a year earlier, he had signed the constitution that created the American Anti-Slavery Society, an act that set into motion a powerful series of campaigns to end slavery that was countered by a far more dangerous, and often less coordinated, anti-abolition response. Stepping amid the rubble of the church, Williams contemplated the next steps for his congregation, which had splintered from Trinity Church in 1809 to form its own congregation that was still not fully independent from white institutional leadership. Succinct direction came from above. The next day, Benjamin Onderdonk, the bishop of the Episcopal Diocese of New York, wrote to Williams: "Let me advise you to resign, at once, your connexion, in every department, with the Anti-Slavery Society, and to make public your resignation. . . . My advice, therefore is, give up at once."[1] New York City officials had responded similarly just a few years earlier when, instead of preventing the rash of attacks on black New Yorkers by white ruffians outside the African Grove Theatre, they decided to close the black-owned and operated establishment that largely featured Shakespeare's plays.[2] Though

the theater folded, Williams did not. Aware of the power and hierarchy of his Episcopalian superiors, he resigned from the AASS's leadership but continued to attend society meetings and support the cause of antislavery until his death in 1840. His copious contributions to the causes of abolitionism, the education of African Americans, religious leadership, and voluntary black emigration abroad ultimately led one of his congregants, artist Patrick Henry Reason, to engrave and sell a commemorative portrait in his honor.

There was much to celebrate and honor in Rev. Peter Williams's experienced life. Born enslaved in 1786, he gained an education at the African Free School and supported his father, who had helped organize the African Methodist Episcopal Zion Church after having persuaded the John Street Church to purchase him before he repaid the debt to free himself.[3] Williams distinguished himself as an excellent student and gifted speaker. His 1808 speech celebrating the law that made the international slave trade illegal so impressed his audience that some listeners felt it was too proficient to have been written by the twenty-one-year-old black man, which prompted the publication of his oration.[4] The next year, he and other black congregants left Trinity Church to worship separately after the pernicious discrimination and segregation they faced there.[5] He repeatedly overcame racial prejudice within the Episcopal Church to be ordained a deacon in 1820 and later, in 1826, a priest.[6] The virulent racial discrimination that mounted as New York gradually abolished slavery at the turn of the nineteenth century, coupled with the racial obstacles black people encountered elsewhere in the United States, led Williams to support black emigration to Haiti and Canada. His stance provoked enduring criticism but provided an option for free black people as other opportunities for black rights and freedoms closed. He participated in successful strategies to secure and practice black autonomy such as helping to establish the first black newspaper, *Freedom's Journal*, in 1827. For decades, Williams engaged in the most pressing issues concerning the livelihood of African Americans in, and well beyond, New York City.

Two black artists—Patrick Henry Reason of New York and Robert Douglass Jr. of Philadelphia—shared many of the same concerns and waged many of the same battles to secure black freedoms as Williams. They had greatly expanded their activist networks during the 1830s and forged ties with powerful leaders within the abolitionist movement. In the following decade, they rallied behind and occasionally took the lead in championing antislavery, black achievement, and voting rights for free black men.[7] Furthermore, they marshaled their artistic skills to commemorate, honor, and celebrate black and white advocates of black rights.[8] Their images of

people of African descent highlighted black success and intelligence when scores of images depicting black people during this era claimed otherwise. Douglass's and Reason's counternarratives to these dominant discourses of racism marked yet another strategy in the quest for black rights. Antiracist struggle in the mid-nineteenth century is often understood within the context of public demonstrations, religious activities, marches, campaigns to purchase the freedom of enslaved people, and petitions to state and federal governments.[9] Douglass and Reason participated in many of these activities during the 1840s, but they also created images that highlighted the evils of slavery and the promises of freedom with the intent of persuading their images' viewers of these ideas. Together, the circumstances surrounding the images fashioned by Douglass and Reason and an analysis of their images expands the antebellum arsenal of strategies African Americans drew on in the service of increasing black rights. Likewise, their participation in benevolent societies, religious institutions, and state conventions shed light on how political activity influenced their production of visual culture and how they desired it to affect viewers.

THE POWER OF VISUALIZING BLACK COMMEMORATION

Images of black leaders became sources of inspiration for antebellum New Yorkers. Antislavery writers encouraged readers to collect and ponder Reason's engraving of the late rector of St. Philip's Episcopal Church in New York City. In 1841, a letter published in the *Colored American* praised Reason's steel plate portrait engraving of Williams.[10] As a tireless advocate of funding black schools, abolishing slavery, and a host of other campaigns to enable African Americans to determine their futures without racist restraints, Williams served his black parish, which included "a large congregation, and about 350 communicants."[11] He, like Reason, attended the African Free School, where he paired its secular education with the religious instruction he later received to become a steadfast advocate for African Americans in his role as deacon and priest at St. Philip's Episcopal Church in the Five Points neighborhood in Manhattan. His was a life marked by a constant drive and battle for black autonomy and self-determination that extended to education, religious practice, and voluntary emigration abroad. So, nearly a year after his death in October 1840, a committee at St. Philip's sent Reason's engraving of Williams to the office of the *Colored American*. The images impressed its editor, Charles B. Ray, and his published letter of thanks provides insight into how viewers of the portrait could display and contemplate

its subject. In addition to complimenting Reason, "who has displayed, in the workmanship, very great taste, as well as having given a most accurate and perfect likeness [of Williams]," Ray encouraged owners of the portrait to "be glad to have their parlors graced with his profile" and purchase the print from two New York City locations.[12] The parlor, the area of the home used to receive and entertain guests as well as the space designated for personal and family activities, was a prime place for the portrait's exhibition, where it could be enjoyed by visitors and residents alike. "Certainly, no member of St. Philip's Church or congregation will suffer many days, certainly not weeks, to elapse," Ray continued, "without possessing themselves of a likeness of their long, faithful and devoted pastor."[13]

As such, Ray imagined the portrait to benefit those members of the St. Philip's congregation who survived the Reverend Williams (fig. 3.1). The image of the deceased clergyman, Ray assumed, provided its viewers with solace and comfort because of its ability to preserve Williams in the land of the living. The published letter implies that Reason completed the portrait nearly a year after the reverend's death, so the portrait resurrected and reified his memory in physical, collectible form. The image, after all, evoked not only his appearance but also his widely known qualities of devotion to his congregation and New York's African American population. The image was a reminder of his life's work. It could be collected and displayed as a tool of remembrance, and those who purchased the print likely knew the Reverend Williams and his service in the cause of racial justice.

The editor of the *Colored American* also envisioned the portrait influencing those not belonging to the St. Philip's congregation. Ray recommended to readers of his newspaper that "no acquaintance, who saw or appreciated the excellencies and the virtues of the man, but will be glad to have their parlors graced with his profile."[14] His words signal how individuals in the nineteenth century imagined the reasons for which others would purchase and display images intended for the private space of one's home.[15] The portrait was not merely commemorative; it enabled individuals to remember the causes that Williams supported, such as abolishing slavery, educating black children, and social activism informed by pious observance. His portrait acted as a portal through which viewers could engage with the issues and virtues he championed. That viewers needed to know Williams personally was irrelevant; merely those who "*appreciated* the excellencies and the virtues" he held and exhibited were sufficient, the writer wrote, to benefit from the portrait.[16] Ray thus communicated the same belief in the moral-

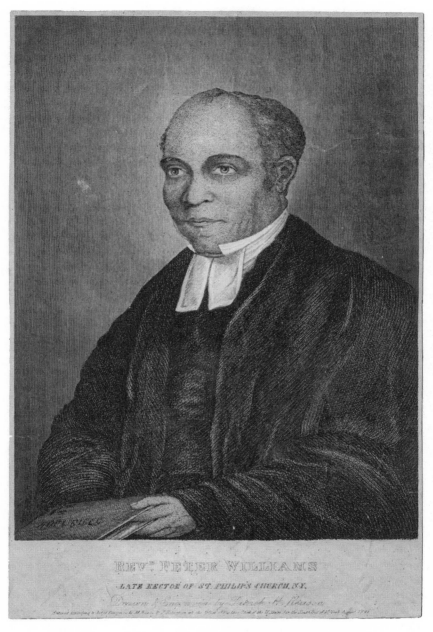

Figure 3.1. Patrick Henry Reason, *Revd. Peter Williams*, August 1841.
Courtesy of the Moorland-Spingarn Research Center at Howard University.

izing possibilities of Williams's portrait as Reason believed images should possess. These images were models of the deeds accomplished by African Americans as well as the challenges yet remaining.

Portraits of African American clergymen had a long history by the time Reason engraved his portrait of Williams. Completed by white artists and engravers, these images lacked elements of racial caricature and instead depicted these religious men as pious, capable, and respectable leaders.[17] Historian Richard Newman has shown that early portraits of Philadelphia's black clergymen "challenged the racist imagery of ''bobalition' (or anti-black) broadsides."[18] Bishop Richard Allen, who founded the African Methodist Episcopal Church in Philadelphia, commissioned several oil portraits of himself that engravers then reproduced. He commissioned an oil painting of himself in 1823 — less than a decade before his death — "to reestablish his image as a black founder," after rumors of financial malfeasance swirled and congregants broke from the congregation.[19] These portraits became tools to aid simultaneously in the struggle over one's present condition and future legacy. The production of these images of African American clergymen bore evidence of their enterprise of self-fashioning their social status and principles.

Reason's engraving of Williams established a connection between church politics and visual culture. Williams participated in many debates regarding the rights of and opportunities available to African Americans before his death. The review of his posthumous portrait — made available to the public by Ray's estimation for "not more than $1" — highlighted the multiple functions of the image.[20] The review hinted at the viewing practices and meaning making that resulted from the portrait of Williams. Furthermore, the review hinted how the image functioned differently for congregants of St. Philip's Church and others. Intended for personal reflection in one's home and display to one's family members and close friends there, the image could communicate the principles that the reverend practiced. At the very least, however, the image depicted an accomplished African American community leader whom viewers could emulate. That a committee appointed by the Church of Vestry of St. Philip's asked Reason to engrave the clergyman's likeness nearly a year after his death showed the desire to preserve, circulate, and perhaps profit from his memory. The alternative could have been the reprinting of his sermons or written works, yet the choice of creating and advertising Reason's portrait of the respected community leader highlighted the power of visual culture to bind communities and celebrate black achievement.

Compositions of No Ordinary Merit

At the same time that Reason created images he hoped would further the moral development of viewers, he helped organize African Americans in New York for the cause of black male suffrage. The New York Constitutional Convention of 1821 had extended voting rights to more white men while stripping black men of the vote unless they could prove their status as free-men and their ownership of $250 worth of property.[21] The effect was swift and devastating. In four years' time, just 68 of the 12,559 African Americans in New York City could vote.[22] Disenfranchising black voters enabled Buck-tail Republicans to deliver the final blow to the Federalist Party, which most African Americans had supported.[23] The loss of black male suffrage occurred during the state's gradual abolition of slavery, which ended in 1827. As free-dom in one form arrived for black New Yorkers, others disappeared. For many decades that followed, black New Yorkers gathered to strategize how to win back the right for black men to vote unhindered by qualifications. Patrick Henry Reason helped spearhead the cause.

Reason became deeply invested in the cause of suffrage for African American men in New York.[24] At a public meeting in the summer of 1838, Reason's peers elected him to the executive committee of a political associa-tion to win back black men's right to vote unimpeded by property ownership qualifications. Assembled in Philomathean Hall, one of black New York's energetic centers of political and organizational activity, the gathering con-cluded that a statewide push to organize supporters of black suffrage should culminate in elected delegates assembling a "General Political Convention of the Colored people" in the state's capital of Albany.[25] Reason delivered a speech along with other prominent black leaders such as Charles Lenox Remond and Philip A. Bell.[26] In October 1838, Reason attended the first quarterly meeting of the "New York Association for the Political Elevation and Improvement of the People of Color," which gathered dozens of lead-ing black figures living in New York City to discuss "the removal of unequal constitutional and legal disabilities" experienced by them.[27] He also served on the Committee of Arrangements for a joint public exhibition of the Philo-mathean and Phoenixonian Societies in New York City. The event—which included musical performances, prayers, recitations about slavery, and the singing of hymns—raised money for the captives of the *Amistad*.[28] Be-cause of fundraising activities such as this one, northern abolitionists pre-vented the extradition of the formerly enslaved Africans aboard the *Amistad*

to Cuba after their onboard mutiny and subsequent trial in Connecticut. The joint public exhibition of the Philomathean and Phoenixonian Societies profited $84.25 for the cause.[29] The next month, Patrick Henry Reason sat on the Committee of Arrangements for the political association aiming to enfranchise black male voters by signing petitions to the New York legislature urging the change.[30]

Drumming up support in New York City for African American men's right to vote resulted in a massive campaign that assembled a convention championing the cause. Reason affixed his name to the public call for the Colored Convention in New York to be held in August 1840. Beginning in Philadelphia in 1830, the colored convention movement fostered discussions and debates about such topics as African American emigration, education, antislavery, voting rights, and citizenship. The invitation for the 1840 event, to be held on August 18, noted that the primary purpose for the meeting was to "obtain a relief from those political disabilities," primary among them being the disenfranchisement of nearly all black men.[31] In the weeks before the convention, dozens of black men from across New York State signed their names, which the Colored American then printed. Three weeks before the convention, Reason's peers called him to chair a "very large public meeting" of black New Yorkers at Philomathean Hall in New York City. He described the various "political disabilities black people" experienced across the state and pointed to them as "an auspicious sign of the necessity of the Convention." A week later, Reason chaired a preparatory meeting for the convention in which members of the gathered assemblage offered amendments and resolutions.[32] Just three days later, acting as elected secretary on recommendation by the governing committee, Reason appointed delegates to represent New York City after the Colored Convention. His peers elected him one of the twenty-five delegates representing his city.[33]

The convention in Albany mobilized scores of black men and heightened their visibility among the Whig Party. When Reason arrived in Albany on an overnight steamer from New York City before dawn on the morning of August 18, he joined thirty-nine other black men as delegates to the convention held in the Hamilton Street Baptist Church. Elected to a business committee, "through whose hands all business proper for the Convention should pass," Reason and the other committee members transacted a large amount of business, which fellow New Yorker Samuel Cornish estimated to be as much as "our anti-slavery annual meetings."[34] By the second day of the convention, upward of 140 delegates from across the state gathered to discuss petitioning for rights, electing town committees, and reestablishing

black men's voting rights.[35] Scores of spectators, both women and men, paid close attention to the morning, afternoon, and evening proceedings: they "manifested no less interest than the delegates themselves, and were ready to applaud debates, which excited their deep interest."[36] Additionally, many of the "leading men" in Albany's Whig Party attended each of the convention's sessions and expressed "grave and dignified respect" for the convention's members and oratorical skills.[37]

Reason's philosophy of activism centered on the equal political rights among men of different races. Working with the black intellectual and black rights advocate Alexander Crummell, Reason drafted a petition that he then delivered on the second day of the convention.[38] Couched in the language of racial uplift, the petition requested that black men be extended the right to vote, which would have the effect of "elevating the character of the humblest members of the State." Reason and Crummell wrote that they desired that the property qualification required for black male voters be abolished so as to enable black men's "enjoyment of equal political rights and privileges." The black vote, wrote Reason and Crummell, marked "the most efficient instrument of their elevation."[39] Just as Reason believed that individual improvement marked a starting point for broader public improvement, so the right to vote was an important means by which an individual action, and a collective group of actions, greatly affected a community.[40] After having been elected chairman of the committee responsible for a plan to extend suffrage to all black men, Reason proposed a system of gathering signatures and circulating petitions to be implemented statewide.[41] Outrage and fear gave way to collective action across the state of New York.

Reason's public campaign against black colonization further clarified his core beliefs in racial equality. Troubled by threats of forced emigration made by attendees of the Maryland Colonization Convention,[42] Reason and eight other black men, including his brother and the influential black New York doctor James McCune Smith, called a meeting in New York City in July 1841.[43] Chosen as the vice president of the Great Anti-Colonization Meeting in New York, Reason gathered with others at the Asbury African Methodist Episcopal Church to denounce the recently held colonization convention held in Maryland. At their meeting, they unanimously "expressed our opposition and abhorrence of the doctrines, measures, and influence of the scheme of expatriation, viewing it as the main prop of American caste."[44] Their choice of the word "caste" pinpointed the hierarchy created to exclude people of African descent from enjoying the same rights and privileges as white Marylanders. Though the Maryland Colonization Society posed no

direct threat to these black New Yorkers, they knew the power of legal precedence. The American Colonization Society and the New-York Colonization Society claimed powerful members who could outline forced removal plans just as colonization advocates passed resolutions to remove free and enslaved African Americans in Maryland. These members resolved that "the idea that the colored people will ever obtain special and political equality in this state is wild and mischievous," and if "they continue to persist in remaining in Maryland . . . circumstances . . . will deprive them of the freedom of choice, and leave them no alternative but removal."[45] The organizers of the meeting warned readers of the "THREATS OF FORCE" perpetuated by those in Maryland and urged them to meet and publish their disagreement of such threats if they considered themselves "the friends of human rights throughout the free States."[46] Their meeting condemned, in no uncertain terms, any plan for expatriation with the rationale that "fidelity to our enslaved countrymen, love to the great principles of the American Revolution, secured by the blood of our patriotic fathers, and a just appreciation of our holy religion, clearly indicate our religious duty as a people, to live, labor, and die upon the soil of our birth" required them to live, and continue to dwell, in the United States.[47]

Unlike the threats of forced colonization, Reason worked to secure the free passage of escaped slaves as they passed through New York. His work with the New York Committee of Vigilance marked a continuation in the long struggle to end all forms of slavery in the state. On June 14, 1841, a joyful gathering of activists met by invitation of the New York Vigilance Committee at the Asbury African Methodist Episcopal Church and elected Patrick Henry Reason its secretary. There was much to celebrate. Reason and many attendees rejoiced over the passage of the new state law that prevented non- and part-time residents from bringing enslaved people into New York.[48] This eliminated another route that enabled the enslavement of people well after the 1827 abolition of slavery in the state. With David Ruggles, the radical black activist, as the law's strident early advocate, the New York committee was a model for other vigilance committees to assist free and enslaved African Americans in other states.[49] By the time it published its fifth annual report in 1842, the New York Committee of Vigilance had assisted 1,373 people escaping slavery and free black people who had been kidnapped, not including those assisted by its auxiliary committees.[50] Ruggles spearheaded these activities and documented them in his periodical, *Mirror of Liberty*; these actions, along with his support for other black rights and women's rights, made him dangerous to his detractors. His growing public presence as a radi-

cal activist attracted the attention of Edward Williams Clay, the racial cari-
cature artist well known for his *Life in Philadelphia* series.[51] He produced a
print that lampooned Ruggles and other abolitionists after they attempted
to secure the freedom of a fugitive slave in 1838.[52] Derision circulated in print
and visual culture was but one danger of being a high-profile abolitionist in
New York City. Ruggles had long been engaged in radical civil disobedience
and counted Reason among a select few who might be interested in partner-
ing with antislavery activists in Albany.[53] While most of the connections be-
tween Ruggles and Reason are obscured, what is known is that they worked
together in the same organization dedicated to the absolute end of slavery in
their state and that Reason earned Ruggles's respect, no easy task for a radi-
cal reformer known for his disagreements among fellow activists.

Given his extensive connections within antislavery circles, Patrick
Henry Reason knew well the precarity of escaped slaves' lives and produced
images that celebrated their successes. In 1849, Reason created what would
be his last known engraving of a fugitive slave, which appeared as the frontis-
piece of the *Narrative of the Life and Adventures of Henry Bibb* (fig. 3.2).[54]
The autobiography told the story of Bibb's life that he shared with midwest-
ern and New England audiences since his final escape from slavery in 1841.[55]
Born enslaved in 1815, he quickly rose to prominence within antislavery
circles as a powerful orator who detailed his numerous escapes from slavery,
several recaptures, and multiple sales that characterized his enslavement in
at least seven states. His forced relocation through these states was the story
of the westward expansion of slavery during the 1830s and early 1840s. After
his last, successful escape, he spoke alongside William Lloyd Garrison and
Abby Kelley Foster[56] and was celebrated as "a second Frederick Douglass"
for his powerful recollections of his life as an enslaved man.[57] Like Douglass,
Bibb attended conventions of free black people that convened to advance
the cause of black rights.[58] He extended his political involvement by work-
ing for the Liberty Party as an antislavery lecturer. He and his wife, Mary
Elizabeth Bibb, later published the *Voice of the Fugitive* newspaper in Canada,
where they moved after the passage of the Fugitive Slave Act of 1850.[59] A
strong supporter of black emigration to and colonization of Canada, Bibb
clashed with proassimilationist black activists like Mary Ann Shadd Carey
and Frederick Douglass and died without fulfilling his plan of a black sepa-
ratist colony.

Reason's frontispiece in Bibb's 1849 *Narrative* depicts the formerly en-
slaved man as a respectable future possible for enslaved African Americans.
Reason signed the larger of the two images that showed Bibb standing and

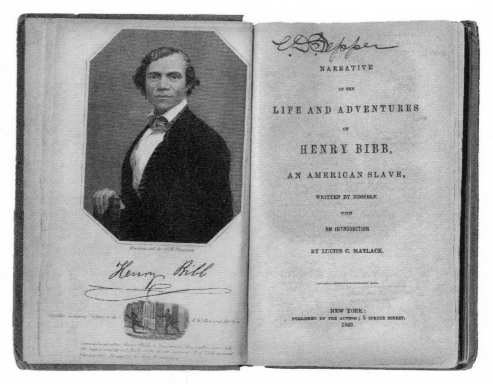

Figure 3.2. Patrick Henry Reason, *Henry Bibb*, frontispiece from *Narrative of the Life and Adventures of Henry Bibb, an American Slave*, 1849. Courtesy of the Library Company of Philadelphia.

facing the viewer in a three-quarter-length pose wearing a waistcoat over a crisp white shirt. Unlike Reason's earlier frontispieces of escaped slaves printed in the 1830s, the image shows Bibb with an object—a book—that physically manifested his literacy, intelligence, and education. His grasp on the slender volume established his control over its contents and represented his distance from the stereotypical characteristic of ignorance attributed to people of African descent, especially enslaved and formerly enslaved people. Furthermore, his well-appointed appearance identified Bibb as an individual with the financial means and ability to acquire such clothing. His commanding pose, genteel clothing, and accompanying book echoed the conventional visual tropes of oil paintings.[60] The meticulous rendering of Bibb's face, hair, and the patterns on his clothing worked together to create a vivid image, almost photographic, that greeted readers of his tale. The meticulous work required to create the crosshatched background and Bibb's face hinted at the significant time and energy expended in the creation of this image. The

Compositions of No Ordinary Merit

image, likely a steel plate engraving, combines content with exceptional detail to emphasize Bibb's respectability. Reason's precision here echoed the detail present in his earlier frontispieces of Peter Wheeler and James Williams in their escaped slave narratives. In each narrative, Reason portrayed the author as a black man who defied racial stereotypes.

A second frontispiece image depicts Bibb's escape from slavery. Below Reason's engraving, a small image of Bibb escaping from his owner, Henry Lane, situated Bibb within the urban slavery setting of Louisville, Kentucky in 1838. The row houses and cobblestone streets set the scene where a white man, in midstride, extended his arm to convey movement toward a black man fleeing with his hands in the air. Rendered shorter than the white man to convey distance from him, Bibb ran toward an imaginary light source that spotlighted him and cast a long shadow beneath him. Both figures lacked the detail of Bibb in Reason's frontispiece, but meticulous drawing in the escape scene does not greatly matter to convey its message that Bibb emancipated himself before being sold at auction.

Analyzing both frontispiece images and the accompanying text underscores how Reason communicated Bibb's distance from slavery. The two images worked as a chronological sequence, with the bottom image communicating the speed and intensity of Bibb's moment of escape. Studied in isolation, the identity of the fleeing man is indeterminate. Bibb's obscured face likened him to the millions of enslaved people living in the South. This is not to say that these people lacked individuality; rather, by making the figure unidentifiable, the artist represented the millions of enslaved people, nearly any one of whom could have been the individual escaping in the scene. The simultaneously anonymous but widely recognizable image depicting Bibb's escape echoed the indistinct but discernible image of the supplicant slave that Reason fashioned more than a decade earlier. His detailed rendering of Bibb's face in the book's main frontispiece showed readers the now identifiable and verifiable Henry Bibb. No longer turned away in shadow, he looked directly at the viewer.

Henry Bibb's signature bound the two markedly different images together with a personalized mark that authenticated and authorized both. The signature and the book held in his hand mutually reinforced his literacy in contrast to the laws in southern states that barred the education of enslaved people, especially after Nat Turner's Rebellion.[61] Bibb's signature substantiated the truth of his images that testify to his past enslaved status and his current free status. Only infrequently did two images grace the same page on which the frontispiece was printed. Because Bibb's *Narrative* frontis-

piece included two images, choices regarding the size, content, and position of each image affected the messages proposed by the images individually and jointly. The signature confirmed that both images represented Henry Bibb and his history. Furthermore, both the book Bibb clutches in his hand and his calligraphic signature reinforce each other to validate his education and, by extension, his intellectual capacity.

The two frontispiece images operated together on the registers of the individual and communal to highlight the oppressive, but surmountable, horrors of slavery in the United States. The lower image communicated the terror of escape and pursuit while the above image of Bibb instructed viewers that formerly enslaved people should not be viewed as perpetual chattel but upright, respectable individuals. Abolitionists imagined such images to be especially provocative and influential for viewers, "the bulk of whom are more immediately and thoroughly affected by a picture, than a verbal description. Why then should they not be used, in the exposure we purpose to make of our national wickedness??"[62] The power of antislavery images lay in their ability not merely to engage viewers but also to expose the immoral and inhumane practices of slavery. This belief largely explains the explosion of antislavery images produced and circulated during the 1830s and 1840s. The frontispiece images that greeted readers of Bibb's escaped slave narrative both countered misperceptions of enslaved people and confirmed slavery's cruelties.[63]

BLACK GENIUS IN PHILADELPHIA

The image of black respectability took on a new guise in Philadelphia only a few years before Reason completed his image of Henry Bibb. Francis Johnson, the preeminent black musician and composer who regaled audiences in Philadelphia, the moneyed crowd in Catskill resorts, and even Queen Victoria in England, led a life with musical flourish. Celebrated for his dozens of compositions and musical dexterity, Johnson was born and raised in Philadelphia at the turn of the nineteenth century and largely taught himself to play the keyed bugle after having been introduced to the military instrument by Richard Willis, a renowned bandleader and keyed bugle soloist. Johnson's fame increased with the musical prowess he exhibited at Philadelphia's finest cotillions, balls, assemblies, and public parades. Although he performed mostly secular music, he conducted orchestras that played sacred music on several occasions.[64] Invitations to appear across a wide geographic expanse — from St. Louis to Canada to England — increased his fame as well

as his exposure to new melodies and compositional influences, bringing him professional success. This musical accomplishment was unprecedented for any African American artist. Working with other black musicians and composers, Johnson became well known in the musical world far beyond Philadelphia. Along with his travels, his compositions took on international themes with pieces titled "President Boyer's Cotillion" and "Recognition March of the Independence of Hayti." While most of his music featured instruments only, his song "The Grave of the Slave" featured antislavery lyrics by Sarah Forten, the daughter of the wealthy black Philadelphian James Forten.[65] Johnson had been "the chief supplier of dance music in Philadelphia for almost twenty years" by the late 1830s, and as a black Philadelphian native, he established connections with black churches and benevolent societies in addition to his more lucrative business elsewhere.[66] Like Robert Douglass Jr., Johnson worshipped at the African Episcopal Church of St. Thomas, one of the most prominent black churches in Philadelphia. Given his social connections and success, it was not surprising that Johnson sat before Robert Douglass Jr. for a daguerreotype sometime before the musician's death in 1844.[67]

In the daguerreotype, Douglass made sure to include the objects that marked Johnson as a successful, educated, respectable black man. The resulting image became the model from which an artist named Alfred Hoffy created a lithograph that Douglass published and sold at the 54 Arch Street storefront that he shared with his barber father, Robert Douglass Sr. (fig. 3.3).[68] Although the location of Douglass's daguerreotype is unknown, the tradition of reproducing various visual media as lithographs holds that Hoffy's lithograph likely matched Douglass's daguerreotype closely, and it therefore provides clues about Douglass's daguerreotype. Seated squarely facing the viewer, Frank Johnson grasped a bugle in one hand and rested his other arm on a table laden with sheet music, a quill, and an inkwell, highlighting Johnson's profession as a composer. His slightly tilted head and the expression of ease and warmth on his face, marked by an unfurrowed brow and the slightly upturned hint of a smile, lent him an air of friendliness. His expression, coupled with the accoutrements of his profession—a musical instrument and sheet music—underscored his musical skill and aptitude. The lithograph drew attention to Johnson's musical proficiency as well as his professional success, the results of which enabled his purchase of the multiple layers of elegant clothing he wore in the portrait. His image projected a vision of respectability, black success, and musical achievement.

That it existed in the lithographic medium signaled that the flattering

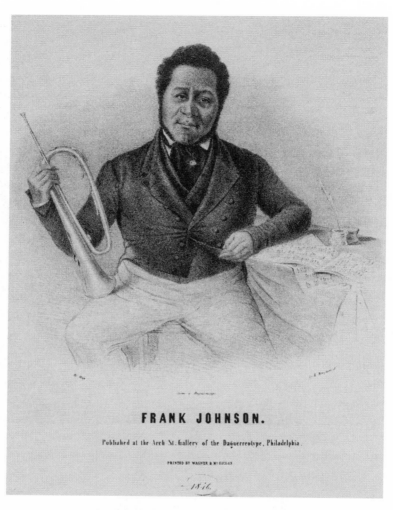

Figure 3.3. Alfred Hoffy, *Frank Johnson*, 1846.
Courtesy of the Historical Society of Pennsylvania.

portrait was intended to be circulated among a greater audience. The fragility of daguerreotypes made them impractical to be passed from person to person. Lithographs enabled the mass production of more affordable images that could maintain much of the noticeable detail displayed in a daguerreotype. Successfully copying daguerreotypes proved difficult; they could not be copied cheaply, quickly, safely, or efficiently, especially en masse. Made with glass and/or metal, each daguerreotype was unique. They could be mounted or otherwise fixed in a public place to increase their visibility, but this created a viewing experience often more fleeting than that of possessing

Compositions of No Ordinary Merit

a lithograph. Although the creation of lithographs required much more time compared to daguerreotypes, lithographs could be produced for, and viewed by, exponentially more people. From a business standpoint, the production of lithographs may have cost less than the production of daguerreotypes, and the money earned from the production of hundreds or thousands of copies of a lithographic print could be exponentially greater than the sale of one daguerreotype. From an activist's standpoint, greater circulation meant the likelihood that more people would be receptive to the image's ideas about black success and intellect.

The year that Douglass printed the lithograph of Francis Johnson raises questions about its creation. Douglass published the image of Johnson in 1846, two years after Johnson's death in Philadelphia.[69] Like Reason's post-mortem engraving of the Reverend Peter Williams, the reproduction of Douglass's image of Francis Johnson was an act of commemoration. The lithographic medium of this memorial allowed for that which daguerreotypy did not; lithographs of people could be created long after they had died. Johnson's band continued after his death, and its new leader, Aaron J. R. Connor, frequently attempted to capitalize on Johnson's name by reminding readers of his musical performance advertisements that he became the band's new conductor.[70] The mass reproducibility of Johnson's lithographic image reminded a larger audience of Johnson's accomplishments than a single daguerreotype could. In this sense, the 1846 lithograph of Johnson was not merely a memorial to Johnson's life but a testimony to his compositional creativity, musical talent, and prolific publishing.

Douglass publicly called attention to the genius of Frank Johnson. Just three days after Johnson's death, a group of men mourning his passing elected a committee that included Douglass and vowed to publish a "testimonial to [Johnson's] worth" in the *Elevator*, the *Philadelphia Ledger*, and the *Philadelphia Sun*. These men recognized the importance of print culture in furnishing the public with examples of African American success on their own terms. In their printed tribute, they testified that Johnson "eminently and successfully proved that genius is sufficiently powerful to overcome *even prejudice.*"[71] It was a bold statement but evidenced their recognition that Johnson secured employment and accolades despite his race. A month later, Robert Douglass Jr. delivered a monody on Johnson's death at a musical festival before a crowd in the African Episcopal Church of St. Thomas.[72]

Clues about Douglass's respect for Johnson and his fashioning of Johnson into an exemplar of black virtuosity can be found in a spring 1841 address that Douglass delivered at a concert held within the sacred walls of St.

Thomas.[73] "The modern Orpheus," Douglass proclaimed of Johnson, "truly, is our friend." This reference to Ovid's *Metamorphoses* signaled Douglass's classical education and self-referenced his mastery of classical texts. Douglass continued: "And [Johnson] will not let *you*, like the Banks, suspend— / But for *his notes* cash payments from you draw, / In aid of knowledge and of moral law." In likening Johnson to a bank providing payments to aid in knowledge and moral law, Douglass mixed contemporary events with the achievements of the black community in Philadelphia. His reference to the banks and suspended cash alluded to a congressional resolution in May 1838 that repealed specie circular.[74] Douglass's double play on "notes"—bank notes and musical notes—hinted at his lyrical creativity. Douglass layered his epic Roman poetry when he referred to Johnson as "Orpheus the ancient, [whom] e'en the rocks obeyed, And danced in order to the tunes he played." Recognizing a well-known character of a renowned Roman lyric poet may have been easier than recognizing two lines plucked from a lesser-known Roman poet, Horace. The "obey[ing] rocks . . . that danced in order to the tunes he played" were two lines from Horace's *Odes* referring to the ability of Amphion, a musician, to use his lyrical gifts to build the walls surrounding the ancient city of Thebes.[75] Such classical references communicated Douglass's elite education and witty creativity while it bespoke the high esteem he held for Johnson. Immediately after Douglass's delivered these words, Francis Johnson led his band in the commencement of the day's musical performances.

Douglass organized events to mobilize support for the Philadelphia Library Company of Colored Persons, the black literary society he helped establish in 1833. The address Douglass delivered in St. Thomas marked his continued involvement in that literary society. The advertisement for the events that day labeled it a "Grand Concert" and depicted a lyre, a trumpet, and vines of ivy in front of a musical score background. Addressed to "Friends and the Public," the advertisement stated that men and women who had attended and thoroughly enjoyed a previous concert had requested the performance. Unlike the previous event, this one included "the addition of several brilliant and Scientific Pieces" much to the edification of the attendees. The advertisement specifically welcomed "all the lovers of Music, and those who feel interested in the cultivation and extension of that beautiful and sublime Science" to attend.[76] Every attendee also benefited the Philadelphia Library Company because the twenty-five-cent admission fee was used to purchase more books for the society's growing library.[77] The purchase of books for the black literary organization's library marked one strategy of "improv[ing]

the mind" and "providing for the intellectual development of youth," about which Douglass spoke at length.[78] Preparing and delivering public speeches complemented literary scholarship and provided another avenue to education.[79] It further developed the qualities contemporaneously understood to be the province of men and male leaders.

Douglass's original address offered further insights into his beliefs regarding colonization and black emigration.[80] He explicitly rejected the idea that African Americans should emigrate to areas of Africa, the Caribbean, and Central and South America. After describing the merits of educating young people, Douglass continued that those youth

> May be thus successfully disprove
> Assertions foul, of those who would remove
> The native hence, to some far distant spot,
> Where death from climate soon would be [their] lot.
> But this is vain, no other spot on earth
> Is half so sweet as that which gave us birth:
> For *this our* Fathers also fought and bled;
> Here lie their bones, here shall be our last bed.[81]

Douglass's reference to "death from climate" echoes the problems regarding heat and disease anticipated by individuals contemplating emigration to the Caribbean and Africa.[82] Conversations about black emigration had circulated in Philadelphia and other parts of the United States for decades. For example, Bishop Richard Allen, one of Philadelphia's most prominent black men, earlier advocated for the emigration of black people to Haiti. Like the efforts of Rev. Peter Williams in New York City, Bishop Allen led the Haitian Emigration Society of Philadelphia believing that black people would be able to achieve the freedoms and equality in Haiti that they were denied in the United States.[83] Both leaders disavowed forced colonization efforts. In disagreement with the initial stance on emigration taken by Bishop Allen and others, Douglass provided arguments to dissuade black people from emigrating.

Douglass made clear in his speech at St. Thomas that the attempt to emigrate was "in vain" because "no spot on earth . . . is half so sweet as that which gave us birth."[84] Such rhetoric echoed a belief among many African Americans that the United States afforded greater opportunities for black people than those possible in the proposed places of black emigration. Douglass's inclusion of the life cycle — "which gave us birth . . . shall be our last bed" — further illustrated his belief that black people born in the United States

should remain until their death. Instead of leaving the United States, Douglass called on his listeners to

> Prove to the world that Genius dwells within
> The immortal soul; — the color of the skin,
> Whence this celestial essence gives its light,
> What boots it, whether it be black or white?[85]

In other words, African Americans needed not settle in places around the world to show African Americans' capabilities to others. Francis Johnson, Douglass would continue, had proven his capacity for genius to both black and white people in Philadelphia and beyond.

Douglass also aligned the history of African-descended people by using and amending the rhetoric of the Revolutionary Era. His belief that African Americans should continue to reside in the United States, coupled with his words "For *this our* Fathers also fought and bled," evoked the rights promised in the nation's founding documents and the bloodshed of the Revolutionary War to realize those promises. His connection between the bones of the "Fathers" and "our [African American]" bones signaled an affiliation, an inseparable bond between that history and the people seated before Douglass. His language possessed a double meaning; generations of African Americans had "fought and bled" for freedom, freedom from slavery and the same freedoms enjoyed by white Americans. Ultimately, Douglass's speech was one about belonging—of African Americans belonging in the national polity with equal rights. While his use of the word "Fathers" hinted at those white men so often revered as the "Founding Fathers" who spoke of liberty, equality, and freedom, his words also referenced the black men who fought in the American Revolution. Claims of African American citizenship based on black patriots' service in the Revolution had long circulated among African American communities.[86]

Later in his speech, Douglass leveled a threat at oppression—and perhaps the oppressors themselves—that if they did not "change while [they] yet can," that is, if racial oppression did not cease, it was only a matter of time before the coming of "the Hour and the Man." His reference to Harriet Martineau's book *The Hour and the Man*, published only two months before, may have incensed some of his listeners and spurred others to nod their heads in agreement. Martineau's historical fiction detailed the Haitian Revolution and Toussaint Louverture's role in the transformation of Haiti at the turn of the nineteenth century. Douglass assumed that those he addressed would understand his reference. Many of his peers knew that Douglass had spent

a year and a half in Haiti and that his reference to *The Hour and the Man* implicitly threatened that black revolutionaries could forcefully overthrow racially oppressive rulers. Douglass left his audience members to interpret that portion of his address as they saw fit.

Douglass's visual production and oratory repeatedly stressed that African Americans could enjoy success in the United States. Denouncing emigrationist rhetoric that circulated in Philadelphia and other cities, Douglass encouraged black youth to take pride in their national homeland despite the travails that awaited them because of their racial heritage. Douglass spoke from experience; he had traveled to Haiti and could make firsthand comparisons between the opportunities and livelihoods available to African-descended people in both places. The print of Francis Johnson based on Douglass's daguerreotype visibly verified the capacities of African Americans. From his speech, it remained clear that his recent experience living and painting in Haiti had indelibly marked his life. Douglass further proved this when he later juxtaposed the paintings he completed in Haiti with those he completed in England to make radically subversive assertions about black achievement and Haitian culture.

ANTISLAVERY AND ARTISTIC TRAINING IN LONDON

Douglass used his abolitionist networks to plan a trip to London to benefit his career and develop his racial politics. Within two weeks of arriving home in Philadelphia in 1839 after spending a year and a half in Haiti, Douglass applied for a passport to travel to England.[87] The story of his passport application survives thanks to his sister, Sarah Mapps Douglass, and her friendship with Angelina Grimké Weld. In a letter to the British abolitionist Elizabeth Pease, Weld wrote that she felt "induced to write thee thus soon again that I may introduce to thee and thy dear friend of the brother of our friend and sister in Christ, Sarah M. Douglass of Philadelphia, with whose name and that of her precious other thou art acquainted, as bearing a prominent place in the facts I adduced to show the existence and extent of prejudice among Friends."[88] As a means of relating truth and encouraging sympathy, she continued: "This family has suffered deeply from this unhallowed and cruel feeling." Getting to the central point of the letter, Weld wrote that "Robert Douglass's object in visiting England is to obtain further instruction and the means of improvement in his profession as a portrait painter; he takes with him letters of recommendation from Thomas Sully who crossed the Atlantic to take the portrait of Queen Victoria. He will probably show you these let-

ters and they will be better testimonials than any thing I can write."[89] Weld's letter animated several important bits of information about the transatlantic abolitionist network and the circumstances affecting Douglass's artistic career.[90] The letter testified to the extensive abolitionist network to which Sarah and Robert belonged. Weld also solicited Pease's sympathy in referencing the racial discrimination that Sarah suffered earlier at the hands of Philadelphia Quakers perhaps for the intent of securing favor for Robert. The letter also established Douglass's credibility as a portrait painter by referring to his support from Thomas Sully, one of the preeminent painters in the United States.

The closing of Weld's letter attributed urgency to Douglass's attempt to travel to and study in Europe. In the postscript, Weld added that as she ate breakfast with Sarah Mapps Douglass that morning, Sarah "mentioned that her brother had been refused a passport to England on account of his color, the Secretary of State alleging that by the new Constitution of Pennsylvania the people of color were not citizens and therefore had no right to passports to foreign countries."[91] Secretary of State John Forsyth had personally rejected Douglass's application. As it turned out, Richard Vaux, a prominent white member of the Pennsylvania State House of Representatives, had written to Forsyth to request a passport on Douglass's behalf. Vaux praised Douglass as the son "of highly respectable parents — [and] himself a man of worth and respectability — and a man of color."[92] In his letter to Forsyth, Vaux mentioned that Douglass intended to travel to "England, &c. . . . at the suggestion of some of the artists of this city, to improve himself in his profession which is portrait painting."[93] Forsyth's one-sentence reply, which ended, "The Department will not justify a compliance with your request," was swift but not inhibitive.[94] Like Douglass's earlier dismissal from the Pennsylvania Academy of the Fine Arts, people harboring racial prejudice again sought to stifle Douglass's artistic efforts, but this time at the hands of the government. Regardless of the state-sanctioned discrimination, Douglass gained entry to England when he arrived there by April 1840.

England proved to be fertile ground for Douglass's artistry. In April 1840, he mailed a letter to his family in Philadelphia relating the auspicious news that he walked freely throughout the National Gallery and the British Museum in London. He relished the opportunity to study paintings by Raphael, Titian, Correggio, Claude, Annibale Carracci, Leonardo da Vinci, Anthony van Dyck, Peter Paul Rubens, Joshua Reynolds, and Benjamin West unmolested. He found comfort in the fact that the British "do not consider it a miracle that I should wish for an acquaintance with the 'great masters,' but

do all in their power to assist me, and condemn the ridiculous prejudices of my own countrymen." He detailed the diversity of people studying art alongside him in the galleries and wrote that, when speaking to other artists studying there, he felt a "proud consciousness that I am received on terms of equality." He acquired more formal training by attending lectures on painting and sculpture given by Royal Academy members.[95] The *Pennsylvania Freeman*, the abolitionist newspaper that printed the letter that Douglass sent to his family, took pride in telling readers that, whereas two other newspapers refused to print the letter, the paper "gladly give[s] it a place in our columns, and rejoices in the fresh testimony it furnishes us of superior talent, and ability, in a colored man."[96] The newspaper reaffirmed Douglass's social capital as a man who "has made his way to a standing of high respectability in his profession, and in Society generally."[97] Such a feat was especially admirable given that "he has done [so] through a weight of prejudice, which would have kept under any mind of not much more than ordinary strength."[98]

Two months later, the World's Anti-Slavery Convention provided opportunities for Douglass to both improve his skills as a portrait painter and surround himself with prominent abolitionists. Held in London, the convention attracted more than five hundred abolitionists from the Caribbean, the United States, and Europe.[99] They counted among the most prominent and outspoken advocates of the abolition of slavery, including Lucretia Mott, Elizabeth Cady Stanton, Wendell Phillips, William Lloyd Garrison, Charles Lenox Remond, George Thompson, and Thomas Clarkson. Douglass met some of these individuals during his time in London. In her diary, Lucretia Mott wrote that she breakfasted with Douglass and George Thompson, the fiery British abolitionist, in London on June 9 and visited with Douglass on June 16. Though she did not detail her conversations with Douglass, the topics of black rights and women's rights likely arose, given the upheaval over women's participation at the convention.[100] Douglass joined Mott when she visited the painter Benjamin Robert Haydon to have her portrait painted for his now-famous view of the convention's attendees. He accompanied Mott for her sitting and took instruction from Haydon there.[101] These meetings in London expanded and strengthened Douglass's constellation of artists and activists.

Meeting with Lucretia Mott — a powerful and connected antislavery and women's rights advocate — was no unimportant matter. Mott had attended and spoken at the founding meeting of the American Anti-Slavery Society in 1833 and was a founding member of the Philadelphia Female Anti-Slavery

Society.[102] Douglass's mother, Grace Douglass, and his sister, Sarah Mapps Douglass, both served with Mott on the board of the Philadelphia Female Anti-Slavery Society and knew one another from the Arch Street Meeting House. As Quakers, all three women had attended the Anti-Slavery Convention of American Women in 1837. Known as a powerful speaker, Mott campaigned for the expansion of women's ability to speak in public and to serve as participants and leaders in activist organizations. Her exclusion from the original proceedings of the World's Anti-Slavery Convention highlighted the rift that formed over the topic of women's inclusion in antislavery organizations. Mott's meetings with Robert Douglass Jr., even after the discrimination she faced days earlier at the start of the convention, apparently made a favorable impression on her; years later, she later introduced him via letter to the radical abolitionist Wendell Phillips. Douglass, fresh from the electric environment of London's activist circles, returned to Philadelphia with a novel plan to showcase his Haitian and English paintings.

"HAYTIEN LADIES" AND THE BRITISH
AND ITALIAN MASTERS

Published after his return to Philadelphia from London, the advertisements for Douglass's exhibition of Haitian paintings revealed his strategies to attract members of the public to learn about Haiti. In March and April 1841, Douglass took out long advertisements in the *Pennsylvania Freeman*. In them, he promoted an exhibition and lecture on Haiti where he and his paintings took center stage. Beginning the advertisement for his "Haytian Collection," Douglass itemized his many skills as a "Portrait and Miniature, Sign and Ornamental Painter and Gilder, Teacher of Drawing and Painting, the French Language," and even his prior instruction of "Spanish Guitar, etc."[103] Creating a list of such varied artistic skills conveyed the idea that Douglass was an experienced artist who had received the benefits of an extensive education. He "respectfully inform[ed] his friends and the Public, that having returned to his Native City after a residence of 18 months in the Republic of Haiti, he purpose[d] delivering a Lecture on that interesting country, and some of its most distinguished personages."[104] He also included the important detail that "the lecture will be illustrated with accurate Portraits principally executed by R. D. Jr. while in the Republic."[105] Douglass highlighted the fact that he painted the portraits in Haiti to create the idea of a more "accurate" art that was created on location. Furthermore, Douglass's mention of

his long stay in Haiti communicated a knowledge of, and familiarity with, a place of great interest to black and white Americans.[106]

The paintings cataloged both the social history of the Haitian elite as well as the military and governmental history of the Caribbean country. As people entered St. Thomas Church to hear Douglass speak about Haiti, he treated them to a visual display rich with information drawn from his experiences there. Facing them were eleven paintings on varied subjects: former Haitian president Alexander Pétion, Haitian president Jean-Pierre Boyer, Haitian general Joseph Balthazar Inginac, three portraits of "Haytien Ladies," the funeral of former Haitian president Pétion, Haitian Independence Day of 1839, "Haytien Fruit — Gazettes, Proclamation, &c.," and a portrait of Douglass himself executed by his friend the Haitian painter M. Colbert Lochard.[107] For a twenty-five-cent entrance fee, attendees also viewed a painting of the Haitian independence celebration about which Douglass had written to his family in 1839.[108] The advertisement describing the painting of the independence celebration listed it as having "accurate views" of several governmental buildings and "more than 200 figures" taking part in the festivities.[109] The number of figures likely denoted a large canvas. Overall, the advertisement indicated Douglass's proficiency in several painting genres, including portraits, still lifes, and history paintings. Listing the subject matter as well as the variety of painting styles marked yet another strategy for Douglass to encourage interest in his exhibition.

One painting in the exhibition celebrated symbols of the Haitian governmental documents, journalism, and culture. The painting is not known to be extant, though its title and short description, along with the other paintings in the exhibition, illuminate its subject matter and message. Titled *Sketches of Haytien Fruits*, with a description following the title that read "Gazettes, Proclamations, &c.," clarified the meaning and content of the painting. That Douglass labeled the unnamed gazettes and proclamation to be fruits of Haiti reveals his thinking of the Caribbean country as a place of black achievement and empowerment. The fruit borne by black self-government and black intellectual production led to governmental documents, journalism, and political culture. In other words, black leadership enabled the growth of culture and black institutions. Douglass outlined this process of growth in a speech in St. Thomas during which he stressed the importance of black cultural institutions. In front of fellow members of the Philadelphia Library Company of Colored Persons, he praised "a soil where knowledge warms the ground / [in which] the glowing fruits of Genius will be found."[110]

The ingredients of knowledge, access, and opportunity resulted in the production of black cultural "fruits" that needed the tending and nurturing that he envisioned Haiti and its people provided. A review of the joint lecture and exhibition recorded that it "afforded evident gratification" to those who attended the lecture on Haiti's "discovery, history, condition, and the manners and character of its people."[111] The review lauded Douglass, "whose skill as an artist is highly creditable to his talents and perseverance under all the discouragements to which one of his complexion is exposed."[112] The images became a medium through which audience members experienced the sights and events of the Caribbean country, though the reviewer lamented that the audience, "though respectable, was much smaller than we should have been glad to have seen present."[113]

Less than a month after his Haitian exhibition, Douglass unveiled to the public his painted copies of works by Claude, Thomas Lawrence, and Correggio that he studied while in London. Students of academic art regularly copied famous paintings as an instructional method to "lead students through imitation to invention" while providing them with a visual cache of art from which to draw procedural and thematic inspiration.[114] The title of his advertisement — "Benjamin West, P.R.A., John Kemble, Esq." — included names familiar to those knowledgeable of British culture. West was a famous painter from the United States who painted and lived in England, while Kemble was a famous British actor known for his Shakespearean roles. Both had been dead for about twenty years when Douglass displayed their paintings at St. Thomas in 1841. Douglass described the paintings of Kemble and West as "accurate copies . . . from the originals," thereby lending an air of authenticity and verisimilitude to the paintings.[115] He charged adults twelve and a half cents for admission, thus making it more accessible than his Haitian exhibition the previous month.[116] In keeping with the spirit of supporting the education of youth as per his speech in March, Douglass encouraged the attendance of children by admitting them for half price.[117] In keeping with his address about the importance of black education and cultivating knowledge from which resulted moral growth, Douglass himself engaged in the act of educating members of the black community in Philadelphia — old and young — in the arts.

Douglass took the opportunity to display his paintings of black Haitian leaders alongside his British copies. His radical pairing of these subjects made bold statements about black civilization. By exhibiting these paintings side by side, Douglass subverted the idea of Haiti as uncultured, unrefined, and uncivilized. The medium of the oil painting — itself imbued with signi-

fications of culture, refinement, and wealth—further elevated the status of the Haitians depicted in Douglass's paintings to the status afforded to the subjects of the Italian and British paintings that Douglass studied. Making the paintings and the ideas they communicated accessible to a viewing public was important. Douglass again displayed his paintings of Haitian presidents Pétion and Boyer as well as another dignitary, General Inginac, whom he had seen at the Haitian independence celebration.[118] He described these individuals as "some of the great men of the Republic of Haiti" to attract attendees to his exhibition, not out of personal agreement with their support of African American emigration to Haiti.[119] Such images stood in stark contrast to the 1839 print *Johnny Q, Introducing the Haytien Ambassador to the Ladies of Lynn, Mass.*, by *Life in Philadelphia* creator Edward Williams Clay, who used broken English, caricatured facial features, and derogatory references to the Haitian ambassador's lips and body odor to ridicule the black dignitary. Clay's print openly maligned white female abolitionists by repeatedly implying that they joined the antislavery cause because of their sexual desire for black men.[120] In producing his own visual representations of Haitians and Haitian achievements, Douglass undermined the assumed racial and cultural hierarchy between black Haitians and white Europeans. It is probable that oil paintings displaying black leaders, never mind Haitians, had never before been exhibited in the United States next to copies of British and Italian paintings. Yet again, Douglass's painting was a corrective to the visual culture that circulated about Haitians and those affiliated with the antislavery cause.

IMAGES INFORMING PUBLIC SENTIMENT

By the 1840s, the belief that images held persuasive power that could affect their viewers in positive and substantial ways was widespread.[121] *Parley's Magazine* proposed that its pages would feature a plethora of images "selected not only with a view to adorn the work, but to improve the taste, cultivate the mind, and raise the affections of the young to appropriate and worthy objects."[122] Of a series of panoramas depicting Thebes and Jerusalem, the *Pennsylvania Freeman* lauded the works and gave "our hearty amen" to a *Christian Observer* review of the paintings, which it then reprinted. The *Christian Observer* recommended "these beautiful pictures" for their readers "who are seeking for useful and intellectual recreation."[123] "If such intellectual and moral exhibitions were appreciated," it continued, "their influence on society, and especially on the young, would be felt extensively, and we

might hope to see the day when our citizens would have a disrelish for the demoralizing representations of the stage and other similar amusements."[124] Looking at images of the panoramas could be "intellectual recreation," meaning that individuals could engage with the image and glean from it teachings, messages, and ideas that nurtured their intellectual growth. The choice of the word "recreation" signified the range of meanings, and consequently interpretations, understood by readers. Paired with "intellectual," "recreation" could mean "amusement," but more probably "an educational exercise, lesson, or problem intended to be both instructive and enjoyable."[125] According to the article in the *Pennsylvania Freeman*, images could influence society and alter the habits of its members and convince them to stop partaking in "demoralizing" spectacles such as those on stage, which invariably included minstrel performances. Images held the power not only to entertain but also to educate their viewers. The firm hope that images could drastically alter the sensibilities of their viewers to individually and collectively reform society lay at the heart of the image's potential. More explicitly religious or moralistic imagery such as a supplicant slave or the respectable portrait of a formerly enslaved person heightened such beliefs.

The opposite also held true; negative representations of black people could be destructive. The *Pennsylvania Freeman* chastised the editor of the *Cincinnati Herald* for having "puffed a nigger song book recently published in Cincinnati, and also for having advertised and puffed a concert of a similar character."[126] According to the *Freeman*, the *Herald* editor's undue praise of the offensive material reflected poorly on his moral character. The editor of the *Cincinnati Herald* countered the critique by writing that a number of black high school students imitated northern white students at a school function. The students' "powers of mimicry," he wrote, "are very strong, so that they can turn the tables whenever they choose upon white caricaturists."[127] The *Pennsylvania Freeman* replied:

> But is not [Editor Gamaliel] Bailey aware of the very great difference
> in position which exists between the Yankees and the colored people?
> They can afford to be ridiculed and caricatured, whose wealth and
> influence and standing are respected all the world over; but it is quite
> another thing when the subject of ridicule is an oppressed, despised,
> and suffering classes of people. Then the ridicule is cruel and none
> can indulge in it without violating the law of love.
>
> In one of the towns of Canada, the civil authorities forbade the
> Ethiopian Minstrels to hold their concerts, assigning as a reason, that

Compositions of No Ordinary Merit

such exhibitions tended to degrade the colored population; and are abolitionists more slow to perceive this fact? Such exhibitions may be "sport" to the audience of white people, but they are "death" to a sensitive colored man. Let us imagine ourselves in their situation, think for a few moments with their thoughts, and feel with their hearts, and we shall shrink from inflicting such wounds upon them, as are sometimes inflicted, in a moment of thoughtlessness, even by their true friends.[128]

Editorials about the cultural forms mocking black Americans volleying between these newspapers demonstrated the contrasting beliefs about these materials as either innocuous entertainment or imprudent abuse. Pro-black allies understood racial caricature in its many forms to display and reinforce the racial hierarchy established by white Americans that placed black people—free and enslaved—on the lower rungs of the social order. The writer of the article implored his readers to imagine themselves as their black, racially subjugated neighbors in order to foster empathy and alter future behavior. Just as Douglass closed the metaphorical distance between viewer and subject in his Haitian paintings, the editor guided white readers to "imagine ourselves in their [African Americans'] situation, think for a few moments with their thoughts, and feel with their hearts." Doing so, he hoped, would prevent "inflicting such wounds" caused by the degrading nature of minstrel shows.[129] His narrative approach to make his white readers conscious of the power of popular cultural representations reveals an argument simultaneously to locate the site of racial intolerance, identify with its victims, and foment its destruction.

Beyond encouraging white readers to sympathize with those "oppressed, despised, and suffering" black members of society, some newspapers urged their white readers to *imagine* themselves as black people suffering racial injustices. In its advertisement soliciting young girls and boys to distribute antislavery tracts, circulars, notices, and other abolitionist prints, the *Pennsylvania Freeman* insisted that "your young minds are unclouded by avarice, prejudice, or pride; then give free scope to your generous sympathies for the poor, despised, down-trodden slaves—bring their sufferings home to yourselves; think what would be your feelings to see *your* father or *your* mother whipped until the blood ran down their backs; or *your* brother or *your* sister torn from you forever, and sold to some monster in the south or west, who felt no pity for them or for you."[130] Using second-person pronouns, the advertisement directly addressed its young readers. The article also hailed

its readers using the possessive "your" to make the proposed events—witnessing familial brutality and separation—address the reader directly and intimately. The linguistic strategy of using possessive and second-person pronouns, coupled with the graphically violent scene outlined in the advertisement, intended to elicit a strong personal reaction against such a situation that would then spur the reader to abolitionist thinking or action. The article, and the American Anti-Slavery Society children's publication, *The Slave's Friend*, operated under the logic that youth were especially impressionable and receptive to image and text.

A lawsuit brought against Robert Douglass Jr. in 1841 revealed that adults knew well the combined power of image and text especially when wielded against them. Though the documents pertaining to this case are scarce, Douglass created and printed lithographic images of several prominent black Philadelphian men that raised their ire and provoked legal action. On September 1, 1841, Douglass appeared before Alderman Griscom in Philadelphia and was held on $1,000 bail for libel. Although the court docket does not specify the form in which the alleged libel occurred, newspapers reported that Douglass had committed libel by caricature.[131] As one newspaper reported: "It appears that Douglass prepared a caricature, representing the members and editors [of the Demosthenian Shield] aforesaid, in ludicrous figures and characters, which he had lithographed. He procured a large edition [to be] struck off, which he proposed to sell to the aggrieved party, or otherwise he would offer them for sale. They not agreeing to what they considered a gross imposition, he did expose them to sale, and hence the suit against him for libel."[132] Indeed, this is the first known instance of a racial caricature depicting African American men created by a black visual artist. The print is no longer extant, and the circumstances of its publication show that Douglass did not create it with the intention of advancing black rights.

A contextual analysis of its production elucidates the contested nature of racialized images in the 1840s and the lengths to which some went to limit their effects. The men depicted in Douglass's lithograph included Frederick Augustus Hinton, Thomas Crouch, Benjamin Stanley, and Joseph Willson. These men edited and contributed to the *Demosthenian Shield*, a black Philadelphia periodical published in conjunction with the Demosthenian Institute, an organization created by black men for the literary and general education of African Americans. The increasingly sharp words traded between Willson and Douglass in the weeks before the lawsuit hinted at the reasons for the creation of the lithograph. The surviving record captures Douglass's re-

sponses only; Willson's words are unknown. It appears that personal attacks in print on each other's character began the feud. Judging from an article Douglass published in August 1841, however, Willson's writings about Douglass proved provocative. After Willson refused to print Douglass's response to an article in the *Demosthenian Shield*, Douglass published an article in the *Public Ledger*. Douglass set a jeering tone by beginning the article with a sharp critique of Willson's "ignorance." Evidently, Douglass felt that the *Demosthenian Shield*, with Willson at its helm, printed malicious misinformation about Douglass and perhaps his family.[133] According to Douglass, Willson "impertinently" invited a conversation with Douglass and then "refused to insert [Douglass's response] in his columns [thereby] proving that if he possesses not a vestige of the eloquence of [the seventeenth-century writer Samuel Butler] yet he inherits all *his courage*."[134] Willson's editorial power and his attempt to silence Douglass prompted Douglass's accusation, "But from the *shadow* of the shelt'ring 'Shield' / Dealest out thy blows at those who love the light." Sardonically pointing out "the [*Demosthenian*] 'Shield' [is] as invulnerable as 'Achilles,'" Douglass commenced a thirty-four-line stanza that hinted at the imagery he may have used to depict Willson in the libelous lithograph:

> But for a caricature, oh hidden elf,
> Sketch for the world a likeness of thyself.
> Some say thou art a "Lion" but I know,
> Now thou has *spoken*, it is but in show,
> Oh' *such* a one, of old disguised did pass
> He spoke, the world recognised but—an ass.
> Erect now, I beseech thy lengthy ears
> Patient take counsel, banish all thy fears.[135]

If the caricature for which Douglass later found himself in court resembled the poem Douglass printed in the *Public Ledger*, Willson would have been depicted as a cowardly donkey with long ears. Several lithographs of politicians depicted as doltish donkeys circulated in the decade before Douglass's lithograph.[136] The animal evoked ideas of feckless leadership and foolish interests. Douglass employed both ideas throughout his published poem wherein he insulted Willson's intelligence, harshly judged Willson's writing ability, and mocked Willson's editorial competency.

Why did these black men decide to escalate the dispute over Douglass's image with a lawsuit? Negative representations of individuals, regardless of

race, could be severely detrimental to one's reputation, business, and liveli-
hood when made public. Defamation of character, via newspaper, litho-
graph, or another medium, could quickly circulate among groups of people
and damage the social status of the person being represented. As described
earlier, the visual and material medium of a lithograph allowed for the quick
circulation of this information. The lawsuit over a libelous caricature re-
vealed that what was at stake was how the image would affect viewers. The
crux of the case rested on the assumption that the derogatory image would
negatively influence viewers' perceptions of the depicted men. The preoccu-
pation was on both the style and substance of the image and, more impor-
tant, the feared *effect* of the image. Therefore, the case unveiled the implicit
knowledge that images held the power to persuade, deceive, and convince
viewers of deleterious ideas about these black men.

The men who were part of the lawsuit against Douglass recognized the
importance of their image and, more specifically, the effect that their image
would have on those who viewed and purchased the lithograph. For them to
bring the suit against Douglass, the men must have first understood what a
caricature was and its potential consequences. They needed to identify what
constituted a caricature, and to do so, they learned by viewing other carica-
tures. As evidenced by their lawsuit, they understood images, and caricatures
in particular, to have potentially detrimental effects on the viewer's percep-
tion of the image's subject. Furthermore, the plaintiff and witnesses needed
to be knowledgeable of the arguments and definitions by which the courts
operated. What does it mean that these men took legal action against an art-
ist? First, it means that they knew that legal recourse could award them dam-
ages or prevent Douglass from circulating the print. Second, it showed that
filing the charge might not have been the first measure they took to prevent
the image's dissemination; after all, the business and personal relationships
Douglass had with both Frederick Augustus Hinton and his daughter, Ada,
hinted that Hinton and Douglass likely attempted to mediate the flared tem-
pers before the lawsuit was filed. If so, the talks failed, and Douglass found
himself in court before a jury. They found Robert Douglass Jr. not guilty of
libel by caricature in 1841. Douglass, however, was ordered to pay the costs
associated with the trial.[137] Such a verdict must have greatly relieved Doug-
lass, though being forced to pay the costs of the trial likely did not.

Hinton certainly recognized the power of caricature because Edward
Williams Clay had disparaged him and a female companion in a print a few
years earlier (fig. 3.4). The print depicted these two figures looking directly at
the viewer. Dressed in expensive layers of clothing, wearing numerous pieces

Compositions of No Ordinary Merit

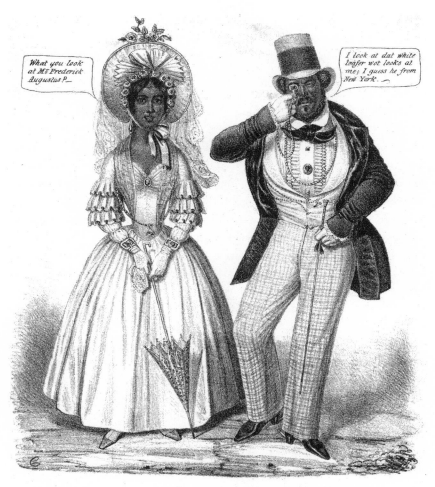

Figure 3.4. Edward Williams Clay, *Philadelphia Fashions, 1837*, ca. 1837. Courtesy of the Library Company of Philadelphia.

of jewelry, and holding the fineries of elite society, the begloved couple wears their wealth. The print's title—*Philadelphia Fashions, 1837*—referred knowing viewers to Clay's popular racial caricatures in his *Life in Philadelphia* series, which appeared beginning in 1828. Clay employed other stylized and complex referents and signifying processes that helped viewers derive meaning from the image and its accompanying text. Here, Clay rejected the dis-

proportional bodies that typified the figures of his earlier *Life in Philadelphia* series. Instead, he communicated the race of the two figures in *Philadelphia Fashions, 1837* through broken syntax, skin color, and hair texture. Frederick Augustus Hinton's spheres of coiffed hair resembled the hairstyles of several African American men and women Clay mocked in *Life in Philadelphia*. Likewise, the same objects of leisure featured in *Life in Philadelphia* such as the parasol, cane, and ornately oversized bonnet, reappeared in *Philadelphia Fashions, 1837*. The lack of background and the positioning of the figures prominently in the print's foreground highlighted these intentional details.

The print underscored an allegedly discordant relationship between the expectations of African Americans' interior intellect and their exterior appearances. The couple's attire and ornamentation conveyed a level of socioeconomic achievement, but the sheer amount of finery with which they adorned themselves likely conveyed that they perhaps tried too hard to impress. Clay conveyed that one should distrust African Americans who presented signs of accomplishment; their interior intellect did not match their exterior acquisitions. Their interiority, as displayed in their speech, unmasked the truth. When asked what he was looking at, Frederick Augustus Hinton responded, "I look at dat white loafer wot looks at me. I guess he is from New York." The print averred that the finely adorned clothes and accoutrements of the African American couple belied their allegedly inferior racial background as marked by their verbal mistakes. In other words, their broken language communicated to viewers that Hinton and his companion incongruously belonged to the class that their expensive and ornate clothing and jewelry signify. Their refined clothing implied that they are cultured, but their imperfect language told a different story.

Their captioned words revealed Clay's complicated racial humor and cultural interplay. Clay's use of the word "wot" is one that communicated the figures' lower social stature, or at least their allegedly lower intellect. Although "wot" was not specifically stereotypical black dialect, newspaper articles that contained the word attributed it to those of the lower classes, who pronounced "what" as "wot." Another semantic signifier used in the print more commonly ascribed to members of the lower classes was "loafer." A word that entered common parlance only a few years before the publication of *Philadelphia Fashions, 1837*, the word "loafer" connoted ideas of idleness, vagrancy, and general industrial worthlessness attributed to those of the lower classes.[138] One newspaper article noted, however, that "the propensity to loaf is confined to no rank in life: all conditions are, more or less, troubled with it."[139] Hinton's mention of New York may have referred to what

some newspaper articles described as the birthplace of the term "loafer."[140] It is also where Clay created and sold the lithograph. The intended joke is that white nineteenth-century viewers understood the pictured Hintons as loafers because of her parasol and his cane, both of which hinted at the leisure of an outdoor stroll. This concept of the loafer, coupled with the attribution of idleness and vagrancy to the black community of Philadelphia by Clay and others, placed the Hintons squarely within the understood parameters of who could be a loafer, regardless of their exterior appearance. From this analysis of the language and visual markers, the game of looking and seeing that drives the meaning of the print becomes clearer. The woman's question not only directs the conversation and viewer's gaze to Hinton but also highlights the act of seeing undertaken by both figures. Using his monocle, Hinton looks out from the page at the imagined viewer. Using text and the game of looking, Clay thus established a triangular relationship between the print's viewer, the woman, and Hinton.

Given the sharp criticism that Clay's caricature could circulate among a broad viewing public, it makes sense that Hinton and others acted to prevent Douglass's caricature from reaching the public during a time when "the terrain of ideological and cultural struggle was becoming so ocularcentric."[141] In other words, the struggle over shaping and controlling opinions played out in images and in texts that featured images. With the invention of the daguerreotype in 1839, more visual media existed, and were increasingly accessible to broader audiences, than ever before. Hinton's use of the court system to limit the potential damage of Douglass's print communicated his struggle over how peers and strangers would perceive him if they viewed his massproduced image. Furthermore, Douglass's decision to produce visual material during an argument reinforced the idea that visual culture was a powerful tool in shaping debates among black Philadelphians in the early 1840s.

DOUGLASS'S EXPANDING BUSINESS

The period shortly after the libel suit proved challenging for Douglass professionally. In March 1842, Lydia Maria Child hastily penned a letter to her fellow abolitionist friend Wendell Phillips. Lucretia Mott and Esther Moore had earlier written to her with letters of introduction that "[spoke] highly" of Douglass and now Child expressed the guidance and encouragement that she felt Douglass needed. "I wish you would advise with him, and speak a true, frank, and friendly word," she wrote. "He needs counsel."[142] She described his difficulty establishing himself as a portrait painter while

he "painted signs, when he could get nothing of a higher order to do" and suggested that he work in Boston or New Bedford, Massachusetts. The large community of antislavery activists there might be more supportive. Child communicated the instruction and "considerable interest" that Benjamin Robert Haydon and Charles Robert Leslie invested in Douglass during his time in London. Child's inclusion that Douglass "belong[ed] to a very intelligent and respectable family" likewise sought to impress Phillips and further prompt him to reach out to the artist.[143] In the meantime, Douglass seemed to return to work that had sustained him in the previous decade. He advertised a temperance banner and its exhibition so that members of the public could "compare it with others and judge whether [Douglass] merits encouragement." Furthermore, he advertised his lithographed and now "handsomely" colored portraits of William Lloyd Garrison "from his original painting," which was then "in possession of the *Liberator*."[144] Likely returning to subjects that had already proven profitable, Douglass aimed to increase the desirability of his artistic skills.

Just a few months later, Douglass had started afresh in New York City and adopted a more diverse business model that focused on producing and teaching art. During the summer of 1842, Douglass advertised his "Gallery of Paintings" and welcomed visitors to his gallery at 202 William Street, where he admitted those eager to see his artwork without charge. The advertisement framed the purpose of the gallery venture as largely a means to an end; Douglass exhibited his work not only to sell it and earn new commissions but to attract students.[145] To demonstrate his skill, it was the first known time in his career that Douglass displayed his art in New York. Away from his hometown of Philadelphia, and "having terminated his studies in the 'divine art,'" Douglass marshaled his diverse artistic talents, his social connections, his elite artistic training, and his mastery of several visual artistic skills to attract pupils. He sought to impress the readers of the advertisement with all the people whose portraits he had recorded from life. His list of illustrious people — including President Boyer of Haiti, Prince Albert, the Duke of Sussex, the Lord Mayor of Dublin Daniel O'Connell, abolitionist Thomas Clarkson, Archdeacon Samuel Wilberforce, and François Guizot — highlighted his international travels and the social networks required to gain access to these prominent individuals.[146] The absence of inhibitive entrance fees enabled greater numbers of people to visit his gallery than otherwise would have.

Increasing the number of potential customers by diversifying his work was a shrewd business strategy. In his "Gallery of Paintings," Douglass also

Compositions of No Ordinary Merit

sold his translation of F. Lamennais's *Book of the People*. He included the note that the "translation had been approved of by writers of established reputation, and other capable judges."[147] Mentioning his translation along with his "specimens of Lithography, humorous and otherwise," Douglass further attempted to attract customers. After all, as he noted, the lithographs "designed, drawn on the stone, and splendidly colored by R. D., Jr., may at all times be seen in the Gallery."[148] This may have appealed to customers who preferred the accountability of an artist who controlled each aspect of his lithographic production—research and design, execution, postproduction detail, advertisement, and sale. In doing so, he broadened the appeal of his advertisement to include those individuals interested in viewing or purchasing humorous lithographic prints, a very common visual genre in the 1840s. His venture apparently was not successful. If his quick return to Philadelphia was any indication, his entrée into art education did not proceed as hoped, but he arrived in Philadelphia with a renewed vigor to use his artistic skills for a broad range of work.

Douglass diversified his artistic portfolio and benefited from an expanded customer base when he reestablished himself in his home city. He placed an advertisement in the *Public Ledger* that called on local firemen to retrieve the equipment that he had painted.[149] Later that month, Douglass took out a recurring advertisement that touted his ability to offer his painting skills at lower prices than competitors. He also advertised his drawing and oil and watercolor painting classes "according to the practice of the best foreign schools."[150] Douglass later received a commission to paint a fire engine for the Globe Engine Company. The company, described as "active and respectable," took home their "repainted and much improved" fire engine in February 1843 after Douglass helped make it "one of the very handsomest and most serviceable engines in the city and county." The unnamed writer who viewed the engine praised Douglass's paintings on the sides of engine as "highly creditable," thus making it "altogether worthy of the company, and a subject of their pride."[151] Such reviews testified to Douglass's painterly skill and his entrepreneurial spirit.

An advertisement for Douglass's daguerreotypes that recurred for nine months in 1844 hinted at additional business aspects of Douglass's profession. He promoted his broad range of visual artistic skills, which included portrait and miniature painting honed at four London art institutions. He also advertised his ability to produce daguerreotype miniatures for the first time. This makes him the first known black daguerreotypist in Philadelphia. The "Arch Street Daguerrian Gallery," the advertisement announced, "is in

the same building, where miniatures can always be obtained, executed in the best manner, and the process willing[l]y explained to the curious by the proprietor."[152] Douglass appealed to both his potential customers' desire for images and their wish to understand the process by which Douglass crafted them.

As he had during the previous decade working as a visual artist in Philadelphia, Douglass shared his 54 Arch Street workspace with his family. His sister, Sarah Mapps Douglass, displayed her own goods for sale at the Arch Street Daguerrian Gallery. Visitors to the space saw her "marking[s] on linen, silk, &c" and could purchase them for an undisclosed sum.[153] Passersby entering the storefront to view Sarah's merchandise might be enticed to have their portrait painted or daguerreotype created. Likewise, people attracted by the daguerreotypes in the street may have purchased one of Sarah's products. Douglass advertised a range of goods and skills: signs, banners, transparencies, and Masonic emblems.[154] Douglass's advertisement also revealed his return to advertising the artistic profession that he first advertised in the early 1830s — sign painting. Offering these products in one space expanded the possibilities for the financial success of both Robert and Sarah. Their family business venture spoke to the methods that Robert and Sarah adopted to make a living.[155] Fancying to label his workplace as "The Central Sign Painting Establishment," Douglass noted his willingness to describe the process of daguerreotypy in his gallery to the curious visitor.[156] Douglass also mentioned that "having acquired the above mentioned arts by great labor and expense, and having had to struggle against peculiar difficulties, [he] flatters himself that a liberal public will not refuse him encouragement."[157] By alluding to racial prejudice that he had experienced, Douglass appealed to his reader's sympathy in the hope that it would fuel his visual production.

CONTINUED PRODUCTION OF
ANTISLAVERY VISUAL CULTURE

While expanding his business of producing a variety of visual media, Douglass created images of the famed abolitionist Abby Kelley Foster to advance the antislavery cause. In 1846, Foster visited Douglass's Daguerrian Gallery to sit for a series of daguerreotype portraits. In a letter he wrote to her, he enclosed one of the daguerreotypes he created during her visit to his studio. Douglass explicitly recorded the reason for which he had produced her daguerreotypes: "for the purpose of being lithographed."[158] Expanded visibility via circulation was the primary reason to transform a daguerreo-

Compositions of No Ordinary Merit

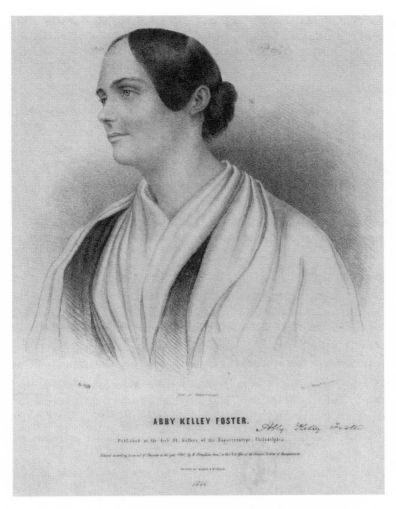

Figure 3.5. Alfred Hoffy, *Abby Kelley Foster*, after a daguerreotype by Robert Douglass Jr., 1846. *Courtesy of the American Antiquarian Society.*

type into a lithograph (fig. 3.5). Copying daguerreotypes proved impractical, and they could not be mass-produced because of material and technological constraints. Their fragility made them impractical to be passed frequently from person to person. Lithographs, however, allowed for the mass production of comparatively cheaper images that resulted in larger numbers of viewers. Douglass made clear that viewership was a critical component of Douglass's production of Foster's image. "If in regarding your portrait," Douglass wrote, "a single spirit is encouraged to enter upon the same glorious, although arduous labors, or excited to action for the advancement of

the great and Holy cause in which you are so indefatigably engaged I shall be amply rewarded.[159] What had almost certainly been a reason for reproducing images of Garrison and others earlier in Douglass's career were elucidated in his letter to Foster.[160] Persuading the viewers of his portraits to empathize with the cause of abolitionism was one of Douglass's important motivations for his work.[161] Even more specifically, Douglass hoped that his work spurred those who viewed the image, black and white, to enable those freedoms. This lithograph in particular could also be a souvenir; Foster had given lectures in Philadelphia as part of her speaking tour that year. In his letter to Foster, Douglass made clear his hope that viewers of his abolitionist images become "excited to action" in the cause of enslaved people's rights. Soon, he offered the lithograph for sale.[162] Printed praise of it amplified its message. Described as a "handsome lithograph," the "handsome picture [is] a likeness that will be recognised as far as it can be seen, by any one who has ever seen the original."[163]

Douglass continued his dedication to the abolitionist movement at the annual fair of the Philadelphia Female Anti-Slavery Society in 1846. Held in December, the eleventh annual fair raised money for the cause of abolition through the sale of abolitionist literature for "children and adults, daguerreotype likenesses of British abolitionists Thomas Clarkson and [William] Wilberforce, and a vast variety of goods suitable for the Christmas gift-giving season."[164] The Committee of Arrangements, composed of black and white women, included such leading African Americans as Amy Matilda Cassey, Margaretta Forten, Harriet Purvis, and Sarah Purvis. Together, they envisioned the annual fair to direct the resources of their "brethren and sisters . . . to the *poorest of the poor—the crushed and smitten slave*."[165] After the fair ended, an article in the *Pennsylvania Freeman* gushed about the fair's success in raising the incredible sum of $1,432.68. "Never before," the article read, "had the interest in the Fair been so general, or active participation in it so extensive among the abolitionists of eastern Pennsylvania."[166] As people from Pennsylvania and several other states perused the merchandise during the three-day fair, Douglass's artwork greeted them.

Douglass's participation in the abolitionist fair underscored his dedication to the cause of emancipation. In giving a favorable description of the interior space housing the annual fair, one reviewer described Douglass's picture, hung for all to see:

On entering the Saloon the eye first rested on a large and beautiful picture of a Liberty Bell painted by Robert Douglass, an artist of this

city, and generously presented to the Fair. Its station was at the head of the room, over the orchestra. It bore the inscription, PROCLAIM LIBERTY THROUGHOUT THE LAND. Underneath this picture, and in front of the orchestra, were inscribed in large characters the following sentences, "DUTY IS OURS; CONSEQUENCES ARE GOD'S. ARE WE NOT VERILY GUILTY CONCERNING OUR BROTHER?"[167]

Douglass's picture and accompanying text expressed the message of deliverance from slavery about which the Committee of Arrangements had written in its advertisement for the fair. Hung at the head of the large room—the most visible and prominent position in the space—the painting attracted visitors' attention and invoked messages of religiosity, national pride, and abolition. Guilt, too, played a role in motivating the charity of attendees. After all, "Proclaim liberty throughout the land" referred to the inscription on the increasingly iconic and infrequently rung Liberty Bell situated only blocks away. The quotation derived from the book of Leviticus, chapter 25, verse 10: "Proclaim liberty throughout all the land, to all the inhabitants thereof." The image of the Liberty Bell had been used by various abolitionist societies for nearly a decade before Douglass displayed his painting at the fair. Familiar to many, the bell symbolized the unfulfilled revolutionary principles of freedom and democracy that Douglass and other abolitionists championed for free and enslaved black people. That Douglass "generously presented" the image to the society bears noting, since it implied that Douglass donated the picture to the fair and therefore did not benefit financially from it. The visual centerpiece of the antislavery event, coupled with its accompanying text, acted as a political call to action and marked an extension of the various forms of public activism that Douglass had participated in over the past two decades.

LAYERING IMAGES AND ACTIONS

The 1840s ended on a more somber note for Douglass than it did for Reason. Douglass experienced several difficulties during the decade, such as the libel suit, moving his business to New York City, and then, sometime between late 1846 and February 1847, traveling to Kingston, Jamaica, because of the inability "to gain a livelihood by his profession" in Philadelphia.[168] Douglass's peripatetic time in Jamaica was fraught with unmatched expectations and displeasing realities related to its people, city life, and the high cost of busi-

ness there.[169] After more than a year in Jamaica, he returned to the United States.

The lives and visual production of Robert Douglass Jr. and Patrick Henry Reason during the 1840s tell us a great deal about the struggle for black rights during that decade. The countercultural images created by both men acted as a cultural battleground on which black actors challenged stereotypes of blackness and produced competing counternarratives in the service of black political enfranchisement and freedom from slavery. Their activities during this decade reveal the vast reach and importance of abolitionist networks, the organizational structures used by black rights' supporters, and the reasons for which they created imagery in support of free, enslaved, and formerly enslaved African Americans. By studying how viewers interpreted the content and context of visual materials during this decade, the meanings of these images come into focus. The actions and desired intentions of the artists themselves spotlight visual culture as a contested and influential terrain during the 1840s. The viewers of their images, they believed, had much to gain by reflecting on the ideas of black respectability, success, and intelligence in the service of black rights. African American image-makers' activism demonstrated that the fight for black rights not only took place at marches, political conventions, and benevolent societies; the fight included print and visual culture created and disseminated by Robert Douglass Jr. and Patrick Henry Reason. Studying their participation in elocution societies, literary societies, and political conventions provides a frame for situating their artwork in a particular historical context and revealing what ideas, discourses, and events influenced their visual production. Both Douglass and Reason marshaled technological advances and developed their artistic skills to communicate countercultural messages about who African Americans were and what they could be in the United States. Their image production expands further the scope of abolitionist activity by considering the production of abolitionist images to be intertwined with, and essential to, the abolitionist movement and debates about the future of African Americans during the 1840s.

4

SPECTACULAR ACTIVISM
Black Abolitionists and
Their Moving Panoramas

On the night of March 16, 1852, more than a hundred men, women, and children crowded into an exhibition hall in Wolverhampton, England. After they paid the entrance fee and took their seats, an assistant drew back a curtain to reveal a massive plane of canvas stretched taut between two moving cylindrical rods. Lamps illuminated the moving panorama from behind, while in front, audience members saw a sheet of canvas that stood between eight and twelve feet tall and extended for more than a thousand feet. Over the course of the evening, their host used the forty-six separate painted views depicted on the canvas to describe the horrors of the Middle Passage, regale the audience with views of cities in the United States, and recount his life as a formerly enslaved man in Virginia. Both the range of images and the subjects covered that night—from "Gorgeous Scenery of the West India Islands" to enslaved people "Burning Alive"—amazed and horrified many of the attendees. They may have taken solace knowing that the proceeds of their admission fee were to be used to purchase freedom for the enslaved wife and children of the host, Henry Box Brown.[1]

Henry Box Brown and other African American men, William Wells Brown and James Presley Ball, fashioned their own moving panoramas to help realize the goal of ending slavery in the United States during the 1850s.[2] A "very mild" visual depiction of slavery featured in another moving panorama prompted William Wells Brown, a formerly enslaved man, to counter with his own moving panorama of slavery.[3] He then donated the entrance fees paid by its visitors to the Massachusetts Anti-Slavery Society, its annual

antislavery bazaar, and the American Anti-Slavery Society.[4] More urgent motivations spurred escaped slave Henry Box Brown to commission a moving panorama of slavery; he raised funds to purchase the freedom of his enslaved family members.[5] A desire to raise awareness of slavery's brutalities inspired James Presley Ball to leave his lucrative photographic business in Cincinnati and tour with his moving panorama of slavery. Never before studied in tandem, these three men and their panoramas reveal antislavery activists' multiple strategies to secure emancipation for enslaved Americans. Through their touring exhibitions, many thousands of New England, western, and European audience members viewed their creations. The vast diversity of their audience members — black, white, men, women, children, young, old, slave owner, and abolitionist — testified to the wide appeal of the moving panoramic medium and its creators' ability to convey the crises wrought by the continuance of slavery and the passage of the 1850 Fugitive Slave Act.

Henry Box Brown, William Wells Brown, and James Presley Ball each used the medium of the moving panorama to center the ordeals of enslaved people. Each adopted a popular visual technology to engage more audiences on topics related to slavery and its abolition. These black men subverted the genre of the panorama to varying degrees by exhibiting views that shifted the primarily panoramic narrative from landscapes to the experiences of African-descended people. In doing so, their "oppositional and autonomous political expression" promoted representations of black people that contradicted conventional popular cultural conceptions.[6] They refashioned the moving panorama to spotlight the experiences of free and enslaved African Americans and imbued the visual medium with activist intentions. In doing so, William Wells Brown, Henry Box Brown, and James Presley Ball harnessed the strengths of the panoramic medium to entertain, educate, and then encourage viewers to experience vicariously the scenes that came to life in front of them. These black cultural producers charged themselves with advancing alternative cultural representations of slavery and African Americans, and in so doing, they expanded and refined discourses of race on both sides of the Atlantic.

VISUAL SPECTACLE, CULTURAL EDUCATION

The panorama as a medium of entertainment and education had existed since the late eighteenth century in England. Initially stationary — with viewers gazing at an interrupted image that extended for great lengths — the panorama became popular with European and American audiences as

Spectacular Activism

a means to view faraway lands, military battles, and other historical scenes. After its popularity diminished in the United States during the first quarter of the nineteenth century, the moving panorama enjoyed a "vigorous revival" in the late 1840s.[7] These panoramas often depicted European locales, but the most popular moving panoramas sated and generated an increasing interest in the frontier by picturing scenes of the American West, especially along river voyages.[8] Indeed, the growth of moving panoramas' popularity mirrored the rapidly expanding boundaries of the United States in the late 1840s and early 1850s. With keen interest, Americans became familiar with the Mexican-American War, the annexing of Texas, the California Gold Rush, and the stunning landscape largely foreign to those living on the Eastern Seaboard. Panoramas increasingly became a critical tool that viewers used to understand their changing nation.

Several men capitalized on the fascination of the West and its most visible, easternmost demarcation—the Mississippi River—by using the medium of the moving panorama. John Banvard was perhaps the most successful exhibitor of a moving panorama in the 1840s. He transformed the sketches he made during multiple raft trips down the Mississippi River into two traveling panoramas of the Mississippi that attracted more than a quarter million viewers in Boston alone.[9] Railroad companies created new schedules to accommodate the passengers flocking to see his work. He toured his spectacular commercial success in Boston for six months and in London for twenty months, where more than six hundred thousand Londoners turned out for the show and Queen Victoria requested a private viewing.[10] Banvard was far from alone in his exploits. In the United States, many thousands attended the moving panoramas exhibited by John Rowson Smith, Samuel Stockwell, Leon Pomarède, John Skirving, and Henry Louis that depicted the Mississippi River and the expanding U.S. West.[11] Spectators eagerly attended panoramas of the Mexican-American War, Mexico, and, by December 1852, John Wesley Jones's *Pantoscope of California, Nebraska, Utah, and the Mormons.* Jones's panorama "marked just how much the national imagination of the far West had expanded since the mid-1840s," as historian Martha Sandweiss has written, "when the Mississippi River seemed the boundary between the settled East and an only vaguely understood West."[12] Many scholars of moving panoramas in the United States have argued that, after the medium's revival in the late 1840s, Manifest Destiny became a prominent theme in these educational spectacles.[13] Taken together, these shows celebrated an allegedly untouched, topographical beauty that promised vast, untapped economic wealth.[14]

At its core, the moving panorama offered audiences visual accessibility to a broad diversity of subjects and locales. In fact, as one scholar has written, the moving panorama acted as a travelogue that proffered "liberating access to an apparently encyclopedic reality."[15] Observers attended these exhibitions to learn about faraway lands to which they would likely never travel in person. In other words, visitors could "experience the foreign and exotic" on a grand scale with the assistance of a narrator who acted as a knowledgeable tour guide but without the costs and "inconveniences of actual travel."[16] The calculus of accessibility coupled with comfort left undisturbed the intensifying debates over the westward expansion spread of slavery. But it was precisely the ways in which viewing scenes became a form of knowledge production that Henry Box Brown, William Wells Brown, and James Presley Ball used the medium to articulate the oppression of slavery and hasten its downfall. Instead of presenting the western landscape as untapped economic wealth, their panoramas stridently portrayed the economic wealth generated by, and withheld from, enslaved African Americans. Their exhibitions offered encyclopedic knowledge of slavery without the pains suffered by the people painted on the canvas. Black cultural producers provoked attendees to experience the domestic issue of slavery that was foreign, in an intimate sense, to them.

Scholars have shown that assertions of veracity and authenticity partly propelled the popularity of moving panoramas.[17] Advertisers and those who narrated moving panoramas repeatedly contended that scenes accurately represented what viewers would see and encounter if they journeyed to the depicted locations. Attendees often described these views, "each one a correct likeness of the original," with language that mimicked the declarations of veracity and authenticity that panorama promoters publicized.[18] Citing the artists' personal experiences rafting down the Mississippi River, traveling to California, or exploring Niagara Falls bolstered the authority of their claims. These occasionally gymnastic strategies of persuasion were not the sole realm of panorama promoters; scores of nineteenth-century writers and artists rooted their assertions of veracity and authenticity in personal experience.[19] Advertisers and narrators of panoramas capitalized on the desire to be entertained by a medium that alleged to reproduce a mirrored reality rooted in vision. As such, many observers at the very least desired that paying an admission fee and viewing a panorama engendered a simulated, vicarious experience.

Several characteristics of moving panoramas aided in the dissemination of their messages by encouraging a captivating experience for the viewer. The

Spectacular Activism

grand dimensions of this visual medium offered attendees large amounts of detail and enabled narrators to shift times of day, locations, and complete storylines with the turn of a lever. Unlike the single, enormous panoramic view that characterized immobile panoramas, moving panoramas could create suspense and anticipation for the next view yet to be unrolled by the panorama assistant.[20] Moving panoramas also benefited their exhibitors and audiences through their portability. Exhibitors disassembled these massive planes of canvas and transported them to another location where they could attract new patrons. As a result, moving panoramas circulated both their views painted on canvas and the ideologies embodied in those views. The affordability of these moving panoramas also rendered them accessible to most of the population. Taken together, these elements contributed to the "vigorous revival" of the panorama in the United States during the late 1840s.[21]

Just as the resurrected visual medium of the moving panorama changed the nation's visual and cultural landscape, so too did African American activists change the trajectory of the antislavery movement during the 1840s and 1850s. Entering more public leadership roles after repeated instances of paternalism and racism, black antislavery activists increasingly broke with established white abolitionists. Frederick Douglass's founding of the *North Star*, his split with William Lloyd Garrison, and the more than threefold increase of "colored conventions" in the 1840s than in the previous decade are but a few examples. Scholars have argued that the marginalization of black abolitionists accounted in part for their later, more visible leadership positions.[22] Escaped slaves such as Henry Bibb, Ellen Craft, Sojourner Truth, Henry Box Brown, Samuel Ringgold Ward, and Frederick Douglass provoked audiences to grapple with firsthand testimonies of slavery's brutality as they organized colored conventions and used domestic and international lecture circuits to amplify their concerns.[23] Beginning in 1830, black women and men who attended colored conventions addressed pressing national and state issues, including the abolition of slavery, emigration campaigns, voting rights, land ownership, and the education of black youth. These conventions strengthened black antislavery networks and nurtured political conversations among, by, and for people of African descent in spaces where white peers could not sideline or silence black activists.

Moving within the circles of well-established abolitionist societies in Boston and New York City, Henry Box Brown and William Wells Brown adopted the new abolitionist strategy of exhibiting an antislavery panorama to sustain, ignite, and spread abolitionist fervor. Riding the swell of the mov-

ing panorama's popularity, Henry Box Brown, William Wells Brown, and James Presley Ball toured panoramas that deviated significantly from the moving panoramas of their predecessors. The revived visual technology of the moving panorama engaged millions of viewers. While many antislavery activists used "the panoramic perspective" to claim moral superiority over practitioners of slavery in antislavery literature, these black activists used the medium of the moving panorama to hasten slavery's downfall.[24] Box Brown, Wells Brown, and Ball increased the public presence of black activism and, each recognizing the importance of popular culture to reach broad audiences, marshaled the moving panorama to aid in the cause of emancipation.

HENRY BOX BROWN'S REFLECTIONS
IN HIS *MIRROR OF SLAVERY*

Henry Box Brown's rise to fame was meteoric after he escaped slavery in a wooden box that a shipping company delivered to Philadelphia abolitionists in 1849. His improbable tale of flight and his skilled retelling of his journey for freedom resulted in tours throughout New England and the Middle Atlantic states. Brown's itinerant lectures overlapped with the 1849 publication of his autobiography, *Narrative of Henry Box Brown*, which further disseminated his life story to thousands of readers.[25] A showman who often reenacted his escape from slavery before crowds of supporters, Brown decided to give Bostonians something they had never seen before: a moving panorama highlighting the brutalities of slavery narrated by a formerly enslaved man.

Brown gathered and instructed a team of men to create the moving panorama. He also acquired a partner, James Caesar Anthony Smith, the free black Virginian responsible for providing Brown with the name of the man who boxed him up and shipped him to freedom in Philadelphia. Three men—Josiah Wolcott, and two others with the last names Rouse and Johnson—painted the panorama as Brown lectured throughout New England. Little is known about the creation of the panorama other than the names of these artists and that the panorama required approximately "several months" of preparation, which included painting its tens of thousands of square feet of canvas.[26] When audience members attended moving panoramas during this era, they often received a booklet explaining the forthcoming views, but no such accompanying summary of Henry Box Brown's panorama survives. There remain, however, several detailed testimonies and newspaper articles that document the disconcerting, amusing, and evocative performance of

Spectacular Activism

Brown and his moving panorama. They reveal Brown's use of several strategies to make his exhibition popular: provocative advertisements, discounts for child visitors, the playing and singing of music, and the display of disturbing images.[27] Brown regaled audiences with a spectacle — simultaneously autobiographical, entertaining, and subversive — that detailed his former enslaved life.

First attended by the public in April 1850, the *Mirror of Slavery* was intended to secure freedom for Brown's enslaved family. One newspaper published a letter written by Brown for the public to contemplate: "I travel in the free states, and denounce slavery and slaveholders. I appeal to the public for assistance to buy my wife and children. I obtain the money; I offer it; I am refused. I raise more money; I offer twice their commercial value, and the reply of their owners is — you shall not have them. I have tried, sir, and others have tried, and the remorseless slaveholder still holds her and my children in bondage."[28] Beyond this personal demand, the subject matter of the *Mirror of Slavery* conveyed an urgent need for immediate emancipation. Given his need to purchase and free his loved ones, Brown had great incentive to ensure his panorama's financial success. He focused viewers' attention on the human suffering wrought by slavery instead of the conventional landscape views offered by most other moving panoramas that largely marginalized or left absent the role of people within the view. Brown took the opposite approach. His *Mirror of Slavery* emphasized the presence, rather than the absence or marginality, of nonwhite figures. He rejected the established practice of depicting enslaved people at the literal and figurative margins of the canvas. Instead, Brown placed enslaved people at the literal and metaphorical center of his narrative process. He sublimated the conventional visual trappings of the landscape panorama for the sake of presenting viewers of the *Mirror of Slavery* with the pressing message of abolishing slavery.

Brown and his business partner, James C. A. Smith, used several strategies to increase the popularity of the *Mirror of Slavery*. Advertisements heralded both the arrival and continuation of its exhibition and, in keeping with mid-nineteenth-century advertisements, used hyperbole to attract attention. Repeatedly billed as being "painted on 50,000 feet of canvas," the *Mirror of Slavery* appealed to audience members' desire to be captivated by a large-scale art form, or the enormity of what art historian Angela Miller has called "the spectacular."[29] Additionally, Brown and Smith encouraged young attendees by offering them half-price admission. This strategy made the antislavery messages of the panorama accessible to more people, financially rewarded Brown and Smith, and inculcated antislavery messages among

children. Advertisements also marketed musical performances that supplemented the visual education of the *Mirror of Slavery*; variations of sacred, instrumental, vocal, and even "plantation melodies" were exceedingly popular with audiences.[30]

Brown worked to encourage viewers to trust his panorama's claims of authenticity and credibility. Divided into two parts, the forty-six scenes that comprised Brown's *Mirror of Slavery* narrated a story of slavery in the United States that began with the African slave trade and ended with universal emancipation. While the twenty scenes in part one presented views of free Africans living peacefully before being captured and transported to North America by Europeans, Brown understood that many of his audience members would never visit any of the locations depicted in the *Mirror of Slavery*. Brown trafficked in anticipation; given the conventions of the panoramic medium, audiences expected to witness landscape views. Tropes of the panorama genre interspersed the scenes detailing the horrors of the African and transatlantic slave trade. Views entitled *Beautiful Lake and Mountain Scenery in Africa*, *View of the Cape of Good Hope*, *Gorgeous Scenery of the West India Islands*, and *View of Charleston, South Carolina* presented audiences with landscapes scenes that rocketed the visual medium to fame.

The contrast between freedom and slavery intensified in part two of the *Mirror of Slavery* as enslaved people battled the forces of slavery. Its opening views offered audiences some reprieve from the violence in part one. The first four views depicted events and tasks common to the southern United States. Scenes of a sugar plantation, a cotton plantation, *Women at Work*, and *Sunday among the Slave Population* detailed the conditions of enslavement. Together they displayed a range of the work that enslaved people regularly performed. Coupled with the violence in part one, these scenes of subjugation laid the foundation for a series of views that depicted the escapes of Ellen Craft, Henry Bibb, Henry Box Brown, and unnamed *Nubians, Escaping by Night*. Symbols and places representing liberty — *George Washington's Tomb*, *Jefferson's Rock*, and a distant view of *Philadelphia* — echoed the attempts at freedom undertaken by these fugitive slaves. In several scenes, these efforts are met with severe violence. Scenes of the *Whipping Post and Gallows in Richmond, Va.*, *Slave Prisons at Washington*, *Nubian Slaves Retaken*, and *Burning Alive* detailed both the threats to, and the consequences suffered by, enslaved people. The extreme violence illustrated the necessity for emancipation. In scenes of Brown's arrival in Philadelphia, *West Indian Emancipation*, and the closing scene of the panorama, *Universal Emancipation*, the *Mirror of Slavery* communicated hope in both realized and imagined freedom.

Spectacular Activism

One way of inducing support for the antislavery cause involved appealing to the audiences' expectations for the landscape scenery that they turned out in droves to see at other panorama exhibitions. One attendee of the *Mirror of Slavery* noted that "all persons were highly gratified with the splendid views of American scenery," and another commented that the panorama proffered "some of most picturesque scenery of the New World" of any panorama.[31] Yet another marveled at the "tranquil beauty and magnificent grandeur of African scenery" presented in the first half of the exhibition.[32] The views of scenery did not merely impress; they both calmed and excited. Viewers took note of the free Africans' "enjoyment of his freedom [a]midst his own beautiful lake and mountain scenery" before the slave trade initiated "his arrival at the auction mart of the freest country of the world."[33] The confined interior of the auction house starkly contrasted with the freedom, beauty, and pleasing elements of the African and New World panoramic views. Most people reading these published reflections as well as those attending the panorama would never visit Africa, Latin America, or the United States. The panoramic images of Latin America and several cities in the United States regaled audiences who would only vicariously experience these places and their inhabitants. This armchair travel lent the moving panorama an element of the spectacular in which the "travails of actual experience were displaced by an expedited, edited, and misleadingly simple passage through a simulated reality."[34] One reviewer, as though countering potential naysayers, wrote that "this is no fancied sketch, but one which many stand ready to vouch for in reality."[35] Though a simulated reality, viewers of Brown's *Mirror of Slavery* applauded what they wrote to be the authentic nature of the images illuminated before them.

The *Mirror of Slavery* traded in the performance of persuasion by depicting both beauty and horror. One attendee celebrated the panorama as a "brilliant work of art" that also "represent[ed] in a graphic manner the chief features of that fearful scourge—slavery."[36] The choice of the word "scourge" allowed for a double meaning both as a "whip"—a physical threat and punishment—and as a source of calamity. The multiple forms of violence depicted in Brown's panorama resulted in the word "horror" becoming the most commonly published word describing the *Mirror of Slavery*.[37] One writer captured the juxtaposition of beauty and horror when he recorded that "all persons were highly gratified with the splendid views of American scenery, but were horrified on witnessing the curse of slavery as depicted and carried on in the United States."[38] He continued by writing that "a gentleman called out when the performance was half done 'Mr. Brown, we have

seen sufficient; not that we are tired, but you show too much for so little a charge.'"[39] The man's phrase "we have seen sufficient" referred to the violence of slavery and that he required no more convincing of its horrors. Brown's panorama proved amply convincing. They proved "just and vivid" to one newspaper editor who described Brown's "conception of the horrors of slavery."[40] Brown's "simple, earnest, and unadorned eloquence" coupled with the "graphically delineated" "horrors of the slave trade" disturbed observers.[41] These factors aided in the persuasive appeal of Brown's panorama, for, in the words of another viewer, the panorama possessed a "startling vividness that leaves no doubt of the inherent depravity of man."[42] Provoking this realization and then using this response precisely mirrored Brown's panoramic intentions to persuade his audience of the horrors of slavery. One review confirmed this when writing about the transformative possibility of Brown's panorama and firmly advocated on its behalf: "We would urge our readers to visit this panorama; and if any of them have thought lightly of the injustice done by America to three millions and a half of our fellow-creatures, we feel assured they will leave the exhibition in another frame of mind."[43] The writer's faith that witnessing the panorama would provoke them to consider more seriously slavery in the United States revealed the extent to which antislavery visual culture was thought to compel people to recognize slavery's inherent injustice.

Some reviewers raved that Brown's panorama could invigorate and advance the antislavery cause in ways that antislavery lecturers and other abolitionist strategies had not. "From the opinion of persons who have encouraged this moral and instructive diorama, this exhibition," wrote one reporter, "if wisely conducted, will create more in favor of philanthropy than a legion of such anti-slavery lecturers as now swarm the community."[44] The reviewer hinted that the panorama would compel more financial support for the antislavery cause than the antislavery lecture circuit. His use of the word "swarm" suggested not only that several lecturers had attempted to bolster the antislavery cause but that, in doing so, they had irritated those to whom they appealed. Large numbers of antislavery activists, especially formerly enslaved African Americans like Henry Box Brown, traveled to the British Isles during the 1840s and early 1850s to engender antislavery sentiments through their peripatetic abolitionist lectures. Though activists had long visited Europe to elicit antislavery support, the uptick in black transatlantic activism marked a powerful method of authenticating black self-representation to an international community in the hope of intensifying pressure on the United States to end slavery.[45] To describe the number of antislavery lecturers as a "swarm,"

however, hinted at lecture fatigue. The reviewer understood Brown and his panorama to breathe new life into the antislavery cause.

The influence of the panorama's lessons in part depended on its visual execution. Reviews of Henry Box Brown's panorama frequently noted that its artistic dimensions both impressed viewers and inculcated its antislavery messages. Encouraging members of the public to patronize Brown's panorama, one reviewer wrote that "the paintings are well worthy of inspection," while another labeled it an "elegant work of art."[46] A third praised the *Mirror of Slavery* as a "great production of art," but the purpose of such critical acclaim became more apparent when reviewers specified the educational effects of the panorama.[47] "No one can see it," wrote another reviewer, "without getting new views and more vivid conceptions of the practical working of the system than he had before."[48] The panorama thereby acted as an art form that animated "new views" of slavery. It offered its viewers a more expansive understanding of slavery by confronting viewers with elements of slavery with which they may not have grappled. As such, the *Mirror of Slavery* enabled the expansion of the attendees' visual vocabulary of slavery and a broader conception of the history and practice of slavery.

Part of the persuasive power of Brown's panorama rested in its ability to educate. Contemporaries believed the *Mirror of Slavery* to be an instructive device about slavery in the United States. Although several viewers believed Brown exhibited the panorama "for the purpose of enlightening the English mind with respect to slavery," many reviewers envisioned that British youth would benefit greatly from attending Brown's panorama. The landscape scenery provided one form of education. "The young especially should not neglect the opportunity [to attend the panorama]," wrote one journalist, "as they may derive more information from the impressive scenery than they can do from the perusal of many works written on the subject."[49] Such promotion encouraged both parents and children to attend. That the multimedia experience of the panorama, undoubtedly coupled with its subject matter, promised to be more fruitful than many text-based resources about slavery demonstrates the power of personal testimony and visual education. Brown encouraged the attendance of children by offering them discounted admission in several towns and advertised that "the scholars and teachers in Sunday schools would be admitted by special arrangement."[50] As one attendee wrote, "There are other sources of interest, replete with lessons of instruction" that both children and adults alike could absorb by "pay[ing] Mr. Brown a visit."[51] The same writer recorded that "Mr. Brown is making arrangements with schools for attendance at his morning exhibitions."[52]

Students could hear and see the experiences of the African slave trade and slavery in the United States narrated by a formerly enslaved man. Evidently, "a vast number of individuals, including a great number of school children," in several cities Brown toured were, according to one viewer, all "gratified by their visit."[53]

Those observers whom the panorama did not gratify revealed that they spurned its claims of veracity and authenticity because they doubted its educational value and did not trust Brown himself. Though the views were "generally good," one witness testified, "some of them appear to exceed the limits of probability."[54] The focus of the observer's doubt rested in Brown's depictions of slavery and its extreme violence. The disbelief of one William Benjamin Smith, the editor of the *Wolverhampton Herald and Birmingham Mercury*, manifested itself in a scathing condemnation of Brown and his panorama in March 1852. "[A] gross and palpable exaggeration," according to Smith, the *Mirror of Slavery* should be attended by those "expect[ing] only amusement" and not an education on slavery.[55] Smith denied the authenticity of Brown's panorama by citing several other sources that allegedly revealed the true nature of slavery in the southern states. Smith pitted the truth claims of Brown and his panorama against "pictorial illustrations of the southern states, given to us by Banvard, Risley, Smith, Russell, and other artists," testimony of those who had visited slave states, and "the statements of even former slaves themselves."[56] The depictions of slavery in moving panoramas and which authority figures to believe came into conflict. Smith's words are revealing. They conveyed his doubt that Brown himself had been an enslaved man. They also reinforced the idea that the medium of the moving panorama convinced viewers of its purported veracity, as evidenced by the allegedly superior exhibitions of Banvard, Risley, Smith, and Russell.

The editor's doubts of the panorama's claims to represent enslavement truthfully did not stop at attacks on the panorama's authenticity. Smith described Brown as a "bejeweled 'darkey,' whose portly figure and overdressed appearance bespeak the gullibility of our most credulous age and nation."[57] When framed as an ostentatious figure hawking fraudulent accounts to naive and susceptible audiences, Brown posed a threat to the public; he took people's money and in return sated their desire to know a violent and exoticized version of slavery. "The representation, to our thinking, instead of benefitting the case of abolition," wrote Smith, "is likely from its want of *vraisemblance* and decency, to generate disgust at the foppery, conceit, vanity, and egotistical stupidity of the Box Brown school."[58] Writing with the weight of the newspaper behind him, Smith continued: "We therefore cau-

tion those who may attend to expect only amusement, as the horrors related in the richest nigger style are as good as pantomime, and to be chary in giving evidence to the astounding and horrified details with which Box Brown overwhelms his wide-mouthed and wonder-gaping audiences."[59] After repeatedly insulting the panorama, Brown himself, and the crowds attending the *Mirror of Slavery*, the review caused the numbers of people attending the panorama to drop off precipitously. The resulting lack of income prompted Brown to leave Wolverhampton for Lancashire, but not before nixing the idea of exhibiting the panorama in the Birmingham district because of the noxious effects of Smith's article. Brown fought back using the courts. On July 30, 1852, Brown and a team of lawyers presented Smith's article as evidence of a libel case they brought against the editor. The editor's printed denunciation, coupled with a register of receipts detailing the sharp decline in attendance in Wolverhampton, convinced a judge and jury to award Henry Box Brown more than one hundred pounds in damages.[60]

Smith's words revealed more about racial ideologies that shaped perceptions of African Americans than they revealed about Brown himself. As evidenced by his fixation on Brown's jewelry, body, and attire, Smith believed Brown's visual presentation to be incongruous with his notion of acceptable blackness and respectability. As scholar Daphne Brooks has argued, Smith's labeling of Brown's performance to be "in the richest nigger style" rife with stereotypical dialect underscored Smith's categorizing Brown's showmanship and his character as part of the realm of blackface minstrelsy.[61] Smith expected what he perceived to be more respectable antislavery advocacy. In fact, Smith warned readers to doubt the veracity of Brown's panorama *because* he believed Brown to present a persona of aloofness and extravagance. Smith demonstrated his attempt to reinforce a system of racial hierarchy through social codes determined and enforced by a white subject. In other words, Smith's written words "shift[ed] the referent of Box Brown's performance so as to return it to the realm of white authorial control."[62] The perception that he overstepped the social and cultural boundaries presumed for African Americans and deserved to be not merely publicly censured but forsaken by patrons elucidated the racial strictures constraining Henry Box Brown.

Media coverage of the trial provided insight into the audiences who saw the *Mirror of Slavery*. The reporting revealed that Brown began locally exhibiting his panorama on March 15, and for two nights, large crowds attended. Charging one shilling for prime seats, sixpence for second-tier seats, fourpence for third-tier seats, and admitting schoolchildren for half price,

Brown collected seven pounds the first night and nine pounds, nine shillings, the second night.[63] This translates to a minimum of 140 people the first night and 189 people the second night, though those numbers were impossibly low, for not everyone could purchase primary seats, making the likely audience in the low hundreds. "Clergymen and others who had an interest in schools" attended those nights. Smith sat among these attendees on March 15. With an informed estimate of the size of the audience in Wolverhampton, one scholar has estimated that Henry Box Brown exhibited the *Mirror of Slavery* as many as two thousand times, and it is therefore probable that many tens of thousands of people viewed the panorama.[64]

Apart from Smith's editorial upbraiding, Henry Box Brown's panorama generally enjoyed widespread acclaim and publicity during its extensive travels. As entertainment, it appealed to people desiring to view expertly delineated paintings and to learn about slavery in the United States. Advertisements noting Brown's status as a formerly enslaved man marked him as an authentic and credible source for his depictions of slavery. With few published exceptions, audience members invested Brown, his life story, and his panorama with their belief in the multimedia testimonies of slavery. Imbued with the trust of veracity and authenticity, Brown harnessed multiple strategies to heighten the popularity of his panorama. He satisfied his audience's expectations for viewing panoramic scenes but interspersed the panorama with depictions of subjection that created contrasts of subject matter and emotion. All served to educate and persuade audiences of the injustices of slavery and the necessity for its dissolution. Emancipation for his wife and family ultimately did not materialize, but in the process of working to free them, Henry Box Brown heightened the visibility of the antislavery cause in the United States and the perils to which enslaved people were subjected.

FOCUSING ON THE ENSLAVED PEOPLE IN WILLIAM WELLS BROWN'S PANORAMA

The parallels between the panoramas and intentions of Henry Box Brown and William Wells Brown, another formerly enslaved man who toured a panorama of slavery in the early 1850s, are numerous. William Wells Brown marshaled the panorama as a medium to persuade audiences in England and Scotland that slavery in the United States must be abolished. In doing so, his moving panorama increased the visibility of the brutalities of slavery while its entrance fees raised funds for antislavery organizations in the United States. Brown envisioned that his panoramic enterprise would realize free-

dom for enslaved people en masse just as Henry Box Brown envisioned that his panorama would secure the freedom of his family. The surviving booklet that accompanied his panorama booklet documents that William Wells Brown deliberately distinguished the moving panorama as a medium that could cogently and efficiently convince its viewers of slavery's evils. The booklet made clear the strategies he used to heighten the believability of his panorama's message. Brown invoked claims of authenticity and veracity to heighten observers' acceptance of his message, but he also explicitly attempted to impart a vicarious experience upon the viewer. Though consisting of fewer views than Henry Box Brown's panorama, William Wells Brown's panorama dedicated most of its scenes to the depiction of enslaved people. The further inclusion of people marked another move away from the panorama's conventional focus on topography toward a panorama that placed enslaved people center stage. He created a moving panorama because of the medium's popularity and its ability to spread antislavery beliefs as it moved among locales. William Wells Brown hoped that his panorama would accelerate the destruction of slavery by increasing public support, financial and ideological, for the antislavery cause.

William Wells Brown's life as an enslaved man informed the content and thrust of the panorama that he exhibited. Born in Kentucky in 1814, he lived most of his first twenty years as an enslaved man in Missouri. Over these two decades, Brown experienced much of what would later be depicted in the panorama he displayed in Europe. Several attempts to free himself from bondage resulted in whippings, being hunted by dogs, and severe beatings. Brown labored at many tasks for those to whom he was hired out: he toiled in fields, served as a waiter, and obliged as a coachman. One of his many employers, James Walker, forced Brown to travel the slave-owning lands along the Mississippi River and lead slave caravans to be sold at the New Orleans slave markets. After a successful escape from slavery in 1834, Brown enjoyed success as an antislavery lecturer and author of his 1847 autobiography, the *Narrative of William W. Brown, a Fugitive Slave*. Escaped slave narratives and the antislavery lecture circuit, two popular forms of self-expression marshaled by formerly enslaved women and men, were strategies for spreading abolitionist beliefs. These texts also increased the visibility and expanded the coffers of abolitionist societies in the decades before the Civil War. Brown paired his memories of slavery with his experience as an itinerant antislavery lecturer, outspoken temperance advocate, and autobiographical writer.[65] While in Europe, Brown added moving panorama exhibitor and narrator to his activist repertoire.

William Wells Brown recognized the power of visual culture when he witnessed a moving panorama that inadequately depicted slavery. Using the same visual medium, he countered and corrected these ideas of slavery with a moving panorama of his own. He detailed the origins of his idea in the booklet that supplemented his moving panorama. After attending John Banvard's moving panorama of the Mississippi River in Boston during the autumn of 1847, Brown wrote: "I was somewhat amazed at the very mild manner in which the 'Peculiar Institution' of the Southern States was there represented, and it occurred to me that a painting, with as fair a representation of American Slavery as could be given upon canvass, would do much to disseminate truth upon this subject, and hasten the downfal[l] of the greatest evil that now stains the character of the American people."[66] Banvard's exhibition attracted more than a quarter of a million attendees in Boston alone in 1847 and claimed a profit of approximately fifty thousand dollars.[67] Though the famous panorama is no longer extant, its accompanying pamphlet described its sole mention of enslaved people and its several views of plantations with romanticized and superlative language. In one view, "slaves working in the cotton fields" worked on "a large and beautiful island" on "fine cotton plantations" among "beautiful mansions of the planters" "and lofty cypress trees, the pride of the Southern forests."[68] The "splendid sugar plantations" of Louisiana, the planters living in "romantically situated" Natchez, Mississippi, and a "view of a plantation with all its busy and cheerful accompaniments" proved problematic for William Wells Brown.[69] In envisioning his own creation, Brown believed that the moving panorama held promise to advance the cause of antislavery.

While many praised Banvard's panorama, Brown immediately identified what he believed to be its deficient representation of slavery. Banvard's panorama took viewers on a journey of the varying landscapes, as seen from the Mississippi River, southward from St. Louis to New Orleans. In response to the "the very mild" depictions of slavery, Brown inverted the focus from landscape to black bodies and enslavement. Like the black people depicted in Banvard's other paintings, the enslaved people Banvard depicted in his panorama were likely physically small, rhetorically tangential figures.[70] In contrast, almost every description of the two dozen scenes in Brown's panorama highlighted that enslaved people were central to his scenes. What was shown unsatisfactorily in Banvard's panorama became the focal point of more than a thousand feet of canvas toured by Brown, who not only altered the medium of the panorama by changing *what* people saw but directed *how* they should see it.

It was no small endeavor to create as "fair a representation of American Slavery as could be given upon canvass" in order to "disseminate truth upon this subject, and hasten the downfal[l]" of slavery. Just two years earlier, when speaking to members of the Female Anti-Slavery Society of Salem, Massachusetts, William Wells Brown expressed his doubts about representing slavery: "Slavery has never been represented; Slavery never can be represented. . . . I may try to represent to you Slavery as it is; another may follow me and try to represent the condition of the Slave; we may all represent it as we think it is, and yet we shall all fail to represent the real condition of the Slave."[71] Representing slavery in its totality, in other words, was impossible. Each depiction would inevitably exclude the details of another person's experience of enslavement. Nevertheless, after Brown moved to England in 1849, he drafted plans for a moving panorama depicting the "real condition of the Slave," incomplete as it might be, to challenge misrepresentations in the visual cultural landscape. Brown's cultural production marked a direct and pointed disapproval of Banvard's panorama and other representations of slavery viewed by hundreds of thousands of people in the United States. In his act of rejection, Brown fashioned himself into a cultural producer charged with subverting the dominant visual culture of slavery with his own replacement. Viewers would see that Brown's panorama subverted racial stereotypes popular in visual culture and produced counternarratives in the service of antislavery.

Much of what can be known about Brown's intent as well as the content of his moving panorama survives in its accompanying descriptive booklet. The panorama is not extant, which leaves the booklet as the main guide to the subject matter and the purposes of the panorama's exhibition. Published in London by Charles Gilpin, the booklet included information about each of the twenty-four scenes that comprised Wells Brown's panorama. Beginning with a preface that testified to the authenticity of the views, the booklet contained descriptions of varying lengths of each scene on canvas. The conclusion included several descriptions of fundraising efforts by abolitionists in the United States and a list of women in twenty-eight cities throughout England, Ireland, and Scotland who had volunteered to collect funds to be sent to Boston. The booklet ended with a reprinted letter from William Wells Brown to his former master, Enoch Price, and a page of testimonials celebrating Brown's *Narrative*.

Brown's deliberate choices to incorporate subject matter in his panorama resulted in what he believed to represent more truthfully the lives of enslaved black Americans than Banvard's panorama. In the booklet that ac-

companied the panorama, Brown detailed his methodology for the creation of the twenty-four scenes. Brown first collected "a number of sketches of plantations in the Slave States" and later "succeeded in obtaining a series of sketches of beautiful and interesting American scenery."[72] He assembled a team of artists who copied the drawings that he had procured "after considerable pains and expense."[73] It might be no surprise, then, for some British attendees to have recognized visual elements of the panorama from American abolitionist literature. Brown aggregated and adapted images to form a visual foundation from which he constructed his panorama of slavery. Using canvas, Brown took license to privilege his personal experience as an enslaved man. More than half of the views depicted the circumstances faced by southern slaves, and audiences listened as Wells Brown narrated these scenes of his life. Though the precise language of these lectures is unknown, he purposefully selected anecdotes to effect slavery's demise.

Like then-common claims to convince members of the public of the veracity of a narrative, Brown testified to the truth of the ideas contained in the panorama when he wrote in the preface of the booklet that "many of the scenes I have myself witnessed."[74] He highlighted his status as a formerly enslaved man and the firsthand testimony of his nearly twenty years of enslavement. Both examples signified Brown's strategies to affirm and reaffirm the credibility of the views to be seen in his panorama.[75] Furthermore, Brown buttressed his claims of the twenty-four scenes' authenticity by writing that "the truthfulness of all of them is well known to those who are familiar with the Anti-Slavery literature of America."[76] This reference revealed that he expected some viewers to be familiar with abolitionist literature from across the Atlantic. It also underscored his implicit assumption that his audience members understood abolitionist literature from the United States to represent truths about slavery. Furthermore, Brown advertised the panorama as composed "from Sketches chiefly taken on the Spot" to convey both the veracity and the authenticity of the information he exhibited.[77] By celebrating the panorama as believable and worthy of attending, William Wells Brown crafted a marketing plan to solicit visitors and donations.

For Brown, believability came at the cost of excising features of slavery to which some would object. When deciding which views to include in the panorama, Brown wrote that he "refrained from representing those disgusting pictures of vice and cruelty which are inseparable from Slavery; so that whatever may be said of my Views, I am sure that the Slaveowners of America can have nothing to complain of on the score of exaggeration."[78] His assumption that slave owners would object to his visual depictions of

slavery implied that Brown expected slave owners to be some of the pano-
rama's viewers or, at the very least, learn of its content. Withholding these
images circumvented his anticipated claims that slaveholders would attack
the work as "exaggeration" and discredit his truth claims. As one attendee
of the panorama noted, "All disgusting details of American slavery, which
would be offensive to English taste, are withheld, and exaggeration has
been scrupulously avoided."[79] The cultivated strategy of omitting especially
heinous imagery offered one way to heighten the believability of the infor-
mation displayed in the panorama. Brown's decision likely made his pano-
rama more appealing and respectable to audiences; displaying gory images
of the brutalities experienced by enslaved people would likely have deterred
some potential patrons. Preempting possible claims of fictive representa-
tion, Brown modeled his panorama on perceived audience expectations and,
as a result, omitted elements of slavery that some viewers perceived to be
dubious.

The first half of the Brown's panorama presented the contextual and his-
torical arc of slavery in the United States. The panoramic performance began
with a view of Virginia in 1620. Described to readers as "slavery in its mildest
form," the booklet assigned some blame to the British because the British
imported slaves to its colony. Thus, from the first scene, Brown implicated
the British in North American slavery. The next ten scenes presented view-
ers with information with which many were familiar: slaves heading to mar-
ket, the separation of enslaved mothers from their children, the sale of black
people in Washington, D.C., and New Orleans, the picking of cotton on a
plantation, the harvesting of sugarcane, and the whippings endured by en-
slaved women. Brown's descriptions of these views make plain the multiple
registers of suffering, difficulty, and violence that accompanied slavery. Of
a view of a cotton plantation, Brown's pamphlet told readers that "'picking
season,' as it is called, is the hardest time for slaves on a cotton plantation
. . . the slaves are usually worked, during this season of year, from fourteen
to sixteen hours out of the twenty-four."[80] Brown pointed out that men and
women were expected to pick eighty and seventy pounds, respectively, a day,
"but they [slave drivers] often work them far above this task."[81] Failure to
accomplish the weight resulted in "five cuts with the cat-o'-nine-tails . . . for
every pound of cotton that is wanting."[82] To reinforce his point, Brown's
scene showed viewers "a woman being whipped at the whipping-post, near
which are the scales for weighing cotton."[83] In the following scene of a sugar
plantation, Brown eschewed the romantic language used in Banvard's pam-
phlet and instead showed the cane-cutting and sugar-boiling season, which

he termed "the hardest period of the year on a sugar plantation."[84] The rigor
of the work and threat of violence became apparent "in the foreground of
the view [where there] are slaves at work cutting the sugarcane" under the
surveillance of a black slave driver with a whip.[85] The placement of enslaved
people laboring during the most demanding period of the year in the fore-
ground of the view literally and metaphorically brought to the fore the bru-
talities of slavery. Brown underscored the veracity of his testimony by repro-
ducing several advertisements for slave auctions in the panorama booklet.
Brown had also participated in or witnessed many of these scenes. When
he had been hired out to James Walker, he accompanied slaves to the slave
market in New Orleans and watched sales of human flesh made on the auc-
tion block. From memory, he recalled two "white" girls being sold for $1,500
and $2,000 on a New Orleans slave block.[86] Brown's reference to the sex
trade these girls had been sold into — "for what purpose such high sums were
given all those who were acquainted with the iniquities of American Slavery
will readily suspect" — echoed the subject of "white slaves" present in three
views spread through his panorama.[87]

Brown invited viewers to experience a broad spectrum of emotion by
displaying diverse subjects in his panorama. In the second scene, the booklet
detailed an "[enslaved] woman who will not go on" after her child is stripped
from her, and as punishment, white slave agents "are now whipping her to
make her proceed without it."[88] In the seventh scene, enslaved men and
women wearing iron collars labor in a New Orleans chain gang. Brown re-
called: "I have myself seen, at one time, three free coloured men in the Cala-
boose [prison] in New Orleans; one of whom could not prove his freedom,
and was afterwards sold and carried to a cotton plantation."[89] Brown de-
cided that the eleventh scene depicting a slave funeral at night by torchlight
"need[ed] little or no explanation."[90] According to the booklet, only mas-
ters residing in "the better portions of Virginia, Kentucky, and Maryland"
allowed deceased slaves to be buried during the day, presumably because
the ritual would detract from the productivity afforded by daylight. The
text describing these three scenes — of a mother's whipping, the chain gang
composed of formerly free African Americans, and a funeral by torchlight —
encouraged viewers of the panorama to experience such emotions as anger,
loathing, anguish, grief, compassion, and repugnance. The second half of the
scenes in the panorama represented a narrower spectrum of subject matter;
all twelve represented the effects or process of escaping from slavery. As the
panorama progressed, viewers witnessed harrowing scenes of slaves fleeing

on horseback, escaping from a burning boat, fighting white slave catchers, and crossing the Niagara River to reach Canada. The intensified drama of escape, pursuit, and capture focused the attention and importance of the panorama on experiences of enslaved people. They depicted the precarious and dangerous decisions black men and women made to free themselves.

Before he toured England, Ireland, and Scotland with his panorama, Brown printed two editions of his autobiography, *Narrative of William W. Brown, A Fugitive Slave*, in London. Like the many African American abolitionists lecturing throughout the British Isles during the 1840s and early 1850s, including Henry Box Brown, Brown sold his tale of escaping from slavery as a means of promoting the antislavery cause and raising money to support his antislavery activism.[91] These editions included three full-page images interspersed throughout the *Narrative* that depicted traumatic events in Brown's life not featured in the 1847 Boston edition. It is possible that Brown sourced these three images as inspiration for several scenes depicting events in his life for his panorama. If representative of the scenes depicted in his panorama, they present a glimpse into the themes, subject matter, and artistic style conveyed in the panorama. They offer a portal into the visual tropes used to convince viewers of the inhumanities of slavery and to "disseminate truth upon this subject, and hasten the downfal[l]" of slavery.

The first image depicting a scene from William Wells Brown's life greeted viewers opposite the first page of the main text of the *Narrative* (fig. 4.1). The image closely matched the description of the panorama's twelfth scene, in which Wells Brown escaped from slave catchers' dogs by taking refuge in a tree before being captured and reenslaved. Escaping the violence that would be inflicted when it became clear that the slave catchers' dogs would surround him, he ascended the tree "knowing that all possibility of escape was out of the question."[92] Scholar Michael Chaney notes that Brown's position in the tree recalled the image of the supplicant slave made popular by Josiah Wedgwood in the late eighteenth century.[93] The symbols of a kneeling slave, slave catchers' dogs, and the slave catcher riding on horseback tapped into decades of abolitionist imagery. For viewers who had seen images with these iconic figures before, the scene could be simultaneously familiar and unique; the ideas of the image may have been recognizable, yet Brown explained that the scene depicted a deeply personal and traumatic moment of his life. For those viewers unaware of the use of slave catchers' dogs, the panorama booklet featured seven reprinted newspaper testimonies, with citations signifying their authenticity and believability, that detailed the use of dogs to track and

The author caught by the bloodhounds. (See p. 21.)

Figure 4.1. *The Author Caught by the Bloodhounds*, in *Narrative of the Life of William W. Brown, an American Slave*, 1850. *Courtesy of the Library Company of Philadelphia.*

recapture enslaved people. On multiple registers, Brown's panorama educated both its knowing and unknowing audiences of enslaved life for the purpose of accelerating its demise.

The second image depicting a scene in Brown's life showed him escorting enslaved men and women to the slave markets of New Orleans with his employer, James Walker (fig. 4.2). An image of contrasts, the woodcut presented enslaved people in crisp, lightly colored shirts, vests, and dresses. The knapsacks they carried would have been familiar to any viewer who had seen one of the thousands of stereotyped images of an escaped slave with a knapsack tied on a stick that had been slung over the shoulder. The knapsacks, women's headwraps, bare feet, and manacled hands marked these people as slaves. Sitting atop a horse, the authoritative Walker looked down at the people he led south to be sold. The dog by Walker's side signaled the threat of violence and one of the mechanisms of control wielded against enslaved people. In fact, each of the three full-page images featured in Brown's *Narrative* depicted slave catchers, their dogs and horses, and Brown. The posi-

Spectacular Activism

The slave-trader Walker and the author driving a gang of slaves to the southern market.

Figure 4.2. *The Slave-Trader Walker and the Author Driving a Gang of Slaves to the Southern Market*, in *Narrative of the Life of William W. Brown, an American Slave*, 1850. *Courtesy of the Library Company of Philadelphia.*

tioning of Brown behind the enslaved multitude and away from Walker and the dog visually distanced him from the authority of the slave trader, though his position on a horse reveals his forced participation in transporting the group of enslaved people. In the distance, Brown is rendered smaller than Walker and situated among the enslaved people, who occupy the left half of the image. This positioning conveyed Brown's lesser role in the trafficking of slaves; visual cues related to positioning underscored Walker's violent power and minimized Brown's responsibility for the tragic task.

Although no single view in the panorama depicts Walker, Brown, and a group of slaves being led to New Orleans, groups of soon-to-be-sold slaves presided over by authority figures appear in two scenes. In one, agents of the infamous and wealthy slave traders Franklin and Armfield led a coffle of slaves to be sold in Washington, D.C., and in the following scene, the same group of slaves are "chained and driven past the Capitol."[94] The booklet instructed viewers to contemplate the "hypocrisy, or gross inconsistency" of politicians "making speeches and passing resolutions in favour of Republicanism in France" while supporting slavery in the United States.[95] The ref-

The author and his mother arrested and carried back into slavery.

Figure 4.3. *The Author and His Mother Arrested and Carried Back into Slavery,* in *Narrative of the Life of William W. Brown, an American Slave,* 1850. Courtesy of the Library Company of Philadelphia.

erence to French republicanism marked another instance of hailing a particular audience knowledgeable of the contemporaneous celebrations of the emergence of the Second Republic in France. Such a reference would have been familiar to many British attendees of the panorama. The choice to locate the scene in front of the United States Capitol is telling. Few places could visually and metaphorically expose the insincerity of republican ideals. The panorama scene subverted the iconographic symbol of liberty and justice into one stained with inequality and hypocrisy.

The nineteenth view of Brown's panorama resembled a woodcut image of Brown and his mother's recapture that was featured in his autobiographical *Narrative* (fig 4.3). In the panorama booklet, Brown wrote that this view "shows that a fugitive slave has no security whatever that he will not be returned to his owner, until he shall succeed in escaping to Canada, or some other territory over which the United States Government has no control."[96] The booklet then directed readers to the page where they would find another description of the recapture. In the woodcut image, as Brown resisted one slave catcher's attempt to enslave him, he stumbled backward as a second slave catcher grasped his wrist in one hand and, in the other, a rope, later

Spectacular Activism

used to bind his hands together. The iconic knapsack that denoted Brown and his mother's status as escaped slaves resting on the ground between them, Brown's mother looked on, immobile. Following five scenes of people escaping from slavery, this scene of the panorama reminded viewers of the sobering reality of slave recapture. The violence symbolized by the recurring image of the slave catchers' dog kept visible the uncivilized depths to which men had sunk to perpetuate the institution of slavery.

The narrative arc of the second half of the panorama focused on the struggles of escape and recapture. Five consecutive scenes celebrated group and individual escapes from slavery. Though many of these were daring, dangerous, and sometimes innovative—they included defending one's family from wolves, escaping a burning boat, and cross-dressing as disguise—they depicted flight from bondage and the hope of freedom. One panorama attendee, writing that "the object has been to show the hardships of the slave, and the sufferings to which he is willing to submit, in order to gain freedom," accurately pinpointed the design of the second half of the panorama.[97] The view of Brown's and his mother's arrest ended a series of tantalizing freedom views and refocused the viewer's attention on the dangers of slavery. Lest viewers believe that an escape into another state guaranteed freedom, Brown transported them through various scenes located in northern states that endangered the provisional freedom of fugitive slaves. In a few of the panorama's final scenes, Brown exhibited views of a group of fugitive slaves living in Buffalo, New York, who banded together to liberate a family of escaped slaves after they "had been seized and dragged from their home at dead of night" by slave catchers.[98] High drama ensued as the band of fugitive slaves initially retook the "brother Fugitive and his family" but were soon surrounded by white canal workers and a sheriff attempting to reenslave them.[99] The panorama scene displayed the "terrible conflict" between the two groups with the group of fugitive slaves emerging victorious. The defiance of the fugitive slaves, who jeopardized their own freedom while assisting the captured fugitive family, demonstrated the precarious notion of freedom and the lengths to which fugitive people fought to fulfill it. As an escaped slave who sought refuge in Massachusetts and then as an escaped slave exiled in the British Isles after the passage of the 1850 Fugitive Slave Act, William Wells Brown knew well the uncertain and unstable realities of being a fugitive.

In the last scene of his panorama, Brown implored his British audiences to accept their responsibility to end slavery with a vicarious appeal. As they viewed the triumphant last view, *The Fugitive's home—A Welcome to the*

Slave—True Freedom—wherein fugitive slaves escape to safety in Canada after being surrounded and attacked by their pursuers—the booklet urged attendees to be eyewitnesses to the events shown in the panorama. The description read: "You have now accompanied the fugitive, amidst perils by land and perils by water, from his dreary bondage in the Republican Egypt of the United States to the River Niagara. *You must now imagine yourselves as having crossed that river, and as standing, with the Slave,* upon the soil over which the mild scepter of Queen Victoria extends; that sceptre not more the emblem of regal authority than of freedom and protection to the persecuted Slave."[100] Brown explicitly encouraged his readers to imagine themselves as having participated in the narrative and being bound to the fate of newly free slaves in Canada through Queen Victoria's rule over Canada and the land upon which they viewed the panorama. He envisioned Canada as a safe haven of "true freedom" for fugitive enslaved people and linked their fate with the actions taken by British attendees. Brown further encouraged the audience members' vicarious experience of the panorama by describing "[a] white man—an Englishman—[who] is extending his hand to his coloured friends, giving them, at the time, the comforting assurance that, on British soil, they are safe from the 'hunters of men.'"[101] The description was an overt appeal to white viewers. It encouraged audience members to see elements of themselves in the figures giving aid to the African-descended people shown in the panorama. Brown beseeched his audience members directly: "O Britons! . . . Still let it be the privilege of your countryman, in whatever country or clime he raises his voice, to assert the dignity and rights of humanity."[102] His appeal was nothing less than a transatlantic call for action.

William Wells Brown elucidated a transatlantic network of activism that attendees could use to contribute directly to the downfall of slavery. In language that echoed the description of the last scene of the panorama, Brown wrote: "If any, touched by contemplating the wrongs of the American Slave, should feel a desire to hold out to him a helping hand, they may be assured that opportunity is not wanting" before describing the antislavery societies in Boston, Massachusetts and their annual antislavery bazaar.[103] Beseeching his audience members to donate money as well as goods to be sold at the bazaar, Brown stated that the donations would fund antislavery lectures, public meetings, and publications. His list of women in more than two dozen cities who had volunteered to collect funds for the Massachusetts Anti-Slavery Society and the American Anti-Slavery Society evidenced the antislavery network that his moving panorama helped sustain.[104] If suf-

Spectacular Activism

ficiently compelled, viewers of the panorama could send money to any of these women with the promise that it would be used to aid in the downfall of slavery.

When exhibiting his panorama, Brown promoted various strategies to convince attendees of the need to contribute to the dissolution of slavery via donations and by intensifying antislavery sentiments. He harnessed numerous strategies to affirm the authenticity and veracity of his panorama in advertisements and his panorama booklet. Furthermore, Brown strategically invited audience members to experience vicariously the displayed events of the panorama. Instead of merely exhibiting a visual display marked by rigidly defined lines between observer and that which was observed, Brown encouraged his audience members to participate in certain scenes he exhibited and, after the viewing ended, participate in antislavery fundraising. Conceived as a direct refutation to the visualization of slavery in a popular panorama, Brown's project subverted commonly circulated narratives of enslavement that downplayed the violence of slavery and the substantial attempts made by enslaved people to free themselves. In doing so, Brown subsequently countered the stereotype of the romanticized version of slavery in the United States and refocused the panorama to emphasize the experiences of enslaved African Americans and centered them as the narrative focus of his panorama. This explains the panorama's repeated and detailed descriptions of enslaved people's attempts to find freedom. As such, his moving panorama greatly deviated from the landscape genre upon which it was based. Brown negotiated *what* his audiences saw, instructed them on *how* they should see it, and directed them to take action to *change* it.

FEIGNING OBJECTIVITY IN JAMES PRESLEY BALL'S *SPLENDID MAMMOTH PICTORIAL TOUR OF THE UNITED STATES*

Only a few years after William Wells Brown and Henry Box Brown exhibited their moving panoramas of slavery, another African American man named James Presley Ball followed suit. Ball established his own moving panorama that took its viewers on a visual tour that began in Africa, focused primarily on the United States, and ended in Canada. Compared to the black abolitionists' panoramas before his, Ball most explicitly warned of a "retrograded" national character caused by slavery. Ball's panorama featured more views showing the conditions of the enslaved than those of both William Wells Brown and Henry Box Brown. Though he was less personally urgent than

Henry Box Brown, who desired to free his wife and children from slavery, Ball instructed audiences that nothing short of a violent upheaval would leave the nation a "shapeless mass of wreck and rubbish" unless they helped end slavery.[105]

Like William Wells Brown and Henry Box Brown before him, Ball had an established reputation before turning to activism and launching his moving panorama. Born free in June 1825 in Virginia, Ball learned the process of daguerreotypy from another free black man, John B. Bailey, while in Sulphur Springs, West Virginia, in 1845. The young Ball took these skills and experience to Cincinnati, where carving out a living as a daguerreotypist proved difficult. In three months, Ball created but two pictures: one for cash, the other on time. Thinking that life as a photographer would prove successful elsewhere and having waited until the worst of the winter weather passed, Ball set out for Pittsburgh in the spring of 1846 and proceeded to Richmond, Virginia soon thereafter. He worked in a hotel dining room until he had saved enough money to rent a room near the state capitol, where his luck changed. "Virginians rushed in crowds to his room; all classes, black and white, bond and free," yet Ball returned to and traveled throughout Ohio for two years before settling in Cincinnati in 1849.[106] His profits steadily mounted, and on January 1, 1851, Ball opened another Cincinnati gallery to create and display his daguerreotypes.

News spread far and wide of James Presley Ball's skill and spectacular success. On December 26, 1853, Samuel Ringgold Ward, an escaped slave and antislavery activist, spoke to the Cheltenham Literary and Philosophical Institution in Cheltenham, England, and proclaimed Ball the best daguerreotypist in Ohio.[107] In April 1854, the full page that *Gleason's Pictorial Drawing-Room Companion* dedicated to Ball's growing photography business increased the visibility and reputation of Ball's skills. Half of the page displayed a richly detailed view of the gallery space — replete with a pianoforte, Greek statuary, plush window drapery, ornate carpet, fine furniture, dozens of mounted paintings and daguerreotypes, and more than a dozen finely attired men, women, and children perusing Ball's three-floor studio. The accompanying half-page article provided considerable information detailing the trajectory of Ball's career. Though "his early struggles were many and great," the article reported, "his love for art and firmness of character overcame every obstacle to his advancement."[108] The writer gushed: "[Ball] is the very essence of politeness — nor are his brother less tinctured with this sweet spirit of human excellence and a disposition to please every one who patronizes them."[109] This demeanor, the article continued, coupled with

"the best materials, "the finest instruments," and the ability to create a daguerreotype "with an accuracy and a softness of expression unsurpassed by any establishment in the Union," resulted in the fame and monetary success that Ball enjoyed.[110] Later in April 1854, *Frederick Douglass' Paper* identified Ball's gallery as "one of the most creditable indications of [African American] enterprise" in Cincinnati, which stood as "one of the best answers to the charge of natural inferiority we have lately met with."[111] In May 1854, *Frederick Douglass' Paper* amplified Ball's fame by reprinting on its front page the image of Ball's gallery and a portion of the descriptive text featured in *Gleason's Pictorial* the previous month.[112] In June 1854, the Toronto-based *Provincial Freeman* also reproduced the text for its readers.[113]

When several Boston periodicals received word that Ball would exhibit a panorama, they built anticipation for the coming show. "Mr. J. P. Ball of Cincinnati is in this city, making arrangements for the production and exhibition of a new panorama upon a national subject," reported the *Boston Evening Transcript*.[114] They anticipated that the panorama would "be ready for display in December next and will doubtless prove a very attractive and popular exhibition."[115] The *Boston Daily Atlas* provided more details and wrote enthusiastically about Ball's future work, noting that he "is about getting up a Panorama on a very extensive scale, to illustrate American scenery and, American institutions. This work, we understand, will cover some 35 or 36 thousand square feet. It will represent scenes in different parts of the country, and is designed to be true to nature and to facts."[116] Inclusion of the enormous surface area of the work hinted at the newspaper's appeal to readers eager to observe such a large moving panorama. The *Boston Daily Atlas* further mentioned that Ball was in Boston to take sketches of the city for inclusion in his production, further expanding public appeal to include the national and local.[117] Advertisements stressed diverse geographic attraction as well as interest regardless of background. *Gleason's Pictorial* wrote that Ball's developing project was "a subject particularly interesting to all classes, and which will be exhibited here ere long," and reminded its readers of Ball's fame and its article published five months earlier.[118] The reviews of Ball's panorama later stressed the moving panorama's accessibility, massive scale, popularity, and refined sensibilities.

Ball recorded his intentions for the fifty-three scenes in the lengthy booklet that accompanied the work. *Ball's Splendid Mammoth Pictorial Tour of the United States* explained most of the scenes shown in the panorama and often added information thought to be useful to readers. As he documented in its preface, he penned the booklet "thinking that the lessons sought to be

inculcated by Ball's Mammoth Pictorial Tour of the United States, could be further enforced by a collection of the facts upon which the picture [panorama] is based."[119] In recording these "facts," Ball claimed that he "endeavored to avoid the insertion of any thing that cannot be substantiated as truth. Of the laws and customs of the people, North and South, he has tried to give us an unbiased account, and 'Nothing extenuate, nor aught set down in malice.'"[120] Ball explained that he intended his audiences "to be inculcated" with "lessons" when experiencing his panorama. Since these lessons "could be further enforced by a collection of the facts upon which the picture is based," it stands to reason that the words inscribed in the booklet directly related to the lessons Ball sought to instill in the viewers of his panorama. Scholar Shelley Jarenski has argued that the didactic qualities of Ball's panorama marked its appropriation of the form rather than a disruption of it.[121] While true, this approach does not factor its content or its antislavery activism into the calculus for the disruption of the panoramic medium. Each is an essential element for understanding how Ball both appropriated and disrupted the prevailing characteristics of the panoramic medium. Like many panorama exhibitors before him, Ball repeatedly claimed the veracity of the panoramic experience and even proclaimed himself an objective, detached narrator of truth. In a line intended to support his claims of veracity, Ball wrote that the booklet "tis but a plain attempt to record plain facts for plain people."[122] His claims of veracity, objectivity, and accessibility were studied and intentional.

Launched in the same city as his successful daguerrean galleries, the panorama garnered much acclaim in Cincinnati. After showing the panorama to audiences for several weeks in March 1855, Ball traveled with it to Cleveland. Advertisements for "Ball's Mammoth Panorama of American Scenery" focused on the urban and landscape views as a means to attract the public.[123] Newspaper reviewers in Cleveland incited public interest by claiming that "all the Cincinnati papers, without a single exception are loud in their praises of Ball's Pictorial Tour of America."[124] Pinpointing the qualities that would interest potential attendees in Cleveland, one reviewer noted: "One [newspaper] lauds it for the truthfulness of its sketches, another for the excellence of its execution. The first thinking its views of Northern and Southern cities [are] unsurpassed, the second that its plantation, farm, and river scenes are unequalled."[125] Ball appealed to those audiences eager to see a panorama of scenery in the United States. By advertising that the panorama "finished in the highest style of art" had been completed at a cost of more than six thousand dollars and covered more than twenty-three thou-

sand square feet of canvas, Ball appealed to those people desiring to witness something impressive, expensive, and expansive.[126]

Ball delivered the advertisements' promise of landscape scenery, but he infused racial politics in the scenes. Beginning with African views, the first three scenes both reified and subverted stereotypical notions of Africa and Africans' primitivism during the mid-nineteenth century.[127] Ball showed viewers scenes of a lion hunt, scenery of the Niger River, and festivities following the hunt. Audiences witnessed dancing and banjo-playing Africans, but Ball noted that Africans "are far from being the indolent and ignorant savages that many suppose them to be."[128] He provided evidence of this claim by citing Africans' large-scale agricultural production, education of children, study of the Koran, highly efficient trade networks, and "considerable advancement in the science of government."[129] The next scenes showed the disorder caused by European intervention. The *Murderous Onslaught of the Slave Hunters, Natives Flying in Confusion*, and testimonies of starving bondspeople forced to march to the ocean and board ships bound for North America communicated to audiences the chaos, suffering, and death wrought by the transatlantic slave trade.

Ball's panorama traced the degrading effects on the work ethic, cultures, and peoples of the United States as slavery spread to American shores. A view of Charleston, South Carolina, marked the first view of North America. Ball lampooned the city as once "among the commercial cities of America," but "the withering influence of slavery," which its residents "cherish with fanatic zeal," now reduced Charlestonians to publicly whipping "delicate women . . . naked and bleeding, their flesh torn by the merciless lash."[130] Ball evidently did not restrain from using graphic imagery. South Carolina's support for slavery had contaminated the minds of its people and made victims of African-descended people while "making merchandize of her sons and daughters" and "exhaust[ing] her soil."[131] The symbol of Charleston as a city of immense wealth belied its retrograde underpinnings. Moving viewers' attention next to several scenes of the port of New Orleans and its scenic monuments, Ball showed how the common practice of slavery corrupted those who lived among it. He narrated an interior scene of Bank's Arcade, where men casually laughed, smiled, and read the news before forcibly separating and selling enslaved families. The evils engendered by slavery had taken root in "one of the most lecherous-looking old brutes I ever set eyes on" as he purchased an enslaved woman.[132] In a reference to sexual violation assuredly not lost on his audience, Ball prayed: "GOD shield the helpless victim of that bad man's power—it may be, ere now, that bad man's—lust!"[133]

Slavery enabled vice and victimization and its growth even in the few years before Ball exhibited his panorama showed its preservation and expansion.

As the scenes progressed north into the Mississippi River Delta, Ball underscored the variety of dangers that slavery imposed on the enslaved. During the presentation of landscape views of sugar plantations, a cypress swamp, and regal residences of the wealthiest slave owners, Ball identified — by name — those slave owners known to be especially vicious. Referencing the well-known violent slave owner in Harriet Beecher Stowe's book *Uncle Tom's Cabin*, Ball wrote that the bayous and swamps are "where tyrants reign king; [and] the Legree's [*sic*] rule their trembling slaves with a bloody hand."[134] The literary reference could immediately make recognizable the intentions and actions of the slave owners whose real names would be unfamiliar. Views alternated between the deadly process of sugar cultivation and processing and the immense wealth it generated in views of the residences of Valcour Aimé and Madame Beaujoie.[135] Using tables and numerous statistics, Ball presented readers of his booklet with population figures to prove that the brutal living conditions produced the very high death rate of enslaved people in Louisiana. To save themselves, enslaved people escaped by moonlight to surrounding woods as dogs set loose by slave masters chased them in scenes presented to viewers. Recounting one particularly ferocious newspaper account of a man who dismembered the body of a recaptured slave and "fed a pack of dogs with the limbs," Ball hoped to convince his audiences how slavery manufactured human depravity.[136] In contrast, Ball celebrated the courage of escaped slaves, who "are men of daring fortitude, and defy their pursuers even in death."[137] A study in contrasts, like the moving panoramas of William Wells Brown and Henry Box Brown, these views emphasized the inequality and injustice produced by slavery.

Public accolades of Ball's moving panorama took a decidedly antislavery tone as the exhibition moved to Boston in April 1855. Cleveland reviewers primarily celebrated the production's landscape, artistic execution, and size. Although several Boston periodicals lauded the panorama's scenic views, they quickly labeled the work as antislavery and heralded it as a work completed entirely by black artists.[138] The first article about the panorama printed after its arrival in Boston noted that "this picture has been executed by colored men who have lived over twenty years in the South."[139] Communicating claims of authenticity, the inclusion of this information implied that living in the South produced the skill to depict it truthfully. Furthermore, to note that black men had created the panorama alerted those Bostonians who endeavored to patronize black businesses.

Spectacular Activism

Reviewers gave varying reasons for attending Ball's panorama. While the panorama's "many beauties" prompted some reviewers to urge the public to attend, a recurring motive given for attending the panorama was to support free and enslaved African Americans. One writer challenged "every one to see it . . . especially all such as claim to be friends of the colored race."[140] Another reviewer remarked that those wishing to "assist in elevating a despised and oppressed race" should attend the panorama. An author writing for the *Liberator* pointed out that the panorama's exhibition coincided with the anniversary celebrations of the New England Anti-Slavery Society. As such, the reviewer desired that "all who claim to take an interest in the development of genius, talent and moral worth, on the part of free colored persons" would attend the panorama.[141] Visiting from Salem, Massachusetts, seventeen-year-old Charlotte Forten attended the society's annual event and Ball's panorama, the latter of which she "liked very much."[142] That night, she witnessed Charles Lenox Remond, a renowned black abolitionist and fellow resident of Salem who was advertised as the panorama's "delineator."[143] Only one Boston review of Ball's panorama described Remond as having "skillfully explained" the views before the audience. It is unclear for what duration Remond acted as the delineator of the panorama, but because Ball had presented a petition "for leave to exhibit" his panorama in Boston's Amory Hall, it is likely that both Ball and Remond shared the role.[144]

The violent views in Ball's moving panorama proved especially provocative and persuasive among audiences. "If any of our citizen's [sic] are contemplating a trip to the sunny South," wrote one reviewer, "they had [better] remain at home and save their money."[145] The experience of Ball's panorama, in other words, provided such a comprehensive range of views and information that a costly and difficult trip was unnecessary. Another reviewer attested that "the tableaux representing a pack of negro dogs seizing runaways, on Ball's great Anti-Slavery Panorama, is of itself sufficient to crown the Atheneum."[146] Yet another reviewer wrote that the plantation scenes detailing the suffering of enslaved people "should be seen by all."[147] The compelling depictions of the brutalities of slavery provoked these writers to advertise publicly that which they believed the public should see and learn for themselves. That the public should have attended Ball's panorama to see these scenes of subjection highlighted the idea that the scenes of slavery needed public visibility to expose the truths of bondage.

A critical component of the panorama was its didactic power. Interspersed between urban and riparian views of Mississippi, Missouri, Kentucky, and Ohio, Ball educated his viewers on the various crops that enslaved

people produced. Several antislavery societies waged boycotts of goods produced by enslaved labor simultaneous to Ball's exhibition as a means to weaken these industries and morally cleanse participants from supporting slavery's economies.[148] Views of sugar, cotton, tobacco, and corn cultivation complemented by meticulous explanations of the images appeared in the panorama booklet. In it, Ball repeatedly argued that slavery made possible the vast agricultural fertility of the Mississippi River Delta. The wealth of slave owners and the growing prosperity of the nation resulted from the stolen labor of enslaved people.

For some attendees, experiencing Ball's panorama was not merely an artistic or educational exercise to be studied from a distance but rather an immersive event that suspended reality. One reviewer detailed the sensation of "glid[ing] along insensibly with the picture from the cities, rivers and plantations of the 'Sunny South,' to the rivers and cities of the rough but free North."[149] The choice of the word "insensibly"—meaning "imperceptibly" or "unconsciously"[150]—hinted that the moving panorama so captivated this attendee that it suspended reality as it transported the viewer along its geographical journey. One scene flowed seamlessly into the next. In keeping with analysis of moving panoramas as presenting "passage through time and history by means of a movement through space," this attendee experienced the connection between Ball's depictions of topography and enslavement.[151] Since Ball proposed that the institution of slavery endangered the nation and prompted the degeneration of its people, Ball would have counted this viewer's experience as a successful realization of his exhibition.[152]

Ball argued that the toxicity of slavery and racism extended beyond the South and poisoned all areas of the country. In describing a view of the western city of Cincinnati, Ball wrote of "a period in the history of the city from 1835 to 1844, that scarcely a year passed that was not disgraced by mobs, against the anti-slavery whites, and colored people."[153] He described the demolition of abolitionist printing presses, the destruction of property, and violence suffered by its citizens with "the wild mob spirit being at times so general and strong, as to defy law and hold possession of the city for several days in succession."[154] Yet the outspoken critics of slavery and racism prevailed. "The right of free speech triumphed" because "as fast as one press was destroyed, they set up another, when driven from one office they secured another."[155] In recounting how antislavery forces triumphed, he offered readers hope that the proslavery forces and ideas gathering strength in the United States at the time of his exhibition could be defeated.

Moving east from Cincinnati, the panorama and its accompanying

booklet evidenced the long shadow of the Fugitive Slave Law darkening those states that had abolished slavery. Here, Ball employed visual culture to critique the politics of race in the United States. Describing eastern Pennsylvania as "beautiful," Ball warned that it "seemed fated to be the theatre of bloody contests" as he proceeded to list the history of clashes between Native Americans and colonists, Whigs and Tories, and, most recently, slave catchers and fugitive slaves.[156] The actions of the slave catchers, "whom the Fugitive Slave net had armed with arbitrary power," had "disgraced" the area by attempting to capture and murder the fugitive slave William Thomas in Wilkes-Barre before he found freedom in Canada.[157] Yet prejudice and the legal power of the Fugitive Slave Law forbade anyone from aiding Thomas; according to Ball, "not one hand was lifted to prevent" the violence that Thomas experienced.[158] In response, Ball castigated those in and near Wilkes-Barre specifically and Americans more broadly: "The blood that bred *murderers* in the Revolutionary era, breeds *cowards* in this."[159] Like the landscape scenes that impressed many attendees, the text of the panorama booklet argued that the violence wrought by slavery adulterated the natural beauty of the nation. The institution of slavery had mutated with the assistance of the Fugitive Slave Act of 1850 and subsequently sullied the character of the nation's citizens.

Ball contended that proslavery forces subverted the antislavery activism in New England. As the panorama displayed a view of Boston, Ball wrote that slavery had defiled the principles of freedom and justice that many of its citizens professed. Praise for Boston's public schools and its revolutionary spirit that gave birth to a new nation laid the foundation for a "noble" population that "continually . . . pointed the American people to the wrong and danger of slavery."[160] "But that accursed institution," argued Ball, "blunted the American conscience," "sapped its manhood," and "has had its blasting effect in Boston as elsewhere."[161] The extended reach of the Fugitive Slave Act, he wrote, "has made Massachusetts slave territory, and the Bostonians have submitted, restively tis true; but still they submitted."[162] Such a statement elided black and white Bostonians' repeated and sometimes successful attempts to thwart the recapture of escaped slaves who sought refuge in their city.[163] Ball maintained that the institution of slavery grew in strength and geographical reach to the detriment of the people of the United States — black and white.

Like William Wells Brown and Henry Box Brown before him, Ball imagined Canada to hold the promise of freedom from fugitive slaves. In the views leading up to the last scene of the panorama, Ball displayed views of

Niagara Falls. Panoramas depicting the waterfalls at Niagara proved popular among audiences in the middle of the nineteenth century, and Ball no doubt capitalized on the excitement that they generated. The international boundary between the United States and Canada marked by the waterfalls further assisted in the narrative trajectory of Ball's panorama. Unlike previous views that marked the landscape with violence and brutality, the view of Niagara Falls and its natural beauty signaled the possibility of freedom. Ball titled the last scene of his panorama *Queenston: Arrival of the Fugitives on British Soil* in order to show "a terminus of the Underground Railroad" that offered hope to fugitives.[164] There, Ball stressed the perseverance of those who often "make their way unaided to Canada, and freedom, and perform deeds that 'give the world assurance of a man.'"[165] Ball's language both underscored the humanity of enslaved people and reified their unnamed actions that implicitly made them more worthy of the title "man" than those who supported or practiced slaveholding.

According to Ball's panorama, slaveholding spelled the doom of the nation. The accompanying booklet ended with violently foreboding words for the future of the United States. Ball included a portion of Henry Wadsworth Longfellow's 1842 poem "The Warning" to convey the impending danger:

> There is a poor, blind Sampson in this land,
> Shorn of his strength, and bound in bands of steel,
> Who may, in some grim revel, raise his hand,
> And shake the pillars of our commonweal,
> Till the vast temple of our liberties,
> A shapeless mass of wreck and rubbish lies.[166]

In Ball's panorama and booklet, the promise of freedom existed only in Canada; freedom from slavery was beyond the current realm of possibility for those living in the United States. As a result, Ball directed a stern warning to the people of the United States. The debates over slavery or the violence suffered by enslaved people, Ball seemed to imply by reproducing Longfellow's lines, could eventually destroy the "temple of our liberties"—the government. Using this logic, emancipation could prevent this violence. Yet Ball directed the warning as a possibility, not a determined destiny.[167] Indeed, Ball intended his panorama to disseminate and strengthen antislavery ideologies that would prevent the violence described in Longfellow's poem. The reproduction of the poem presciently anticipated the violence of the Civil War that would erupt just a few years after the exhibition of Ball's *Splendid Mammoth Pictorial Tour of the United States*.

With revived interest in the moving panorama in the middle of the nine-teenth century, several African American men appropriated the medium to spotlight the injustices of slavery for the purpose of inspiring observers to aid in the downfall of slavery in the United States. They harnessed numerous strategies to attract audiences to their exhibitions and to persuade attend-ees of all ages that they provided authentic and truthful information about enslavement. Two formerly enslaved men, Henry Box Brown and William Wells Brown, rooted their claims of authenticity in their experience as en-slaved men in the United States. Both men sought refuge in Britain from the Fugitive Slave Act of 1850, which endangered their liberty in the United States, while they both engaged in antislavery activism. Although each en-gaged a visual medium conventionally focused on topography, both cen-tered the experiences of African Americans in their views. William Wells Brown supplemented the cogent powers of his panorama by advocating that audiences experienced select scenes vicariously. He envisioned audi-ence members as participating actively in the narrative of the panorama by imagining themselves as assistants in the cause of antislavery.

Not having been born enslaved, James Presley Ball did not make the same claims of authenticity and veracity stemming from personal experi-ence that Henry Box Brown and William Wells Brown used to attract and persuade audiences. Like them, however, Ball elevated the lives of enslaved people to occupy the center stage of his exhibition. More than his two pre-decessors, Brown emphasized the destructive forces of the institution of slavery on the nonenslaved. Like a metastasized cancer, slavery and its detri-mental effects spread throughout the country, infecting even hotbeds of antislavery activism like Boston. Ball frequently identified what he believed to be the retrogressive effects of slavery on the people of the United States. Exhibited in Ohio and Massachusetts, two states with extensive and power-ful antislavery activism, Ball's panorama invited viewers to contemplate the manifold ways in which their lives connected with the effects wrought by slavery and the Fugitive Slave Law of 1850.

When taken together, these three panoramas catalog the extent to which African American visual artists countered common representations of Afri-can Americans by appropriating a visual medium that allowed them to ex-press their own narratives of slavery and freedom. They marshaled moving panoramas not only to convince viewers of the injustices of slavery but also persuade them to act to dismantle the institution that shackled millions of

African Americans. Brown, Brown, and Ball appropriated the visual medium of the panorama to help visitors visualize the brutalities of slavery. Through this medium, some attendees found themselves unconsciously transported along a journey that educated them about the exploitations of slavery and the picturesque scenery that harbored these activities. Each of the panoramas stressed the urgency to end slavery because of its violence, immorality, and denial of human and legal rights, sometimes for the sake of enslaved people and sometimes for the future of the United States.

5

THE OPTICS OF
LIBERIAN EMIGRATION

Having sailed across the Atlantic Ocean for a new life in the recently in-
dependent black republic of Liberia, Augustus Washington finally spotted
land. His fiddle-playing had lightened, and sometimes soured, the moods
of his fellow African American emigrants during more than a month at sea,
but nothing was as buoyant as the verdant land, beautiful beaches, and the
promise of seemingly boundless possibilities as their new homeland came
into view.[1] Reaching the shores of Liberia in December 1853 with his wife,
Cordelia, and two children, Washington began the process of establishing
his photography business in, and well beyond, the Liberian capital of Mon-
rovia. While he had enjoyed remarkable success as a photographer in Hart-
ford, Connecticut, he came to believe it impossible that people of African
descent would attain equal rights and racial equality in the United States.
After he closed his successful daguerreotype studio in Hartford, he opened
a photographic practice across the Atlantic Ocean in Monrovia that enabled
him to diversify his business investments and enter Liberian electoral poli-
tics. Washington's image production established a network of colleagues and
increased his wealth while documenting the successes and opportunities for
African Americans in a land free from antiblack discrimination. Liberia was
not a country free from all discrimination, however. It did offer Washington
a place to thrive; perhaps not even he would have imagined that his photo-
graphic business would pave the way for his becoming a senator of Liberia.

It was for Washington's skill and his history as an eminent daguerreo-
typist that the American Colonization Society supported the family's emi-
gration to Liberia. Washington possessed the photographic experience and
technical training to command a camera to produce the images of emigra-
tion that ACS leaders desired to publicize widely. They hoped that in viewing

these scenes of black independence in Liberia, many more people of African descent, both those free and those recently emancipated, would journey across the Atlantic to support its enterprise. Washington captured images to send to the ACS, but he also created hundreds for Liberians and those in the Gambia, Sierra Leone, and Senegal, where he traveled for business. He yearned to escape racial discrimination, celebrate black independence, and realize economic success for himself and his family. A desire to travel and see the western coast of Africa — in part to explore business prospects — coincided with his racial pride and hopes for the continent he considered home. In the meantime, his photographic enterprise became a means to a political end because his economic success translated into political success. His photography business acted as a stepping-stone to other economic ventures and enabled him to meet powerful people wishing to document their image. Traveling widely in Liberia and well beyond its borders, Washington ventured into real estate and agricultural production, which helped launch his political career.

The images that Washington produced in Liberia signaled the possibilities for African Americans in a black republic. Working closely with the American Colonization Society's organizational affiliate in New York, Washington and his images extolled the virtues of emigration and repeatedly advertised the futures that black emigrants could achieve across the Atlantic. Washington's images provided an alternative outlook to the constrained freedom that black people in the United States experienced during the 1850s. His daguerreotypes, their daguerreotype copies, and their resulting engravings circulated the achievements of Liberian emigrants and their families as well as the opportunity to improve the vast wilderness and native peoples of West Africa. Washington's images of Liberian officials highlighted a political and cultural citizenship within the comparatively new nation of Liberia that drew upon the cultural currency of the United States for its markers of social class, status, and achievement. His images promulgating black Liberian political leadership and economic promise abroad offered a vision of freedom that belied a hierarchical, and often oppressive, Liberian society. Washington's Liberian images bring into focus the debates among African Americans about the uncertain, and perhaps imperiled, future of black people in the United States. They taught viewers about the livelihood attainable in a black republic that granted many more rights to its citizens, especially men's right to vote. Washington crafted a vision of equality and potential for black Americans that proved impossible for black people in most of the United States.

Before he achieved success as an artist, entrepreneur, and politician, personal and professional attempts to flourish within a racially restrictive society marked Augustus Washington's early life and activism. Born in 1820 or 1821 in Trenton, New Jersey, to a formerly enslaved father and a woman of South Asian descent, Washington received an early education comparable to those of his white peers. After enduring discrimination among individuals who questioned his pursuits of "the studies which white boys did — to become a teacher, scholar, and a useful man," he vowed at the age of fifteen to "constant[ly] study to learn how I might best contribute to elevate the social and political position of the oppressed and unfortunate people with whom I am identified."[2] One year later, he established a school for African American students in Princeton, New Jersey, but soon closed it after realizing his students' advanced educational proficiency. After entering into correspondence with New York antislavery activists and enrolling in the Oneida Institute with Henry Highland Garnet and Alexander Crummell as his peers, Washington became an agent for the *Colored American* newspaper. Deeply involved in the political activism of the antislavery movement of the 1830s, he served as a secretary for an anticolonization meeting held in New York City in January 1839 and attended the American Anti-Slavery Society's annual meeting of 1840. Over the next year and a half, Washington dedicated himself to the campaign to secure voting rights, without property requirements, for African American men in New York. When not organizing meetings, penning petitions, and attending conventions to advance the cause of black men's enfranchisement, Washington taught students at the African Public School in Brooklyn and studied to attend Dartmouth College. After passing his entrance exams, he entered the business of daguerreotyping at Dartmouth to pay for his college expenses. After a year of study, he withdrew from the college for financial reasons and moved to Hartford, where he returned to teaching black students. There, Washington embarked on what would be many years of photographic success in Connecticut.[3]

In Hartford, Washington dedicated himself to advancing black education and maintaining his antislavery connections. Located in the basement of the Talcott Street Congregational Church and next door to his residence, Washington's North African School taught young black children for several years and received praise from the city's education officials.[4] Around this time, Washington created several daguerreotypes of antislavery activist John Brown, whose radical approach to ending slavery culminated in his raid on Harpers Ferry, Virginia. Before those fateful events in 1859, Washington and Brown met with Frederick Douglass in Springfield, Massachusetts, in 1848.

Recalling their private meeting, Douglass described Washington as "thoroughly imbued with the spirit of reform, and determined to labor for the elevation of his race."[5] Spending his time intermittently in New York and Connecticut, where he came to meet numerous emigration leaders,[6] Washington was appointed to the Corresponding Committee of the Connecticut State Convention of Colored Men, charged with promoting resolutions that prioritized black men's demand to vote.[7] Despite numerous petitions across the state that African American men and women signed and submitted, Connecticut continued to withhold suffrage from black men.[8] Washington soon looked to distant shores for the franchise and other opportunities for himself and his family.

EMIGRATION AND THE OPTION OF LIBERIA

During the late eighteenth century and early nineteenth century, the prospect of African Americans colonizing distant shores, unaided or with the assistance of organizations such as the American Colonization Society, made most black communities uneasy. But many people envisioned a future of promise. Thousands left the United States for Sierra Leone, Liberia, and Haiti under the guidance of black and white leaders organized under the ACS. In public lectures, printed testimonies, and publicized images, supporters of emigration attempted to persuade white and black Americans of the benefits that they claimed would follow black people's removal abroad. Most African Americans believed colonization to be a scheme to deny black Americans an earned place in the national polity. Others, such as Paul Cuffee and enslaved African Americans who escaped to British forces during the American Revolution, pursued possibilities outside the United States. Most of Cuffee's early supporters lived in New York City, Philadelphia, Baltimore, and Boston, but the unappealing prospect of removing to lands distant, different, and foreign was widespread. In fact, many detractors of removal believed that colonization leaders adopted their mission as a crude attempt to rid the United States of its black inhabitants, free and enslaved.[9] Indeed, later in the century this became the explicit aim of the Maryland Colonization Society.[10] Support for colonization among African American communities waxed and waned during these decades largely in response to domestic crises.

The Compromise of 1850 and its attendant Fugitive Slave Act was one such crisis that created a wave of panic among African American communities. It prompted widespread concern over the safety not only of escaped

slaves but also of free black people who feared for their well-being. It also in-spired many black Americans to leave the country. Traveling or living abroad afforded a veil of protection from the Fugitive Slave Act to a notable, but comparatively small, group of African Americans such as Henry Box Brown, William Wells Brown, and Ellen and William Craft. Despite his free status, Augustus Washington had planned to extricate himself and his family from the inhibitive racial environment of the United States well before the Fugi-tive Slave Act became law. Less than two weeks after the law's passage, he recorded resolutions drafted by black residents of Hartford in the Talcott Street Congregational Church rejecting the new law and its effects on Afri-can Americans.[11] Yet he knew that his support of emigration was unpopular. "I am aware that nothing except the Fugitive Slave Law," Washington wrote, "can be more startling to the free colored citizens of the Northern States than African Colonization."[12] Not wishing to do what was popular but rather what felt most promising for his future and that of his growing family, Wash-ington resolved to secure their freedom outside the United States.

Washington squarely grounded his decision to start a new life in Liberia on receiving and exercising rights denied to people of African descent in the United States. Despite his successful career, Washington believed that African Americans would never enjoy the social and legal equality of white people in the United States. Emigration to Liberia, he believed, would secure "an equality of rights and liberty, with a mind unfettered and space to rise."[13] In his mind, the United States offered a constrained and oppres-sive space for people of African descent, despite the recent emergence of the Free Soil Party, which opposed the expansion of slavery into any terri-tory or state. Washington criticized its platform for being "not so much de-signed to make room for our liberties, as to preserve unimpaired the liberties of the whites."[14] His disenchantment with U.S. politics mounted. Stopping slavery's geographic expansion was important, but the Free Soil Party's de-mand for "free soil" largely benefited white Americans' appetite for western land claims and did not publicly advocate for equal rights for black Ameri-cans.[15] Even if slavery ended in the United States, Washington did not be-lieve it possible for white people to disavow deeply held "human pride and passions" in favor of acknowledging "the equality and inalienable rights of those who had been their slaves."[16] Washington's invocation of the rheto-ric of the American Revolution echoed the language used for decades by antislavery activists, black and white, to challenge the nation's racial status quo. Securing these inalienable rights and having them respected by white people would be quite a feat, considering the historical pattern that Wash-

ington identified. "Ever since the adoption of the Constitution, the government and people of this country," he wrote, "have pursued but one policy toward our race. In every contest between the great political parties we have been the losers."[17] For him, racial prejudice was too deeply embedded in the people and government of the United States; no law sent before Congress or any speech given by an antislavery lecturer could engender the change that Washington demanded. Disenchanted with the unfulfilled promises of the Revolution and opportunistic political parties, he looked to Africa.

For Washington, the cure for racial oppression was the physical separation of the races. This had been his long-standing belief; he had championed plans for a separate state for African Americans while a student at Dartmouth.[18] He fervently believed that African Americans' "entire separation from oppression and its influences" was the "only one way to develop the faculties of our people."[19] To him, racial prejudice was inextinguishable. Washington did not foresee coexistence of the races because, in pointing to a history of racially discriminating revisions to state constitutions, "securing the rights and liberties of one class at the expense of the liberties of another" inhibited African Americans' career prospects.[20] Although he pointed to Free Soilism as one example, he identified the rampant employment and educational discrimination that diminished economic and scholarly opportunities for most African Americans. According to him, this made it "impossible for us to develope [sic] our moral and intellectual capacities as a distinct people, under our present social and political disabilities."[21] Physical separation of the races, therefore, benefited people of African descent because it removed political oppression while simultaneously expanding moral and intellectual engagements.

Washington heralded the possibilities for work in Liberia in contrast to the employment discrimination that frustrated African Americans' success in the United States. "[African Americans] are shut out from all the offices of profit and honor," Washington argued, "and from all the most honorable and lucrative pursuits of industry, and confined as a class to the most menial and servile positions in society."[22] This restricted the overwhelming majority of African Americans to a fixed status as "constant consumers" who were further prevented from "deriv[ing] profit from the production of others." Liberia offered a solution. Washington heralded it as a land of "mineral and agricultural wealth, and on whose bosom reposes in exuberance and wild extravagance all the fruits and productions of a tropical clime."[23] To Washington's mind, Liberia's economic potential beckoned emigrants and would soon benefit native Africans. He described the continent as "lying waste

The Optics of Liberian Emigration

for want of the hand of science and industry" that he and other emigrants would bring with them to its shores. At its foundation, the racial uplift ideology Washington espoused held at its foundation a moralizing hierarchy that sought to realize racial equality by standardizing the practices of middle-class, even elite, practices and principles. Like many emigrants and missionaries to Africa during this era, Washington understood his role to be one for "uplifting" and developing the continent and its peoples. In his calculus, all parties would benefit from emigration: African Americans would escape racial oppression and bring industry to Africa, and native Africans would become productive and enterprising in business. Washington assured himself that emigration "must result eventually in the redemption and enfranchisement of the African race."[24]

Washington's writing and his preparation for removal from the United States revealed the principles that guided his racial worldview related to political rights and emigration. His belief in racial uplift provided motivation to leave the United States not only to secure a better life for himself and his family but also to bring the moralizing values that, in practice, created hierarchies and binaries — Christian and non-Christian, civilized and barbaric — that left little room for intermediacy. The themes of economic promise, independence, and the fully vested rights of citizenship for African American emigrants became visible in the daguerreotypes he produced in service of the emigration movement. As nineteenth-century examples of artistry and science, Washington's daguerreotypes interwove his desire for Liberia to be fertile ground for his own spirit of enterprise as well as the potential home for African Americans dissatisfied with the legal, economic, and social limitations they experienced in the United States.

SUPPORTING COLONIZATION WITH PHOTOGRAPHY

Once ashore in Liberia, Washington quickly used his photographic skills to earn a living in Liberia and support the emigration movement. Though occasionally forbidden by his doctor to work after having acquired the "acclimating fever" (malaria), Washington made a handsome sum through his photography business. "He can make from ten to fifteen dollars per day, and if he will mind his eye he will make an independent living in a few years," one African American visitor to Liberia reported.[25] Washington described his early business strategy whereby he determined to sell daguerreotypes at a price that "the people consider cheap" and then "hired boys whom I send to sell as many as I can attend to."[26] Washington began his Liberian photo-

graphic business so quickly because he had taken with him from Hartford his camera, daguerreotype chemicals, and cases; these supplies would later need to be imported in order for Washington to continue his practice. Putting into action the work ethic that he later advocated among emigrants, Washington wrote, "Whenever I am able to work, I can make so much more by my time in taking miniatures that the temptation is to work when I can."[27] His start-up capital, his determination to work, and clients' demand for portraits resulted in his ability to make approximately thirteen hundred dollars from his daguerreotype business in his first year in Liberia.[28]

The completion of Washington's business agreement to send back daguerreotypes of Liberia to the New-York Colonization Society (NYCS) also awaited him when he arrived in Liberia. The society eagerly desired that he produce daguerreotypes that they could transform into engravings for their monthly periodical, the *New-York Colonization Journal*. Communicating the landscape of the Liberian terrain via images was a way for the NYCS to depict the land as worthy of settlement by black emigrants. Testimonies in the form of settlers' letters, missionaries' accounts, and visitors' dispatches from Liberia depicted the West African country along a spectrum ranging from ideal utopia to regrettable experiment. Visual evidence in the form of daguerreotypes and engravings, however, was far more limited and marked another strategy to display the promise of the new nation for settlers of African descent. The NYCS wanted Washington to produce several landscape views, and he got to work.

Washington's first published image depicting the city of Monrovia stressed the civilization of the Liberian capital (fig. 5.1). The original daguerreotype has been lost, but Washington set up his camera on a sand outlet northwest of the city and sent the resulting image to the United States, where artists transformed it into an engraved woodcut for printing. Published on the front page of the *New-York Colonization Journal*, the image displayed Monrovia as a burgeoning city on a hill. The city appeared as a developed settlement neatly arranged with its Methodist church rising above all other buildings. This superlative symbol of Christianity communicated the religious characteristics of moral uplift as a redemptive force able to right the moral transgressions of a population. Orderly and composed of three distinct horizontal planes—water, land, and sky—the view of Monrovia rejected assumptions of the African continent as untamed, savage, and dangerous. Emigrants, the visual argument implied, brought civilization and uplifted its inhabitants. Likely absent from Washington's daguerreotype be-

Figure 5.1. *View of Monrovia from the Anchorage,* in *Twenty-Fourth Annual Report of the Board of Managers of the New-York State Colonization Society,* 1856. *Courtesy of the Library Company of Philadelphia.*

cause of his camera's long shutter speeds, the birds in midflight in the engraving's foreground served as metaphors for freedom. The view of sailboats, as opposed to natives' canoes, as well as textual descriptions of the double-piazza Methodist high school and warehouses dotting the hill that rose from the shore rounded out this view of civilization. The buildings and maritime trade communicated the professional prospects to possible black emigrants.

Descriptive text framed the city view as bearing the hallmarks of modernity and civilization. Describing the scene's buildings, the *New-York Colonization Journal* assured readers twice that the view was accurate: the newspaper "safely appeal[ed] for the very minute faithfulness of the picture" and described Washington's image as the "truest view yet obtained of Monrovia."[29] Such repeated claims sought to remove any doubt of the evident success of its inhabitants and encourage emigration there. To pique the readers' interests in Monrovia further, the description included the note that, "of course, but a small section of the town can be seen from the level of the water at the river mouth, most of it being situated on and over the ridge of the Cape." Anticipation aside, this description communicated a far more expansive settlement than the view from Washington's camera; in effect, the view was a but limited glimpse of the established city on Liberia's shores. To spur further interest in emigration and Liberia, the text explained that yet more could be seen in a second view of Washington's that the NYCS had on

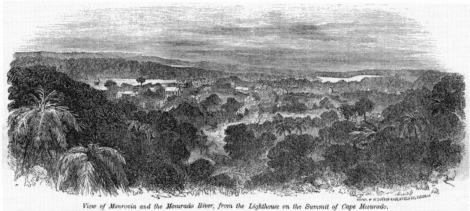

Figure 5.2. *View of Monrovia from the Mesurado River,* in *Twenty-Fourth Annual Report of the Board of Managers of the New-York State Colonization Society,* 1856. *Courtesy of the Library Company of Philadelphia.*

hand. It depicted more buildings, major streets, "and a view of a large portion of Monrovia" and could be published if readers collectively contributed at least twenty dollars to defray the cost.[30]

The response was swift and successful. The *New-York Colonization Journal* soon published Washington's second image, which communicated the desire for more emigrants to "civilize" Liberia. Creating an image that could be used for the purpose of encouraging emigration proved tricky. Still feeling the effects of malaria and working in the rainy season during the summer of 1854, Washington ascended the lighthouse that stood approximately one mile from Monrovia with his daguerreotype equipment. His resulting panoramic view captured the dense forest between the lighthouse and Monrovia with an aerial perspective commonly used by photographers who captured the essence of a frontier or city (fig. 5.2).[31] It showcased the expansive wilderness that African Americans had begun to settle but, importantly, showed the vast land that remained for potential settlers. The wilderness visible in the foreground and background communicated the idea that emigrants should arrive to subdue the "wild" landscape and bring order to it.[32] Here, racial uplift and Manifest Destiny combined to create a vision of transformative possibility for both the land and its inhabitants. The image conveyed the notion that self-reliance and independence were qualities that must be prac-

ticed in a new country that offered new opportunities to its citizens. Funda-
mental to the idea of Manifest Destiny was the concept of harnessing and
altering the landscape, two practices that Washington had already engaged
in as he cleared and cultivated large tracts of land along the St. Paul's River.
The density of wooded areas and the numerous rivers and tributaries that cut
the coast perpendicularly heightened the challenge.[33]

The aerial view of the landscape is standard for the time and borders on
the panoramic view that promised to reveal a literally and metaphorically
fuller picture of Liberia and its economic promise. Like the moving and sta-
tionary panoramas displayed during the era of Washington's photographic
business, his landscape view from the lighthouse surveyed an enormous
area of the Liberian landscape. Intended to capture the seemingly bound-
less opportunity of the visually untamed terrain outside the capital of Mon-
rovia, the image communicated the prospects of Manifest Destiny to those
considering emigrating to Liberia. With this published image, the NYCS
and Washington attempted to persuade people of African descent to join
the thousands who called Liberia home. The lighthouse Washington stood
atop projected its beam of light as a protective economic measure for coastal
watercraft and symbolized the arrival of "enlightenment" to Liberia. One
of the main goals of the NYCS included emigrants from the United States
"redeeming" the African continent from the alleged darkness of polygamy,
paganism, and a host of other cultural differences. Thus, an attempt to prove
black respectability with the logics of pathologizing these differences pre-
vailed.

The landscape images depict the products — and potential — of physi-
cal labor at the foundation of emigrationist understandings of nationhood.
While Dalila Scruggs and other scholars argue that Washington sought to
prove the Americanness of the Liberians, Washington's landscapes also dem-
onstrate his distancing of the United States from Liberia.[34] In other words,
he demonstrated that it was a place to prove how people of African de-
scent could thrive outside the United States. In effect, Washington's images
of Liberia sought to prove that African Americans could reject the stifling
racial climate of the United States and establish their own success. By tap-
ping into and appropriating the established landscape genre that possessed
a strong current of Manifest Destiny in the United States by the 1850s, Wash-
ington pictured what the landscape of liberty looked like for people of Afri-
can descent. People of African descent could use the unfulfilled ideals of the
American republic, which included life, liberty, and the pursuit of happi-
ness, and graft them onto the Liberian landscape. They did so not to prove

how American they were but to prove how they adapted concepts to create a society on the coast of West Africa complete with expanded rights and opportunities for people of African descent. Intended for mass circulation once engraved and printed, the landscapes advanced the idea of Africa as a place of civilization but also as a place needing to be civilized according to the strictures of the NYCS and religious leaders. Like many other emigration societies, the NYCS and the ACS charged their emigrants with "civilizing" the allegedly backward religious and cultural practices of the Liberian natives.[35]

In Washington's view of the bay, he chose to represent the mercantile trade and maritime commerce that helped sustain the economy of Liberia. Determined in his belief of hard work and capitalism, Washington depicted Monrovia as more than a place of economic promise; it was a location that held the potential for the highest achievement and fullest realization of dignity for people of African descent. Thousands of African Americans emigrated to the black republic after its independence in 1847 in the wake of intensified racial discrimination in the United States.[36] Both of Washington's views of Monrovia showed viewers a land ripe with the promise of large-scale agriculture in a new republic. After all, Liberia's borders were expanding—its coastline alone doubled between 1850 and 1860—as Liberian politicians signed treaties with area natives. The country's leadership believed that attracting more people to more land available for their cultivation would establish Liberia as a successful provider and protector of black rights.

Washington's professional life embodied the emigrationist ideals that the landscapes promoted. Nearly twenty miles up the St. Paul's River he established a large plot of land, where he began to grow sugarcane and establish commercial deliveries along the river. His two NYCS landscape views symbolized two areas of economic growth: the port city of Monrovia and the Liberian interior. Both locations held great agricultural and commercial possibility—two guiding economic concepts that Washington ardently promoted in his writings. Swift development away from the coast into the country's interior echoed the same kind of settler movement intrinsic to the history of U.S. expansion. Indeed, the idea of Manifest Destiny had strengthened and its course had accelerated in the United States by the time that Washington emigrated to Liberia. Many of the same values that drove Americans to push farther and farther west on the North American continent propelled the emigrationist project of Liberia. The desire to cultivate land in large-scale agriculture, "civilizing" the natives of the area, spreading Christianity, and answering the call of self-reliance and independence all worked together to motivate Washington.

Scholars have studied Washington's images of Liberian politicians and landscapes as a means of evidencing the civilization of African Americans and the images' ability to communicate ideas of upstanding Liberian nationhood.[37] Likewise, both Scruggs and Marcy Dinius demonstrate how the images, especially landscapes, produced by Washington were intended to demonstrate the success, viability, and expansion of Liberian colonization. In short, they advertised a horizon of opportunities for black emigrants. The NYCS certainly used Washington's images to this effect. An analysis of Washington's guiding philosophies of business, racialized masculinity, and photography also allows for a deeper understanding of the power of photography and how his photographs embodied activism.

Augustus Washington desired to attract "more of the best class of Northern colored men than any one has yet done" in part because of the rights that Liberia offered them. Though he proclaimed himself "no politician," Washington exercised political rights in Liberia that African American men and women rarely enjoyed. Washington "took the stump" to support the political candidacies of Stephen Allen Benson and Beverly Yates, and his letter evidenced the investment in the political stability and success of his new homeland. Motivated to advocate for these men because he felt that "my country [is] in danger from a seditious political faction," Washington envisioned people of African descent immersed in electoral politics in ways impossible in most places within the United States.[38] His pride and defense of "my country" signaled his investment in its future, a kind of determined investment that often accompanied considerable reservations held by people of color in the United States.

According to Washington, political stability depended upon a sustained work ethic and a developed spirit of enterprise among people of African descent. Persuaded of the importance of physical labor to benefit the character of Liberians, Washington valued manual labor and economic development because he imagined it to be essential for the political livelihood of his new homeland. "Our people must learn the worth, the true character and dignity of labor," he warned, "or our political structure will soon become but a baseless fabric."[39] Washington coupled this philosophy with an aggressive view of expanding the economic clout of Liberia when he wrote, "Our motto must be northward, southward, onward, and upward, 'Labor omnia vincit.'"[40] This Latin phrase from Virgil's *Georgics* celebrated the dignity and redemptive qualities of the labor performed by emigrants and native Liberians alike. Given the rapid expansion of the country's borders during the 1850s and Washington's writings on manual labor, it is possible that Washington hoped

to re-create Rome, replete with its democratic government and extensive trade network, in West Africa. Photography aided this mission.

Washington captured the panoramic view from a lighthouse, a towering symbol of modernity and civilization. A few years after emigrating, Washington benefited from the lighthouse guiding the ships along the coast when he began a shipping route up the St. Paul's River and along the Liberian coast. He named one of these vessels, or "packets," after his daughter, Helena Augusta. His packets helped develop the burgeoning trade of Liberia with its neighbor Sierra Leone and with commercial ships from Britain and the United States.[41] Washington recognized the economic opportunity afforded by increased agricultural production as well as the importance of trade with English, German, and American ships for the development of the Liberian economy. His business facilitating commerce along the St. Paul's River grew as the trade networks with Sierra Leone and Senegal increased.

Washington believed Liberia to be a place of opportunity for people of African descent because their physical and mental labors would be rewarded. In a letter written in Liberia and published in Hartford, Washington testified, "I have worked hard and have something to show for it," to emphasize that no obstacles prevented those dedicated to earning a living by their own labor and efforts.[42] Antiblack discrimination such as that which plagued the United States, Washington implied, had no footing in Liberia and therefore enabled people of African descent to ascend to social, economic, and political heights if they exercised a dedicated work ethic. Of course, unlike most emigrants to Liberia, who arrived with few possessions after having been recently emancipated from slavery, Washington arrived with substantial wealth that he shrewdly and successfully developed into a diversified portfolio that enabled him to quickly ascend the Americo-Liberian socioeconomic ladder.

Difficulty procuring photographic supplies accelerated Washington's business diversification. He related to a colleague that while he waited for a new shipment of daguerreotype materials, he had "not been daguerreotyping for a long time, because I found it difficult to make remittances for materials, and be without the use of my money for so long."[43] From the proceeds of his photography business, he had accumulated two houses, several plots of land in Monrovia, and six farms. He acquired several of these properties through speculation and received others as payment from debtors.[44] He owned two boats that plied the St. Paul's River trade route to Monrovia and rented one of his homes to the American Colonization Society for lodg-

ing recent emigrants from the United States, on account of the poor housing provided for them by the ACS upon their arrival.[45]

Washington's agricultural ventures made him a model of physical labor and independence possible without racial discrimination. Washington cultivated a diverse array of crops—cassavas, sugarcane, potatoes, ginger, cotton, yams, and rice—in part because of intermittent market shortages, and he preferred to rely on the security and stability of his own crop production.[46] In other words, he worked to anticipate local crop scarcities so that his own crops might fetch increased revenue because of diminished supply. News of his Liberian marketplace decisions, printed in the *New-York Colonization Journal*, supported the idea that wealth could be generated from agricultural production in Liberia. This would not be lost on recently freed African Americans, many of whom were poor in capital but rich in knowledge and experience in agricultural labor, who contemplated relocation to Liberia. In addition, the ostensible ease of acquiring fertile land and of Washington cultivating crops after having not farmed in Hartford, Connecticut, demonstrated the practicability of emigration. Moreover, Washington testified that although food shortages occurred, one's agricultural independence and work ethic could overcome these issues. The virtue of self-reliance that champions of emigration advocated were fully realized in Washington's letters. He became a model of and for the prosperity achievable in the new black republic of Liberia.

Washington's main source of wealth derived not from the production of fruits and vegetables but from his production and widespread sale of sugarcane products. Using the money he earned from his photographic business, he invested in fertile land that he developed into a sugar plantation. During the wet summer months of 1859, Washington sold sugar, cane syrup, and camwood in Freetown, Sierra Leone, where he lived temporarily with his wife and children.[47] Proud of his crop and of crops produced by other Liberians, Washington challenged a published assertion that "Liberia is considered so far to be a failure."[48] In response, he shipped specimens of Liberian products—cane syrup, sugarcane, cotton, and hemp—to be inspected for quality and appraised in value.[49] For Washington, one only need turn to Liberian agricultural products to gauge the country's success. He continued to trade his sugarcane and cane syrup between Liberia and Sierra Leone and by 1864 had become one of the largest sugar planters in Liberia.[50] Despite the challenges of getting sugarcane to market, Washington managed to sell between thirty thousand and sixty thousand pounds of sugar in Sierra

Leone and along other parts of the West African coast each year between 1860 and 1866.[51] The labor of one person alone could not produce such an immense yield. In 1867, he reported that eighty people—both natives and emigrants—worked on his sugar plantation.[52] He even traded his sugar—twenty-five thousand pounds' worth—in the New York market in 1868 and sold nineteen casks of sugar in the same market in 1875.[53] Like his daguerreotype business, Washington's sugar production made him a well-known citizen in Liberia and heightened his visibility among its people. His economic success embodied the dream that many black Americans hoped to achieve in the United States, but it was all possible because of his occupation as a photographer.

PORTRAITS OF A LIBERIAN PEOPLE

Washington's peripatetic photographic business in and around Monrovia enabled him to establish and strengthen networks with some of the most powerful families in the area. Although most of his daguerreotypes have not been found or survived, Washington's prolific business generated revenues of more than a thousand dollars in little more than a year. With the most affordable size of daguerreotype costing three dollars, he likely created hundreds of portraits in his first year in Liberia alone. Surviving portraits of Urias Africanus McGill, a wealthy merchant, and a woman likely of the McGill family, represent the wealth that several Liberian emigrants and their families accumulated. Furthermore, within his first few years in Liberia, Washington sent images of President Stephen Allen Benson to the ACS, which allowed Rufus Anson in New York City to copy the daguerreotype and the NYCS to transform the portrait into an engraving and publish it in its monthly periodical. The unattributed Benson portrait appeared opposite the page from the engraving of Washington's *View of Monrovia and the Mesurado River* with a favorable biography of President Benson. The editor proposed that the "wood-cut likeness . . . will witness to all who see it, that whatever honor may be reflected upon Liberia by this administration, will redound to the African race."[54] Emigrationists, therefore, used Washington's portrait as a symbol of intrinsic intellectual and moral qualities of people of African descent.

Washington's interest in depicting the past and future achievements of Liberian emigrants included numerous portraits of Liberian officials. In late 1856 or early 1857, Washington captured the likenesses of at least eleven Liberian officials: the vice president, six senators, and the chaplain, secretary,

The Optics of Liberian Emigration

clerk, and sergeant at arms of the legislature. Arranged in poses that sig-
naled their role in the Liberian government, these portraits embodied Wash-
ington's beliefs about the political success possible for men in the black Li-
berian republic. The images demonstrate the composure and attainments of
African American men that, in Washington's eyes, exemplified the highest
achievements of civilization. Several of these men had been formerly en-
slaved in the United States, and their images of political success and educa-
tional achievement communicated the possibilities of racial uplift ideology.

The portraits of Liberian officials drew on details that made those pic-
tured recognizable as respectable citizens. Donning formal clothing, includ-
ing suits, neckties, pressed and collared shirts, satin vests, and the occasional
pair of glasses, the men pictured in the portraits reflected assumptions of
respectability in fashion. That many of them sat at desks with pen or paper
in hand signaled their education, literacy, and mental capacity during an era
when many regarded people of African descent possessing all three with sus-
picion, doubt, or denial. These individuals had acquired the physical and in-
tangible markers of respectability that their daguerreotypes made visible.
Physical markers of respectability, coupled with the knowledge of their
positions within Liberian society, visually substantiated their fitness to be
citizens fully vested with Liberian rights. As officials of the state, they both
represented and belonged to the national polity, which relied on them for
its continued existence and growth. The daguerreotypes became material
records of the capacity, grit, and accomplishment of African Americans who
had transformed themselves into Liberians. Black men accepted the respon-
sibility of running a country, and their portraits projected the idea of their
aptitude and worthiness that their citizenship enabled.

The portrait of Edward James Roye, a Liberian senator, communicated
these ideals of citizenship (fig. 5.3). Dressed in a fashionable suit, vest, and
necktie, Roye stood squarely facing the camera with one arm out, bent at
the elbow, with his palm raised to the camera. His other arm remained at his
side as he looked into the camera with a resolute, clear-eyed facial expres-
sion. The position of his raised arm made it appear as though he were in the
middle of pledging an allegiance or oath to the viewer.[55] Undistracted by the
blank background behind him, the viewer of Roye's portrait is encouraged to
focus on the senator, whose political and business achievements made him
one of the best-known Liberian emigrants at the time Washington captured
his likeness. Having emigrated to Liberia in 1846, Roye benefited from the
wealth that he brought with him from his home state of Ohio.[56] There, he
had inherited money from his father that he used to start a barbershop be-

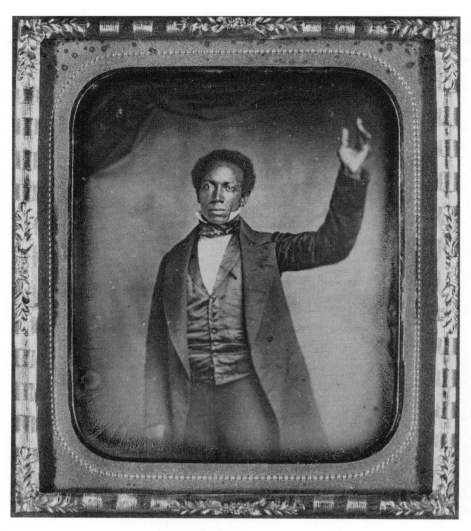

Figure 5.3. Augustus Washington, *Edward James Roye*, ca. 1856–60.
Daguerreotype Collection, Prints and Photographs Division, Library of Congress.

fore selling the business and emigrating. In Liberia, he established a thriving
shipping business before being elected a member of the House of Represen-
tatives and then its Speaker just a few years after his arrival. Washington cap-
tured his dedication to Liberia both in the act of his emigration and, later, in
his political career captured in Roye's daguerreotype.

Another in this series, a portrait of James Skivring Smith, communi-
cated its subject as a black intellectual (fig. 5.4). Seated and facing the cam-

The Optics of Liberian Emigration

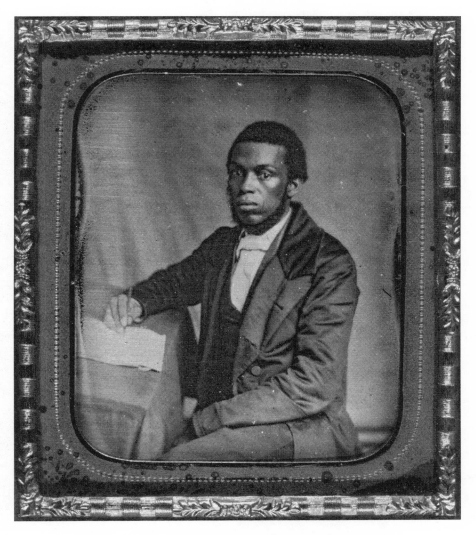

Figure 5.4. Augustus Washington, *James Skivring Smith*, ca. 1856–60. *Daguerreotype Collection, Prints and Photographs Division, Library of Congress.*

era in a three-quarter view, he laid one arm on a downward-angled desk on which rested a small collection of papers. These papers corresponded with Smith's status then as the secretary of state of Liberia. The vertical tilt of the desk, coupled with it having been pivoted slightly away from the camera and Smith's body, gave viewers a fuller view of the papers resting on the desk. The composition of the scene also signaled Washington's knowledge of perspective. Grasping a pen and pressing it to the paper, Smith appeared caught

in a moment of writing. His fine clothing—a long suit jacket, a vest, and a necktie—conveyed Smith's elevated class status, as did his ability to write. These markers of respectability were not simply performance for the camera; Smith lived in Liberia before completing medical school in the United States and returning to Liberia to practice medicine.[57] Washington's camera showcased Smith's mental capacity as a man of letters and science while it highlighted Smith's political and professional work in Liberia.

Yet although Washington's portraits trafficked in messages of the pictured black Liberians' civilization, the images elided the hierarchies that oppressed native Liberians. By drawing on the period's cultural markers of respectability and civilization, the images legitimated the officials as civilized, but they also demonstrate that "civilization" was achieved in Liberia with greatly expanded rights for emigrant men. Native Liberians, however, could not vote because their collective property ownership disqualified them according to Liberian law. Private, individual ownership of land, as well as being a man, became the legal gateways to Liberian democracy for African American emigrants. The grounds upon which political rights and the promise of citizenship were extended to individuals solidified as successive Americo-Liberians elected leaders from their communities. In an era of U.S. history when many states abolished requiring land ownership for white men to vote, African American settlers in Liberia made property ownership among black men a prerequisite to vote. In determining the parameters for suffrage by writing the Liberian constitution, individual landowning men created a political structure that marginalized natives not according to race but according to cultural practice. To conform to their understanding of civilization, they adapted a discriminatory restriction on political rights that African Americans experienced in the United States. In doing so, they created a rigidly divided society where they sought equality and freedom as black emigrants even as native Liberians who did not conform to their standards of comportment and cultural practices suffered.

Soon after landing in Liberia, Washington noticed the damaging effects of strictly delineated hierarchies between settlers and native Liberians. He wrote three letters to the *New-York Daily Tribune* detailing his emigration experience in both laudatory and scathing terms. After decrying the basic, cramped, and unhealthy living quarters granted to most recent emigrants who arrived without much capital, he described native Liberians in the language used for enslaved people in the United States: "hewers of wood and drawers of water."[58] In addition to their occupations as servants or cooks, for which they sometimes received no payment but a place to sleep, Washing-

ton recorded that "in nearly all families it is customary to keep a rawhide or cat-o'-nine tails handy, to flog them when they please."[59] Despite the abysmal treatment of native Liberians and the lack of medical attention for impoverished settlers, Washington still wrote: "I love Africa, because I can see no other spot on earth where we can enjoy so much of freedom, and yet find such ample scope for doing good and getting good."[60] Washington enjoyed the freedoms of land ownership, the right to vote, and the ability to live with his family free from racial violence, though his letters to the United States made clear that these freedoms resided largely with the emigrants and not with native Liberians.

This freedom often accompanied rapid socioeconomic mobility when emigrants brought desirable skills and capital with them when they landed in Liberia. Washington's swift profits from his daguerreotype business evidenced this, but he recognized it to be true for other emigrants as well. Enjoining African American readers to relocate to Liberia, he strongly advised that emigrants arrive with a few hundred dollars or goods of similar value because "with a few hundred dollars you may soon be worth thousands, with a few thousands you may be worth millions, for this is truly a great country, in which, by industry, to make money, if you have means to begin with."[61] Wealth could be accumulated in agriculture, maritime trading, real estate, and construction, given that demand for these industries increased as more African Americans relocated to Liberia in the 1850s following passage of the Fugitive Slave Act. A few years later, Washington reiterated his invitation for enterprising black men in the United States to join him in Liberia, for he believed they "could not fail to succeed": the potential of Liberia was vast.[62]

CLAIMING AND EXERCISING RIGHTS

Augustus Washington's success as a photographer laid the foundation for his political career. His reputation as a skilled photographer and champion of emigration preceded his arrival in Liberia. Instead of lodging in the squalid conditions when he arrived, Washington and his family stayed with the president in the presidential residence. In January 1858, the president of Liberia, Stephen Allen Benson, appointed Augustus Washington chairman of the monthly and probate courts, where "he has given perfect satisfaction."[63] The appointment highlighted how Washington sufficiently impressed powerful Liberians shortly after his arrival. By then, he had amassed significant wealth through his daguerreotype business. He had further fashioned himself into a real estate developer, farmer, river merchant, and high

school teacher. President Benson likely recognized Washington as an asset to the political structure of the country because of Washington's experience and deep investment in the nation's success. After all, Washington exhibited the social, cultural, and economic capital that made him appear able to fulfill political responsibilities. By 1864, he had been democratically elected as a congressman in the House of Representatives of Liberia, and the next year he was chosen to be the Speaker of the House, a position he held for several years.[64] He continued ascending the ranks of Liberian politics, when, as of January 1, 1872, he had been selected as a senator of Liberia.[65] While little more about his political leadership offices is known, what is certain is Washington's determination to claim and exercise the rights that Liberia offered to those who demonstrated education, work ethic, and moral uprightness.

Washington exercised freedom of the press by creating his own. He founded a newspaper entitled the *New Era*, which he began publishing at his residence on the St. Paul's River in 1873. Though no extant copies have been found of the *New Era*, brief excerpts from his periodical made their way into other publications that circulated in the United States. In its first issue, Washington continued his long-standing belief in the worth of manual labor for enterprise. "We wish first to commend ourself to the workingmen of Liberia," he wrote, "and to establish a reputation for modest merit and honest labor, and to show in the sequel that we must sustain ourselves by the products of the soil."[66] For Washington, independence and its continuation rested on Liberia's agricultural production, which would drive its economy and inculcate the lessons of civilization in its citizens. Though short-lived before Washington died in 1875, the *New Era* marked the value of print culture in Washington's life; Washington submitted for publication several letters that newspapers and periodicals published for their readers' benefit.[67] As early as 1848, Frederick Douglass identified Washington's support for the expression of African Americans in print when, during a private meeting with John Brown and Augustus Washington, he recorded that "Mr. Washington has determined to do all he can to sustain our national press."[68] Occasionally, Washington published letters that challenged the emigrationists who supported him, but he maintained that "my daguerreotype shall be a true one," meaning that his prose would accurately reflect the conditions — hopeful and challenging — faced in Liberia by all its people.[69] Once, when sensing the forthcoming anger and disappointment directed at him for his withering testimony of life in Liberia, Washington held fast to his right to free speech. "When those who oppose us shall have here suppressed freedom of speech and the press," he reflected, "we shall then wander over the

trackless desert and the ocean deep to find another asylum of Liberty."[70] Here, Washington made clear that the denial of the rights to free speech and press in Liberia would prompt him to leave in search of another place that guaranteed these rights. A long history of mobs attacking presses and editors over progressive social issues existed in the United States; Washington rejected this suppression of rights out of hand.

In the years after Washington departed with his family for Liberia, a series of crises brought the United States closer to civil war. As debates raged among those who alternatively wished to spread and contain slavery farther to the west of the Mississippi River, social unrest and antislavery activism mounted. African Americans adopted popular visual technologies and advanced debates for black rights that broke out into the open with the advent of war. As the Civil War continued, they strategized to bring to the public's attention their achievements and intellectual contributions to the nation. In doing so, African American champions of black rights and visual culture used their visual skills to prove the merits of black citizenship.

FREEDOM AND CITIZENSHIP
Conflicting Views of Wartime

The young woman buried herself deeper beneath the stack of hay in the back of a wagon moving too slowly under the cover of night. Refusing to be sold to a house of prostitution, she had fled from her slave owner to a Union army camp near Lexington, Kentucky. Hidden by members of the Twenty-Second Wisconsin Volunteers from the man who pursued her, she had avoided detection, but freedom remained farther away. Still and silent as the two Union soldiers who drove the wagon spoke the password that allowed them through the picket lines and out into the night, she knew what would happen to her if she was discovered and sent back to her slave owner. The spare set of soldier's clothes that the woman wore could disguise her in the darkness when she emerged from the hay if anybody chanced to see the wagon as it made its way to Ohio. The fear of being captured during each of the more than one hundred miles they journeyed to Cincinnati must have been too great for them to sleep. The three traveled together almost without stopping until they reached the house of the noted abolitionist Levi Coffin, who was known to usher fugitive slaves to safety. She changed out of her soldier's uniform and into women's attire. Soon thereafter, wearing clothing— a dress, gloves, and a veil—that covered her entire body, she traveled to the studio operated by the black photographer James Presley Ball with the two Union soldiers who aided her flight. When she lifted her veil to reveal her brown face, Ball released the camera's shutter.[1]

The portrait of the unnamed woman is one of a few images of an African American known to have been created by an African American photographer during the Civil War. The dearth of black-produced visual materials stands in stark contrast to the multitude of images depicting African Americans in the pages of popular illustrated periodicals printed during the same

era. The desire for news of the Civil War helped drive the remarkable demand for these publications. They labeled escaped slaves "contraband" as they would such inanimate objects as bottles of liquor or boxes of dry goods. The images printed in widely circulated illustrated periodicals cataloged some of the physical violence suffered by enslaved people as well as their possible futures in the United States. The enlistment of African American men in the Union navy and army prompted a shift in the visual representations of African Americans during the Civil War. With black soldiers mustering out to the front lines, artists now rendered uniformed African Americans on the battlefield and in camp.[2]

As hundreds of thousands of illustrated periodicals weekly found their way to readers eager to learn the latest war developments, a handful of African American artists used cameras to record images of African Americans during the Civil War. They joined a multitude of white photographers who saw in the war an ability to carry on a business while communicating views related to wartime that people throughout the nation eagerly demanded. The visual medium with which they worked did not allow for the massive economies of scale that illustrated newspapers used. Few of the images are known to scholars in contrast to the popular images produced during the Civil War by artists — Mathew Brady, Alexander Gardner, Timothy O'Sullivan, and George Barnard, among many others — whose images appeared in several other media forms.[3] Though the attendant images created by African American photographers remain more limited in number, they too expressed opinions about contraband people and black Union sailors and surgeons. At times they conformed to common photographic practices of depicting Union soldiers, and at other times they noticeably diverged from the common representations of contraband people. James Presley Ball and Edward Mitchell Bannister, the two African American photographers whose images are examined here, shared not only a profession but also support for an exhibition of African American art and industry organized by another black man, Edward M. Thomas of Washington, D.C.

Analysis of the planned, but never fully realized, exhibition of African American art and industry illuminates how many African Americans envisioned images to correct widespread perceptions of black intellect, improve race relations, and encourage the recognition of black achievement among African American communities. Although the more pressing concerns created by the upheaval of the Civil War and black emigration helped derail the exhibition, preparation for the exposition, as evidenced in several black newspapers, rendered visible the networks of black leadership that criss-

crossed the country during the Civil War. Furthermore, the planning of the exhibition demonstrated the widespread support for art among African Americans even as it hinted at the kinds of revolutionary possibilities that many African American leaders recognized that art made possible. These figures stressed that the modes of production, and who controls that production, determined the parameters of visual cultures of race. Furthermore, the different options available to, and decisions made by, Brady and other white photographers well known today help explain the preservation, and sometimes mythical value, of the images captured by Brady and his colleagues.[4] Images created by African Americans could subvert widespread representations and their accompanying significations of black people, while at other times they could document their lives with common visual touchstones. People of all races watched as assumptions and judgments of African Americans played out in the images created during the Civil War. Many viewed their first images of the war in the pages of illustrated periodicals that circulated widely throughout the nation.

THE PHYSICAL TRAUMA OF SLAVERY AND CIVIL WAR

Many Americans learned of the events of the Civil War by corresponding by mail, conversing with neighbors, and reading periodicals such as newspapers and newsmagazines. Taking their cues from the *Illustrated London News*, editors in the United States established several periodicals that specialized in printing images for the pleasure and enrichment of eager audiences. Fanning out from cities on the Eastern Seaboard, *Gleason's Pictorial Drawing-Room Companion*, the *Illustrated American News*, *Frank Leslie's Illustrated Newspaper*, and *Harper's Weekly* would come to educate their readers with textual and visual descriptions of recent news.[5] Though many publications were short-lived, such illustrated periodicals as *Frank Leslie's Illustrated Newspaper* and *Harper's Weekly* flourished for many years, especially after technological advances in the late 1850s allowed them to lower business costs, share news more quickly, and increase revenues as never before.[6] Many hundreds of thousands of people studied their pages weekly to learn about the Civil War and other events.[7] The periodicals' claims of reporting authentic and verified views and news of the Civil War extended to images that they published of African Americans.[8]

Soon after the outbreak of war, images of escaped slaves greeted viewers of these periodicals. Illustrators appropriated the visual genealogy of blackface minstrelsy to depict this newly labeled group of people, deemed "contra-

Freedom and Citizenship

band," that blended multiple stereotypes of African Americans to shape the public consciousness of formerly enslaved people.[9] The most popular illustrated periodicals frequently claimed the accuracy and authenticity of the news reported in their pages.[10] These images, along with the text that often accompanied them, instructed viewers in how to read the nature and character of escaped slaves; pervasive stereotypes of puerile, docile, and dependent African Americans soon came to be challenged by the massive expansion of Union army rolls when the Emancipation Proclamation enabled black men to join its ranks. More than 180,000 black men altered the trajectory of the Civil War when they joined the Union army. Though black men served in the Union navy well before 1863, their enlistment in the Union army prompted a stark shift in the universe of imagery that illustrators and photographers drew upon to represent black men. In addition, thousands of escaped slaves of all ages — men, women, and children — who never enlisted in the military nevertheless guided the Union to victory by serving as cooks, laundresses, teamsters, assistants, and spies.[11]

Three images printed as a triptych in *Harper's Weekly* captured the visual shift in black male bodies made possible when the Emancipation Proclamation helped dismantle slavery (fig. 6.1). The triptych demonstrates an incomplete but chronological sequence of an escaped slave whose name is Gordon, according to the author of the corresponding article and his interactions with the Union military. The image to the left displayed *Gordon as He Entered Our Lines* in Baton Rouge, Louisiana, and depicted the escaped slave in worn and tattered clothing but sitting in a dignified pose with one leg crossed over the other at the knee and his hands folded in a parallel manner. His multiple layers of clothing were ripped and frayed. He sat on a chair, barefoot, looking into the camera that would reproduce his likeness as a carte de visite, a small and affordable photographic medium that gained a foothold in the United States just a year before the outbreak of war. The second and central image showed viewers Gordon's naked back interlaced with raised, keloid scars from a whipping he had received before his escape to Union lines. Turned to the left to offer a profile view of his face, Gordon extended his left arm and elbow outward before resting the fingertips of his left hand against his waist. Listed as having been taken during "surgical examination previous to being mustered into the service," the woodcut engraving of Gordon's back was much larger than the other two images. The third and chronologically last view depicted *Gordon in His Uniform as a U.S. Soldier* standing in a three-quarter-length portrait as he looked directly at the viewer in a full Union uniform. His left hand grasped the barrel of a musket that extended down to the

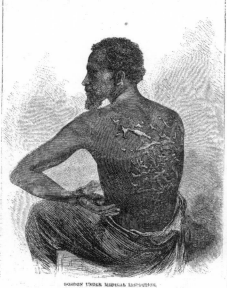

[A TYPICAL NEGRO.]

We publish herewith three portraits, from photographs by M'Pherson and Oliver, of the negro Gordon, who escaped from his master in Mississippi, and came into our lines at Baton Rouge in March last. One of these portraits represents the man as he entered our lines, with clothes torn and covered with mud and dirt from his long race through the swamps and bayous, chased as he had been for days and nights by his master with several neighbors and a pack of blood-hounds; another shows him as he underwent the surgical examination previous to being mustered into the service —his back furrowed and scarred with the traces of a whipping administered on Christmas-day last; and the third represents him in United States uniform, bearing the musket and prepared for duty.

This negro displayed unusual intelligence and energy. In order to foil the scent of the blood-hounds who were chasing him he took from his plantation onions, which he carried in his pockets. After crossing each creek or swamp he rubbed his body freely with these onions, and thus, no doubt, frequently threw the dogs off the scent.

At one time in Louisiana he served our troops

as guide, and on one expedition was unfortunately taken prisoner by the rebels, who, infuriated beyond measure, tied him up and beat him, leaving him for dead. He came to life, however, and once more made his escape to our lines.

By way of illustrating the degree of brutality which slavery has developed among the whites in the section of country from which this negro came, we append the following extract from a letter in the New York Times, recounting what was told by

the refugees from Mrs. GILLESPIE's estate on the Black River:

The treatment of the slaves, they say, has been growing worse and worse for the last six or seven years.

Flogging with a leather strap on the naked body is common; also, paddling the body with a hand-saw until the skin is a mass of blisters, and then breaking the blisters with the teeth of the saw. They have "very often" seen slaves stretched out upon the ground with hands and feet tied down to stakes driven into the ground for a "staking." Handfuls of dry corn-husks are then lighted, and the burning embers are whipped off the naked back. This is continued until the victim is covered with blisters. If in his writhings of torture the slave gets his hands free to brush off the fire, the burning brand is applied to them.

Another method of punishment, which is inflicted for the higher order of crimes, such as running away, or other refractory conduct, is to dig a hole in the ground large enough for the slave to squat or lie down in. The victim is then stripped naked and placed in the hole, and a covering or grating of green stakes is laid over the opening. Upon this a slow fire is built, and the live embers sifted through upon the naked flesh of the slave, until his body is blistered and swollen almost to bursting. With just enough of life to enable him to crawl, the slave is then allowed to recover from his wounds if he can, or to end his sufferings by death.

"Charley Reed" and "Overton," two hands, were both murdered by these cruel tortures. "Silas" was whipped to death, dying under the infliction, or soon after punishment. "Overton" was laid naked upon his face and burned as above described, so that the cords of his legs and the

GORDON AS HE ENTERED OUR LINES.

GORDON UNDER MEDICAL INSPECTION.

GORDON IN HIS UNIFORM AS A U. S. SOLDIER.

Figure 6.1. Triptych of "Gordon," *Harper's Weekly*, July 4, 1863. Courtesy of the William L. Clements Library, University of Michigan.

ground, unseen to the viewer. His right hand rested at the end of the gun's barrel, covering it. The nondescript tonal shading of the background highlighted the detailed subject in each image. Taken together, the images form a linear narrative of Gordon's interaction with the Union army.[12]

The most provocative of the three images for nineteenth-century viewers of the three pictures, however, proved to be the center image of Gordon's scarred back, which broke the chronological narrative of the triptych by recalling slavery's past cruelties. Viewers quickly marshaled its power of showing slavery's atrocities. In the months after photographers McPherson and Oliver captured the image on April 2, 1863, studios in London, Boston, New York, Philadelphia, and Washington, D.C., reproduced and sold the image.[13] A writer for the New York *Independent* suggested that "this Card Photograph should be multiplied by 100,000, and scattered over the States. It tells the story in a way that even Mrs. Stowe can not approach, because it tells the story to the eye."[14] Indeed, the picture was multiplied by more than one hundred thousand as an illustration within the pages of *Harper's Weekly* on Independence Day, 1863. The date of its publication provided a visual analog to

172

Freedom and Citizenship

Frederick Douglass's speech "What to the Slave Is the Fourth of July?" delivered eleven years earlier, which identified the hollow meaning of freedom for enslaved people on Independence Day. As one Union surgeon wrote of Gordon's image, "I have found a large number of the four hundred contrabands examined by me to be as badly lacerated as the specimen represented in the enclosed photograph."[15] In doing so, he testified to the veracity of the photograph and signaled the representative nature of Gordon's past abuses.

A large body of visual representation of slavery's violence spanning hundreds of years and multiple continents preceded the circulation of images displaying Gordon's back. Only a select few images, however, graphically displayed the violence of slavery in photographic form.[16] Early visual technological forms, such as engravings, lithographs, and etchings that largely appeared in books, pamphlets, and broadsides, communicated the horrors of slavery to geographically diverse audiences, but the development of the daguerreotype and its ferrotype and ambrotype cognates could capture striking detail. Daguerreotypes, however, could not be reproduced unless a photographer copied the original, and such a process could not feasibly circulate hundreds or thousands of copies of one image. The development of the carte de visite expanded the horizon of photography's possibilities by enabling usually a dozen photographic images to be made at once. Nineteenth-century audiences in the United States knew well the woodcut images of slaves being branded, beaten, and separated from their families, but perhaps the most reproduced image of slavery's violence depicted whippings.[17]

Most images in such periodicals as *Harper's Weekly* and *Frank Leslie's Illustrated Newspaper* did not present images of personal trauma of the kind that documented Gordon's injuries. Landscapes, seascapes, military leaders, and military maneuvers filled their pages. Although many images communicated the ravages of war on the landscape, only a handful displayed the physical trauma of the war on people's bodies before the publication of Gordon's lacerated back. Even the image of hanged Confederate soldiers on the front page of the *Harper's Weekly* issue that carried the triptych of Gordon rendered their clothed bodies in almost complete shadow with minimal detail. The crisp delineation of Gordon's scarring marked a stark difference in the representation of bodily trauma in these periodicals that provided otherwise sanitized versions of the violence of war using the rapid technology of the steam-powered printing press.

The technology that paired the woodcut image with the steam press enabled periodicals to disseminate the word and image of slavery's trauma rapidly to hundreds of thousands of people. Though many thousands had

already read about the image in other periodicals or seen a carte de visite of Gordon's back, *Harper's Weekly* brought Gordon's scarred body and corresponding ideas about slavery to exponentially more people. Two of the benefits of the woodcut engravings published in illustrated periodicals included a wide tonal range and the ability to alter the prototype. In the image of Gordon's displayed back, the raised keloid scars that resulted from a brutal whipping contrasted starkly with Gordon's dark skin. Those who created the engraving exercised artistic license when transforming a photograph of Gordon into the image printed in *Harper's Weekly*. Of the three very similar versions of the cartes de visite known to show Gordon, none exhibited the skin of his upper back as dark as the *Harper's Weekly* reproduction. Artists at the periodical darkened the hue of Gordon's back, creating a greater contrast between his dark skin and the scars rendered near white in highlight. Furthermore, the *Harper's Weekly* image provided crisp detail of his head and back. Other details, including the edges of his arm, hand, and clothing, become considerably softer the farther their distance from his scars. The resulting visual effect attracted viewers' eyes to the areas of his body with the greatest detail and the sharpest focus. The illustration represented the culmination of various decisions — Gordon to sit for the image, McPherson and Oliver to capture the image, and the artists at *Harper's Weekly* to alter the image — that fueled the antislavery movement.

Despite the uncommon publication of such acute physical violence, the text accompanying the three images of Gordon described him as "a typical negro." The violence he sustained was at once both representative and extraordinary. Ironically, like many other references to escaped slaves who assisted Union forces, the text adopted the common trope of explaining that Gordon "displayed unusual intelligence."[18] Apart from stating his name once as an introduction, the article described him only as "the negro." Confederates "infuriated beyond measure, tied him up and beat him, leaving him for dead" on capturing him while he served as a guide to Union troops in Louisiana. After "he came to life" and escaped to Union lines, Gordon enlisted. In one sense, perhaps his story was representative of the thousands of escaped slaves who suffered under slavery who then aided Union forces after escaping to Union-held territory. However, the image of his scarred back was not representative of the wartime images that were widely circulated until that time. The article title and the brief history of Gordon's life pointed to the goal of including the image: as one scholar has written, Gordon "mattered more as evidence than as a person."[19] As visual evidence of one form of violence wrought by slave owners, the image of his back subsumed his

brief biographical sketch. In other words, Gordon's personhood became secondary to the brutality of slavery that his body displayed. The multiple names attributed to the man depicted in the *Harper's Weekly* triptych further evidenced this point. Some images and publications referred to him as Gordon, others as Peter, and still another as Furney Bryant. The multiple names, coupled with the physical differences among the figures depicted in the *Harper's Weekly* triptych, has led one scholar to suggest that the three images may depict more than one individual.[20] The inability to identify the enslaved man correctly revealed how little his personal identity mattered to those who captured his likeness and wrote on his behalf. His physical marks of trauma took priority.

Many other provocative cartes de visite depicting formerly enslaved people quickly followed the publication of Gordon's triptych. Advocates of abolitionism circulated images of "perfectly white" formerly enslaved children from Louisiana, which, while trading in eroticism and fears of the white slave, also followed the same technological trajectory as those depicting Gordon.[21] They appeared as cartes de visite and illustrations viewed throughout the nation in the pages of *Harper's Weekly*. These portraits revealed no raised scars; the imagined horrors suffered by these children replaced the pain of slavery evidenced by Gordon's back. Formerly enslaved adults with darker complexions who appeared in cartes de visite and published illustrations with these children offered more insight into the visible horrors of slavery akin to those inscribed on Gordon's body. His former slave owner's initials branded into his forehead, Wilson Chinn became another example of the physical trauma of slavery for those who viewed his portraits in cartes de visite and *Harper's Weekly* illustrations.[22] His burn scars were much less prominent than Gordon's, even after having been retouched so that they became more noticeable.[23] In more than one carte de visite, Chinn posed with the implements of torture—including a three-pronged spike collar and leg irons—that further highlighted slave owners' violence. Taken together, these mass-produced images expanded the visual terrain of the traumas of slavery in ways that previous textual and visual technologies did not so accessibly exhibit.

As the war progressed, the enlistment of black soldiers in the Union army prompted another shift in popular representations of African Americans. The visual transformation from "contraband" to citizen-soldier became a pattern in the pages of illustrated periodicals as military service became one strategy for black men to secure a place in the republic as a free person helping to secure a Union victory. Thousands of formerly enslaved men like

Gordon enlisted in the Union military forces before published and private images celebrated their service. Scholars have framed the debates over, and the performance of, black men's enlistment within the broader concepts of masculinity and citizenship and have recently analyzed the broader push for citizenship among black women in contraband camps.[24] Like Gordon's triptych, several images exhibited formerly enslaved men before and after they enlisted to preserve the Union, thus displaying the characteristics of patriotism, valor, courage, and sacrifice as embodied in the Union uniform they wore. Visually transformed from barefoot escaped slaves into proud soldiers, these black men projected respectability to a nation eagerly following wartime developments.

SHADES OF VISIBILITY: JAMES PRESLEY BALL AND THE CONTRABAND WOMAN

It was precisely the trappings of fashionable middle-class white womanhood that enabled a contraband woman to travel to Wisconsin after her initial escape from slavery in Kentucky. The tale of her journey from a slave owner near Nicholasville, Kentucky, to a Union army camp near Cincinnati, to Chicago, and to Racine, Wisconsin, survives because of the recollections of the Quaker activist Levi Coffin and the image produced at the studio of the black Cincinnati photographer James Presley Ball.[25] Though the woman's story may not have been uncommon, surviving photographs of black people created by African Americans during the Civil War are exceedingly rare. Thousands of African American soldiers likely had their photographs taken during the Civil War.[26] Yet the prolific black Cincinnati photographer James Presley Ball is known to have captured only one image of an unnamed contraband woman during wartime. Fugitive slaves escaped to Cincinnati with great frequency and the Civil War did not stem their movement. For Ball, the act of photographing contraband people could be incriminating evidence of aiding in their escape. The Fugitive Slave Act of 1850 was enforced in Ohio, and a photograph of an escaped slave might be used as proof that Ball had refused to surrender an escapee. Before the outbreak of war, failure to do so could result in prosecution and jail time for Ball or any other person implicated in the crime. That he captured a photograph of the young African American woman seeking freedom might have shown his confidence that she would be deemed legally free under the Confiscation Acts — the series of acts passed by Congress in wartime to remove enslaved people from their owners engaged in insurrectionary and treasonous activi-

ties—or that her story was too remarkable not to record with an image or that he trusted its owner to keep it out of sight. Perhaps it was all three.

The photograph depicted two standing white men flanking a seated African American woman (fig. 6.2). Each man held a revolver in his right hand drawn across his chest and pointed to the left. The man standing on the left side of the image is Quartermaster Sergeant Jesse L. Berch of the Twenty-Fifth Wisconsin Regiment. He wore tall boots, baggy pants, a rounded hat, and a heavy coat that reached his knees. The African American woman, seated on a chair completely covered by her clothing, wore a floor-length dress, a shawl drawn across her shoulders, and a veil that rested atop and behind her head. She displayed one glove-covered hand on her lap. The man on the right side is Postmaster Frank M. Rockwell of the Twenty-Second Wisconsin Regiment, who wore clothing similar to Quartermaster Sergeant Berch. The three figures stood on square-patterned flooring in front of a plain backdrop.[27]

The recorded history of the three figures and how they came to be in Cincinnati provides a foundation from which to interpret this image taken in Ball's studio. The young African American woman, approximately eighteen years old, escaped from slavery and journeyed to the Union army camp near Nicholasville, Kentucky, after learning that she would be sold into a house of prostitution in Lexington, Kentucky. Hidden by the white Union soldiers of the Twenty-Second Wisconsin Regiment from her slave owner, who came to the Union camp hunting for her, the woman escaped on a wagon to Cincinnati with her two Union chaperones in the dead of night. The three made their way to the house of Levi Coffin. One of the men knew Coffin and that he assisted formerly enslaved people seeking freedom. The three rested for a day or two at Coffin's home and made their way to James Presley Ball's gallery to have their photograph taken. The soldiers then telegraphed friends in Racine, Wisconsin, and arranged for the woman's passage there by train via Chicago. "Presenting the appearance of a white lady," the African American woman wore a veil that covered her face and took her first-class seat on the train while being escorted by the white Levi Coffin. He and the soldiers bid her good-bye as the train departed, the black woman waving her handkerchief on her way to freedom. What remains of her story is Coffin's testimony and Ball's image.[28]

Ball's composition of the image of the three figures underscores the precarious status of an escaped slave during the Civil War. The two soldiers flank the young woman and appear to stand ready, with guns drawn, to ward off any person attempting to recapture her. The lines created by the men's

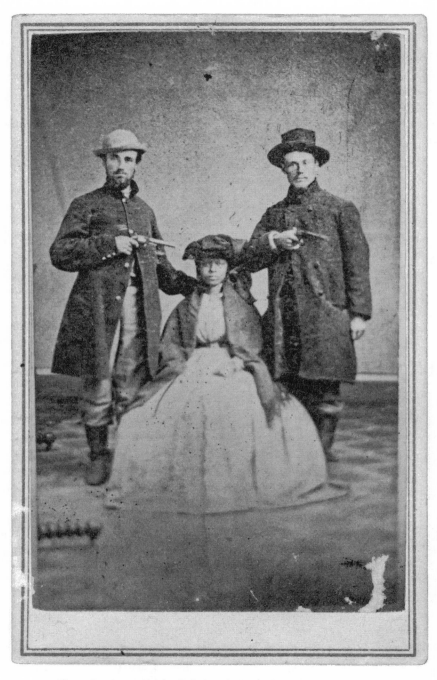

Figure 6.2. James Presley Ball, *Jesse L. Berch, Quartermaster Sergeant,*
22 Wisconsin Regiment of Racine, Wis., [and] Frank M. Rockwell,
Postmaster, 22 Wisconsin of Geneva, Wis., September 1862.
Prints and Photographs Division, Library of Congress.

angled, inward stance and the light-colored outline of the woman's dress form invisible lines that create an "X" that centers on the woman's head. Like rotated crosshairs of a rifle's scope, the invisible lines marked the formerly enslaved woman as the target of Confederate capture and reenslavement. The drawn guns, especially the one held by Quartermaster Sergeant Berch, which is pointed at the woman's head, signify the imminent danger that each of these individuals, but especially the young woman, faced in Cincinnati that September day in 1862. Although the Confiscation Acts protected runaway slaves in the possession of Union forces on paper, it did not guarantee their safety or freedom from slave catchers. The pose of displaying one's revolver across one's chest was uncommon in photographs taken during the Civil War.[29] The weapons represent the force of military power, embodied within the young soldiers, to defend and protect the woman despite the law that did not allow northerners to harbor fugitive slaves who sought refuge within their lines unless they previously aided Confederate troops.

The deliberate choice to brandish and position the revolvers visually captured the liminal state of freedom of the African American woman. The guns simultaneously signify her chaperones' commitment to her protection and the danger that she faced as an escaped slave constantly facing reenslavement. The chosen standing position of Quartermaster Sergeant Berch and the chosen seated position of the unnamed African American woman enabled the revolver to align with her head. Dangerously aimed, his gun pointed to the main subject of the photograph. With the ability to terminate life, the revolvers in the image were brandished to demonstrate how they would preserve the safety and tentative freedom of the seated woman. As such, the image is paradoxical in its staged placidity and its violent potential: violence in the service of defending the African American woman and the violence suffered by the enslaved woman upon recapture.

Ball's image documented the intersecting racialized and gendered performance of escaping from slavery. Levi Coffin's autobiography vividly recalls not only the details of the image but also how the African American woman passed as white and, therefore, a free person. But first, the woman arrived at Coffin's home in soldiers' clothing and "presented the appearance of a mulatto soldier boy."[30] The next morning, after having been tended to by Coffin's wife, the young escaped slave had "transformed into a young lady of modest manners and pleasing appearance."[31] The donning of a large hoop skirt, gloves, and eventually a veil dramatically altered her appearance to improve her prospects for freedom. This transformation echoed the actions of Harriet Jacobs, who immediately purchased a double veil and gloves to dis-

guise herself and another enslaved woman when they arrived in Philadelphia.[32] Another fugitive slave, Dinah, also disguised herself in a double veil to attend church repeatedly before escaping by ship to Philadelphia while wearing the veil.[33] So too did the Reverend William Troy dress a young enslaved boy in "dresses and skirts, and bonnet and veil," to enable his escape from a crowd of policemen staking out his location.[34] A veil also helped Jacob Green escape; he tied the hands of his mistress behind her back with her own veil before fleeing.[35] For the fugitive slave who visited Ball's studio, the accoutrements of respectable white womanhood — the veil, clothes, dress, and shawl, as well as not one but two male chaperones — disguised the woman's racial identity, which she and her protectors evidently understood to be a liability to her freedom. The composition of the photograph stressed the importance of representing womanhood: taken at a distance, the photograph highlighted her voluminous dress. The image drew attention to her attire, the vehicle that helped transport her safely not only to the photography studio but later to freedom in Wisconsin.

Seated, the young woman projected the image of a lady at leisure. The photograph showcased her dress, emphasizing her respectable attire. As evidence of one method by which enslaved African Americans pursued freedom, the photograph visually highlighted how publicly perceived white womanhood could be fashioned entirely out of clothing and company, not physiology. Her racial identity was revealed to the photographer and the viewers of the image as Quartermaster Sergeant Berch held her veil back to reveal the woman seeking refuge beneath it. The viewer of the image was privy to the secret of her racial background, unlike the train passengers who shared a first-class cabin with her. In fact, her attire in Ball's gallery may have been precisely what she wore as she boarded the train; Coffin recorded that she "was nicely dressed, and wore a vail [sic], presenting the appearance of a white lady."[36]

The photograph of the three figures catalogs the importance vested in the creation of an image of a formerly enslaved person seeking freedom. Though only in Cincinnati for a maximum of two days before departing, the three people in the photograph decided to record their transgressive activity by risking discovery when they ventured out in public. The very creation of the photograph documents its importance to the figures. At the cost of risking exposure and seizure, the young woman covered herself in the trappings of white womanhood to visit a black photographer. Indeed, the three trusted Ball to keep their freedom mission secret. One can imagine them walking to Ball's daguerrean gallery, the woman's dark veil drawn to cover her face,

Freedom and Citizenship

her gloves worn to cover her brown hands, and her shawl drawn high on her neck to cover any glimpse of skin color. The duality between exposure and invisibility continues in Ball's photograph, which shows the woman displaying only her left, gloved hand; the other is tucked somewhere beneath her shawl. Draped under clothing and hidden in plain sight, her concealed hand is a metaphor for her time in Cincinnati as a fugitive slave.

Although Ball's image and Levi Coffin's testimony provide much information, they do not record the name of the young woman who escaped enslavement. Coffin wrote that, after the young woman changed out of her soldier's clothing, she "won the interest of all by her intelligence and amiable character."[37] It would be expected that at some point she revealed her name to the two men who accompanied her to Cincinnati and to the members of Levi Coffin's household. The bottom front of the carte de visite does not bear the names of the three figures, though on the back someone recorded the names, hometowns, ranks, and regiments of the two men. Not included is the name of the young woman. A letter from Quartermaster Sergeant Berch, whose friends in Racine arranged her arrival, revealed that she had married a barber and moved to Illinois.[38] No more is known about her.[39] The story of her escape and the image captured in Ball's studio offer a testament to her life and the subversive decisions of escaped slaves to realize their freedom.

JAMES PRESLEY BALL AND EDWARD MITCHELL
BANNISTER: THE TROPES OF RECORDING
BLACK UNION MILITARY MEN

Few photographs captured by African American photographers of black Union soldiers remain extant, but those that do offer insight into black photographers' avoidance of traumatized black bodies. Though some surely have yet to come to scholars' attention, the histories surrounding the photographs reveal specific reasons for which more images of African Americans taken by black photographers are not currently known. White photographers such as Mathew Brady, Alexander Gardner, Timothy O'Sullivan, and George Barnard are well known to scholars today. Beginning nearly two decades before the Civil War, Mathew Brady dedicated his professional life to creating and preserving a visual record of the most influential figures in American life. His tireless self-promotion and assiduous drive to establish an archive of domestic and international politicians, artists, actors, businessmen, scientists, and military leaders were unmatched by any photographer during the Civil War era.[40] Compared to Alexander Gardner, his former apprentice who struck

out on his own, Brady largely eschewed images of death and wartime loss for portraits of regiments and landscapes "from which all evidence of war had vanished."[41] Views of African Americans, with the exception of images of contraband youth at the feet of Union soldiers, likely reminded viewers about the divisive topic of slavery over which the war was fought, and thus either a conscious or an unconscious decision was made to leave largely un-documented the hundreds of thousands of escaped slaves following soldiers and fleeing to Union camps. It was in these spaces, as scholars have argued, that formerly enslaved people living in contraband camps made claims for citizenship and helped secure their freedom.[42] Photographing these indi-viduals of lesser social status certainly did not align with Brady's professional goal to preserve for posterity the likenesses of the great historical figures of the United States.[43]

Compared to the white Civil War photographers well known to scholars today, African American photographers possessed different ideas and com-peting interests around the role of visual culture. Highly ambitious, James Presley Ball did not have the well-established reputation of capturing the likenesses of presidents and politicians before the Civil War. Many presi-dents, cabinet members, senators, and presidential candidates, after all, had posed in Brady's studio before the outbreak of the Civil War. Ball's decision to develop his career in Cincinnati, and not Washington, D.C., or New York City, like Brady and Alexander Gardner, influenced who sat before him. Like-wise, Edward Mitchell Bannister decided to remain in and around Boston, where he had established himself within the African American community. The priorities of Ball and Bannister to remain on the home front help explain why no black photographers are known to have created their own images on or near battlefields. The rare images by Ball and Bannister that survive from this era underscore that though geographically distant, the weight of the Civil War was near to them. Indeed, neither Ball nor Bannister aggressively attempted to replicate the professional trajectory of Brady or Gardner. Their images testify to competing ideas over what the role of visual culture could be during the Civil War. Instead of Brady's "essentially romantic" project or the visceral death and loss that Gardner's images emphasized, the few re-maining images by Ball and Bannister testify to people carrying on with their lives while continuing to be mindful of the unrest that war creates.[44] These images could be identified as part of a growing genre of documented cele-bration of black contributions to the Union. They avoided images of present and past African American suffering and instead focused their sights on the present and future of African Americans in a changing nation.

Freedom and Citizenship

The business of being a photographer on or near the front lines presented a host of scenarios that photographers otherwise would not have encountered. Transporting supplies not only compromised the chemicals and other supplies needed to create images but also required the proper equipment and assistants. Though new clients could be secured in new areas, photographers jeopardized potential income from communities where they had established their practices. Furthermore, the closer to warfare one traveled, the greater was one's likelihood of becoming a victim of unintended or deliberate violence. Being black was likely another liability near Confederate forces. Traveling to and photographing on the warfront separated photographers from their families and was a gamble that could compromise financial well-being. The process of transferring revenue from the warfront to the home front was yet another challenge. In short, the risks of being a black photographer following Civil War soldiers and sailors were great indeed. Given these drawbacks, it should be no surprise that neither Ball nor Bannister documented the Civil War from outside their hometown studios.

For Edward Mitchell Bannister, the path to becoming a noted visual artist began after he moved to Boston in approximately 1850. Born around 1828 in St. Andrews, Canada, Bannister first tried his luck as a barber and painted on the side.[45] Many came to know of the young painter after William Cooper Nell, the influential black activist and writer, praised one of Bannister's seascape paintings in his 1855 book *The Colored Patriots of the American Revolution*.[46] Even before that, Nell had published a letter in the *Liberator* praising the same painting, which hung in the study of John Van Surly DeGrasse, the first African American doctor admitted to a medical society in the United States. In 1854, Nell remarked, "It is safe to predict for him [Bannister], at no distant day, that encouragement which should reward such self-taught exertions."[47] Bannister put his barbershop in Marlboro, Massachusetts, up for sale in the summer of 1857 and listed his reason for selling as "going into other business."[48] It was true; that June, Bannister married Christiana Babcock Carteaux, a successful entrepreneur of African American and Narragansett Native American heritage who owned several hairdressing salons in Boston. With the financial stability provided by Carteaux's business acumen, Bannister gave up barbering for painting and photography.

The antislavery community in Boston and its vibrant African American community fostered Bannister's political awareness.[49] His social circles included the most prominent African American leaders living in Boston, where Bannister became extensively involved in several causes to aid free and enslaved African Americans. In an effort to resurrect and preserve the

memory of Crispus Attucks, an African American and Native American man killed in the Boston Massacre of 1770, Bannister performed as a member of the Crispus Attucks Glee Club during the Commemorative Celebration of Crispus Attucks and the Boston Massacre in Faneuil Hall on March 5, 1858.[50] There, William Lloyd Garrison and Wendell Phillips joined Charles Lenox Remond as speechmakers and attendees who vociferously protested the recent *Dred Scott v. Sandford* Supreme Court decision.[51] The next year, Bannister attended the New England Colored Citizens' Convention in Boston, where other delegates appointed him to the Committee on Roll when members discussed further opposition to the Fugitive Slave Act, the *Dred Scott* outcome, and colonization in Africa.[52] There, Bannister had the opportunity to speak with Remond, William Wells Brown, William Still, J. Sella Martin, and other prominent black leaders. Bannister also rallied Bostonians together to assist those people arrested for freeing an escaped slave, John Price, from slave catchers who had overtaken him near Oberlin, Ohio, in 1858.[53] They then affirmed their support for the people who rescued Price and raised fifty dollars to defend the thirty-seven people indicted by a federal grand jury for the nationally publicized event.[54]

Bannister's activism became more pointed as a result of the exigencies of the Civil War. As a member and later trustee of the Twelfth Baptist Church in Boston, Bannister learned of the dire circumstances faced by contraband people in Washington, D.C., after testimony shared by the church's spiritual leader, the Reverend Leonard Grimes, a pillar of Boston's black community well known for secreting many fugitive slaves to safety.[55] Bannister served as the secretary for a meeting that created the Association for the Relief of the Destitute Contrabands. With the organization's constitution drawn up and the all-women officers appointed, the meeting collected twenty barrels of clothing and twenty-four dollars for these self-emancipated people needing relief.[56] A week before President Abraham Lincoln announced the final draft of the Emancipation Proclamation on January 1, 1863, Bannister again recorded the proceedings of a crowded meeting at the Twelfth Baptist Church. There, he heard several black leaders debate whether to hold an event celebrating the implementation of the Emancipation Proclamation because of widespread doubt that it would take effect.[57] Given the western expansion of slavery in the preceding decades, the effects of the Fugitive Slave Act of 1850, the *Dred Scott v. Sandford* Supreme Court decision of 1857, and Confederate proslavery obstinacy, those gathered had reason to question. Amid the "greatest confusion" in the "tremendous crowd," a vote determined that the celebration would occur, and Bannister served on the Committee

of Arrangements for the momentous event. Free and open to the public, the event's morning and afternoon sessions featured readings of the proclamation in Tremont Temple interspersed with choral music. Organizers collected a ten-cent admission fee to aid the "National Freedmen" during the evening session.[58]

Christiana Carteaux Bannister promoted her husband's work and aided the cause of escaped slaves and black Union soldiers. She helped organize a fundraiser that raised money for the widows of the "colored American heroes" of Harpers Ferry and advocated for the building of a monument to their memory.[59] The radical abolitionist John Brown had close ties to Lewis Hayden, the formerly enslaved man who sometimes defended fugitive slaves in his Boston home from slave catchers with weapons and boarded the Bannisters in his home between 1859 and 1860.[60] But it was Christiana Carteaux Bannister who, as president of the Colored Ladies of Massachusetts, planned a fair to benefit the black soldiers of the Fifty-Fourth and Fifty-Fifth Massachusetts Volunteers and their families in May 1864.[61] The Fifty-Fourth and Fifty-Fifth regiments refused their salaries to protest the federal government's initial refusal to pay black and white soldiers equally. The fair assisted their families during the resulting financial hardship. The famous author and abolitionist Lydia Maria Child attended the fair and reported later that "at the head of the hall was a full length portrait of Col. Shaw, painted by Bannister; and above it, in large embroidered letters, was the touching and appropriate motto, 'Our Martyr.'"[62] The three-quarter-length portrait of Colonel Robert Gould Shaw, the white commander of the black Fifty-Fourth Massachusetts Regiment, who had died at Fort Wagner, South Carolina, hung above attendees for the weeklong fair. Estimated to fetch two hundred dollars by raffle, the painting helped the fair raise nearly four thousand dollars.[63]

Around the time that Bannister painted Colonel Shaw, he photographed his friend and fellow black activist John Van Surly DeGrasse (fig. 6.3). One of Bannister's earliest known patrons, DeGrasse sat for his portrait in 1852, as did his wife, Cordelia Howard DeGrasse.[64] The couple participated in Boston's activist circles in a broad range of events, such as Cordelia performing on the piano and John singing at the commemorative celebration of Attucks.[65] A student of the Boston doctor Samuel R. Childs, DeGrasse received his medical degree after graduating from Bowdoin Medical College in 1849 and then practiced medicine in Paris.[66] He settled in Boston, where his house calls to aid fugitive slaves and other patients made him well known among the African American community. When not practicing medicine, he attended meetings that debated the merits of African colonization, con-

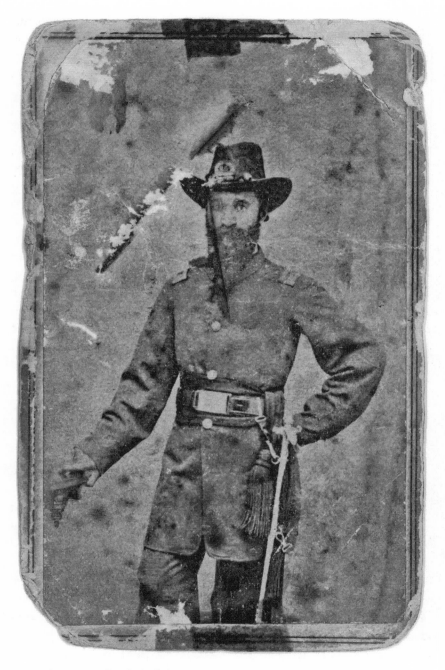

Figure 6.3. Edward Mitchell Bannister, *John Van Surly DeGrasse*, ca. 1863–65. *Courtesy of the Massachusetts Historical Society.*

ferred Masonic honors on Hayden Lewis, and participated in the dynamic Twelfth Baptist Church congregation.[67] He enlisted in the Union army and served as an assistant surgeon in the Twenty-Fifth Colored Infantry.

Bannister's image of DeGrasse bore many of the standard elements of Civil War portraiture of Union soldiers taken in photographic studios. Standing, dressed in his military uniform, DeGrasse looked at the camera in a three-quarter view that prominently displayed a saber at his hip, a military object of high rank emphasized by its contrasting color against DeGrasse's uniform and the placement of his hand on the same hip from which the saber hung. His right leg bent at the knee in a contrapposto pose, he rested his right hand on the edge of a table on the left side of the image. Beneath his dark hat, he wore a long, full beard. With a plain, light-colored background that contrasted with DeGrasse's blue Union uniform, the image encouraged viewers to concentrate on DeGrasse and his military paraphernalia. Without one of the painted background scenes to place DeGrasse within an imagined context of the battleground, his status as a Union officer was the sole focus of the photograph. This may come as no surprise, given the heated debates among free black Bostonians to fight for the Union cause. Wearing the Union uniform and serving the Union was a mark of pride and character, especially after the long fight to enlist black men.[68]

Another image of a black Union military member created during the Civil War is known to survive from the Cincinnati photographic studio of Ball and Thomas. The black photographer James Presley Ball had established several photography studios in Cincinnati and previously toured a moving panorama that displayed the regressive effects of slavery in the United States in the 1850s. His African American brother-in-law, Alexander Thomas, became his business partner after working several years in his photography studio. Together, they created images of black and white patrons of all ages in multiple studios in the same neighborhood of Cincinnati, and they especially welcomed business from enlisted military members as the Civil War began. Wearing the standard uniform of a Union sailor, the young black man stood facing the viewer in the full-length portrait (fig. 6.4). Immediately behind him can be seen the feet of a posing stand that held the sailor's body, and perhaps his head, motionless so that the resulting photograph would not record blur from movement. Farther behind, a background scene depicted a gracious outdoor terrace beyond which trees, mountains, and sky filled out the peaceful setting. The placid background contrasted strikingly with the realities of war. Black men from Ohio who enlisted in the army mostly joined the Fifth and Twenty-Seventh Colored Infantry Regiments. Those

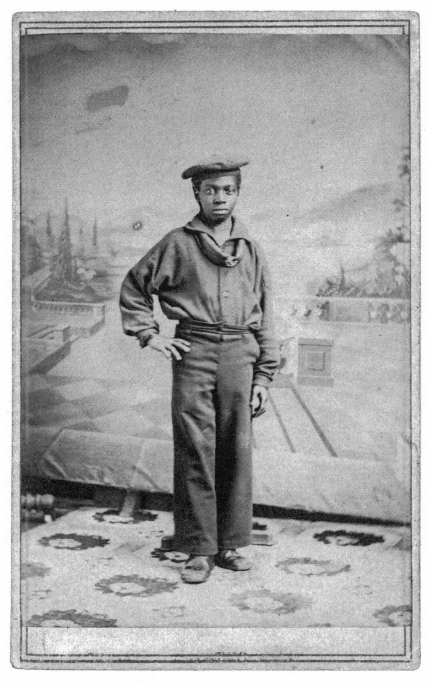

Figure 6.4. Ball and Thomas Studio, *Full-Length Portrait of
an African American Sailor, Facing Front*, ca. 1861–65.
Prints and Photographs Division, Library of Congress.

who joined the Union navy were, as scholar Steven Ramold has argued, often able to gain more leadership positions, receive equal pay, and experience fairer treatment than their black Union army counterparts.[69]

Though the collective visual archive largely records African American men enlisted in the army, Ball and Thomas's image of an enlisted black sailor was more typical of African American men's experiences in Cincinnati. The city's advantageous location on the Ohio River supported a thriving population of black dockworkers. By 1850, boatmen made up the largest percentage—18 percent—of black male workers in Cincinnati.[70] Ten years later, the census listed 18.5 percent of African American men as boat hands, but that did not include other occupations on board such as steamboat firemen, barbers, cabin boys, and cooks.[71] Highly segregated, in part, because of the southern mores that traveled with the steamboats up its alluvial lifeline, the city fostered a free black community inextricably bound to various enterprises on the Ohio River. Sometimes black dockworkers assisted fugitive slaves escaping to freedom,[72] just as Union sailors occasionally did.[73] Black men with experience working on ships and completing tasks along the docks would have found much of the work in the Union navy to be similar.

Like other Cincinnati photographers, Ball and Thomas attracted Union service members to their studio by appealing to customers' patriotism and romantic interests. By March 1861, Ball was advertising that he "[was] introducing a new style of Pictures, known as Photograph Visiting Cards," that were "neat and cheap."[74] In other advertisements, he addressed military men: "Soldiers about to leave home should not forget that the Mammoth Daguerrian Rooms of J. P. Ball, at No. 30 West Fourth-Street, will supply them with splendid pictures, at panic prices."[75] In another, he reminded those about to muster out to the warfront: "Don't go to the wars without first repairing . . . and sitting for one of [Ball's] truthful Pictures, which [you should] present to the girl you leave behind you."[76] That week, Ball and Thomas reported that their studio was "overrun with business" because, as the title of their advertisement read, "The War Has Begun."[77] Ball's proximity to the Union headquarters of Camp Dennison brought one member of his targeted demographics near his studio. In an article about Ball and his clientele, a pseudonymous Union soldier reported that "girls have a great love for regimentals, and the boys are sending to their 'ladyloves' the 'shadow' ere it passes away."[78] Conversely, one young man "exhibited a picture of his 'gal' as he called it, and said that he was going to fight just for her sake, the promise of the girl being that she would marry him on his return from the war, if he sustained the honor of his country's flag."[79] Soldiers captured their

shadows for a host of reasons that transformed their cartes de visite into mementos, romantic gifts, and documents of Union service. Their visual self-representation recorded their present acts of patriotism and served as a vehicle of memory for those they left behind.

THE ANGLO-AFRICAN EXHIBITION
OF INDUSTRY AND ART

Though they were nearly nine hundred miles apart, Edward Mitchell Bannister and James Presley Ball together developed during the Civil War what was intended to be the most impressive display of African American art and industry in the nation's history. Bannister and Ball, along with other black visual artists—William Simpson, John Chaplin, and William Dorsey—sat on the board of directors for "The First Exhibition of the Anglo-African Institute for the Encouragement of Industry and Art." Proposed by the prominent black Washingtonian Edward M. Thomas in late 1861, the event revealed the networks of black leadership that supported the notion that an exhibition of black art and industry could greatly improve race relations and cogently demonstrate black aptitude. Furthermore, the exhibition demonstrated the faith of these leaders in the social and political effects of art created by African Americans. Last, the planning of the affair made apparent the priorities of several African American leaders, given the pressures and anxieties forged in the furnace of the Civil War.

In letters published in two African American periodicals in early 1862, Edward M. Thomas sounded the clarion call to hold an enormous exhibition of art and other objects created and owned by African Americans. Though interested in spotlighting African Americans' mechanical inventions, Thomas was most interested in African American art and its creators. In letters published in both the *Christian Recorder* and the *Weekly Anglo-African*, Thomas did not name any black inventors but instead praised many painters—John Chaplin, Robert Duncanson, William Dorsey, William H. Simpson, David Bustill Bowser, and S. G. Brown—while listing their cities of residence. In a later letter published in the *Weekly Anglo-African*, Thomas described a "truly magnificent work of art" painted by the black artist John Chaplin.[80] It was but one "triumph of art" that Thomas wished that "public eyes [could] feast upon [because of] its great beauty"; he hoped that Chaplin would display another painting that depicted the death of Hannibal in the upcoming exhibition.[81] A third letter published in the *Weekly Anglo-African* celebrated the work of the black Philadelphian painter William H. Dorsey.

190 *Freedom and Citizenship*

Though signed "Critic" from Washington, D.C., the author's writing style and vocabulary mirrored Thomas's two previously published letters and described in detail the "inventive genius" displayed in two paintings created by a black artist. Taken together, Thomas indicated his deep investment in adding African American painters to the celebrated oeuvre of American art. For him, the stakes were high; black artists needed national recognition of their accomplishments during an era when conversations swirled about the possible future of African Americans within the nation as escaped slaves increasingly entered Union lines and black communities challenged the ban on black army service.

The reactions printed in African American newspapers that covered the exhibition's planning eagerly supported the venture and its goals. The *Weekly Anglo-African* praised the project and solicited its readers to write in with their comments. One reader named and commended three black Philadelphian artists while another writer offered the names of an artist — Edward Mitchell Bannister — and a black mechanic, both of Massachusetts. "Quadroon," writing from Boston, proposed to send her own "specimens of music and poetry" to the exhibition.[82] Furthermore, the *Weekly Anglo-African* office wrote that it would field any questions or comments that its readers may have had while stating that they were "earnestly requested to lose no time in getting their articles ready" for the exhibition.[83] More than two thousand miles away, an editorial note in the *Pacific Appeal*, a black newspaper published in San Francisco, communicated details of the upcoming event and firmly stated: "We opine it will astonish the pro-slavery libelers, who imagine there is no inventive nor artistic genius in our race."[84] Subsequent issues of the newspaper described the "good progress" being made in the preparations for the event, welcomed its readers to purchase stock in the venture, urged its readers to send their creations by steamer to New York City, and even vowed to send a file of the *Pacific Appeal* for public display.[85] An editorial published in the *Christian Recorder* expressed that those at the Philadelphia newspaper "are greatly in favor of just such a movement of our people, annually exhibiting to the world a fair."[86] Envisioned there as a recurring national event with international implications, the exhibition was believed to "give us [African Americans] full credit for all our humble endeavors" from the English, French, and Germans even "if we did not get what we richly merit from those in this country who claim to be our lords."[87] Understood to give African Americans room on the world stage, the exhibition offered the opportunity to allow a large audience to realize fully black intellect and achievement. Supporters of the event envisioned the objects on display to

convince viewers of African American intelligence, creativity, and mastery of various trades. One letter writer believed that the "exhibition would convince a large number of white persons, who are ignorant of what art and science there is among the people of color, of what we can do."[88] Meant also to dispel racial stereotypes, the exhibition promised to force African Americans' talents into the international spotlight.

Bringing African American art out of the long shadow cast by racial discrimination marked another reason for Thomas's exhibition. For those who claimed that African Americans either did not create art or lacked the capacity to produce it, Thomas countered: "The very fact that they are urged by persons, demonstrates that such persons have never had an opportunity to judge of these facts; there has never been an occasion where the genius, talent, and acquirements of our race could be fairly exhibited."[89] Thomas lamented that African Americans had never been able to display their artistic and inventive capacities on such a large scale, which he believed impeded a broad recognition of black skill. He argued that displayed art provided incontrovertible proof of African American achievements on the cultural terms judged by white Americans. Thomas demanded of his black readership: "Let no consideration withhold us from the attempt, and let us redeem ourselves in the eyes of those bigots who impute inferiority to us of talent."[90] In the face of claims of African Americans' inferiority, Thomas urged his black readers to "stand forward boldly and intrepidly, and demonstrate to a biased world, that few works of art, and they [are] far between, having been visible, is owing to our want of encouragement, and our lack of opportunity to give them publicity."[91] Thomas imagined that racial prejudice would wither with the recognition of the black artists' physical and conceptual talents. Such thinking relied on several assumptions: white viewers would attend the exhibition, judge the work there using the same standard of qualifications used to judge artwork produced by white artists, and find that black intellect and skill overcame racial prejudice. It was a formidable challenge, and Thomas's confidence in the exhibition's radical promise motivated him to move quickly.

Thomas envisioned that the exhibition would render black cultural achievements visible by saving from obscurity African American artistic and mechanical works. He knew that African Americans possessed objects produced by black men and women in private but that public display would make these more valuable and powerful. He imagined objects as outward manifestations of their producers' inner capacities in much the same way that portraits were widely believed to reveal the inner character of the de-

picted. Not making public black achievement posed a considerable problem for Thomas: "Many a masterpiece, for want of appreciation, is left unheeded, to decay among rubbish and ruins. By having this exhibition, we may bring to light some picture of precious value."[92] In effect, an exhibition would "rescue from perpetual obscurity many gems of Art" that evidenced African American artistry and cultural production.[93] Thomas determined the significance of these works according to the race of their creators, their quality, and their public display. Those black people who created such work, Thomas lamented, "remain still totally unknown, together with their works, excepting to the circle of private friends, and," as he feared, "so it is, and always will be, that the talent which is now in our people, buried in obscurity and the humble walks of private life, will remain totally unknown, unless some manner of giving their talents publicity be contrived."[94] Thomas hoped that the increased viewership provided by the exhibition would increase the recognition of these black cultural and industrial producers. As an act to make visible African American "genius," Thomas believed that the exhibition would serve as both an excavation and a public corrective to assumptions of black inferiority. He wrote that black artists displaying their work at the event "will be rescued from the obscurity of private life — we have, in fact, nothing difficult to overcome but our own inactivity; and the dislodging from the names of our people the accusations of want of genius, by presenting to the world the stern facts themselves."[95]

Much as Ball and Bannister documented black national loyalty and military achievement, so Thomas endeavored to record a history of African American–produced art and objects. Indeed, the title for the exhibition celebrated the event as the "first National Exhibition of Anglo-African Industry and Art." Its scale, its aims, its publicity in black newspapers, and its range of invited materials hinted at Thomas's vision of the event to be one that documented and celebrated black achievements. The purpose of gathering artwork and other objects in one location enabled a visible and allegedly irrefutable accumulation of black talent while it established a large-scale, public historical record of artistic production. Thomas's proposal of the exhibition marked the creation of a public record of African American "genius." While black men and women had long been meeting in literary and debating societies, in state and national colored conventions, at religious conferences, and in select colleges and universities, the national exhibition that Thomas envisioned during the Civil War would ideally encourage national and international attention. It would be the first of its kind in the United States.

The planning logistics of the "Anglo-African Exhibition of Industry and

Art" revealed the expansive black leadership network of support. The network of black men and women who planned the event stretched north from Washington, D.C., to Massachusetts and west to Indiana. New York, Pennsylvania, New Jersey, Ohio, and Maryland rounded out the states where organizers planned the logistics of the event. The Reverend Henry Highland Garnet would commence the proceedings with a prayer, and Frederick Douglass agreed to deliver the opening address. The "Lady Managers" included Ada Hinton, Augusta Lake, Juanna Howard, Harriet Rogers, and Emeline Bastien. James McCune Smith, William Whipper, and the Reverend Daniel A. Payne of the African Methodist Episcopal Church each held the title of vice president, while the board of directors included AME Reverends Willis Revels and Daniel Payne as well as the artists James Presley Ball, William Dorsey, and William Simpson. The Reverend James Gloucester, a black Presbyterian minister who had offered space to host the exhibition in Brooklyn, also sat on the board of directors.

Despite the extensive collaboration and planning, Thomas jeopardized the success of the exhibition when he supported Lincoln's plan for black emigration to Central America. Having initially adopted resolutions denouncing the emigration schemes advanced by Congress and President Lincoln, Thomas met the president as part of an African American delegation to hear his proposal in person. Only a few days later, Thomas wrote to Lincoln with the idea that delegates be sent to convince African Americans in Philadelphia, Boston, and New York whom he believed would "join heartily in sustaining such a movement."[96] This turned out to be a fateful miscalculation. Thomas did not report the proceedings of his meeting with Lincoln to Union Bethel Church, where he had been chosen as a member of the delegation. When it was discovered that he supported Lincoln's colonization plan, the backlash was quick and severe.[97] The episode caused distrust of Thomas among African American leaders because they believed both that he misrepresented their stance on colonization and that he mismanaged funds related to his trips to northern cities. James McCune Smith then resigned from his position as one of the exhibition's vice presidents of the planning committee. His published reason — "Whilst our country is overwhelmed with the horrors of a bloody and disastrous war, I cannot uphold an exhibition which typifies the calm of prosperous peace" — might not fully explain his decision.[98] That Smith made public his reason, did so during the fracas surrounding Thomas, and was staunchly opposed to Lincoln's plan for black emigration makes it likely that he also withdrew his support from the exhibition to distance himself from Thomas.

Support wavered among other members of the planning committee. Just weeks before the exhibition's scheduled opening on October 1, the "urgent solicitation" of supporters of the event in Baltimore, Washington, D.C., and Cincinnati resulted in a postponed opening, now scheduled for May 1863. As the only member of the planning committee from Cincinnati, James Presley Ball evidently expressed his wishes to postpone the event. The reason for oscillating support may have also been related to the pressing issues of the massive influx of escaped slaves seeking relief in and around Washington, D.C., as the war progressed. Edward Mitchell Bannister, who sat on the exhibition's board of directors alongside Ball, led a meeting in Boston on September 17, 1862, to encourage attendees to donate clothing, money, and other forms of aid to the newly free people.[99] As 1862 came to a close, planners of the exhibition pushed back the opening further to October 1863.

Along with vacillating support, political fallout, and more pressing humanitarian issues, two more events ultimately ended the plans for the exhibition's successful implementation. The death of Edward M. Thomas in March 1863 marked an end to the exhibition's most vociferous and passionate advocate. Advertisements for the exhibition continued after his death in the now renamed *Anglo-African* newspaper, but where the name of the president had been listed, several dashes signaled that no one had assumed the position in his absence.[100] Advertisements and news coverage of the exhibition preparations abruptly ended little more than a week after the New York City draft rioters attacked black New Yorkers and destroyed black institutions.[101] The pressing issues of the war took precedence, and the violence that visited New York City, where many of the exhibition's planners resided and prepared to host the event, snuffed out Thomas's dream.

Edward M. Thomas's desire to counter black stereotypes indicated the omnipresence of these images and ideas that lampooned African Americans before and during the Civil War. Technological developments enabled illustrated newspapers to reproduce and circulate images at unprecedented speed and scale, while the explosion of popularity in cartes de visite enabled images to proliferate affordably and quickly. Many of the images circulated by illustrated newspapers propagated tropes of blackface minstrelsy and other derisive stereotypes of blackness that signaled anxiety over the present and future circumstances of many thousands of escaped slaves. Yet, popular representations of African Americans varied dramatically as the war progressed. The enlistment of African American men into the Union military threw into relief the illustrated newspaper artists' mediation of these images with their preconceived judgments of contraband people. Within this visual

and political battleground, the few extant images of African Americans created by African Americans during the Civil War provided insight into the questions surrounding the place of black Americans within the nation. The contrasts between these images and those widely circulated in illustrated newspapers revealed how black photographers produced images that celebrated black military service and raised concerns about escaped slaves. Their images of enlisted African Americans paralleled other images of enlisted men that underscored their patriotism, masculinity, and fitness for citizenship.

Racial stereotypes remained pervasive, and Edward M. Thomas's plans for the "Anglo-African Exhibition of Industry and Art" intended to subvert them. Calling on support from the readership of black newspapers, Thomas aligned the work of prominent black visual artists with preeminent black activists to display the accomplishments of and cultural wealth held by black people. He theorized that African American artworks and inventions could accomplish domestic and international recognition of black genius. He trusted that art and objects produced by African Americans could stamp out race prejudice and motivate black people to produce more material that would challenge racism and jumpstart black achievement.

Thomas's dreams never materialized, though the groundwork for the massive event revealed that African Americans across the country sought to claim a stake in the visual culture of the Civil War era. Questions remain about the dearth of images created by African Americans during the war, especially in comparison to those white photographers history has come to remember. The names and images of Mathew Brady, Alexander Gardner, and Timothy O'Sullivan have become recognizable for a host of reasons that include memorable, sometimes harrowing images reporting some of the scenes of a war unmatched in its scale of death in the United States. They also cemented their fame with photographs of famous figures, books that featured their photographs, and galleries that exhibited their images. Black artists did the same throughout the Civil War and Reconstruction, but on a considerably smaller scale. Perhaps if the planning of the Anglo-African exhibition had culminated in a groundbreaking display of African American art, some of the now-forgotten African American images and artists of the Civil War era would be remembered today.

7

RELIGION, RIGHTS, AND THE
PROMISES OF RECONSTRUCTION

In January 1867, Frederick Douglass traveled to Cincinnati to lecture before interracial crowds eager to hear the famed activist. On the evening of January 12, Douglass lectured on the topic of "Sources of Dangers to the Republic" that he would deliver in St. Louis the following month.[1] The newspaper coverage of the Cincinnati event registered Douglass's apprehension of, and frustration with, Andrew Johnson's presidency.[2] Like many other black women and men before him, Frederick Douglass called for the ubiquitous realization of the principles of equality and republicanism described in the Declaration of Independence.[3] The nation owed African Americans at least that. The Union's victory over the Confederacy and the ratification of the Thirteenth Amendment constitutionally protected freedom from slavery. But it was not enough. The principles that secured racial equality remained out of reach for the many black people in states where they had yet to receive civil liberties, in part because the federal government had not yet compelled all states to provide such rights to African Americans. Moving in the opposite direction, residents and politicians in those states passed numerous laws known as black codes that limited African American freedoms and imposed severe punishments after the Civil War. Douglass discussed the rights needed by African Americans during those January nights in Cincinnati. In striking and controversial gender-inclusive language, he demanded: "Let no man be excluded from the ballot box because of color, nor woman because of sex."[4] Douglass vehemently advocated for the suffrage of African American men, especially on the grounds of Union military service, and demanded that women receive the vote as a means to expand democracy throughout the nation. Douglass challenged his Cincinnati listeners to agree.

Soon after Douglass's first speech in Cincinnati, James Presley Ball

showed the staff of the *Cincinnati Daily Gazette* his recent photograph of Frederick Douglass (fig. 7.1). Turned three quarters toward the camera, Douglass averted his eyes from the viewer and appeared calm as the shutter clicked. Donning a formal shirt, vest, and jacket, he struck a respectable appearance. The uncommonly large dimensions of the "splendid" photograph that Ball created—ten by twelve inches—befit the prominence of the sitter it represented.[5] Typically the most expensive format of photograph at the time, the resulting image recorded Douglass in great detail. Ball also created cartes de visite portraits of Douglass and sold them to fellow Cincinnatians as souvenirs, as was common practice, to finance Douglass's salary and the lecture series of which his speeches were a part.[6] Demonstrating the power and circulation of Ball's image, one Moses Dickson took out a wanted ad down the Mississippi River in St. Louis to attract agents "to sell J. P. Ball's fine steel plate pictures of Frederick Douglass."[7]

Douglass knew that viewers invested pictures with the power to shape not only their assessments of the personal character of those depicted but also broader historical and political ideologies. Nearly two decades earlier, he contended with the forces of scientific racism when he wrote that it was "next to impossible for white men to take likenesses of black men, without most grossly exaggerating their distinctive features."[8] Douglass took a keen interest in sitting for photographs and knew well the power of images to influence personal and public judgments. As the most photographed American of the nineteenth century, Douglass delivered lectures that revealed his belief in the power of images.[9] "The picture plays an important part in our politics," Douglass explained in a speech during the Civil War, "and often explodes political shams more effectively, than any other agency."[10] He believed that individuals empowered photographic materials with a sense of truthfulness that could prove beneficial or harmful. He also recognized that the meaning of images constantly fluctuated according to individual interpretation and that viewing was a socially constructed practice when he stated, "The pictures do not change, but we look at them through the favorable or unfavorable prevailing public opinion."[11] As such, each viewer ascribed a unique series of meanings to any given image according to societal influences particular to his or her historical moment and personal experiences.

Images gave way to a multiplicity of meanings, and these could prove powerful during the tumultuous period of Reconstruction as the battle for black rights continued. As the country rebuilt itself after the end of the Civil War, black image makers crafted images of African Americans that reflected

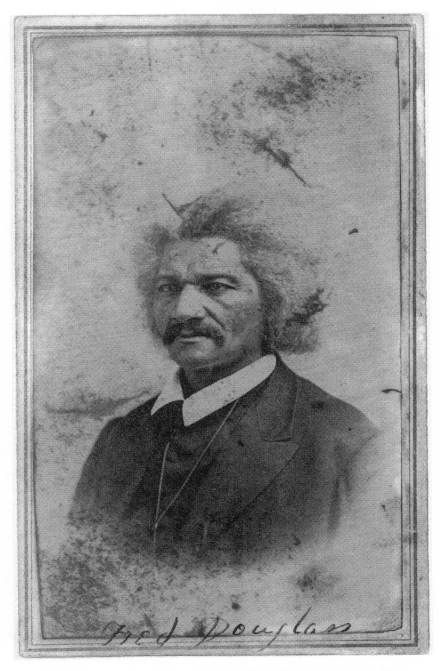

Figure 7.1. J. P. Ball's Photographic Gallery, *Frederick Douglass*, January 1867. *Courtesy of the Cincinnati Historical Library and Archives.*

a variety of the religious, political, and historical debates occurring domestically and internationally. Robert Douglass Jr. and James Presley Ball challenged viewers to imagine an achievable future that welcomed and secured black rights. Images became a means not only to document the successes of black politicians and desire for the widespread implementation of civil rights but also to celebrate the everyday life filled with friends and family members. The increasing accessibility of photographic technologies during Reconstruction enabled African Americans to participate in a kind of visual democracy. This paralleled the political democracy that, though not without its expansion and contraction of rights for African Americans, witnessed the development of black institutions and communities after the Civil War.

African American artist activists used images to advocate for and document black rights during Reconstruction. The African Methodist Episcopal Church and its official periodical, the *Christian Recorder*, played critical roles in fostering the artistic skill and the political positions of Robert Douglass Jr. In the pages of the AME Church's nationally circulated newspaper, Douglass evaluated domestic and international events concerning people of African descent. Furthermore, his published advertisements and writings revealed the ways in which he envisioned transnational issues in Cuba, Haiti, and the United States.[12] More concerned with domestic campaigns to expand black rights, James Presley Ball ventured into electoral politics with the support of civic and political networks that illuminated the intertwined nature of image production and black rights. His endeavors with the Republican Party and the AME Church mutually informed his success as a photographer. An investigation of Ball's photographic activities alongside his participation in Cincinnati's celebrations of black rights, involvement in a failed lawsuit, and connections to religious leaders and politicians, demonstrates how Ball envisioned photography to strengthen black communities. In their visual production, he and his family members captured images that detailed another important project during Reconstruction—the visual self-fashioning of African American respectability.

Charting the activism of black artists during Reconstruction reveals the changing landscape of black rights and Americans' practices of seeing. The people whose portraits they created—politicians, religious authorities, ordinary folk, and family members—underscored the political debates in which these cultural producers participated. The *Christian Recorder*, the chief periodical to feature their articles, political goals, and descriptions of their visual production, was central to the racial politics of Ball and Douglass. Analysis of their images builds upon the historiography of the AME Church and its

Religion, Rights, and the Promises of Reconstruction

leaders' support for African American education during Reconstruction as well as the reading cultures nurtured by the *Christian Recorder*. The periodical and its leadership also encouraged a robust African American visual culture in part because it furthered the church's goals of supporting black learning and providing models for black leadership. In the images, their reception, and their uses, scholars can glimpse Reconstruction's most pressing contemporary debates over the future possibilities of African Americans.

VISUAL CULTURE AND ROBERT DOUGLASS JR.'S POLITICS IN THE *CHRISTIAN RECORDER*

Well before the Civil War, pressing domestic and international issues animated the congregations and motivated the leaders of African American churches. Congregations organized within the AME Church, as in other black churches and denominations, discussed important concerns such as the forced removal of African Americans, the future of black education, and the role of women religious leaders. They debated transnational topics such as emigration to Haiti and African missionary work. Many of the most prominent nineteenth-century AME Church leaders, including Bishops Richard Allen, Benjamin Tanner, and Henry McNeal Turner, provided much more than religious guidance; they participated in campaigns to rid the country of racial discrimination in numerous areas, including education and electoral politics, before, during, and after the Civil War.[13] Cumulatively, the work of church leaders and their congregants demonstrated the profoundly intertwined religious and political missions of the AME Church.[14] While official church documents reveal the evolving philosophies that guided the denomination, the *Christian Recorder* offered deeper insight into not just church policies and values but the interactive nature of the church leadership and its congregants.

The AME Church cultivated reading cultures among its African American audiences through the *Christian Recorder*. Like secular black newspapers that preceded it, the newspaper recorded how the AME Church leadership and its congregants participated in political discussions. "Far from a distinctive and separate phenomenon," one scholar has written, "the black religious press built upon the foundation laid by early pamphleteers to reframe protests in new ways in the second half of the nineteenth century."[15] Scholars have argued that early black periodicals engendered political consciousness and racial identities among African American communities.[16] "The *Christian Recorder*" and other black periodicals "were crucial to the formation of an

ideal of community that affirmed reading and other literary activities as acts of public good on which the intellectual life and civic character of its members could be grounded."[17] Furthermore, the circulation of writings by black authors introduced histories of black Americans as corrective insertions into the historiography of the United States.[18] Editors published articles and letters written by readers that showed African Americans expressing varying degrees of support and concern over issues including voting rights, black military service, emigration to Africa, women's leadership roles, and black education.[19]

Robert Douglass Jr.'s production of visual culture engaged many debates concerning the futures of African Americans during Reconstruction. Under the guidance of editor Reverend Benjamin Tucker Tanner beginning in 1868, the *Christian Recorder* supported Douglass's contributions. Coverage of Douglass's images, art reviews, and translations of foreign language periodicals in its pages fit squarely within Tanner's dedication to black education and the proliferation of the arts among African Americans.[20] These visual materials marked a continuation of Douglass's engagement with political debates concerning the future of African Americans that began decades before the Civil War. Signing petitions, participating in antislavery meetings, and creating images he desired to inspire antislavery activism marked several of his strategies to end slavery. After the Civil War, Douglass continued his business as a sign maker, portrait painter, and banner manufacturer. His strong affiliation with the African Methodist Episcopal Church denoted the clearest shift in his strategies of making visible the successes of, and threats to, black Americans after the war's end. His connection to the church, as well as the political beliefs made manifest in his artwork, can be traced to both the physical space of the Allen AME Church in Philadelphia and the *Christian Recorder.*

Douglass harnessed his visual production skills to weigh in on debates for black men's voting rights. In 1870, he supported the ratification of the Fifteenth Amendment with a painting that portrayed John Brown slaying a monstrous representation of slavery. Described as a "sterling picture" in the *Christian Recorder,* the image depicted John Brown "destroying American Slavery in the shape of a monster half man and half dragon."[21] The image recalled the religious allegory of St. George slaying a dragon before inspiring thousands of townsfolk to convert to Christianity. In much the same way, the allegorical content of Douglass's image communicated that Brown motivated people in the United States to convert to the antislavery cause. The painting valorized the radical abolitionist John Brown, whom the United

States government had executed more than a decade before for treason, murder, and inciting a slave insurrection. Though the religious and antislavery message of the image likely appealed to many readers, AME leadership envisioned the image as having greater public value. Editor Tanner insisted that Douglass's work "would reflect credit upon any procession" and urged: "By all means, let some of our Societies secure it."[22] In keeping with a long tradition of African Americans organizing demonstrations, the editorial made it clear that a "procession" should bring the message of Douglass's image to the public in a parade, march, or demonstration. If exhibited in private, the image would nevertheless indicate Douglass's support for the radical means by which to end slavery to a broader audience than if accessible only within the intimate space of a home's parlor. The spirit of such a public display would be in keeping with "the celebration taking place all over the country" over the ratification of the Fifteenth Amendment.[23]

Douglass's tribute to John Brown continued a tradition of commending Brown's revolutionary actions. Brown's violence and radical egalitarianism quickly became memorialized after his death in songs, paintings, poetry, and a plethora of other celebratory commemorative practices.[24] Heralded by numerous black Americans while vilified by many white Americans, John Brown and his tactics of armed rebellion represented a controversial strategy to effect freedom. Douglass's painting depicted Brown as being the individual whose actions engendered the fall of slavery, despite his small-scale and immediately ineffective strategy. The enduring legacy of John Brown, however, inspired antislavery activists like Douglass in the years after his execution and for many years after the Thirteenth Amendment outlawed slavery in the United States. Tanner's desire that Douglass's painting be purchased for communal display underscored his support for Douglass's work and demonstrated a longer history that culminated in the Fifteenth Amendment. In other words, the demise of chattel slavery and the ratification of the Fourteenth Amendment increased the power of the Fifteenth Amendment by expanding citizenship and enfranchising more people. Furthermore, the language of the Fifteenth Amendment alluded to the end of slavery when it enabled citizens' suffrage regardless of "race, color, or previous condition of servitude."[25] If purchased and paraded through the streets of Philadelphia or elsewhere in honor of black men's voting rights, Douglass's picture suggested that Brown set into motion the collapse of slavery and engendered another form of freedom—the ability to vote—as well.

In keeping with his international travels to Europe and the Caribbean decades earlier, Douglass created artwork that revealed his engagement with

transnational issues concerning individuals of African descent in Cuba. During his lifetime, many such people in the United States, Cuba, and Haiti "perceived themselves as bound to each other, whether politically, ideologically, or otherwise."[26] Douglass's visual production reflected these imagined and real connections. When Douglass advertised his desire to teach students drawing and painting, he called attention to two images—one of Cuba, the other of black Union soldiers—visible in his studio.[27] He titled the first *Cuba Must Be Free*. Though the location of the image and its content are unknown, the title reflects that the subject matter grappled with the ongoing realities of slavery and colonialism in Cuba. A group of slave-owning Cuban planters had rebelled against the Spanish government in 1868 and emancipated their slaves only then to require legally dictated servitude of the newly freed people or their conscription as paramilitary combatants.[28] As many African-descended Cubans moved between various degrees of freedom and enslavement, the *Christian Recorder* and many other newspapers in the United States followed closely. The title *Cuba Must Go Free* likely described the visual arguments that Douglass crafted to condemn the quasi-reenslavement of Cubans. Advertised in the *Christian Recorder*, the picture continued Douglass's long tradition of crafting images intended to spotlight the injustices of slavery for the purpose of provoking its abolition. The large dimensions of the drawing, thirty-six by fifty-six inches, suggested that it was suited more for public display than for personal inspection in the home.

Douglass's second drawing—*Dying for the Flag*—exhibited his tribute to African American Civil War veterans. Douglass dedicated the work to a local chapter of the Grand Army of the Republic for African American veterans in Philadelphia, Post Number 27. Bound together by their war experiences, members of Post Number 27 met for many decades to discuss combat, build friendships, and honor their fallen brethren.[29] The title of the drawing underscored black Civil War soldiers' sacrifices and patriotism in reuniting the nation and ending slavery. Two years before Douglass advertised *Dying for the Flag*, the commander-in-chief of the Grand Army of the Republic, General John A. Logan, urged all Union veterans to decorate the graves of Civil War soldiers on Memorial Day.[30] Advertised less than two months before Memorial Day in 1870, Douglass's image memorialized fallen Union soldiers in keeping with Logan's pronouncement and the recent practices of Union veterans. The sacrifice denoted in the title paralleled the Memorial Day speeches in the North during which audiences heard that "their soldiers had died necessary deaths; they had saved the republic, and their blood had given the nation new life."[31] Advertised in the *Christian Recorder*, the drawing

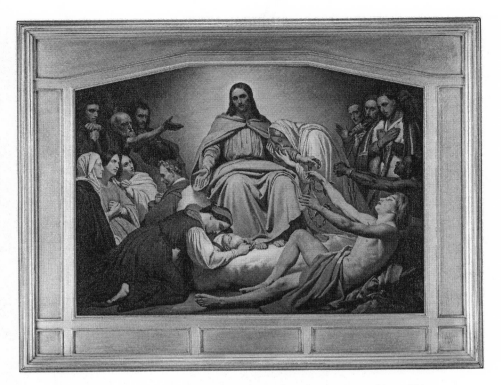

Figure 7.2. Ary Scheffer, *Christus Consolator*, 1851, oil on canvas, 25⅝ × 34½ in. Minneapolis Institute of Art, Given in Memory of Rev. D. J. Nordling by Gethsemane Lutheran Church, Dassel, Minnesota. 2008.101. *Photo: Minneapolis Institute of Art.*

measured thirty-six by fifty-six inches. Its large size suggested that Douglass created it for public display and encouraged its use for didactic purposes.

The religious instruction advocated by leaders in the African Methodist Episcopal Church embraced the educational components of Robert Douglass Jr.'s visual work. In October 1869, Douglass presented an ornate banner of a religious scene to the Sunday school of Asbury AME Church in Chester, Pennsylvania (fig. 7.2). Hired by the church's Sunday school committee, Douglass painted the scene on blue silk. The banner depicted Jesus at its center blessing young children and featured an inscription in gold letters: "Suffer little children to come unto me."[32] The author of the article describing the presentation wrote that "the principal figure reminds me of [the painting] 'Christus Consolator' of Ary Scheffer," which depicted an enslaved man with outstretched, manacle-bound hands similar to the supplicant slave icon produced by Patrick Henry Reason and many others who championed anti-slavery movements.[33] Douglass then "introduced into the group upon this

banner, in a circular composition, a colored mother and her child—which seems appropriately to illustrate the oneness of the human family."[34] Sunday schools educated black children, trained black leaders, and inculcated religious and moral teachings—all goals of *Christian Recorder* editor Tanner and objectives shared by other AME Church leaders.

The reception of and audience for Douglass's banner provide insight into the practices of seeing during the nineteenth century. The individual who described the image noted its circular composition, which stressed the equality of all people, regardless of race, for "on this banner all appear as of one blood" before God. The writer declared, "The principal light, which emanates from the halo surrounding [Christ's] head ... is somewhat Rembrantesque!" Such an interpretation required a studied knowledge of the Dutch painter unavailable to many readers of the *Christian Recorder*. The reflection signaled the author's expansive art historical knowledge while educating readers about a defining characteristic of the seventeenth-century Dutch master. Douglass's silk banner painting inspired the viewer to write, "I could also recognize in the painting a figure from Raphael—which, like an apt quotation in a literary effort, gives an additional charm to the composition."[35] Evidently, Douglass's artistic style impressed the writer, who made European art accessible for the thousands of readers of the *Christian Recorder*. Such sophisticated ways of explaining religious imagery communicated the visual vocabularies that came to be known by the readers of the AME periodical. The importance of bringing the black figures from the periphery to an equal distance with the other figures of the image communicated black people's equal claim to salvation, humanity, and religiosity. Douglass transformed a rarefied piece of art into a visual object that became widely accessible to children and a religious audience. At least one viewer fashioned an intricate interpretation of Douglass's image that itself documented and praised the religious instruction at Asbury African Methodist Episcopal Church.

Douglass linked racialized and religious imagery with the contributions of black soldiers during the Civil War. He delivered an address about the founders of the Sunday schools, Robert Raikes and William Fox, as well as "the opposition they met with and how they triumphed."[36] He stressed the importance of preserving banners "without spot or blemish" before signaling that the Star-Spangled Banner had "once been stained with the foul blot of slavery, but now by the valor of the white and colored 'Boys in Blue,' restored to its original brightness."[37] According to Douglass, black soldiers' military service helped secure a Union victory, end slavery, and redeem the values attributed to the nation as embodied in the Star-Spangled Banner.

Douglass therefore merged religious teaching with a history lesson about redemptive black contributions to the nation. Furthermore, his words possessed a double meaning that urged his audience to maintain the physical appearance of banners and uphold the morals and philosophies that they represented. This included the Sunday school banner he presented that day to the congregants of the AME Church in Chester. As such, Douglass implied that those attending and teaching the Sunday school should practice the morals and principles instilled by religious teachings.

As the *Christian Recorder* supported Douglass's work, so Douglass advanced the educational and moralizing mission of the AME Church. Such an opportunity arose in 1876 when Philadelphia hosted the Centennial Exhibition, which showcased innovations — artistic and otherwise — to millions of visitors. In addition to being a celebration of the one-hundredth anniversary of the signing of the Declaration of Independence, the Centennial Exhibition represented an attempt to substantiate the progress and achievements of the United States to foreign countries and visitors.[38] Douglass attended the Centennial Exhibition and, as a news correspondent for the *Christian Recorder*, published detailed reports of the exhibition's galleries and artwork. He cataloged the various nationalities of the featured artists, but the work of the African American artist Edward Mitchell Bannister attracted his eye and pen. The painting that would catapult Bannister to international fame, *Under the Oaks*, received high accolades from Douglass. He wrote that the painting showed "a quiet pastoral scene, a Shepherd and sheep beneath a fine group of oaks. It is much admired, and it gave me great pleasure to find that it is one of the really meritorious works that have gained a medal."[39] The public recognition of Bannister's painting as among the best to be displayed among international competitors physically embodied the elements of black skill and achievement that Douglass championed. Bannister's success replicated, on a smaller scale, the widespread attention to the black artists' talents that Edward M. Thomas and other black leaders had envisioned when they planned the first "National Exhibition of Anglo-African Industry and Art." Drawing on his experience as an art student in London, where he perused museum galleries and copied British master paintings in 1840, Douglass wrote of Bannister's painting: "To me it recalls some of the best efforts of Constable, the great English Landscape painter."[40] Even if readers did not immediately recognize John Constable, Douglass made them aware that Constable was *"the* great English Landscape painter."[41] Douglass celebrated black achievement by comparing the renowned European artist to the prize-winning black painter.

Douglass's role as an art critic aligned with Rev. Benjamin Tanner's promotion of African Americans' participation in the Centennial Exhibition. Long before the opening of the event, Tanner reasoned that the Centennial Exhibition could offer African Americans the chance to present their contributions to the nation and "the civilization of the world," in contrast to those who asserted that African Americans possessed "neither religion, history, government, or tradition."[42] While physical objects displayed at the Centennial Exhibition such as Bannister's painting and a monument of Bishop Richard Allen served that purpose, Douglass's art reviews testified to his intellectual capacity to both know and judge art. After filing through the enormous buildings filled with paintings and sculptures, Douglass described the environment for readers of the *Christian Recorder*. His testimony echoed the goals of many African Americans who envisioned the Centennial Exhibition as an opportunity to showcase black contributions to the United States.[43] Douglass dedicated a large portion of one of his reports to the statue of a slave created by the Italian artist Milar Buoninsegna. He described the statue and its effect on him — "pity and admiration are irresistibly excited" — after insisting that Buoninsegna's statue, even devoid of whips and chains, "far surpass[ed]" Hiram Powers's famous statue of an enslaved Greek woman.[44] Douglass meticulously fashioned a vicarious experience of Buoninsegna's statue in written form: "In our mind's eye we see the slave-market — We recognize the insolent domineering demeanor of the seller and the stolid sensual curiosity of the buyer."[45] Addressing his readers, Douglass testified, "You can almost discern the blush upon the expressive countenance and the action" of the statue.[46] Detailed descriptions of the art gave readers a vocabulary with which to judge artworks and demonstrated how readers could envision black history within a historically exclusive art world. Using the *Christian Recorder* as his platform, Douglass alluded to important historical components of African American history while explaining how fine art could open up a world to viewers to draw connections to black history.

The *Christian Recorder* repeatedly showcased Douglass's dedication to the educational attainment of black Philadelphians as well as his participation in its realization. In 1878, he served as a librarian for the Union Library Association, which held meetings at the Mother Bethel AME Church.[47] Much like the Philadelphia Library Company of Colored Persons, which he had founded with other black men in 1833, the association counted among its members "practical, professional and business men [who] have for their aim the formation of a Library and Reading Room, the encouragement of

Religion, Rights, and the Promises of Reconstruction

co-operative enterprises, to stimulate persons of talent and genius, [and] to foster and to reciprocate race patronage."[48] In other words, the church-supported association intended to foster black business networks through education. The language of black "genius" echoed the language Douglass used to describe the talents of the musician Frank Johnson nearly four decades earlier. The *Christian Recorder* eagerly reported that Douglass presented a speech at the illustrious Philadelphia Academy of Music and gave a recitation of "The Lay of the Madman" in three languages that was described as a "fair specimen of dramatic art."[49] Later that year, the *Christian Recorder* reported that Douglass "delivered his second lecture on Phonography, in the Hall of the Medical College" while "earnest attention and much interest was exhibited in the lucid demonstration."[50] The AME Church recognized Douglass's contributions to African American education when it inducted him into the Historical and Literary Association of Mother Bethel AME Church in 1878.[51] Such an honor was in keeping with AME efforts to sustain and commend those whose actions championed black education.

The *Christian Recorder* also allowed Douglass to participate in ongoing debates about African Americans and Haiti.[52] During the late 1860s and early 1870s, debates over strengthening economic ties with Haiti and annexing Santo Domingo arose in the U.S. Senate and attracted the attention of black leaders such as Frederick Douglass, who initially supported its annexation.[53] Robert Douglass Jr. engaged in these discussions. In 1870, as these debates swirled in national and international politics, he published a translation of a Haitian newspaper article about the recently executed Haitian president, Sylvain Salnave. What began as a romanticized retelling of President Salnave's overthrow of President Fabre Geffrard ended with Douglass reporting to readers that President Salnave "tore in pieces the [Haitian] Constitution" and "vomited death upon the population of our sea-board" to maintain his despotic rule.[54] Douglass offered readers of the *Christian Recorder* glimpses into some of the realities of Haitian life in early 1870. According to Douglass's translation, the plans of the United States to establish economic partnerships with Haitian businesses and annex part of its occupied country appeared grim, considering the destruction left in the wake of the country's civil war.

Douglass's published translation of Salnave's trial primarily addressed domestic Haitian politics to educate African American readers of the *Christian Recorder*. First, he wrote, "there is so little known of the true character of Sylvain Salnave, late President of Haiti, in this country, that I have translated from 'le Moniteur' (the official Journal of the Republic) . . . a portion

of his trial."[55] In contrast, many black men and women recognized the name, images, and life story of Toussaint Louverture because antislavery activists had frequently invoked his revolutionary actions and legacy during the Civil War.[56] Douglass also chose to translate the article as a means of allowing Haitians to voice their own opinions. He declared: "From it we may learn what Haitians themselves thought of their late ruler."[57] In this way, Douglass sidestepped the interpretation of Haitian events in U.S. newspapers to provide more direct access to Haitian opinions of Haitian events. Like Douglass's trip to Haiti and his completion of numerous paintings of its people and events several decades before, his translation pointed to his investment in black visibility and self-representation. In addition, his work fulfilled editor Benjamin Tanner's goals of cultivating black education by informing readers of black history and contemporary events.

Douglass's position as a widely respected, educated black Philadelphian engaged in the AME community gave him a favored position to articulate that which he believed to be important. In an editorial in the *Christian Recorder*, Tanner praised Douglass as "a great admirer of the Haytian people, having spent some years among them, and knowing possibly more of them, than any colored American in the land."[58] He also thanked Douglass for the Haitian coffee that he gifted to the staff at the *Christian Recorder*. Douglass's cultural knowledge and political sensibilities prompted Tanner to "wish that Mr. Douglass would overcome somewhat of his native modesty and come more within reach of the powers that be." More to the point, Tanner continued: "A master of the French and Spanish [languages], he would make a capital consul for some South American post."[59] The AME Church had established its presence in South America many decades before Tanner penned his praise of Douglass. Yet he chided Douglass's "native modesty," which Douglass would need to overcome if he wanted such a position. Such an assignment was not limited to exceptionally prominent individuals; only three years earlier, Charles S. Douglass, a son of Frederick Douglass, had recently traveled to Puerta Plata, Santo Domingo, as the U.S. consul.[60] It is also possible that Tanner envisioned Douglass continuing his work with the AME Church in South America, given the church's expansion there after it began appealing to converts in Spanish in addition to English.[61]

Though Douglass did not pursue a diplomatic position, Tanner's praise further evidenced how Douglass made numerous forays into domestic and international issues, black art, black triumphs, and the African Methodist Episcopal Church during Reconstruction. His works addressed African American men's voting rights, the disputed future of Cuba, slavery and its

Religion, Rights, and the Promises of Reconstruction

legacy in the United States, sacrifices made by black Union veterans, and the role of women in the church. The didactic qualities of the visual culture crafted by Douglass overlapped with the philosophies of religious instruction advocated by church leaders. Indeed, they honored and publicly recognized his like-minded dedication to the educational attainment of black Philadelphians. Investigating the intended audiences and viewer reception of these images further clarifies the practices of seeing during the nineteenth century. In doing so, it became apparent that Douglass's visual work illuminated the intersection of religion and politics during Reconstruction.

JAMES PRESLEY BALL, THE BUSINESS OF SPECTACLE, AND THE AME CHURCH

Like Robert Douglass Jr., James Presley Ball maintained deep connections with the AME Church and its religious leadership to the benefit of his photography business after the Civil War. In fact, Ball joined several of its black leaders in political ventures in the South during Reconstruction. Before moving south, Ball maintained his successful photography business in Cincinnati alongside several of his family members, including his son, James Presley Ball Jr. There, he welcomed his usual Cincinnati clientele but also entertained visiting black politicians and leaders, such as Frederick Douglass, who lectured on and celebrated the expansion of black rights. Just like Robert Douglass Jr., who produced visual material as his primary method of generating income, Ball used his photography business to secure a livelihood, but he also exercised a more diversified approach to entrepreneurship. His involvement in a lawsuit that centered on the black musical prodigy Thomas "Blind Tom" Wiggins revealed that Ball's business strategies extended well beyond his photographic ventures. His commercial exploits and participation in civic events further reveal how James Presley Ball participated in black electoral politics during Reconstruction.

Ball's involvement in a lawsuit over the legal guardianship of the most sensational African American musician of the era, Thomas "Blind Tom" Wiggins, demonstrated the lengths to which Ball sought professional success. It is well documented that Tom's guardians financially exploited both the musician and his family throughout Tom's life and kept him in a state of neo-slavery.[62] This treatment of Tom made its way into a Cincinnati courtroom wherein two parties vied for Tom's legal guardianship in 1865. Born enslaved and blind in 1849, Tom and his parents lived in Columbus, Georgia, after James Bethune purchased them. After discovering Tom's uncanny ability to

memorize and improvise songs and play them on the piano, Bethune capitalized on Tom's talents. He began exhibiting young Tom to enraptured audiences and entrusted him to concert promoter Perry Oliver for increased profits. Under Oliver's direction, Tom played hundreds of concerts throughout the North and South before, during, and after the Civil War. After the issuance of the Emancipation Proclamation, Bethune convinced Tom's parents to indenture him to Bethune until the age of twenty-one. According to a report of the trial testimony, Bethune claimed that Tom's parents feared that harm would come to Tom after emancipation and purportedly volunteered to indenture him to Bethune.[63] In return, Bethune offered Tom's parents the use of a small tract of his property for the entirety of their lives but stopped short of deeding them the land.[64] Furthermore, the report continued, they would receive five hundred dollars a year and Tom would receive a salary of twenty dollars a month and 10 percent of his performances' net earnings.[65]

James Presley Ball also sought to benefit financially from the young man's musical talents. In June 1865, soon after the close of the Civil War, Ball and another black Ohioan, Tabbs Gross, traveled to Columbus, Georgia, where they proposed to invest in a portion of Tom's management.[66] They agreed to pay twenty thousand dollars in gold for a half interest for five years: a thousand dollars in cash, four thousand more in ten days, another five thousand in six months, and the balance in eighteen months.[67] Bethune agreed to the deal, but Gross did not deliver the entirety of the first two deposits.[68] Bethune then claimed that the contract had been broken and was therefore void. Bethune busily toured Tom throughout the Midwest, and when he arrived in Cincinnati, Ball, Gross, and several other African American men challenged Bethune's legal custody over Tom. Gross applied for legal guardianship over Tom in New Albany, Indiana, on the grounds that Bethune held Tom in illegal restraint. Gross later served Bethune a writ of habeas corpus in Cincinnati. While under examination, Tabbs Gross testified that both parties—Gross and Bethune—had agreed that Gross would adopt Tom in Cincinnati as his own son.[69] James Presley Ball took the stand and corroborated this information.[70] Bethune's testimony differed when he claimed that Gross did not make a request to transfer guardianship of Tom to Gross.[71]

What began as a business proposition morphed into a lawsuit to free "Blind Tom" from Turner's legal guardianship, or what the plaintiffs believed to be slavery by another name. Bethune rebuked charges that he supported slavery, though he conceded in court: "I put my defense of slavery entirely on the ground that the slaves were in a better condition than the whole world

could have put on them, but the Government says that there shall not be slavery, and I am satisfied."[72] The case became more complicated when, before the crowded courtroom, a black man named Isaac Turner testified to the liminal freedoms enjoyed by formerly enslaved people on and near the Bethune estate. Turner visited and spoke to Tom's parents in Columbus, Georgia. There, he witnessed Tom's mother, Charity, remind her husband, Mingo, that he needed a pass in order to travel after the declaration of the Emancipation Proclamation.[73] Mingo later asked Turner if African Americans were indeed free from slavery. Most germane to the case, Turner testified that Tom's father admitted to not fully understanding the contract indenturing Tom to Bethune until the age of twenty-one. Despite this testimony, the parties did not raise the issue of the legality of the indentured servitude contract and, according to reports, the judge did not *sua sponte* (i.e., of his own accord) question the validity of the underlying agreement that formed the basis of the litigation between Bethune and Gross. After hearing the testimony of doctors who examined Tom, discerning no evidence of unkind treatment shown by Bethune, asking Tom whom he wished to care for him, and determining that Gross had no grounds for legal guardianship of Tom because he was not a resident of the state where Gross filed for a writ of habeas corpus, Judge Woodruff decided in favor of Bethune,[74] who resumed touring Tom for many more decades.[75]

The repercussions of the lawsuit indelibly shaped the trajectory of Ball's photographic business. Isaac Turner, the African American man who had traveled to Georgia to speak with Tom Wiggins's parents, sued Ball and Gross. The new lawsuit revealed more information about the previous suit brought by Tabbs Gross against Bethune. Ball testified that Gross came to his Cincinnati gallery and proposed plans to invest in a "Blind Tom" business venture. The men then traveled to Georgia to find Tom, but they first encountered Bethune and entered into a contract with him. According to Ball, Turner attempted to entice Tom to run away, and after Bethune discovered this, Bethune threatened to shoot Turner.[76] Isaac Turner fronted the one thousand dollars that served as the down payment to Bethune, and after he broke the contract with the group, Turner claimed to have not been repaid his money.[77] The legal proceedings against Ball dragged on for nearly two years before the court decided in favor of Turner. Ball's lack of funds became evident when he claimed the benefits of the Homestead Act, which allowed heads of families who did not own homesteads to exempt three hundred dollars from legal execution. Divorced from his wife in July 1867, Ball was not recognized to be the head of household.[78] The court granted him the bene-

fit of the act because he paid spousal alimony and financially supported two children after his youngest child, Robert, had passed away at the age of five in September 1866.[79] Ball's precarious financial situation became clearer when on January 10, 1868, under order of the sheriff of Hamilton County, the possessions held in Ball's West Fourth Street gallery were sold to pay damages in the Turner case. Advertisements invited members of the public to bring cash to purchase chairs, oil paintings, mirrors, and other items.[80] Ever the enterprising businessman, Ball did not let lawsuits and bankruptcy prevent him from trying his luck again.

Despite his compromised financial circumstances, Ball continued his advocacy for the education of black youth. At nearly the same time that Gross brought Bethune to court over the guardianship of Tom Wiggins, Ball supported the musical education of Ella Shepard, another teenager born into slavery. After her father died and a lawsuit left her and her mother without possessions, Ball offered to pay for the music lessons that Ella had begun before her father's death as part of her professional training. Though his financial aid lasted only a few months because of his changing fiscal circumstances, Ball supported Ella immediately before she secured a position at a Gallatin, Tennessee, school before enrolling in Fisk University, where she taught music and the Jubilee Singers.[81]

Ball also participated in the preservation of artifacts related to African American history. Writing from New York City, Elizabeth Keckley wrote to AME bishop Daniel Payne on January 1, 1868, that she had entrusted Ball with a number of "sacred relics" belonging to former First Lady Mary Todd Lincoln. After freeing herself and her son from slavery, Keckley had used her dressmaking skills to earn the business of many of Washington's elite families and eventually became the First Lady's seamstress. The most powerful political office in the country gave her access to the items she delivered to Ball, including the bonnet and bloodstained cloak Mary Todd Lincoln was wearing on the night of her husband's assassination. Keckley donated the items via Ball, who was an agent for Wilberforce College, the black university affiliated with the AME Church outside Xenia, Ohio. Keckley's son had attended Wilberforce, which had suffered a disastrous fire in 1865, and she donated the items "for the cause of educating the four millions of slaves liberated by our President."[82] Ball himself sent his son, James Presley Ball Jr., to the prestigious Boston Public Latin School in 1866 and later to the exclusive Phillips Academy in Andover, Massachusetts, in 1869.[83]

James Presley Ball Sr.'s engagement in civic activities provided training for his development as a black elected official. In the spring of 1867,

Ball served as a vice president for the Lincoln Memorial Club, an organization led by African American men who gathered to commemorate Abraham Lincoln on the anniversary of his death. Students from the recently established all-black Gaines High School sang songs before several African Americans gave speeches about the character and legacy of President Lincoln. One W. H. Parham eulogized Abraham Lincoln, the martyred abolitionist printer Elijah Lovejoy, and John Brown all in the same speech.[84] At a subsequent annual meeting, James Presley Ball's peers elected him to serve as the librarian of the club.[85] Toasting Lincoln and his memory, the group celebrated the Fifteenth Amendment, which had been ratified less than two weeks earlier. A prominent black Cincinnatian, Peter H. Clark, described the amendment at the meeting as "the guarantee of liberty, the cap-stone of the Republic — Its adoption fills our hearts with bright anticipation for our children, hearty good will for our fellow-citizens of all classes."[86] As in prior years, the group offered toasts and then joined together to sing a rendition of "John Brown's Body" before adjourning.[87] The commemoration of Brown by Ball and his fellow members of the Lincoln Memorial Club echoed the tribute to Brown by Robert Douglass Jr. and so many others before and after Reconstruction.[88]

The simultaneous celebration of the ratification of the Fifteenth Amendment and the visit of the nation's first black senator, Hiram R. Revels, to Cincinnati gave Ball another opportunity to ply his photographic trade and advance his political education. It also revealed Ball's relationship to AME Church leaders and set the stage for his decision to seek elected office in Mississippi. Not actively preaching during his congressional term, Senator Revels was an AME Church minister who preached throughout the South and led a congregation in Baltimore before his election. In the summer of 1870, he visited Cincinnati and spoke before about four hundred individuals, urging his mostly African American listeners to invest in the primary and collegiate education of their children, keep abreast of political and social developments, and vote for the Republican Party. James Presley Ball Sr. hosted a reception at his studio, which Revels attended.[89] Earlier that day, Senator Revels sat for photographs in Ball's gallery, some of which featured him in the regalia of the Independent Order of Odd Fellows, a fraternal organization that counted among its members many African American men.[90] On July 14, Senator Revels and Ball joined approximately one thousand African Americans from cities on either side of the Ohio River — the demarcation between a former slave state and a free state — to celebrate the ratification of the Fifteenth Amendment. Joined by a band, they marched through

the main streets of Covington and Newport, Kentucky. Several men offered speeches that stressed the importance of black children's education, black men's responsibility to vote for Republican politicians, and the necessity for everyone to be industrious and frugal.[91] A few days later, Ball advertised his cartes de visite of Senator Revels for twenty-five cents each as being an excellent "likeness and a work of art."[92] Customers could acquire a physical object by which to remember the senator's visit and his convictions for expanding black rights and opportunities.

Ball's creation of the cartes de visite of Senator Revels overlapped with AME Church leaders' broader goal of increasing the visibility of black politicians. In a recurring column published in the *Christian Recorder*, the Reverend Theophilus Gould Steward countered "the charges of *indolence, slovenliness and immorality*" made by white Americans and directed at African Americans by referring to the collection and display of images.[93] He related a story of his visit to the home of a black woman in an unnamed city. Having entered her modest home, Steward looked around the front room and immediately noticed the pictures — "What a lot of them. Here is John Brown, Charles Sumner, Abraham Lincoln, Bishop Allen, and who else? For they are all pictures of men."[94] He then asked, "Have you no pictures of other public men? The colored congressmen for instance?" which prompted the woman to answer enthusiastically in the affirmative before opening her bedroom door to present "five colored congressmen on a sheet about ten by eighteen hung up in the cheapest of frames; the whole cost perhaps twenty-five cents, and here lying on the washstand rolled up is the cheap lithograph of another 'great man.'"[95] To Steward, the woman's practice of collecting and exhibiting black politicians' images should have been more widespread. Images such as those that hung in the woman's home provided visible evidence and frequent reminders of leadership that benefited black communities throughout the nation. Not unlike the practice of collecting and displaying commemorative images as technological advancements made image collection more feasible, the private and public assembly of images during Reconstruction demonstrated African Americans' engaged political consciousness and testified to the understood power of images.

In advocating for the collection of images depicting African American leaders, the *Christian Recorder* underscored the perception that such images remained inaccessible to some of its readers.[96] In response to Steward's anecdote, the *Christian Recorder* published a letter by one Joseph Henry Lee from Albany, Georgia, who lamented the availability of images of prominent black men. "Not upon the walls of Hampton only, but upon our own walls,

Religion, Rights, and the Promises of Reconstruction

also in our parlors, drawing-rooms and our sanctum," Lee insisted, "ought to be found the likeness of all our great men."[97] His list of those whose likenesses he wished to see included Governor Pinckney Benton Stewart Pinchback, the Reverend Henry McNeal Turner, Crispus Attucks, and Prince Hall. Lee explained that "the greatest reason" for the paucity of images of prominent African Americans was "because we don't know where, and through whom to get them. It is true, those of us who are fortunate enough to be a relative or an intimate friend may have them," Lee continued, "but what are the hundreds and thousands of us, who have never beheld the faces of our great men that we read of and roll their names upon our tongues as household words to do?"[98] African Americans, Lee posited, were fluent with the names and deeds of prominent black leaders but had difficulty procuring their portraits. His article revealed the communal practices of viewing portraits of black leaders when he implied that visitors to the homes of relatives or friends viewed their images, such as Steward observing the pictures in the bedroom and front room of a woman's house. Some African Americans did not have images, but many of them wanted them; Lee anticipated "a ready sale for" images of prominent black leaders, past and present, and would eagerly replace the images that currently hung on his own walls "if only I knew where to get them."[99] While some of these images, especially those of recently elected black officeholders, appeared in illustrated newspapers, others like Attucks and Hall were harder to obtain.[100]

New business developments and Ball's recent election to the Colored Republican Rallying Committee heightened his photographic business and political profile. By September 1869, James Presley Ball Jr. had returned to Cincinnati from his Massachusetts boarding school to become a business associate of his father. Having moved from the 30 West Fourth Street gallery to a new 160 Fourth Street storefront, the newly incorporated and named J. P. Ball and Son reentered the photography business in Cincinnati in the wake of the lawsuit that nearly bankrupted the elder Ball.[101] No doubt recovering from this financial setback, James Presley Sr. relied on his skills, experience, and a lofty moniker—"the Great Original"—to advertise his new photographic studio.[102] In an appeal to a diverse Cincinnati audience composed of those with both northern and southern political sensibilities, Ball claimed in one advertisement that "the 19th century has produced but one Henry Clay, but one Daniel Webster, and but one J. P. Ball the Great Original."[103] Offering for sale tintypes and cartes de visite for two dollars a dozen, Ball attracted enough customers to have accumulated fifteen hundred dollars' worth of personal wealth, according to the 1870 Census.[104] Living in the fourteenth

ward of Cincinnati, Ball represented his district along with two other African American men who had been elected to the Colored Republican Rallying Committee and charged to motivate black men to vote.[105]

Ball's participation in the Colored Republican Rallying Committee trained him in the art of canvassing for votes and bespoke his political philosophy. The organization aimed to enumerate all black men eligible to vote in each ward, provide them with electoral information, and convince them to support Republican candidates. At one committee meeting, a debate erupted when attendees disputed who would be chosen to tally individuals and encourage them to cast ballots. James Presley Ball Sr. explained that the person who could persuade the most black men to vote should be offered the job, even if the man's character was not without reproach. This stemmed from the committee's sustained attention on alcohol consumption within its ranks. Ball's philosophy was clear-eyed: maximize the votes of black men without concern for any perceived shortcomings of the canvassers. Ultimately, Ball's dedication to black voter turnout prevailed because the "object was to get all the colored votes polled, and to have all the voters support the Republican ticket."[106] Ball's explanation exhibited his results-driven approach to electoral politics and his passionate support of the Republican Party, despite his disagreement with local committee members.

Ball's career as a photographer benefited his later move into southern electoral politics. Soon after he met with the black senator from Mississippi, Hiram R. Revels, Ball decided to move there. The Cincinnati City Directory of 1871 showed that Ball Sr. claimed his residence as Greenville, Mississippi, while his son continued to live in Cincinnati and operate the gallery.[107] It became clear, however, that Ball Sr. did not remain in Greenville for very long when a Cincinnati newspaper reported that Ball Sr. "resided—that is to say, has been on wheels—in the sovereign State of Mississippi for nearly six months, and is about to run for Congress."[108] Instead of dedicating all of his energies to his political campaigning, Ball maintained his career as a photographer. "His perambulating photographic institution," the Cincinnati newspaper continued, "enables him to canvas[s] the State and attend to business at the same time."[109] His status as an itinerant photographer in Mississippi recalled the beginning of his career when he traveled around Virginia, Ohio, and Pennsylvania creating photographs of subjects. Photographs acted as a souvenir and a reminder that Ball had visited an individual who might potentially vote for him. His peripatetic business allowed Ball to connect in an intimate way with his sitters, who undoubtedly conversed with the photographer over lighting, pose, and other elements of their photographic experi-

ence. Speaking and spending time with those whom he photographed, Ball left his sitters with an object of themselves that they desired. These photographs doubled as marketing souvenirs for Ball's run for office. Collectible, accessible, tactile, and memorable, the images he left with Mississippians encapsulated an experience that lent itself to the goals of politicking.

Ball's entry into southern electoral politics and his photography business demonstrated how visual culture played into Reconstruction politics. Recalcitrant Mississippians labeled black and white people like Ball "carpetbaggers" because they believed that outsiders sought to exploit the black electorate for personal political gain, especially after the ratification of the Fifteenth Amendment in 1870. Ball certainly sought financial success by traveling to and living in the South, a fact representative of many ambitious, educated, and talented northerners who moved to the South during Reconstruction.[110] Many AME Church leaders moved south as the number of their churches increased dramatically after the Civil War. They played an important role in the development of black Reconstruction politics because "they could mix spiritual and political messages in a fashion that resonated powerfully in the rural districts, and because their religious affiliations offered some cover in intensely hostile environments."[111] As AME Reverend James D. Lynch declared, "I commence as a preacher and end as a political speaker."[112] As they had for decades, black churches offered communities a gathering place to worship, discuss politics, educate children, and host a variety of community events. Similarly, Ball commenced the Reconstruction era as a photographer and aimed to become a politician, all the while maintaining strong ties to the AME Church.

Ball crafted a visual record of the achievements of black religious leaders in the Reconstruction South. When the Reverend James D. Lynch, a prominent AME Church leader, visited Cincinnati in 1866, he sat for a portrait in Ball's studio.[113] Lynch followed Bishop Payne's call to minister to formerly enslaved people in the South, where he preached, established schools for black children, and soon entered Republican Party politics.[114] Scholars have shown Lynch to have been an outspoken, and at times daring, advocate of black education and voting rights for black men during Reconstruction.[115] He and a great number of black religious leaders became southern officeholders who charged themselves with securing equitable employment, educational, and political opportunities in addition to keeping black communities safe from mounting white violence.[116] Ball captured "large sized likenesses of [Lynch], and presented fifteen or twenty copies, to be sold for the benefit of the [*Christian*] *Recorder*: they went like hot cakes, and they

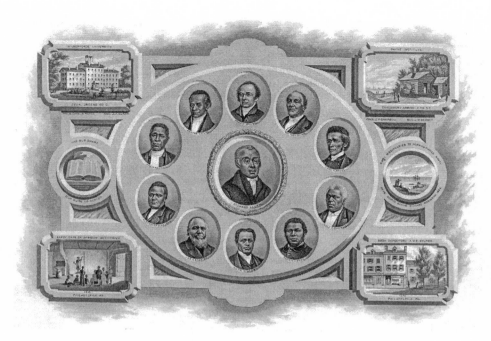

Figure 7.3. *Bishops of the A.M.E. Church*, ca. 1876. *Popular Graphic Art Print Filing Series, Prints and Photographs Division, Library of Congress.*

may be seen adorning the parlors of many of our best citizens."[117] Their quick sale underscored Lynch's popularity as well as a widespread desire to possess his likeness. Portraits became objects of reverence and inspiration. Ball's decision to sell them and donate the proceeds to the *Christian Recorder* spoke to his cooperation with the AME Church. The church benefited by earning money from the images during its rapid expansion throughout the South as newly free people joined its congregations. Furthermore, the images became mementos by which to remember the actions of one of the AME Church's most successful ministers preaching in the South.

Ball's photography of AME Church leaders underscored the importance of images in documenting the church's rapid growth (fig. 7.3). AME churches sometimes featured images as an important component of their religious spaces. For example, the Warren AME Church in Toledo, Ohio, featured in the rear of its pulpit photographs of its previous pastors "on either side of an admirable likeness of Abraham Lincoln." During religious services, these images reminded congregants of the people and historical events that shaped the present realities they experienced inside and outside their house of worship. Furthermore, "the walls of the basement" of the chapel, which

Religion, Rights, and the Promises of Reconstruction

seated approximately three hundred people, "are adorned with pictures and mottoes."[118] In late 1870, when James Presley Ball Sr. "[was] on a Southern tour" and "purposing to meet a number of our Southern conferences," he took a "fine picture of the [members] of the [AME] Conference" in Greenville, Mississippi.[119] "His praise," the author continued, "is in the face of all whose pictures he takes."[120] Several years later, at the West Texas Annual Conference of the AME Church in Brenham, Ball captured the portraits of all the conference attendees.[121] He also displayed a panorama, not his well-known 1855 panorama showing the ills of Africans' enslavement, but one fashioned to represent "prominent incidents of Holy Writ."[122] Ball used his visual skill set to benefit the religious aims of the conference while also commemorating the event with visual souvenirs.

The practice of displaying images of AME leaders in the home was widespread. One writer in the *Christian Recorder* claimed: "Never will I forget the words of that great man, the Rev. H[enry] H[ighland] Garnett, who, as he gazed upon the picture of the immortal [Bishop Richard] Allen which hangs in his own house, said, 'Ah! there is a man who devised something.'"[123] Garnet published a biographical sketch of Allen in which he "rejoiced in having a copy" of a steel plate engraving of Allen, "which he would not exchange for a masterpiece of Rubens."[124] The Reverend Henry McNeal Turner also reflected on "the splendid pictures of our Bishops. I believe there never was more talk about our Bishops than now, as they hang conspicuously beside the pictures of Presidents Lincoln and Grant, the leaders of our people."[125] These reflections pointed to the ways that owners invested images with multiple meanings that included commemoration, reverence, public acclaim, and inspiration. Garnet's exclamation emphasized his admiration for Bishop Allen and implied that he revered Allen's accomplishments. That he hung the image of Allen in his home meant that Garnet would encounter Allen — and by extension the challenge that Garnet succeed in his endeavors — each time he viewed the image.

During his time in Mississippi, Ball preserved ties to the African American civic and political spheres of Cincinnati. Reelected as the librarian of the Lincoln Memorial Club in February 1871, he returned the following year for the club's annual meeting, where men expressed their gratitude for Lincoln, the end of slavery, and John Brown's insurrection.[126] Though his exact words are unknown, Ball praised President Ulysses Grant in accordance with the title of his toast: "Eminent in the Cabinet and eminent in the field."[127] Ball's praise came after Grant supplied weapons to the states of North and South Carolina to countervail the Ku Klux Klan forces that terrorized black resi-

dents.[128] Ball and other members of the Lincoln Memorial Club then reaffirmed their support for the education of black children throughout the country and memorialized Toussaint Louverture and John Brown.[129] The organization's commemoration of these radical figures highlighted their support of extreme interventions to secure freedom or, at the very least, intensify debates over the expansion of black freedoms.

Ball helped sustain his peripatetic business by establishing relationships with influential black southerners. In the summer of 1871, Ball traveled to New Orleans, where the editors of the *Weekly Louisianian*, a Republican newspaper founded by the future black governor of Louisiana, Pinckney Benton Stewart Pinchback, warmly welcomed him.[130] Joined by the Ohio and Mississippi Rivers, Cincinnati and New Orleans both supported large African American communities. Ball visited less than a year later to purchase goods for the gallery he had opened in Greenville, Mississippi. Lauded as the "Pioneer photographer of the Southwest," Ball enjoyed additional advertisement from the writers of the *Weekly Louisianian*, who noted that "from many of the specimens which we have seen of Mr. B's skill we should think that a professional visit to New Orleans would not be unprofitable to him."[131] Ball stayed in New Orleans for at least a week, where he accepted letters at the office of the *Weekly Louisianian*.[132] Only a few years before, black male voters had rewritten the Louisiana state constitution and its bill of rights to introduce sweeping public accommodation rights to include African Americans.[133] In response, white supremacist groups multiplied and massacred African Americans—especially actual or perceived Republicans—throughout the state in the early 1870s and therefore made Ball's trip exceptionally dangerous.[134]

Ball's political canvassing succeeded when voters elected him to lead the board of supervisors in Washington County, Mississippi, but with dire results. He held the position for nearly two years before two lawyers, William Alexander Percy and Judge Leroy B. Valliant, claimed that Ball and his son had defrauded the government of thousands of dollars.[135] As historian Eric Foner has written, the influx of federal funding to southern states provided numerous opportunities for corruption, though white supremacists took many measures—legal and illegal—to reestablish political control after black men were elected to political offices.[136] In Washington County, Mississippi, the local Tax Payers' League brought a suit against the members of the board of supervisors claiming damages resulting from the misappropriation of funds. Arraigned before a grand jury, James Presley Sr. faced numerous indictments. Though both father and son repeatedly claimed their innocence,

the Honorable Charles Shackleford recalled that he took great pleasure when he "overruled their technicalities and refused continuance."[137] On the first indictment of embezzlement, the jury found James Presley Sr. guilty and sentenced him to three years in the Mississippi state penitentiary. Fearing a similar conviction and sentence, James Presley Jr. fled to Arkansas.[138] The local government reportedly acquired six thousand dollars' worth of property upon Ball's conviction and his son's departure.[139] White supremacists often targeted economically and politically successful African Americans during Reconstruction, and the ensuing violence took many forms.[140] The Mississippi court convicted four other members of the board of supervisors and sentenced them each to three years of jail time.[141]

The period between his appearance as a witness in the 1865 "Blind Tom" case in Ohio and his appearance in 1873 as a defendant before a grand jury in Mississippi included several significant moments in the life of James Presley Ball Sr. The AME Church and several of its leaders shaped more than the corpus of visual material created by Ball; like Senator Revels and Reverend James D. Lynch, Ball traveled to Mississippi and entered electoral politics during Reconstruction. He gained training for electoral politics in African American civic groups that, along with the nature of his photographic business, allowed him to not only record but enter southern electoral politics. An evaluation of Ball's photographs illuminates how he crafted a visual cultural record of the achievements of AME leaders during Reconstruction. Ball's visual documentation of Senator Revels, the Reverend James D. Lynch, and other AME leaders in the South evidences how his business overlapped with a broader goal of AME Church leaders to increase the visibility of black politicians. At moments that detail the practices of collecting and displaying images of AME leaders, the meaning of this visibility becomes clear. These images not only document the strength and southern expansion of the AME Church; they testify to the power of visual culture of religion and black politics during Reconstruction.

THE BALL PHOTOGRAPHERS:
FASHIONING FREE BLACK FAMILIES

While James Presley Ball Sr. nurtured mutually beneficial relationships with the African Methodist Episcopal Church, he and his intermittent business partners and family members — Alexander Thomas and Thomas Ball — continued to welcome patrons into their studios. The large visual archive of their images contains mostly white customers, but black men, women,

and children sat for photographs in order to capture a persona projected in a combination of attire, comportment, and background that they collected and often sent to loved ones. As the increasingly affordable carte de visite democratized images during the 1860s and 1870s, these portraits circulated among family, friends, and those wishing to possess reminders of important contemporaries. Furthermore, the production and proliferation of these images prompted new questions about their collection and display; the affordability, small size, image quality, and structural resilience of cartes de visite made possible the family photograph album. As a result, the black family in freedom became much more visibly documented than at any previous time in the nation's history. For Ball, it was a family enterprise.

Though James Presley Ball Sr. had distinguished himself as the preeminent photographer of Cincinnati during the Civil War era, several of his family members operated photographic studios of their own as well as in partnership with Ball. He partnered with Alexander Thomas in 1853 after Thomas's marriage to Ball's sister, Elizabeth, in 1850.[142] In subsequent years and for various durations, Ball worked alongside his two brothers, Thomas Ball and Robert Ball, as well as his brother-in-law, Alexander Thomas.[143] After his son returned from boarding school in Massachusetts, he made James Presley Jr. a partner in what became J. P. Ball and Son in 1869.[144] Just as James Presley Sr. became increasingly involved in electoral politics and his photographic business outside Ohio, so Alexander Thomas and Thomas Ball focused their energies on the black civic organizations in Cincinnati when they worked outside their studio. Both active in the Lincoln Memorial Club of Cincinnati, they petitioned Congress to recognize the deceased president's birthday as a national holiday.[145] Thomas Ball's peers elected him president of the Lincoln Memorial Club in 1870, and he served on the board of the Colored Orphan Asylum for more than ten years, during which he helped organize dozens of benefit concerts, educational campaigns, and community gatherings.[146] Alexander Thomas continued to operate his gallery after his business partner, Thomas Ball, succumbed to tuberculosis in early 1875.[147] Alexander Thomas also participated in the Lincoln Memorial Club, and on February 12, 1876, the members met at his home and the Honorable G. L. Ruffin joined them.[148] With their financial privilege—Thomas Ball had accumulated $5,300 in personal wealth by 1870—both Ball and Thomas actively participated in the African American community in Cincinnati when they were not photographing patrons in their studio.

An examination of a few portraits taken by these photographers reveal the methods by which African American sitters, photographers, and family

members valued and constructed black respectability. The images suggested that the sitters sometimes prepared long in advance of their trip to the studio, and other times photographers made decisions contingent on the circumstances that arose in the photography studio that might undermine the intentions of the sitters or their family members. In other words, one's own actions and the environment within the photographic studio could quickly transform the process of constructing one's photographic persona. The resulting image, intended largely for an intimate group of family or friends, then displayed the multilayered process of the visual construction of respectability.

Multiple elements of the carte de visite depicting James Polk combined to communicate how the viewer should interpret the image. Ball & Thomas's carte de visite of Polk revealed the process of transforming a young boy into a young, respectable adult (fig. 7.4). Seated on a plush, armless chair fringed with tassels and supported with ornamented feet, James crossed his legs, relaxed his hands, and looked directly into the camera. The resulting image depicted a young boy holding his body with an ease more typical of an adult. The trompe l'oeil background featured elaborate casing that added to the appearance of wealth echoed in James's jacket, wool trousers, leather shoes, and crossed short tails. Cumulatively, the image projected a vision of middle-class or elite respectability. The carte de visite presented James, roughly ten years old, with the maturity of a young adult. Circulated to family and friends, and perhaps placed in a family photograph album, the image of James recorded African American decorum during Reconstruction.

By analyzing the full-length portrait of James's younger brother, Wallace Shelton Polk, the tensions between conforming to and communicating middle-class respectability become clearer (fig. 7.5). While the image sought to convey black respectability, it presented the photographer with some visible challenges. Instead of sitting, Wallace stood somewhat awkwardly on the same plush, armless chair fringed with tassels as James. Had the sitter been an adult, he would not have been made to stand, legs crossed, on a chair. Wallace's height proved to be tricky; had he been seated in the chair, his legs would have dangled freely without touching the floor. Furthermore, the proportions of the chair did not complement the bodily proportions of the four- or five-year-old Wallace; had he been seated, the chair would have dwarfed his small frame. As a result, a decision was made to have Wallace stand on the chair. Standing on furniture with boots laced up would have been highly unlikely at home, especially given the range of refuse that sullied the bottoms of little boys' shoes as they walked the streets of Cincinnati.

Figure 7.4. Ball and Thomas Studio, *Unidentified Boy* [*James Polk?*], ca. 1874–75. *Ball and Thomas Photograph Collection, courtesy of the Cincinnati History Library and Archives.*

Figure 7.5. Ball and Thomas Studio, *Wallace Shelton Polk*, ca. 1874–75. *Ball and Thomas Photograph Collection, courtesy of the Cincinnati History Library and Archives.*

Once a gallery employee adjusted the height of the draped table serving as an elbow rest, Wallace could rest comfortably. The covered table, however, now became taller than the chair on which Wallace stood, resulting in another imperfect element of an image that attempted to communicate the trappings of middle-class respectability. A number of decisions—removing or changing the chair, altering the camera's height or angle, replacing the background—could have dramatically altered the image. The trompe l'oeil background that featured geometric casing, artistic edging, and a drawn curtain strengthened the air of middle-class gentility that the tasseled chair and Wallace's refined clothes, parted hair, and polished leather boots communicated.

Decisions made by Mattie Allen and the photographer who captured her portrait revealed the process of self-making femininity in photographic representation (fig. 7.6). Looking away from the viewer, Mattie allowed the camera to glimpse a brooch around her neck and large earrings pulling on her earlobes. Her turned head also provided a view of her intricately layered hair. Topped with a bow, the long hair on the top of her head gave way to shorter, curlier hair above her forehead. Beneath an undulating lace garment worn across her shoulders lay a crisp, light-colored shirt with its collar fanning out from her neck. The oval photograph mirrored the shape of her face. The strong lighting on one side of her face offered the camera a view of her soft expression and facial features. The ornate, lacy print trimming the circumference of the rounded portrait completed the feminine attributes that Mattie Allen presented to the viewer. The amount of time that she prepared for this photograph demonstrated her investment in fashioning an image that family and friends would collect and preserve. Despite all her planning, the precise viewing angle that enabled a glimpse of her brooch, earring, and her layered hair was likely the work of the camera operator. In other words, her self-presentation, coupled with the precise viewing angle, decision to print an oval photograph, and trim it with an ornate, floral print, exhibited how Mattie and the photographer worked together to perform femininity for the viewer of her carte de visite.

A family photograph album belonging to the Ball family revealed some of the decisions made in constructing the keepsake. Though many of its pictures are missing or have been rearranged, the album pages list in pencil the names of the individuals whose images were formerly present. The Ball album once began with an image of "Grandma [Susan] Ball." Likely the mother of brothers James Presley and Thomas Ball, given that the next person featured in the family album was "Aunt Betty," or Elizabeth Ball, James Presley Ball's younger sister, Grandma Ball anchored the album as its oldest

Figure 7.6. Ball and Thomas Studio, *Mattie Allen*, ca. 1874–77.
*Ball and Thomas Photograph Collection, courtesy of the
Cincinnati History Library and Archives.*

depicted family member. Shown to be eighty-five years old and unable to read and write as marked in the 1870 Census, Susan Ball had been a widow for many years before moving into her son Thomas's home in Cincinnati.[149] After Susan Ball followed two images of her daughter, Elizabeth Ball, followed by an image of Elizabeth's husband, Alexander Thomas, and then an image of Alexander and Elizabeth's infant daughter, Alice. The infant wore a long, billowing dress that offered clues as to the wealth that the Ball and Thomas families had accumulated. A caption written on her carte de visite reveals that the image was taken during Easter celebrations. The images that followed Alice's Easter photo, in order, were those of Thomas Ball, Alexander Thomas, and several women of the Thomas family.

The Ball family photograph album established a visual familial connection and mechanism of memory.[150] The arrangement of Ball album images, as well as the content of the images, helped construct ways of seeing in the Ball album. The images and their arrangement represented "constructions of their lives as they saw them and as they wish to have them seen by others."[151] A family member or several family members over the course of generations could build and arrange the family album as they wished, in a way that made the most sense to them.[152] The order and placement of the images in a family photograph album created a unique set of significations that changed according to the viewer. Once the photographer had captured the image, viewers held the power to make meaning from the image and, within the pages of an album, determine the constellation of meanings produced among and between its neighboring images. The Ball family photograph album depicted the celebration of births, religious holidays, adolescence, and old age common to many family photograph albums. While documenting numerous moments and people in the past, one scholar has argued that "photograph albums are intended for future viewing by their creator . . . or for viewing by friends and family members who can supply the necessary contextual information" not readily available to others.[153] This would explain the number of unidentified people in these albums; members of the family and close friends would recognize the people in the images without the need for a name written on the picture. Thus, the people and ideas presented in the image reside in the past, present, and the future. Just as much as the sitters worked to construct an image that communicated ideas about themselves, so too did the collections of images act as a performance of self-presentation that revealed the values and ambitions of those who collected them and assembled them into prized collections.

As one visit from the Reverend Henry Highland Garnet and his wife,

Religion, Rights, and the Promises of Reconstruction

Julia, to the famed photographic Ball and Thomas studio testified, family photographs could be used to forge intimate ties between colleagues. Garnet had escaped slavery in Maryland, attended the African Free School with Patrick Henry Reason in New York City, and studied at the Oneida Institute with Augustus Washington before becoming a Presbyterian minister who advocated militant abolitionism and emigration. When the Garnets visited the Ball and Thomas studio, the wives of the two proprietors "presented us each, with an Album handsom[e]ly adorned without, and within beautified with the portraits of their families, and other dear and valued friends." The meaning that the Garnets derived from the gift became clear when Garnet wrote that "it would be superfluous for us to say that we shall ever feel ourselves under obligations to the Citizens of Cincinnati for their kindness and hospitality, and generosity, and for the refined and delicate way in which they expressed them."[154] The wives of Thomas and Ball offered these albums and images that visually joined their families with the Garnets. Images of the Ball and Thomas family members became tokens of friendship beyond the boundaries of family and, like Senator Revels and Frederick Douglass, documented the visit of powerful black leaders to Cincinnati. Ball later advertised these images of Garnet for sale, describing them as "portraits of this distinguished divine, of different styles and sizes, which are recommended by himself as the best ever taken."[155] Just as Ball and Thomas gifted the Garnets images and albums of their family members, so Cincinnatians could purchase an image of Garnet to include in their photograph album if they wished. Family photograph albums belonging to African American families recorded family relationships as well as the friends, colleagues, and other contemporaries chosen for inclusion. These carefully constructed vehicles of memory recorded black freedom, success, and respectability in ways impossible before the end of the Civil War.[156]

Black artists crafted images of African Americans that reflected a variety of the religious, political, and historical debates occurring domestically and internationally during Reconstruction. Robert Douglass Jr. and James Presley Ball Sr. worked closely with African Methodist Episcopal Church leadership as the organization established connections with black politicians and engaged in strategies to educate African Americans. The scenarios in which their business and personal interests overlapped with the church revealed how visual culture created by African Americans occupied the intersection of religion and politics. Their images highlight their engagement in debates over the voting rights of black men, the future of Cuba, black veterans, and black officeholders and religious leaders in the Reconstruction South. An

analysis of the civic events they attended, hosted, and participated in underscores how they built connections among members of African American communities and celebrated black achievements. Furthermore, the process by which African American sitters, photographers, and family members constructed and developed ideas about black respectability and family in images revealed the power of images to project a crafted persona. In contrast to the images of black figures created by Douglass and Ball intended for broad audiences, these photographs depicted the self-fashioning of African Americans largely for private consumption during Reconstruction. With no explicit visual commentary on the policies and events reshaping the United States during the time of their creation, these images reveal a personal politics that demonstrates the values that their sitters and their families wished to convey with their likeness.

EPILOGUE

The black women opened their umbrellas to shield their faces from the intense Georgia sun before they paused for a photograph (fig. E.1). Wearing long A-line skirts, broad ribbon ties around their waists, frilly lace collars, and modest hats typical at the turn of the twentieth century, these women and the girls and young men who joined them struck a pose outside a wooden building composed of uneven vertical boards. Theirs was a picture of decorum. The young men standing behind and alongside the women wore hats, high collars, ties, and jackets befitting a church service or another important community gathering. No conversation between the pictured black men and women referred to the weather or aspirations of African Americans that Edward Williams Clay mocked in his *Life in Philadelphia* print generations earlier. Instead, in the spirit and tradition of black activists before him, W. E. B. Du Bois exhibited this and hundreds more photographs at the Paris Exposition of 1900 that celebrated black respectability and rejected scientific racism. Du Bois compiled the images into two albums: *Negro Life in Georgia, U.S.A.*, and *Types of American Negroes, Georgia, U.S.A.* The title of the collection recalled and refuted George Gliddon and Josiah Nott's influential book, *Types of Mankind*, which assisted in the scientific acceptance of biological racialism.[1] In Du Bois's words, these "volumes of photographs of typical Negro faces, which hardly square with conventional American ideas" repudiated the stereotypes of inferiority and vice attributed to black Americans.[2] He and his collaborators, black photographer Thomas E. Askew and special agent for the exposition Thomas J. Calloway, depicted many elite African Americans to support their claims but included a considerable number of images that depicted those with fewer means.

The scenes of black life in Georgia conveyed the power of the ordinary. Unpaved streets, outdoor markets, the exteriors of homes and churches, businesses, farms, and musicians provided windows into the lives of black

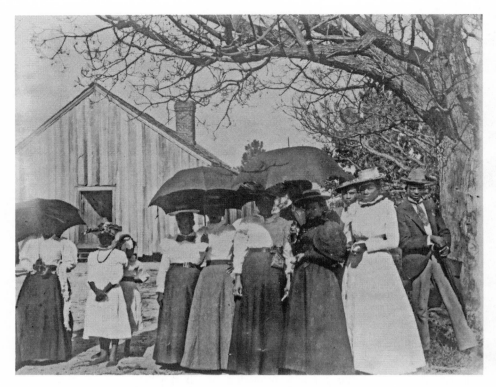

Figure E.1. *African American Women Holding Umbrellas to Provide Shade from the Sun, with Two Men, and with a Building (Church or Meeting House) in the Background,* 1899 or 1900. *Daniel Murray Collection, Prints and Photographs Division, Library of Congress.*

Georgians. These snapshots of everyday black life demonstrated the routines of family, work, prayer, community, and joy that were recognizable to viewers and, like any other population, demonstrated a range of socioeconomic circumstances. Du Bois made it clear to viewers that slavery and other oppressive factors attenuated black achievements. Again countering ideas of innate black inferiority, he coupled these images with a list of racially discriminatory Georgia laws stretching from the colonial period to the present. He displayed a map that depicted the routes of the transatlantic slave trade, including a direct line from the west coast of Africa to Georgia. Not merely rejecting racial stereotypes, Du Bois provided visual evidence of the striving and success of black Georgians *in spite of* the obstacles they faced. Charts and graphs highlighted a range of demographic information, including the growing landownership, wealth, literacy, and educational attainments of African

Americans in Georgia and the United States as a whole. These scientific displays, created by black students at Atlanta University, worked together with the hundreds of snapshots of African American communities and people to give a fair and accurate representation of black Georgians.

Du Bois's efforts in Paris came on the heels of a wave of racist imagery that flooded American homes. The views that Du Bois compiled of African Americans for the 1900 Paris Exposition served as a reminder that the problem of the twentieth century would be that of not only the color line but racial imagery. The mammy stereotype that emerged before the Civil War returned on a massive, enduring scale after the popularity of Aunt Jemima at the 1893 World's Columbian Exposition in Chicago. Racial stereotypes had become marketing tools that bordered omnipresence as caricatured black people grinned, danced, ate, and blundered in countless printed images. These stereotypes also reached wide audiences across the country as three-dimensional household objects, such as dolls, bottle openers, calendars, and personal banks. By the time that Du Bois partnered with Thomas E. Askew, racial caricature appeared as a quotidian element of visual culture. Outside the home, those who attended regional and international expositions encountered people of African descent in ways that emphasized notions of innate racial differences and inferiority.[3] As the number of lynchings rapidly increased through the nation, so did the number and variety of postcards showing the grisly violence that targeted black victims and their communities. As Jim Crow laws increasingly structured racial hierarchies, images and other material objects reinforced them. The enduring life of racial caricatures became clear in the 1902 stereoscopic view inspired by one of the *Life in Philadelphia* prints engraved by Edward Williams Clay approximately seventy years before (figs. E.2 and E.3).

Technology continued dramatically to reshape the possibilities of images by changing what photographs could show and how they could show it. The invention of Kodak's handheld camera in 1888 allowed those with the means to purchase the machine the ability to create their own images by acting in lieu of a professional photographer. Several years earlier, George Eastman had patented paper roll film that photographers could use to create images instead of the glass plates and other formats that were more expensive, delicate, or challenging. With the process of creating images simplified and more accessible to greater numbers of people, the evolving technologies of photography altered the visual landscape available to African Americans. Kodak produced numerous advertisements urging potential consumers to produce or expand their family photo albums using its new handheld camera

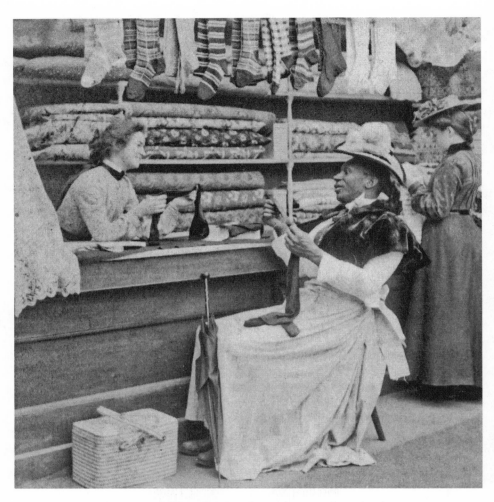

Figure E.2. Underwood and Underwood, *"Is Yo' Sho' Lady When I Wears Dese Stockings I Won' Fin' Ma Laigs All Black,"* ca. 1902. *Courtesy of the Library Company of Philadelphia.*

and an instruction manual for photographing children.[4] Launched in 1900, Kodak's "Brownie" camera cost one dollar and further democratized photography for the estimated ten million people who purchased it in the first five years of its production.[5] Simultaneous to the expansion of leisure cultures in the United States, the rapid embrace of photographic entertainment at home offered visual possibilities unknown to audiences and on a much larger scale than ever before.[6]

Just as several African Americans created images that proved counter-

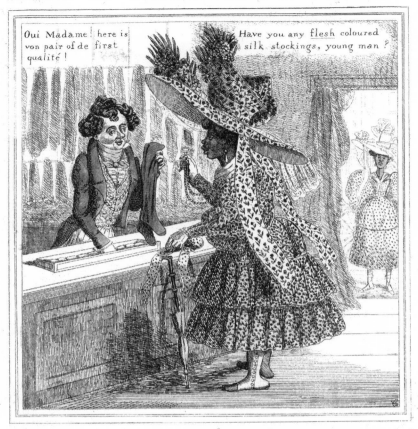

Oui Madame! here is von pair of de first qualité!

Have you any flesh coloured silk stockings, young man?

Published by W. Simpson Nº 66. Chestnut Sᵗ Philadᵃ May 1829.

Copy Right Secured.

Figure E.3. Edward Williams Clay, *"Have You Any Flesh Coloured Silk Stockings . . . ?" Life in Philadelphia* series, Philadelphia Set, May 1829. Courtesy of the Library Company of Philadelphia.

cultural in their depictions of black people during the nineteenth century, so they created images that repudiated racist ideas during the early twentieth century. Du Bois exhibited hundreds of photographs at the 1900 Paris Exposition, mostly portraits of African Americans, which "collectively function as a counterarchive that challenges a long legacy of racist taxonomy."[7] Other black photographers well known to scholars—Cornelius Marion Battey, James Van Der Zee, Hamilton Sutton Smith, Arthur Bedou, Addison Scur-

lock, and many others — engaged in the process of documenting the lives of black Americans at the beginning of the twentieth century. Thousands of other amateur black photographers, equipped with their handheld cameras, produced scenes of their families, friends, and activities. Like Robert Douglass Jr., Patrick Henry Reason, and James Presley Ball Sr. in previous generations, they rejected the racist visual vocabularies of their era. In doing so, these African American photographers of the twentieth century carried on the legacy of nineteenth-century black image-makers into the new century.

NOTES

INTRODUCTION

1. Robert Douglass Jr. to Abby Kelley Foster, May 12, 1846, Abby Kelley Foster Collection, American Antiquarian Society.

2. Instructive sources for the transatlantic influence of antislavery imagery include Hamilton, "Hercules Subdued"; Clytus, "'Keep It before the People,'" 297–301; McInnis, *Slaves Waiting for Sale*; and Yellin, *Women and Sisters*.

3. See Sinha, *Slave's Cause*; Sinha, "Alternative Tradition of Radicalism"; Newman, Rael, and Lapsansky, *Pamphlets of Protest*; Newman, *Transformation of American Abolitionism*; Davis, *Problem of Slavery in the Age of Revolution*; McCarthy and Stauffer, *Prophets of Protest*; and Quarles, *Black Abolitionists*.

4. White and White, *Somewhat More Independent*; Harris, *Shadow of Slavery*; Winch, *Philadelphia's Black Elite*; Winch, *Gentleman of Color*; Nash, *Forging Freedom*.

5. For works on the development of colonization and debates over black emigration, see Tyler-McGraw, *African Republic*; Younger, "Africa Stretches Forth Her Hands"; Clegg, *Price of Liberty*; Fox, *American Colonization Society*; and Nash, *Forging Freedom*.

6. Gundaker, "Give Me a Sign"; Yellin and Van Horne, *Abolitionist Sisterhood*; Mitchell, *Raising Freedom's Child*; Morgan-Owens, *Girl in Black and White*.

7. Important works on racial performance include Holt, "Marking"; Mahar, *Behind the Burnt Cork Mask*; Lhamon, *Jump Jim Crow*; Lott, *Love and Theft*; and Lhamon, *Raising Cain*.

8. Scholars have identified racial uplift strategies of numerous activist leaders and organizations as reifying forms of discrimination that they sought to eradicate. See Kendi, *Stamped from the Beginning*; Gaines, *Uplifting the Race*; and Hall, *Civilising Subjects*.

9. Brown, *Beyond the Lines*; Fahs, *Imagined Civil War*; Masur, "'Rare Phenomenon of Philological Vegetation'"; Gonzalez, "Stolen Looks, People Unbound"; Gonzalez, "Stealing Freedom."

10. Relevant books about the intersection of visual culture and race include Berger, *Sight Unseen*; Smith, *American Archives*; Lee, *Picturing Chinatown*; Bloom, *With Other Eyes*; Johnston, *Seeing High and Low*; and Deloria, *Indians in Unexpected Places*.

11. Berger, *Sight Unseen*, 14.

12. Cobb, *Picture Freedom*; Stauffer, Trodd, and Bernier, *Picturing Frederick Douglass*; Grigsby, *Enduring Truths*.

13. See Shaw, *Portraits of a People*; Smith, *Photography on the Color Line*; Willis, *Reflections in Black*; Willis, *Posing Beauty*; Willis, *J. P. Ball*; Willis, *Black Photographers*; Willis and Williams, *Black Female Body*; Dinius, *Camera and Press*; and Smith and Wallace, *Pictures and Progress*.

CHAPTER 1

1. Pennsylvania Academy of the Fine Arts, *Pennsylvania Academy of the Fine Arts, 1805–2005*.

2. Given the unknown identity of the "Gentleman," there is speculation about its sitter. Phil Lapsansky believes that Douglass painted the wealthy black sailmaker James Forten. If he or any other black man's likeness graced the canvas, such a statement about a black man was radical. It is likely that the *Portrait of a Gentleman* depicted William Lloyd Garrison, since Douglass had described Garrison as a "gentleman" and had painted his portrait by 1834. "William Lloyd Garrison," *Philadelphia Inquirer*, September 25, 1833, 3; author conversation with Phil Lapsansky, October 26, 2011, Library Company of Philadelphia.

3. Rutledge, *Pennsylvania Academy of the Fine Arts, 1807–1870*, 107.

4. "An Appeal to American Women, on Prejudice against Color," in *Proceedings of the Third Anti-Slavery Convention of American Women*, 22–23.

5. "R. Douglass, Jr.," *Pennsylvania Freeman* (Philadelphia), March 14, 1844, 2; "R. Douglass, Jr.," *Pennsylvania Freeman* (Philadelphia), May 9, 1844, 4; "R. Douglass, Jr.," *Pennsylvania Freeman* (Philadelphia), July 18, 1844, 4.

6. Capers, "Black Voices, White Print"; Waldstreicher, "Reading the Runaways"; Sweet, *Bodies Politic*, 378–92; Melish, *Disowning Slavery*, 171–82; Weyler, *Empowering Words*, 68–75.

7. White and White, *Stylin'*.

8. Easton, *Treatise on the Intellectual Character*, 41–42.

9. For more on history of African Americans campaigning for black freedoms, see Sinha, "To 'Cast Just Obliquy' on Oppressors." For more on bobalition prints and their context, see Sweet, *Bodies Politic*, 378–92; Capers, "Black Voices, White Print"; and White, "'It Was a Proud Day.'"

10. Jones, "Reframing the Color Line"; Jones, "Edward Clay's Life in Philadelphia."

11. Jasmine Cobb has written extensively about this series of Clay's prints and their instruction for how to see blackness in order to control free and enslaved black people. See Cobb, *Picture Freedom*. For more on Clay and his career, see Davison, "E. W. Clay."

12. "Children's Department Parley's Magazine," *Emancipator* (New York), February 18, 1834, 4.

13. "Children's Department Parley's Magazine," 4.

14. "Children's Department Parley's Magazine," 4.

15. *Fourth Annual Report of the Massachusetts Anti-Slavery Society*, 20.

16. *Immediate Emancipation Illustrated* (1833), 1833-27W [P.9140], Library Company of Philadelphia.

17. "A Caricature," *Liberator* (Boston), November 2, 1833, 174.

18. Some of the most instructive are Desrochers, "Slave-for-Sale Advertisements"; Waldstreicher, "Reading the Runaway"; Schafer, "New Orleans Slavery in 1850"; Meaders, *Advertisements for Runaway Slaves in Virginia*; and Dojtowicz and Smith, "Advertisements

for Runaway Slaves." The most comprehensive series of publications to study the global representation of black people from ancient Egypt to the present is the multivolume, multiyear series edited by David Bindman and Henry Louis Gates Jr., *The Image of the Black in Western Art*, published by the Belknap Press of Harvard University Press.

19. Lemire, *"Miscegenation."*

20. See Greenwald, *In Search of Julien Hudson*; and Clytus, "'Keep It before the People,'" 297–301. See also Shaw, *Portraits of a People*, for an analysis of black agency and the construction of social and racial identity as expressed through portrait paintings.

21. Dunbar, *Fragile Freedom*, 8–25.

22. Sandiford, *Brief Examination.*

23. Tomek, *Pennsylvania Hall*, 3–4.

24. Sinha, *Slave's Cause*, 19–23.

25. Tomek, *Pennsylvania Hall*, 8–9.

26. Dunbar, *Fragile Freedom.*

27. Winch, *Philadelphia's Black Elite*, 6.

28. Gordon, "African Supplement."

29. Winch, *Elite of Our People*, 31.

30. *Present State and Condition of the Free People of Color*, 24–28.

31. Willson, *Sketches of the Higher Classes of Colored Society*, 93–116; *Present State and Condition of the Free People of Color*, 30.

32. Newspaper advertisements list his perfume business alongside those of another prominent black Philadelphian businessman, Joseph Cassey. See *Poulson's American Daily Advertiser* (Philadelphia), January 19, 1818, 4.

33. For more on Cyrus Bustill's life and his 1787 antislavery speech, see Foner and Branham, *Lift Every Voice*, 20–26.

34. Winch, *Elite of Our People*, 170; Smith, "Bustill Family," 643.

35. Catto, *Semi-Centenary Discourse*, 36–37.

36. Winch, *Elite of Our People*, 23.

37. Winch, *Elite of Our People*, 9, 162.

38. "An Appeal to the Benevolent," *Liberator* (Boston), September 24, 1831, 155.

39. "Appeal to the Benevolent," 155.

40. Saunders, *Address Delivered at Bethel Church*, 12.

41. Dunbar, *Fragile Freedom*, 84.

42. Winch, *Elite of Our People*, 31–32.

43. *Present State and Condition of the Free People of Color*, 28–29. For more on Sarah Mapps Douglass and the antebellum education of black children in Philadelphia, see Baumgartner, *In Pursuit of Knowledge*, 182–88.

44. Anthony, Stanton, and Gage, *History of Woman Suffrage*, 1:325.

45. *Proceedings of the Anti-Slavery Convention of American Women*, 3; Willson, *Sketches of the Higher Classes of Colored Society*, 109–10.

46. Willson, *Sketches of the Higher Classes of Colored Society*, 110–12.

47. Nash, *Forging Freedom*, 203–11.

48. *Register of Trades of the Colored People in the City of Philadelphia*; Nash, *Forging Freedom*; Pilgrim, "Masters of a Craft."

49. Winch, *Elite of Our People*, 12.

50. *Register of Trades of the Colored People in the City of Philadelphia.*

51. Nash, *Forging Freedom*, 205.

52. Nash, *Forging Freedom*, 251. For more on how racial discrimination affected black business enterprises, see Walker, *History of Black Business in America*.

53. *Present State and Condition of the Free People of Color*, as cited in Nash, *Forging Freedom*, 251.

54. As the black population of Philadelphia increased, so did race riots that targeted black churches, homes, businesses, and people. See Werner, *"Reaping the Bloody Harvest,"* 166–229; and Lapsansky, " 'Since They Got Those Separate Churches.' "

55. "To the Public," *Philadelphia Inquirer*, July 14, 1830, 4.

56. "The Subscriber . . . ," *Philadelphia Inquirer*, February 23, 1831, 1.

57. Jones, "Keen Sense of the Artistic," 4, 11.

58. McAllister YI2, 7371.F.12, Library Company of Philadelphia.

59. Phil Lapsansky, "Another View of Famous Scene," *Philadelphia Inquirer*, February 24, 2012, A22.

60. "Robert Douglass, Jr.," *Philadelphia Inquirer*, November 6, 1832, 2.

61. "Equal to Any, Inferior to None," *Poulson's American Daily Advertiser* (Philadelphia), January 19, 1818, 4. Douglass Sr. is listed as a "hairdresser" and "hairdresser and perfumer" in numerous Philadelphia city directories, the earliest being 1800. See Stafford, *Philadelphia Directory for 1800*, 42.

62. Douglass painted Joseph Parrish Jr., the son of a prominent Philadelphia Quaker abolitionist, circa 1827. A carte de visite showing a partial view of the portrait survives from 1887 with an inscription on the back stating that Douglass was commissioned by Joseph Parrish Sr. Many thanks to Stephen Loring Jones for purchasing and showing me this item.

63. Merrill, *Letters of William Lloyd Garrison*, 145.

64. Quarles, *Black Abolitionists*, 20; Pease and Pease, *They Who Would Be Free*, 113.

65. According to lithographic prints and Philadelphia city directories at the Library Company of Philadelphia, several white men practiced the art of lithography in Philadelphia during and before 1833, the year that Robert Douglass Jr. created his lithograph of William Lloyd Garrison. These include William Breton, Cephas G. Childs, Nathaniel Currier, Peter S. Duval, Henry Inman, David Kennedy, William B. Lucas, and Albert Newsam.

66. It is possible that Garrison desired to counter an 1833 print depicting him and other abolitionists as fanatics whose abolitionist activities would engender black-on-white racial violence. See "Immediate Emancipation Illustrated," ca. 1833, Library Company of Philadelphia. Many thanks to Erika Piola for pointing me to this print.

67. *Emancipator* (New York), September 14, 1833, 3; "William Lloyd Garrison," *Liberator* (Boston), September 25, 1833, 3.

68. Jones, "Keen Sense of the Artistic," 11.

69. "A Card: To the People of Color and Their Friends," *Emancipator* (New York), September 14, 1833, 79; "William Lloyd Garrison," *Philadelphia Inquirer*, September 25, 1833, 3.

70. "Calling for Light," *Emancipator* (New York), September 13, 1838, 80.

71. "Circular," *Constitutional Advocate of Universal Liberty* (Philadelphia), October 29, 1836, 31.

72. *Pennsylvania Act for the Gradual Abolition of Slavery*, March 1, 1780, sec. 4.

73. "Circular," 31.

74. "Circular," 31.

75. Dunbar, *Fragile Freedom*.

76. Its members included many prominent black Philadelphians: James McCrummill, William Dorsey, Forten Purvis, Joseph Cassey, and several Forten family members. See Winch, *Philadelphia's Black Elite*, 83.

77. Dorsey, *Reforming Men and Women*, 167.

78. "At a Meeting of the Philadelphia Anti-Slavery Society," *Liberator* (Boston), February 7, 1835, 23; "Anti-Slavery Lectures," *Liberator* (Boston), February 7, 1835, 23; "Philadelphia Anti-Slavery Depository," *Liberator* (Boston), July 6, 1838; "Debate in the Senate," *National Era* (Washington, D.C.), February 21, 1850, 30.

79. *Constitution of the Philadelphia Anti-Slavery Society*, iv, vii.

80. *Constitution of the Philadelphia Anti-Slavery Society*, 11.

81. Willson, *Sketches of the Higher Classes of Colored Society*, 97. See also "To the Public," *Liberator* (Boston), March 23, 1833, 43.

82. *Present State and Condition of the Free People of Color*, 30. For more on literary societies, see McHenry, *Forgotten Readers*; and Augst and Carpenter, *Institutes of Reading*.

83. "Colored People in Philadelphia," *Abolitionist* 1, no. 7 (July 1833), 107.

84. "Colored People in Philadelphia," 107.

85. "Colored People in Philadelphia," 107.

86. "People of Color," *Liberator* (Boston), April 18, 1835, 63.

87. Hamilton, "Hercules Subdued."

88. Scholars have pointed to Thomson's painting as having been based on a story titled the "Booroom Slave" by Mrs. Bowdich. According to the date of the painting (1827) and the first publication date of the story (1828) in the London publication *Forget Me Not*, the opposite is true; the painting preceded the story, which ascribes various meanings perhaps originally unintended by Thomson. Bowdich's narrative assigns the African woman a name — Inna — and details her capture by and escape from slave traders in Africa. After her initial escape from the enslavers, God delivers Inna from her pursuers, and she seeks shelter along a rocky portion of the Atlantic Ocean "till the great ship was gone away." The story may have reached Philadelphia either in the original 1828 edition or in the May 1829 issue of the *African Repository and Colonial Journal*. See Bindman and Gates, *Image of the Black in Western Art*, 130; Shoberl, *Forget Me Not*, 37–76; and "The Booroom Slave," *African Repository and Colonial Journal* 5, no. 3 (1829): 75.

89. For more on friendship albums, see Dunbar, *Fragile Freedom*; Kelly, *New England Fashion*; Gonzalez, "Art of Racial Politics"; Cobb, *Picture Freedom*; and Rusert, *Fugitive Science*.

90. Dunbar, *Fragile Freedom*, 120–47.

91. Robert Douglass Jr., "When the grim lion urged his cruel chace . . . ," Mary Anne Dickerson Friendship Album, 1834, p. 3, Library Company of Philadelphia.

92. Basker, *Amazing Grace*, 92–94. Thomson's painting depicts a moment from a story by Mrs. Bowditch during which an escaped slave kneels, prays, and then listens for divine instruction according to Bindman and Gates, *Image of the Black in Western Art*, 130.

93. Douglass, "When the grim lion urged his cruel chace"

94. Lapsansky, "Afro-Americana," 17.

95. Lapsansky, "Afro-Americana," 17.

96. L. A., "On Seeing the Portraits of Abolitionists Painted by R. Douglass Jr.," *Constitutional Advocate for Universal Liberty* (Philadelphia), November 9, 1837, 36; L. A., "On Seeing the Portraits of Abolitionists Painted by R. Douglass Jr.," *Genius of Universal Emancipation and Quarterly Anti-Slavery Review*, October 1837, 63.

97. Barnes and Dumond, *Letters*, 1:483.

98. For more on the colonization movement before and after the founding of the ACS, see Sinha, *Slave's Cause*; Alexander, "Black Republic"; and Clegg, *Price of Liberty*.

99. "Letter from Lewis C. Gunn," *Pennsylvania Freeman* (Philadelphia), February 8, 1838, 86.

100. "Our Friends in Hayti," *Colored American* (New York), March 3, 1838, 27.

101. Alexander, "Black Republic," 63–66.

102. "Commemoration of Haytien Independence," *Liberator* (Boston), February 9, 1838, 23. For more on antebellum white riots, see Werner, *"Reaping the Bloody Harvest."*

103. "Commemoration of Haytien Independence," 23.

104. "Commemoration of Haytien Independence," 23.

105. White, *Encountering Revolution*, 55–56, 191; Hunt, *Haiti's Influence on Antebellum America*, 21.

106. "Items," *Charleston Courier*, February 27, 1838, 2.

107. "Commemoration of Haytien Independence," 23.

108. "Burleigh and Gunn Returned," *Pennsylvania Freeman* (Philadelphia), May 10, 1838, 3.

109. Ancestry.com, *Philadelphia Passenger Lists, 1800–1945*. Original data can be found at Philadelphia, Pennsylvania, Passenger Lists of Vessels Arriving at Philadelphia, Pennsylvania, 1883–1945, Micropublication T840, RG085, rolls 1–181, National Archives, Washington, D.C.

110. "The Pennsylvania Hall," *Philadelphia Inquirer*, May 16, 1838, 2.

111. "Opening of the Hall," *Pennsylvania Freeman* (Pennsylvania), May 17, 1838, 2. See also *History of Pennsylvania Hall*.

112. For detailed descriptions of the mob's motivations, see *History of Pennsylvania Hall*. For more about rumors of amalgamation concerning Pennsylvania Hall, see Winch, *Philadelphia's Black Elite*, 146–47.

113. Brown, "Racism and Sexism."

114. For more on the regional and national debates and legal proceedings concerning black male suffrage in Pennsylvania during 1837 and 1838, as well as African Americans' response to the them, see Ledell, "End of Black Voting Rights in Pennsylvania"; Wood, "'Sacrifice on the Altar of Slavery'"; and McBride, "Black Protest against Racial Politics."

115. "Circular," 31.

CHAPTER 2

1. Lerner, *Grimké Sisters from South Carolina*, 168–71.

2. Abolitionists used letterhead with Reason's image for more than a decade. Grimké-Weld wedding invitation, but Lewis Tappan also addressed a letter to Peter James Bolton in August 1850 with Reason's supplicant slave as the letterhead. See Catalogue of the Papers of the Anti-Slavery Society, box C113, letter 95, Bodleian Library, University of Oxford. The Library Company holds one sent from Granville, Ohio, to Salburry [*sic*], South Carolina, on May 25, 1840; GC-Allegory [16971.Q]. The Boston Public Library holds several letters that bear Reason's letterhead, and the diversity of their origins — Rhode Island, New Jersey, Massachusetts, New York, and Pennsylvania — records the expansive reach of Reason's image; Boston Public Library, MS A.1.2, 8:28, 12.1:79; MS A.9.2, 3:90, 8:81, 10:26a, 12:2b; MS A.21.5, 51; MS A.4.6A, 1:48. There is also a January

15, 1846, letter with Reason's engraving in container 9, Elizur Wright Papers, Manuscript Division, Library of Congress.

3. For histories of African descended people in New York before the American Revolution, see Harris, *Shadow of Slavery*, 11–71; Hodges, *Root and Branch*; McManus, *History of Negro Slavery in New York*; Wilder, *Company of Black Men*, 9–35; and Foote, *Black and White Manhattan*.

4. White and White, *Somewhat More Independent*, 26.

5. Bulthuis, *Four Steeples over the City Streets*, 28.

6. Townsend, *Faith in Their Own Color*, 1–31.

7. Wilder, *Company of Black Men*, 73–119.

8. Harris, *Shadow of Slavery*, 77.

9. Harris, *Shadow of Slavery*, 77–82.

10. Wilder, *Company of Black Men*.

11. Alexander, *African or American?*

12. "To Our Patrons," *Freedom's Journal* (New York), March 16, 1827, 1.

13. See Jones, *Birthright Citizens*; and Sinha, "To 'Cast Just Obliquy.'"

14. Listed as a hairdresser, Michel (listed as "Michael" or sometimes "Mitchel") Reason (or sometimes "Reson") appeared in numerous New York City directories at 14 Catherine Street and then 5 Catherine Street for several years. See *Longworth's American Almanac* (1817–26). This continuity conveyed at least moderate economic stability. Many black men earned a comfortable living as hairdressers in the years that slavery came to an end in New York. Later, in the 1836 and 1837 Longworth New York City directories, Patrick's older brother, Elwer (listed as Oliver M. Reason), operated as a hairdresser from the 5 Catherine address. He is listed as "col'd" in the 1841 Longworth directory.

15. Box 8 (REA-SYM), folder 1, 179, Miscellaneous American Letters and Papers, Manuscripts, Archives, and Rare Book Division of the Schomburg Center for Research in Black Culture, New York Public Library.

16. Scott, *Common Wind*, 200.

17. Andrews, *History of the New-York African Free-Schools*, 31; Harris, *Shadow of Slavery*, 128–44; Peterson, *Black Gotham*, 66–94; Rury, "New York African Free School," 187–97. Schoolgirls also received training in elocution. "Proceedings of the Common Council of the City of New-York, in Relation to the African Council. May 10, 1824," as reprinted in Andrews, *History of the New-York African Free-Schools*, 36.

18. "Catalogue of Exercises from the New-York African Free School, Exhibited to the American Convention Held at Baltimore, November 1828," as reprinted in Andrews, *History of the New-York African Free-Schools*, 35.

19. "Proceedings of the Common Council of the City of New-York, in relation to the African Council. May 10, 1824," as quoted in Andrews, *History of the New-York African Free-Schools*, 37.

20. "Catalogue of Exercises from the New-York African Free School," 60–61.

21. Sinha, *Slave's Cause*, 117.

22. Box 8 (REA-SYM), folder 1, 179, Miscellaneous American Letters and Papers. Manuscripts, Archives, and Rare Book Division of the Schomburg Center for Research in Black Culture, New York Public Library.

23. Steven Gimber resided at the same address, 33 Chapel, from 1833 until 1835. See *Longworth's American Almanac* (1833–35).

24. Andrews, *History of the New-York African Free-Schools*, 132.

25. Lapsansky, "Graphic Discord"; Cutter, *Illustrated Slave*; Lasser, "Voyeuristic Abolitionism."

26. Box 8 (REA-SYM), folder 1, 177, Miscellaneous American Letters and Papers. Manuscripts, Archives, and Rare Book Division of the Schomburg Center for Research in Black Culture, New York Public Library. Reason is known to have painted a portrait of Isaiah George DeGrasse, a free black New Yorker who studied at the African Free School and later graduated from Newark College (later the University of Delaware). He became an ordained minister at St. Matthews Episcopal Free Church in New York City. He resigned charge of his congregation in the summer of 1840, left to serve as a missionary in Jamaica in November of that year, and died at twenty-seven two months later, in January 1841. Reason's oil portrait of DeGrasse is housed at the Kenkeleba House in New York City.

27. *Longworth's American Almanac* (1838), 525. See "Evening Instruction," *Colored American* (New York), April 12, 1838, 47; and "Evening Instruction," *Colored American* (New York), July 14, 1838, 47.

28. "Patrick H. Reason," *Colored American* (New York), April 12, 1838, 47.

29. "Evening Instruction," April 12, 1838, 47.

30. "Public Lectures of the New York Phoenixonian Literary Society," *Colored American* (New York), February 6, 1841, 1.

31. "The Fourth Lecture before the 'Phoenixonian Literary Society,'" *Colored American* (New York), February 13, 1841, 1; "The Fifth Lecture before the 'Phoenixonian Literary Society,'" *Colored American* (New York), February 20, 1841, 1; "The 12th Lecture before the Phoenixonian Literary Society," *Colored American* (New York), April 17, 1841, 25.

32. "Phoenixonian Literary Society," *Colored American* (New York), July 8, 1837, 3.

33. "Phoenixonian Society," *Colored American* (New York), July 13, 1839, 2.

34. "Phoenixonian Society," 2.

35. Reason's language bears a similarity to an 1839 sermon delivered by Isaiah George DeGrasse. In his sermon on education, DeGrasse explained the duties of a religious education, a professional education, and a "moral and political education" that would inculcate an individual's "several duties as a man and a citizen." See DeGrasse, *Sermon on Education*, 11. These beliefs were longstanding, because at the age of fifteen, DeGrasse wrote an essay in which he deplored that enslaved people were "forced to a distance from the means of proving and defending their rights." See Andrews, *History of the New-York African Free-Schools*, 68.

36. "Phoenixonian Society," 2.

37. Holcomb, *Moral Commerce*.

38. Hamilton, "Hercules Subdued"; McInnis, *Slaves Waiting for Sale*, 31–50; Yellin, *Women and Sisters*.

39. Franklin letter reproduced in McInnis, *Slaves Waiting for Slave*, 31.

40. Advertisements for the book include "Antislavery Book," *State Journal* (Montpelier, Vt.), June 14, 1836, 4; "Freedom's Songs," *Essex North Register and Family Monitor* (Newburyport, Mass.), July 15, 1836, 4; "Anti-Slavery Publications," *Pennsylvania Freeman* (Philadelphia), October 15, 1836, 24; "Just Received," *Liberator* (Boston), March 26, 1836, 52; "List of Publications," *Friend of Man* (Utica, N.Y.), July 26, 1837, 4; "Descriptive Catalogue of Anti-Slavery Works," *Philanthropist* (Cincinnati), December 19, 1837, 3; "New Books," *Patriot and Eagle* (Hartford, Conn.), March 12, 1836, 4.

41. Soderlund, *Quakers and Slavery*.

42. "Books and Stationary," *Christian Reflector* (Boston), June 29, 1842, 4.

43. "The Fountain," *Liberator* (Boston), January 2, 1836, 3.

44. *Slave's Friend* (New York), no. 10 (1836): 15.

45. "Prices of Publications," *Emancipator* (New York), August 1835, 2.

46. "The New York Anti-Slavery Society," *Virginian* (Lynchburg, Va.), May 18, 1837, 3.

47. "Interesting Correspondence," *Christian Watchman* (Boston), July 6, 1838, 4.

48. *Slave's Friend*, 15.

49. "Just Received," *Liberator* (Boston), March 26, 1836, 52; "New Books," *Patriot and Eagle* (Hartford, Conn.), March 12, 1836, 4.

50. Sinha, *Slave's Cause*, 252.

51. Rohrbach, " 'Truth Stronger and Stranger than Fiction.' "

52. Quarles, *Black Abolitionists*, 20; Pease, *They Who Would Be Free*, 113.

53. The sex of the genuflecting figure cannot be discerned from the engraving. The figure clearly does not wear a shirt, but because of the figure's short hair and the figure's arm, which obscures the chest, the sex of the enslaved person cannot be determined. Furthermore, abolitionist organizations used gender nonconformative images of supplicant slaves and altered the text above the figure, for example, "Am I Not a Man and a Brother?" and "Am I Not a Woman and Sister?" to signify the gender of the enslaved person. Reason's image contains no such text.

54. Scholars have written about the role of religion in the abolitionist movement and the intersection of religion and abolitionism more generally. Particularly instructive are Juster, *Doomsayers*; Portnoy, *Their Right to Speak*; and Fagan, *Women and Sisters*.

55. In 1794, George Dance drew Granville Sharp in pencil that very closely resembles Reason's image. In 1817, the *European Magazine and London Review* published an engraving of Sharp completed by Thomas Blood after Dance's drawing. Reason may have seen this reproduction and engraved his image of Sharp after viewing Blood's engraving. Both Blood's and Dance's images are held at the National Portrait Gallery, London.

56. Oxford English Dictionary Online, s.v. "philanthropist, n.," www.oed.com. For further understanding of nineteenth-century philanthropy and its relation to abolitionism, see White, *Encountering Revolution*, 51–86.

57. "Just Published," *New-York Evangelist*, January 2, 1836, 3; "Life of Granville Sharp," *New-York Evangelist*, January 23, 1836, 14; "Descriptive Catalogue of Anti-Slavery Works," *Liberator* (Boston), October 27, 1837, 176; "List of Anti-Slavery Publications," *Emancipator* (New York), January 1, 1836, 4.

58. "Religious Anniversaries," *Columbian Centinel* (Boston), May 21, 1836, 4.

59. "Anti-Slavery Publications," *Philanthropist* (New Richmond, Ohio), January 1, 1836, 5; "The Fountain," *Register* (Newburyport, Mass.), March 18, 1836, 3; "Anti-Slavery Publications," *National Enquirer* (Philadelphia), August 24, 1836, 12; "New Books," *Patriot and Democrat* (Hartford, Conn.), March 12, 1836, 4.

60. For negative representations of African Americans during the 1830s, see Lemire, *"Miscegenation"*; and Lhamon, *Raising Cain*.

61. Williams, *Narrative*, xviii–xix.

62. "To Our Patrons," *Freedom's Journal* (New York), March 16, 1827, 1.

63. "Just Published," *New-York Evening Post*, February 20, 183, 3; "New Publications," *Pennsylvania Freeman* (Philadelphia), February 22, 1838, 95; "James Williams," *Salem (Mass.) Gazette*, March 23, 1838, 4; "Narrative of James Williams," *Friend of Man* (Utica, N.Y.), April 18, 1838, 3; "Narrative of James Williams," *Union Herald* (Cazenovia, N.Y.),

June 1, 1838, 2; "Anti-Slavery Books," *Christian Reflector* (Worcester, Mass.), August 3, 1838, 3; "James Williams and the Alabama Beacon," *Emancipator* (New York), August 23, 1838, 68.

64. "The First Edition . . . ," *Emancipator* (New York), May 3, 1838, 2.

65. "We Have Been Politely Favored," *Emancipator* (New York), April 19, 1938, 199.

66. See Fabian, *Unvarnished Truth*, for more about how certain narratives strove to be claimed as "authentic" and how readers, editors, and images conferred authenticity to the text of the work.

67. Cohen, *Fabrication of American Literature*, 127–28.

68. Hampden, "Political Hints," *Liberator* (Boston), March 23, 1838, 46; "James Williams in Every Family," *Emancipator* (New York), April 12, 1838, 194.

69. Lemire, *"Miscegenation,"* 99.

70. According to the frontispiece, Patrick Henry Reason engraved his image of Wheeler from a painting completed by J. W. Evans, the location of which is unknown to the author.

71. Lemire, *"Miscegenation,"* 99–100.

72. Lemire, *"Miscegenation,"* 100, emphasis added. For more examples of how scientific racism propagated by British, French, and German thinkers during and before the nineteenth century sought to align African descended people with primates while distancing Anglo Americans from primates, see Wright, *Becoming Black*, 27–65; and Fabian, *Skull Collectors*.

73. "A Tribute for the Negro," *North Star* (Rochester, N.Y.), April 7, 1849, 2.

74. "Tribute for the Negro," 2.

75. "Tribute for the Negro," 2, emphasis mine.

76. For nineteenth-century scientific racism in the United States, see Stanton, *Leopard's Spots*. For European scientific racism, see Bindman, *Ape to Apollo*; and Wright, *Becoming Black*, 27–65.

77. Lemire, *"Miscegenation,"* 100. More specifically, Lemire reproduces an image published in Petrus Camper's 1792 treatise *Über den natürlichen Unterschied der Gesichtszüge in Menschen*. As referenced in Lemire, *"Miscegenation,"* see also Schiebinger, *Nature's Body*, for more on Camper's racial ideas.

78. "The Burnt Papers," *Newark (N.J.) Daily Advertiser*, August 22, 1835, 2; R. G. Williams, "Suppressed Newspapers, &c. at Charleston," *Liberator* (Boston), August 22, 1835, 135.

79. "From the South," *United States Telegraph* (Washington, D.C.), August 5, 1835, 2.

80. "Suppressed Newspapers, &c. at Charleston," *Newark (N.J.) Daily Advertiser*, August 13, 1835, 2.

81. "Burnt Papers," 2.

82. "Incendiary Publications, Intercepted and Destroyed," *Boston Daily Advertiser and Patriot*, August 29, 1835, 2.

83. "A Disclosure — Incendiary Publications Destroyed," *Eastern-Shore Whig and People's Advocate* (Easton, Md.), September 1, 1835, 2.

CHAPTER 3

1. "Correspondence between Rev. Bishop Onderdonk and Rev. Peter Williams," *Anti-Masonic Intelligencer* (Hartford, Conn.), July 29, 1834, 2, as partially referenced in Townsend, *Faith in Their Own Color*, 53.

2. Alexander, *African or American?*, 32–34.

3. Townsend, *Faith in Their Own Color*, 11.

4. Townsend, *Faith in Their Own Color*, 29.

5. Townsend, *Faith in Their Own Color*, 27.

6. Townsend, *Faith in Their Own Color*, 38–40.

7. Manisha Sinha, David Brion Davis, Benjamin Quarles, Richard Newman, and others have expanded the chronology of abolitionist activism and included African Americans among its participants. See Sinha, "Alternative Tradition of Radicalism"; McCarthy and Stauffer, *Prophets of Protest*; Quarles, *Black Abolitionists*; Newman, Rael, and Lapsansky, *Pamphlets of Protest*; Newman, *Transformation of American Abolitionism*; and Davis, *Problem of Slavery in the Age of Revolution*.

8. Scholars including Grey Gundaker and Jean Fagan Yellin have demonstrated the importance of print and visual culture in the abolitionist movement. See Gundaker, "Give Me a Sign"; and Yellin and Van Horne, *Abolitionist Sisterhood*.

9. Historians have long studied the tactics of African Americans who adopted strategies to rid the United States of slavery and increase black rights such as voting rights for black men. Sometimes these strategies directly eschewed white institutional assistance. See Rael, *Black Identity and Black Protest*; Newman, *Transformation of American Abolitionism*; Gosse, "'As a Nation, the English Are Our Friends'"; and Horton and Horton, *In Hope of Liberty*.

10. "Likeness of the Late Rev. Peter Williams," *Colored American* (New York), September 4, 1841, 105.

11. "Colored Churches in This City," *Colored American* (New York), March 28, 1840, 2; "Rev. Peter Williams," *National Anti-Slavery Standard* (New York), October 29, 1840, 83. Before having rejected plans for black emigration beyond the borders of the United States, the Reverend Williams had supported emigration efforts especially due to racial violence. For more, see Hewitt, "Peter Williams, Jr."

12. "Likeness of the Late Rev. Peter Williams," 105.

13. "Likeness of the Late Rev. Peter Williams," 105.

14. "Likeness of the Late Rev. Peter Williams," 105.

15. For more on the importance of the parlor and the collection of images there, see Cobb, *Picture Freedom*.

16. "Likeness of the Late Rev. Peter Williams," 105, emphasis added.

17. Gonzalez, "Claiming Space, Bearing Witness." The Library Company of Philadelphia houses many early nineteenth-century portraits of African American clergymen, among them: *Rev. Richard Allen, Founder of the American Methodist Episcopal Church, in the United States of America, 1779*, published by J. Dainty, 1813; *Rev. Christopher Rush*, lithographed by P. S. Duval, 1845; *Revd. Jeremiah Gloucester*, engraved by Tiller, 1828; *Revd. John Gloucester*, engraved by B. Tanner and W. R. Jones, 1823; *The Revd. Richard Allen*, engraved by J. Boyd, 1823; *Revd. Richard Allen*, lithographed by P. S. Duval, ca. 1850; *Revd. William Miller*, ca. 1840; and *Revd. Charles W. Gardner*, lithographed by P. S. Duval, 1841.

18. Newman, *Freedom's Prophet*, 235.

19. Newman, *Freedom's Prophet*, 7, 235.

20. Newman, *Freedom's Prophet*, 7, 235.

21. Gellman and Quigley, *Jim Crow New York*.

22. Malone, *Between Freedom and Bondage*, 55.

23. Malone, *Between Freedom and Bondage*, 20–28.

24. Scholars have documented the participation of African Americans for civil rights, especially voting rights, during the first half of the nineteenth century. See Horton and

Horton, *In Hope of Liberty*; Malone, *Between Freedom and Bondage*; and Peterson, *Black Gotham*.

25. Starting in 1830, African Americans throughout the United States State organized state conventions to strategize how best to achieve racial equality, often in the state where the meetings adjourned. These state conventions met in southern and northern states, from California to Maine, over several decades. For more, see Foner and Walker, *Proceedings of the Black State Conventions*; Bell, *Survey of the Negro Convention Movement*; and Peterson, *Black Gotham*, 124–26.

26. "Public Meeting," *Colored American* (New York), June 16, 1838, 66.

27. "Public Meeting of the Political Association," *Colored American* (New York), October 20, 1838, 139.

28. "Notice — Public Exhibition," *Colored American* (New York), September 14, 1839, 2.

29. "For the Colored American," *Colored American* (New York), September 28, 1839, 3.

30. "Public Meeting of the Political Association," *Colored American* (New York), October 12, 1839, 3. For more information about the later tactics to secure black voting rights in New York, see Swift, *Black Prophets of Justice*, 139–42. In relation to the Liberty Party, see Ali, *Balance of Power*, 29–37.

31. "A Call for a Convention of the Colored Inhabitants of the State of New York," *Colored American* (New York), June 6, 1840, 3.

32. "Public Meeting," *Colored American* (New York), August 8, 1840, 2.

33. "Public Meeting," *Colored American* (New York), August 15, 1840, 2.

34. "Convention of the Colored Inhabitants of the State of New York," *Colored American* (New York), August 22, 1840, 2.

35. "New York State Convention," *Colored American* (New York), August 29, 1840, 2.

36. "New York State Convention," 2.

37. "New York State Convention," 2.

38. Like Reason, Alexander Crummell had been a student at the African Free School in New York City. He attended St. Philip's Church, with Rev. Peter Williams Jr. at the helm. Crummell would become a leading proponent of black emigration, Christian missionary work in Africa, and black nationalism. See Scruggs, "Two Black Patriarchs"; Moses, "Civilizing Missionary"; and Moses, *Creative Conflict in African American Thought*.

39. "From the Minutes of the Albany Convention of Colored Citizens," *Colored American* (New York), January 9, 1841, 1.

40. Despite his belief that racial differences should not be codified into New York's laws concerning the vote, Reason denounced the decision "that women have the right of originating, debating, and voting on questions" that came before the American Anti-Slavery Society further rejected that women "are eligible to its various offices." See *Sixth Annual Report of the Executive Committee of the American Anti-Slavery Society*, 45–47.

41. "From the Minutes of the Albany Convention of Colored Citizens," 1.

42. Plans to remove black Marylanders forcibly were not so distant. See Jones, *Birthright Citizens*, 35–49.

43. "Great Public Meeting. Citizens Attend!," *Colored American* (New York), June 19, 1841, 63.

44. "Great Anti-Colonization Meeting in New-York," *Liberator* (Boston), July 2, 1841, 106.

45. "Maryland Colonization Convention," *Niles' National Register* (Baltimore), June 12, 1841, 227.

46. "Great Public Meeting. Citizens Attend!," 63.

47. "Great Anti-Colonization Meeting in New-York," *Colored American* (New York, NY), June 26, 1841, 67.

48. "Public Meeting," *Emancipator* (New York), June 17, 1841, 26.

49. Hodges, *David Ruggles*, 152–53.

50. New York Committee of Vigilance, *Fifth Annual Report*, 38.

51. Edward Williams Clay's *Life in Philadelphia* series inspired artists such as Anthony Imbert and others to produce their own *Life in New York* series around 1830 modeled visually and topically after the style and topics of Clay's prints.

52. See Edward Williams Clay, *The Disappointed Abolitionists*, Political Cartoons-1838-40W [7779.F], Library Company of Philadelphia.

53. Hodges, *David Ruggles*, 181.

54. Bibb had escaped from slavery several years before the publication of the book and had risen to fame by speaking at abolitionist meetings in Michigan, New York, Maine, and several other states before the publication of his *Narrative*.

55. "The Lectures by Henry Bibb," *Emancipator and Republican* (Boston), December 9, 1846, 131.

56. "New England Non-Resistance Society," *Liberator* (Boston), December 18, 1846, 204.

57. "The Nonconformist," *Liberator* (Boston), December 18, 1846, 202.

58. *Minutes of the State Convention, of the Colored Citizens of the State of Michigan, Held in the City of Detroit on the 26th and 27th of October, 1843*, in Foner and Walker, *Proceedings of the Black State Conventions*, 1:181–95; *Report of the Proceedings of the Colored National Convention*, 3.

59. Finley, "'Land of Liberty'"; Gara, "Professional Fugitive in the Abolition Movement"; Landon, "Henry Bibb, a Colonizer."

60. For more on early oil portraits and African Americans, see Shaw, *Portraits of a People*.

61. For more on the laws passed after slave insurrections, see May, "Holy Rebellion."

62. *Fourth Annual Report of the Massachusetts Anti-Slavery Society*, 20.

63. For information about the other images printed in Bibb's *Narrative*, which are reproductions of images previously used in other antislavery materials, see Wood, "Seeing Is Believing."

64. Southern, "Musical Practices in Black Churches."

65. Jones, *Francis Johnson*, 126–27; Charpie, "Francis (Frank) Johnson."

66. Southern, "Frank Johnson of Philadelphia," 5.

67. It is also possible that Robert Douglass Jr. painted a portrait of Johnson. A June 12, 1841, visitor to Johnson's home recorded that, "suspended in a gorgeous frame, was my visitee's portrait, representing him in his uniform, with a bugle in his hand. Over the mantel was another likeness of Boyer, the President of Hayti, to whom all negroes so much glory. The wall was covered with pictures and instruments of all kinds . . . and in one corner was an armed composing chair, with pen and inkhorn ready, and some gallopades and waltzes half finished." See Mickle, *Gentleman of Much Promise*, 196. Douglass Jr. had also painted a portrait of President Boyer during his trip to Haiti before he advertised and displayed the portrait in Philadelphia, where Johnson lived. The locations of both paintings are unknown to the author.

68. "Frank Johnson," *Public Ledger* (Philadelphia), June 27, 1846, 2.

69. "Died," *Public Ledger* (Philadelphia), April 8, 1844, 2.

70. "Music for Balls and Parties," *North American* (Philadelphia), December, 18, 1845, 3; "Music," *North American* (Philadelphia), November 26, 1845, 2; "Temperance Notice," *Public Ledger* (Philadelphia), March 15, 1845, 2. Connor also composed musical works such as those in the Keffer Collection of Sheet Music in the Rare Book and Manuscript Library at the University of Pennsylvania.

71. "At a Special Meeting of the Young Men," *Public Ledger* (Philadelphia), April 10, 1844, 2, emphasis in original.

72. Jones, *Francis Johnson*, 247–48.

73. For more about the activities, such as benevolent work, undertaken in Philadelphia's black churches and how some white Philadelphians viewed black churches, see Lapsansky, " 'Since They Got Those Separate Churches.' "

74. Timberlake, *Monetary Policy in the United States*, 65; Mayo, *United States Fiscal Department*, 178.

75. Horace, *Odes* 3.11.2. See Martin, *Works of Horace*, 397. For more about how antebellum arts and politics drew on classical texts and philosophies, see Richard, *Golden Age of the Classics in America*; Winterer, *Mirror of Antiquity*; Malamud, *Ancient Rome and Modern*; Shalev, *Rome Reborn on Western Shores*; and Richard, *The Founders and the Classics*.

76. "Unprecedented Attraction. Grand Concert," Gardner Collection, box 1G, folder 1, Historical Society of Pennsylvania.

77. "Unprecedented Attraction. Grand Concert."

78. "Address," *Pennsylvania Freeman* (Philadelphia), April 14, 1841, 4.

79. For a nineteenth-century understanding of elocution and its proposed benefits to one's mind and body, see Bronson, *Elocution; or, Mental and Vocal Philosophy*. Scholars have increasingly argued that elocution was one means by which black Americans carved out space in the public sphere. See Jones, *All Bound Up Together*; and Boyd, *Discarded Legacy*.

80. Much has been written about the colonization movements to Canada, Africa, and the Caribbean as well as the mixed responses it drew from free African Americans. See Alexander, "Black Republic"; Nash, *Forging Freedom*; Burin, *Slavery and the Peculiar Solution*; and Clegg, *Price of Liberty*.

81. "Address," *Pennsylvania Freeman* (Philadelphia), April 14, 1841, 4.

82. See Nash, *Forging Freedom*, 233–45.

83. For more on Bishop Allen's advocacy of Haitian emigration as well as his developing black nationalism, see Newman, *Freedom's Prophet*.

84. "Address," 4.

85. "Address," 4.

86. For more discussion of one of the most prominent black leaders in the Early Republic, Bishop Richard Allen, see Newman, *Freedom's Prophet*. For black citizenship claims arising from military service in the American Revolution, see Roberts, "Patriotism and Political Criticism," 587; Davis, "Emancipation Rhetoric, Natural Rights, and Revolutionary New England," 253; Akers, " 'Our Modern Egyptians' "; and Quarles, *Negro in the American Revolution*, 39.

87. "The Passport Question," *Philadelphia Inquirer*, August 28, 1849, 2. The article quotes a letter dated July 13, 1839, in which Richard Vaux requests a passport for Robert Douglass Jr. Douglass had arrived on a ship from Port au Prince on July 1, 1839.

88. Barnes and Dumond, *Letters*, 792.

89. Barnes and Dumond, *Letters*, 792.

90. Scholars have envisioned networks of abolitionists across the Atlantic Ocean to be influenced by contemporary European thinkers and politics. Correspondence among leaders reveals the shared and disparate strategies related to the business, religious connections, and local political maneuvering of antislavery efforts. See Oldfield, *Transatlantic Abolitionism in the Age of Revolution*; McDaniel, *Problem of Democracy in the Age of Slavery*.

91. Barnes and Dumond, *Letters*, 792.

92. "The Passport Question," *Philadelphia Inquirer*, August 28, 1849, 2.

93. "Passport Question," 2.

94. "Passport Question," 2.

95. "The Subjoined Letter," *Philadelphia Freeman*, June 11, 1840, 2. The article notes that the letter was sent on April 29, 1840.

96. "Subjoined Letter," 2.

97. "Subjoined Letter," 2.

98. "Subjoined Letter," 2.

99. Brown, "Cradle of Feminism," 162; Sklar, "'Women Who Speak for an Entire Nation.'"

100. The meeting organizers initially invited women to the convention but later modified the invitations to invite "gentlemen" only. They barred women from being delegates in the convention and restricted their presence to the gallery, where they watched the convention without debating or voting on the resolutions being discussed by the male delegates below. For more information, see Brown, "Cradle of Feminism," 162; and Sklar, "'Women Who Speak for an Entire Nation.'" See also Tolles, *Slavery Question*, 26, 34.

101. Mott, *Slavery and the Woman Question*, 34, records Douglass's visit to Mott when she and others were in London for the World Anti-Slavery Convention in 1840. He joined her when she visited Benjamin Haydon to have her portrait painted for the huge convention painting. See Haydon, *Autobiography and Memories of Benjamin Robert Haydon*, 684–85; Mott, *Slavery and the Woman Question*, 49, notes that Robert Douglass Jr. accompanied her to Haydon's for a sitting on June 29, 1840.

102. Brown, "Cradle of Feminism," 155.

103. "Haitian Collection," *Pennsylvania Freeman* (Philadelphia), March 31, 1841, 3.

104. "Haitian Collection," 3.

105. "Haitian Collection," 3.

106. For the contested but recurring interest in Haiti and African American emigration to Haiti, see Newman, *Freedom's Prophet*; Clavin, *Toussaint Louverture*, 33–54; and Alexander, "Black Republic."

107. "Haitian Collection," 3.

108. "Haitian Collection," 3.

109. "Haitian Collection," 3.

110. "Address," *Pennsylvania Freeman* (Philadelphia), April 14, 1841, 4.

111. "Lecture on Haiti," *Pennsylvania Freeman* (Philadelphia), April 28, 1841, 3.

112. "Lecture on Haiti," 3.

113. "Lecture on Haiti," 3.

114. Duro, "Lure of Rome," 134. For more on the process and goals of copying art for educational purposes in the nineteenth century, see Chagnon-Burke, "'Career True to

Woman's Nature,'" 127; Finlay, "Introduction"; Singerman, *Art Subjects*; and Masten, *Art Work*, 242.

115. "Benjamin West, P.R.A. John Kemble, Esq.," *Pennsylvania Freeman* (Philadelphia), May 5, 1841, 3.

116. "Benjamin West, P.R.A. John Kemble, Esq.," 3. See also "Lecture on Haiti," 3.

117. "Benjamin West, P.R.A. John Kemble, Esq.," 3.

118. "Commemoration of Haytien Independence," *Liberator* (Boston), February 9, 1838, 23.

119. "Benjamin West, P.R.A. John Kemble, Esq.," 3.

120. For more about this print, see Lemire, *"Miscegenation,"* 62–63, 73, 94–96.

121. Maidment, *Reading Political Prints*; Oldfield, "Anti-Slavery Sentiment in Children's Literature"; Hamilton, "'Am I Not a Man and a Brother?'"; Turley, *Culture of English Anti-Slavery*, 47–50; Midgley, *Feminism and Empire*, 50; *Fourth Annual Report of the Massachusetts Anti-Slavery Society*, 20.

122. "Children's Department Parley's Magazine," *Emancipator* (New York), February 18, 1834, 4.

123. "Jerusalem and Thebes," *Pennsylvania Freeman* (Philadelphia), April 14, 1841, 3.

124. "Jerusalem and Thebes," 3.

125. Oxford English Dictionary Online, "recreation, n.3a, 3d," www.oed.com.

126. "Caricatures," *Pennsylvania Freeman* (Philadelphia), February 19, 1846, 2.

127. "Caricatures," 2.

128. "Caricatures," 2.

129. "Caricatures," 2.

130. "Anti-Slavery Work for Boys and Girls," *Pennsylvania Freeman* (Philadelphia), June 16, 1841, 3, emphasis in original.

131. Cour. 148 v. Robert Douglass Jr. 74 (1841), General Sessions Court Docket, September 1841–January 1842, Philadelphia City Archives; "Local Affairs," *North American* (Philadelphia), September 2, 1841, 2; "The Gatherer," *New York Sun*, September 9, 1841, 3; "City Gleanings," *Public Ledger* (Philadelphia), September 2, 1841, 2.

132. "Local Affairs," *North American* (Philadelphia), September 2, 1841, 2.

133. At least the first few issues of the *Demosthenian Shield* included "sketches" of prominent African Americans in Philadelphia. The second issue included a sketch of Robert Douglass Jr.'s father.

134. Robert Douglass Jr., "The Demosthenian Shield," *Public Ledger* (Philadelphia), August 3, 1841, 3, emphasis in original.

135. Douglass, "Demosthenian Shield," 3, emphasis in original.

136. President Andrew Jackson was one politician depicted as or with a donkey in numerous prints during this era. See the following prints at the American Antiquarian Society: David Claypoole Johnson, *Great Locofoco Juggernaut* [Boston, ca. 1837]; James Akin, *The Man! The Jack Ass* [Philadelphia, ca. 1831–33]; *The Modern Balaam and His Ass* (New York, [ca. 1837]); *The Illustrious Footsteps* (New York, 1840); and Esop Jr., *Let Every One Take Care of Himself!* [New York, ca. 1833].

137. Cour. 148 v. Robert Douglass Jr. 74 (1841); "Court of General Sessions," *Public Ledger* (Philadelphia), October 28, 1841, 1.

138. "Loafer," *Daily Commercial Bulletin* (St. Louis, Mo.), December 16, 1836, 2; "The Loafer," *Cincinnati Daily Gazette*, June 23, 1837, 2; "Untitled," *Public Ledger* (Philadelphia), September 9, 1836, 4; "Untitled," *Baltimore Sun*, August 14, 1837, 2; "Loafer," *Gazette* (New

Bedford, Mass.), September 29, 1834, 1; "A Loafer," *Philadelphia Inquirer*, August 22, 1835, 2; "The First Loafer," *Columbian Register* (New Haven, Conn.), August 26, 1837, 4; "Loafer," *Haverhill (Mass.) Gazette*, December 24, 1836, 2; "Loafer," *Saturday Morning Transcript* (Boston), November 19, 1836, 47; "They Call Me a Loafer," *New Orleans Times-Picayune*, February 19, 1837, 2–3; "The Loafer," *New Orleans Times-Picayune*, September 20, 1837, 2.

139. "Loafers," *New Hampshire Patriot* (Concord, N.H.), July 6, 1835, 40.

140. "Loafer," *Gazette* (New Bedford, Mass.), September 29, 1834, 1; "Loafer," *Haverhill (Mass.) Gazette*, December 24, 1836, 2.

141. Cook, "Seeing the Visual in U.S. History," 441.

142. Lydia Maria Child to Wendell Phillips, March 7, 1842, MS Am 1953, box 11, folder 403, Wendell Phillips Papers, Houghton Library, Harvard University.

143. Child to Phillips, March 7, 1842.

144. "Literature and Art," *Public Ledger* (Philadelphia), April 2, 1842, 3.

145. "R. Douglass, Jr. Portrait and Miniature Painter," *Liberator* (Boston), July 8, 1842, 107.

146. "R. Douglass, Jr. Portrait and Miniature Painter," 107.

147. "R. Douglass, Jr. Portrait and Miniature Painter," 107. This was not Douglass's first translation; two years earlier, he had translated from French the obituary and funeral eulogy of Jonathan Granville. Translated by Robert Douglass Jr. from the "Feuille du Commerce" of Port au Prince, the obituary and eulogy were printed in "Death of Citizen Jonathan," *Colored American* (New York), July 27, 1839, 1, after being reprinted from *Poulson's American Daily Advertiser*.

148. "R. Douglass, Jr. Portrait and Miniature Painter," 107.

149. "To Firemen!," *Public Ledger* (Philadelphia), October 15, 1842, 2.

150. "R. Douglass, Jr.," *Public Ledger* (Philadelphia), October 24, 1842, 3.

151. "Local Affairs," *Public Ledger* (Philadelphia), February 13, 1843, 2.

152. "R. Douglass, Jr.," *Pennsylvania Freeman* (Philadelphia), March 14, 1844, 2.

153. "R. Douglass, Jr.," March 14, 1844, 2.

154. "R. Douglass, Jr.," March 14, 1844, 2.

155. In an 1846 draft of Robert Douglass Sr.'s will, he bequeathed to his daughter, Sarah, half of the value of the property in which the Douglass family resided, with the remainder split evenly between his two other surviving children, Robert Jr. and James. See Leon Gardiner Collection of American Negro Historical Society Records, 1790–1905, box 3GA, folder 1, Historical Society of Pennsylvania.

156. "R. Douglass, Jr.," March 14, 1844, 4, and advertised through December of that year.

157. "R. Douglass, Jr.," March 14, 1844, 4.

158. Robert Douglass Jr. to Abby Kelley Foster, May 12, 1846, Abby Kelley Foster Collection, American Antiquarian Society.

159. Douglass to Foster, May 12, 1846.

160. Douglass also lent sketches to Maria Weston Chapman and a painting to William Lloyd Garrison that he wished to have returned in 1846. Gertrude K. Burleigh to Maria Weston Chapman, May 22, 1846, Special Collections, Manuscripts Ms.A.9.2 v.22, p. 54, Boston Public Library.

161. Douglass also created several images of the well-known abolitionist Cassius Clay. Described as "very fine" in an editorial published in the *Pennsylvania Freeman*, these images, if extant, are in a location unknown to the author. The review also promoted Douglass and his images for "does them handsomely, and at remarkably low prices." See "Daguerreotype Likenesses," *Pennsylvania Freeman* (Philadelphia), January 26, 1846, 2.

162. "Portrait of Abby Kelley Foster," *Pennsylvania Freeman* (Philadelphia), June 25, 1846, 3.

163. "Portrait of Abby Kelley Foster," 3.

164. "Fair in the Assembly Building," *Pennsylvania Freeman* (Philadelphia), December 10, 1846, 3.

165. "Fair in the Assembly Building," 3, emphasis in original.

166. "Report of the Treasurer of the Philadelphia Female Anti-Slavery Society" in *Fourteenth Annual Report of the Philadelphia Female Anti-Slavery Society*, 12; "The Fair," *Pennsylvania Freeman* (Philadelphia), December 24, 1846, 2.

167. "The Fair," 2. See also "It Is Highly Gratifying to Receive . . . ," *Liberator* (Boston), January 29, 1847.

168. "Letter from Robert Douglass," *North Star* (Rochester, N.Y.), June 2, 1848, 1.

169. "Letter from Jamaica," *National Anti-Slavery Standard* (New York), April 20, 1848, 187.

CHAPTER 4

1. "Assize Intelligence," *Daily News* (London), July 31, 1852, 3.

2. A fourth African American man, Anthony Burns, created and toured a moving panorama of slavery in the late 1850s. Best known for his flight from slavery, recapture in Boston, and subsequent purchase from slavery by antislavery activists, Brown (and the historical record) left only trace bits of information regarding his panorama.

3. Brown, *Description of William Wells Brown's Original Panoramic Views*, 2.

4. *Nineteenth Annual Report, Presented to the Massachusetts Anti-Slavery Society*, 67.

5. The practice of purchasing the freedom of fugitive slaves was controversial among black and white antislavery activists because it bought into and further enabled the institution of slavery. For more about the campaign to purchase Frederick Douglass's freedom and William Wells Brown's rejection of just campaigns for his own freedom, see Kellow, "Conflicting Imperatives."

6. Brooks, *Bodies in Dissent*, 83.

7. Miller, "The Panorama, the Cinema, and the Emergence of the Spectacular," 38.

8. Oettermann, *Panorama*, 323. For scholarship on these moving panoramas, see Arrington, "Henry Lewis' Moving Panorama"; Heilbron, "Documentary Panorama"; Arrington, "Godfrey N. Frankenstein's Moving Panorama"; Brewer, "Sensibility and the Urban Panorama"; Arrington, "Story of Stockwell's Panorama."

9. Hanners, "Tale of Two Artists," 205.

10. Hanners, "Tale of Two Artists," 205.

11. For more on these artists and their exhibitions, see Arrington, "Skirving's Moving Panorama"; Dondore, "Banvard's Panorama"; Heilbron, *Making a Motion Picture in 1848*; and Arrington, "Story of Stockwell's Panorama."

12. Sandweiss, *Print the Legend*, 50.

13. Bell, "Sioux War Panorama"; Baker, "Word, Image, and National Geography"; Jarenski, "'Delighted and Instructed'"; Brooks, *Bodies in Dissent*, 81–82; Chaney, *Fugitive Vision*, 220, n. 34; and Oettermann, *Panorama*, 323–42.

14. Martin A. Berger, *Sight Unseen*, has argued that racial ideologies shaped the reception of visual material, even images devoid of people, in the nineteenth century. Racialized perspectives brought to bear on visual artifacts, among them landscape

paintings, communicated viewers' understandings of colonizing and imperialist modes of thinking.

15. Miller, "Panorama, Cinema," 43.

16. Miller, "Panorama, Cinema," 43.

17. Brewer, "Sensibility and the Urban Panorama"; Arrington, "Henry Lewis' Moving Panorama"; Arrington, "Skirving's Moving Panorama."

18. *Reville* (St. Louis), October 29, 1848, as quoted in Arrington, "Story of Stockwell's Panorama," 286.

19. Fabian, *Unvarnished Truth*; Sandweiss, *Print the Legend*; Miller, "Mechanisms of the Market."

20. Miller, "Panorama, Cinema," 49.

21. Miller, "Panorama, Cinema," 49.

22. Quarles, *Black Abolitionists*; Blackett, *Building an Antislavery Wall*; McDaniel, "The Fourth and the First"; Pease and Pease, *They Who Would Be Free*; Levesque, "Black Abolitionists in the Age of Jackson"; Pease and Pease, "Ends, Means, and Attitudes."

23. Blackett, *Beating against the Barriers*; Blackett, *Building an Antislavery Wall*.

24. Goddu, "Anti-Slavery's Panoramic Perspective."

25. Brown, *Narrative*, iv.

26. "Panorama Exhibition of the Slave System," *Liberator* (Boston), April 19, 1850, 62. The names of the three painters can be found in the advertisement "Concert-Hall, Lord Nelson Street," *Liverpool (U.K.) Mercury*, November 15, 1850, 1.

27. For more on the construction of entertainment spectacle that played into audience expectations, fears, and desires in this era, see Cook, *Arts of Deception*.

28. "An Illustration of the Slavery System," *Manchester (U.K.) Times*, November 27, 1852, 1.

29. Miller, "Panorama, Cinema."

30. "Panorama of American Slavery," *Manchester (U.K.) Guardian*, December 18, 1850, 5.

31. "Horrors of Slavery in America," *Leeds (U.K.) Mercury*, May 3, 1851, 10; "New and Original Panorama or Mirror of American Slavery," *Liverpool (U.K.) Mercury*, November 8, 1850, 6.

32. "Mirror of Slavery," *Liverpool (U.K.) Mercury*, November 19, 1850, 4.

33. "Mr. Henry Box Brown and Smith's Mirror of Slavery," *Liverpool (U.K.) Mercury*, November 15, 1850, 8.

34. Miller, "Panorama, Cinema," 41.

35. "Mirror of Slavery," *Boston Herald*, May 1, 1850, 4.

36. "American Slavery," *Guardian* (Preston, U.K.), January 25, 1851, 3.

37. At least nine reviews mentioned used the word "horror" and its lexical derivatives. See "Mr. Henry Box Brown and Smith's Mirror of Slavery," *Liverpool (U.K.) Mercury*, November 15, 1850, 8; "Horrors of Slavery in America"; "The Mirror of American Slavery," *Leeds (U.K.) Mercury*, May 24, 1851, 5; "Prize Essays," *Manchester (U.K.) Guardian*, October 8, 1851, 7; "American Slavery," *Manchester (U.K.) Guardian*, August 30, 1851, 10; "American Slavery," *Guardian* (Preston, U.K.), January 25, 1851, 3; "Panorama of Slavery," *Guardian* (Preston, U.K.), March 5, 1853, 4; "American Slavery," *Guardian* (Preston, U.K.), March 1, 1851, 5; "New York, Aug. 17th, 1852," *Frederick Douglass' Paper* (Rochester, N.Y.), August 27, 1852, 3.

38. "Horrors of Slavery in America," *Leeds (U.K.) Mercury*, May 3, 1851, 10.

39. "Horrors of Slavery in America," 10.

40. "Panorama of Slavery," 4.

41. "Mr. Henry Box Brown and Smith's Mirror of Slavery," 8.

42. "Mirror of Slavery," *Liverpool (U.K.) Mercury*, November 19, 1850, 4.

43. "Mr. Henry Box Brown and Smith's Mirror of Slavery," 8.

44. "Mirror of Slavery," *Boston Herald*, May 1, 1850, 4.

45. Blackett, *Building an Antislavery Wall*.

46. "American Slavery," *Blackburn (U.K.) Standard*, April 9, 1851, 3; "Concert-Hall, Lord Nelson-Street," *Liverpool (U.K.) Mercury*, November 15, 1850, 1.

47. "Mirror of Slavery," *Boston Herald*, May 1, 1850, 4.

48. *Massachusetts Spy* (Worcester), May 15, 1850, 8, as cited in Ruggles, *Unboxing of Henry Brown*, 89.

49. "American Slavery," *Leeds (U.K.) Mercury*, April 19, 1851, 10.

50. "New and Original Panorama!," *Liberator* (Boston), April 26, 1850, 67; "The Mirror of American Slavery," *Leeds (U.K.) Mercury*, May 24, 1851, 5.

51. "Mirror of Slavery," *Liverpool (U.K.) Mercury*, November 19, 1850, 4.

52. "Mirror of Slavery," *Liverpool (U.K.) Mercury*, November 19, 1850, 4.

53. "American Slavery," *Guardian* (Preston, U.K.), January 25, 1851, 3.

54. "American Slavery," *Blackburn (U.K.) Standard*, April 9, 1851, 3.

55. "Assize Intelligence," *Daily News* (London), July 31, 1852, 3.

56. "Assize Intelligence," 3.

57. "Assize Intelligence," 3.

58. "Assize Intelligence," 3.

59. "Assize Intelligence," 3.

60. This was not the first time that Henry Box Brown used the English court system to his benefit. He had previously brought charges in an English court against John Leucy, a man who had worked for Brown as a sceneshifter for the *Mirror of Slavery*. A borough court charged and committed Leucy for trial in January 1850 after he allegedly stole eighty-seven texts—twenty-seven copies of the *Narrative of Henry Box Brown* and sixty unbound parts of the Brown's *Anti-Slavery Harp*—and sold them to an acquaintance. See "Stealing Books," *Manchester (U.K.) Guardian*, January 7, 1852, 7.

61. Daphne Brooks has also argued that Smith used rhetoric of blackface minstrelsy in denouncing Henry Box Brown. See Brooks, *Bodies in Dissent*, 98–99.

62. Brooks, *Bodies in Dissent*, 98.

63. "Assize Intelligence," 3.

64. Ruggles, *Unboxing of Henry Box Brown*, 104.

65. See Greenspan, *William Wells Brown*.

66. Brown, *Description of Brown's Original Panoramic Views*, 2.

67. Hanners, "Adventures of an Artist," 65.

68. *Description of Banvard's Panorama*, 27.

69. *Description of Banvard's Panorama*, 31, 29, 42.

70. Hanners, "John Banvard's Mississippi Panorama," 32.

71. *A Lecture Delivered before the Female Anti-Slavery Society of Salem*, as cited in Greenspan, *William Wells Brown: A Reader*, 108.

72. Brown, *Description of Brown's Original Panoramic Views*, 2.

73. Brown, *Description of Brown's Original Panoramic Views*, 4.

74. Brown, *Description of Brown's Original Panoramic Views*, 2.

75. Much of the most powerful antislavery literature produced by abolitionists until

1850 included escaped slave narratives rife with multiple claims of the truth of the escaped enslaved person's story. See Fabian, *Unvarnished Truth*.

76. Brown, *Description of Brown's Original Panoramic Views*, 2.

77. "Brown's Original Panorama of American Slavery," *Newcastle Courant* (Newcastle-upon-Tyne, U.K.), October 25, 1850, 1.

78. Brown, *Description of Brown's Original Panoramic Views*, 4.

79. "General Intelligence," *Christian Register* (Boston), November 2, 1850, 175.

80. Brown, *Description of Brown's Original Panoramic Views*, 18.

81. Brown, *Description of Brown's Original Panoramic Views*, 18.

82. Brown, *Description of Brown's Original Panoramic Views*, 18.

83. Brown, *Description of Brown's Original Panoramic Views*, 18.

84. Brown, *Description of Brown's Original Panoramic Views*, 19.

85. Brown, *Description of Brown's Original Panoramic Views*, 19.

86. Brown, *Description of Brown's Original Panoramic Views*, 17.

87. The "white" slave appealed to white fears that they, too, might be enslaved. See Mitchell, "'Rosebloom and Pure White.'"

88. Brown, *Description of Brown's Original Panoramic Views*, 7.

89. Brown, *Description of Brown's Original Panoramic Views*, 14.

90. Brown, *Description of Brown's Original Panoramic Views*, 19.

91. Blackett, *Building an Antislavery Wall*, 25–41, 106–10.

92. Brown, *Description of Brown's Original Panoramic Views*, 20.

93. Chaney, *Fugitive Vision*, 132.

94. Brown, *Description of Brown's Original Panoramic Views*, 8.

95. Brown, *Description of Brown's Original Panoramic Views*, 8–9.

96. Brown, *Description of Brown's Original Panoramic Views*, 32.

97. "General Intelligence," *Christian Register* (Boston), November 2, 1850, 175.

98. Brown, *Description of Brown's Original Panoramic Views*, 35.

99. Brown, *Description of Brown's Original Panoramic Views*, 35.

100. Brown, *Description of Brown's Original Panoramic Views*, 37, emphasis added.

101. Brown, *Description of Brown's Original Panoramic Views*, 38.

102. Brown, *Description of Brown's Original Panoramic Views*, 38.

103. Brown, *Description of Brown's Original Panoramic Views*, 39.

104. The treasurer's reports for the Massachusetts Anti-Slavery Society Annual Reports during the early 1850s do not reveal the amount of these donations because the relevant tallied receipts are listed only by month, not location or contributor of donation.

105. Ball, *Ball's Splendid Mammoth Pictorial Tour*, 56.

106. Ball, *Ball's Splendid Mammoth Pictorial Tour*, 8.

107. "Origins, History, and Hopes of the Negro Race," *Frederick Douglass' Paper* (Rochester, N.Y.), January 27, 1854.

108. "Daguerrian Gallery of the West," *Gleason's Pictorial Drawing-Room Companion* (Boston), April 1, 1854, 208.

109. "Daguerrian Gallery of the West," 208. At different points in his career, James Presley Ball worked alongside his brothers Robert G. Ball and Thomas C. Ball. He also partnered with his brother-in-law, Alexander Thomas, for more than two years between the fall of 1857 and the spring of 1860 after Thomas had worked in Ball's studio for several years.

110. "Daguerrian Gallery of the West," 208.

111. "The Colored People of Cincinnati," *Frederick Douglass' Paper* (Rochester, N.Y.), April 28, 1854, 2.

112. "Daguerrian Gallery of the West," *Frederick Douglass' Paper* (Rochester, N.Y.), May 5, 1854, 1.

113. "Daguerrian Gallery of the West," *Provincial Freeman* (Toronto), June 3, 1854.

114. "New Panorama," *Boston Evening Transcript*, August 31, 1854, 2.

115. "New Panorama," 2.

116. "Mr. J. P. Ball," *Boston Daily Atlas*, August 31, 1854, 2.

117. "Mr. J. P. Ball," 2.

118. "Personal," *Gleason's Pictorial Drawing-Room Companion* (Boston), September 16, 1854, 173.

119. Ball, *Ball's Splendid Mammoth Pictorial Tour*, 5.

120. Ball, *Ball's Splendid Mammoth Pictorial Tour*, 5.

121. Jarenski, "'Delighted and Instructed,'" 134.

122. Ball, *Ball's Splendid Mammoth Pictorial Tour*, 5.

123. "At the Atheneum," *Cleveland Leader*, March 26, 1855, 3.

124. "Ball's Tour of America," *Cleveland Plain Dealer*, March 26, 1855, 3.

125. "Ball's Tour of America," 3.

126. "Ball's Tour of America," 3.

127. Hall, "Spectacle of the 'Other'"; Curtin, *Image of Africa*; Jablow, *Africa that Never Was*; Koivunen, *Visualizing Africa in Nineteenth-Century British Accounts*.

128. Ball, *Ball's Splendid Mammoth Pictorial Tour*, 11.

129. Ball, *Ball's Splendid Mammoth Pictorial Tour*, 11.

130. Ball, *Ball's Splendid Mammoth Pictorial Tour*, 18–19.

131. Ball, *Ball's Splendid Mammoth Pictorial Tour*, 19.

132. Ball, *Ball's Splendid Mammoth Pictorial Tour*, 28.

133. Ball, *Ball's Splendid Mammoth Pictorial Tour*, 28.

134. Ball, *Ball's Splendid Mammoth Pictorial Tour*, 30.

135. Ball, *Ball's Splendid Mammoth Pictorial Tour*, 31.

136. Ball, *Ball's Splendid Mammoth Pictorial Tour*, 35.

137. Ball, *Ball's Splendid Mammoth Pictorial Tour*, 35.

138. Robert Duncanson was very likely one of the black artists who helped paint Ball's moving panorama. See Ketner, *Emergence of the African-American Artist*; and Ketner, "Struggles, Many and Great."

139. "New Panorama," *Boston Evening Transcript*, April 24, 1855, 2.

140. "Ball's Mammoth Pictorial Tour of the United States," *Liberator* (Boston), May 4, 1855, 71.

141. "Ball's Mammoth Pictorial Tour of the United States," 83.

142. Billington, *Journal of Charlotte L. Forten*, 61, as cited in Willis, *J. P. Ball*, xvi.

143. "The New Panorama," *Daily Atlas* (Boston), April 28, 1855, 2.

144. "Petitions Presented and Referred," *Traveler* (Boston), May 8, 1855, 4.

145. "Ball's Tour of America," *Cleveland Plain Dealer*, March 30, 1855, 3.

146. "The Tableaux," *Cleveland Leader*, April 3, 1855, 3.

147. "The Plantation Scenes," *Cleveland Plain Dealer*, April 3, 1855, 3.

148. Campaigns in Europe and North America to boycott products manufactured or harvested by enslaved labor existed long before Ball's 1855 panorama. See Glickman, "'Buy

for Sake of the Slave'"; Faulkner, "Root of the Evil"; Blackett, *Building an Antislavery Wall,* 119–21; Drescher, "Women's Mobilization in the Era of Slave Emancipation."

149. "Ball's Pictorial Tour," *Cleveland Leader,* March 31, 1855, 3.

150. Oxford English Dictionary Online, "insensibly, adv.," www.oed.com.

151. Miller, "Panorama, Cinema," 41.

152. Miller, "Panorama, Cinema," 41.

153. Ball, *Ball's Splendid Mammoth Pictorial Tour,* 46.

154. Ball, *Ball's Splendid Mammoth Pictorial Tour,* 46.

155. Ball, *Ball's Splendid Mammoth Pictorial Tour,* 47.

156. Ball, *Ball's Splendid Mammoth Pictorial Tour,* 50.

157. Ball, *Ball's Splendid Mammoth Pictorial Tour,* 50.

158. Ball, *Ball's Splendid Mammoth Pictorial Tour,* 51.

159. Ball, *Ball's Splendid Mammoth Pictorial Tour,* 51.

160. Ball, *Ball's Splendid Mammoth Pictorial Tour,* 53.

161. Ball, *Ball's Splendid Mammoth Pictorial Tour,* 53.

162. Ball, *Ball's Splendid Mammoth Pictorial Tour,* 53.

163. Perhaps the most famous is Anthony Burns. See Lubet, *Fugitive Justice;* and Barker, *Imperfect Revolution.*

164. Ball, *Ball's Splendid Mammoth Pictorial Tour,* 55.

165. Ball, *Ball's Splendid Mammoth Pictorial Tour,* 55.

166. Ball, *Ball's Splendid Mammoth Pictorial Tour,* 56.

167. The fate of J. P. Ball's panorama is unknown. Like those displayed by Henry Box Brown and William Wells Brown, it is unclear what became of these artifacts. William Cooper Nell offered Ball's panorama for sale. After that, the trail runs cold. See "Rare Chance for Investment," *Liberator* (Boston), October 31, 1856, 175.

CHAPTER 5

1. "A Letter from Augustus Washington," *African Repository* 30, no. 6 (1854): 186.

2. Augustus Washington, "African Colonization," *African Repository* 27, no. 9 (1851): 260.

3. Shumard, *Durable Memento,* 2–3. See also Shumard's personal research file at the National Portrait Gallery office in Washington, D.C.; and Johnson, "Faces of Freedom." Just a few months before Washington left for Liberia, he submitted to William Lloyd Garrison a daguerreotype of the famed antislavery activist as a gift for Garrison's wife, Helen. Augustus Washington to William Lloyd Garrison, June 7, 1853, Special Collections, Manuscripts, MS A.1.2 v.22, p. 65, Boston Public Library.

4. Reports in the Thomas Robbins Collection, 1792–1852, box 14, folders 5–8, Connecticut Historical Society.

5. Frederick Douglass, "Editorial Correspondence," *North Star* (Rochester, N.Y.), February 11, 1848, 2.

6. "The Washington Daguerrean Gallery," *Hartford (Conn.) Times,* June 6, 1850, 4.

7. *Proceedings of the Connecticut State Convention of Colored Men,* 11.

8. Harris, "'No Taxation without Representation,'" 167. The Connecticut State Archives possesses at least two petitions calling for black men's voting rights that were drafted and signed by African Americans and sent to, but rejected by, the General Assembly of Connecticut.

9. This appears frequently in the historical record among free African Americans and even those who had emigrated to Liberia. For more, see Nash, *Forging Freedom*, 235–45; Power-Greene, *Against Wind and Tide*; Miller, *Search for a Black Nationality*; Kazanjian, "Speculative Freedom of Colonial Liberia"; Guyatt, "'Outskirts of Our Happiness'"; and Forbes, "African-American Resistance to Colonization."

10. Jones, *Birthright Citizens*, 56–57.

11. "For the Courant," *Hartford (Conn.) Daily Courant*, October 24, 1850, 2.

12. Washington, "African Colonization," 260.

13. Washington, "African Colonization," 259.

14. Washington, "African Colonization," 262.

15. Foner, "Politics and Prejudice."

16. Washington, "African Colonization," 260.

17. Washington, "African Colonization," 262.

18. Washington, "African Colonization," 260.

19. Washington, "African Colonization," 260.

20. Washington, "African Colonization," 262.

21. Washington, "African Colonization," 263.

22. Washington, "African Colonization," 263.

23. Washington, "African Colonization," 260.

24. Washington, "African Colonization," 260.

25. D. H. Peterson, "Rev. and Dear Sir," *African Repository* 30, no. 4 (1854): 124.

26. "Letter from Augustus Washington," 186.

27. "Letter from Augustus Washington," 186.

28. "Letter from Liberia," *Hartford (Conn.) Courant*, September 8, 1855, 2.

29. "View of Monrovia, Liberia," *New-York Colonization Journal* 6, no. 1 (1856): 1.

30. "View of Monrovia, Liberia."

31. Scruggs, "'Love of Liberty,'" 112–15.

32. Scruggs, "'Love of Liberty,'" 115–17.

33. For more on the early Liberian terrain and the resulting challenges that arose in agriculture and commerce, see Saha, "Agriculture in Liberia"; Campbell, *Maryland in Africa*; Martin, "Krumen 'Down the Coast'"; and Tyler-McGraw, *African Republic*.

34. Scruggs, "'Love of Liberty,'" 14. Shawn Michelle Smith makes a similar argument in that Washington's daguerreotypes communicated the absence of rights for African Americans by using symbols in his images to remind viewers of their rights in Liberia. See Smith, *Edge of Sight*, 165–92.

35. Evidence of this abounds in colonizationist and noncolonizationist rhetoric of the era. For periodicals printing news on Augustus Washington that used this language, see "Native in Liberia," *New-York Colonization Journal* 4, no. 12 (1854): 3; "Prejudice against the African Race," *New-York Colonization Journal* 5, no. 2 (1855): 1; "Liberia," *New-York Colonization Journal* 5, no. 2 (1855): 2; "Conditions and Prospects of Liberia," *New-York Colonization Journal* 7, no. 11 (1857): 1; "Latest from Liberia," *African Repository* 32, no. 5 (1856): 136; and "Hope for Africa," *African Repository* 37, no. 9 (1861): 268.

36. Lynch, "Edward W. Blyden," 374.

37. Scruggs, "'Love of Liberty,'" 76.

38. "Liberia, W. Africa," *New-York Colonization Journal* 5, no. 8 (1855): 2.

39. "A Letter from Liberia," *New-York Colonization Journal* 8, no. 10 (1858): 3.

40. "Letter from Liberia," 3.

41. See Hutton, "Economic Considerations"; and Syfert, "Liberian Coasting Trade."

42. "Letter from Liberia," *Hartford (Conn.) Daily Courant*, September 3, 1855, 2.

43. "Liberia, W. Africa," 2.

44. "Liberia, W. Africa," 2.

45. "Fourteenth Annual Meeting," *Frederick Douglass' Paper*, August 17, 1855, 2.

46. "Letter from Liberia," 3.

47. "From Augustus Washington," *African Repository* 35, no. 10 (1859): 331.

48. "Letter from Augustus Washington," *African Repository* 35, no. 10 (1859): 295.

49. "Letter from Augustus Washington," 295.

50. "The Colonization Scheme," *Daily Age* (Philadelphia), December 21, 1863, 2; "The Government of Liberia," *African Repository* 42, no. 6 (1866): 177.

51. "Latest from Liberia," *African Repository* 44, no. 2 (1868): 60.

52. "Latest from Liberia," 60.

53. "Items of Intelligence," *African Repository* 44, no. 12 (1868): 376; and "Fifty-Eighth Annual Report," *African Repository* 51, no. 4 (1875): 40.

54. "Stephen Allen Benson," *New-York Colonization Journal* 6, no. 6 (1856): 2.

55. John Brown, the radical white abolitionist who organized the armory raid at Harpers Ferry in 1859, posed similarly for Augustus Washington in a daguerreotype in 1846 or 1847. See NPG.96.123 at the National Portrait Gallery.

56. Nelson, *Edward J. Roye*; Clegg, *Price of Liberty*, 263–64. See Kremer, *James Milton Turner and the Promise of America*, 62–66; and Lynch, *Edward Wilmot Blyden*, 48–52.

57. Lapsansky-Werner and Bacon, *Back to Africa*, 232, n. 146.

58. Augustus Washington, "Liberia as It Is," *New-York Daily Tribune*, July 26, 1854, 3.

59. Washington, "Liberia as It Is," 3.

60. Washington, "Liberia as It Is," 3.

61. Washington, "Liberia as It Is," 3.

62. "Letter from Liberia," 3.

63. "Letter from Liberia," 3.

64. "The Republic of Liberia," *Daily National Intelligencer*, May 20, 1864, 2; "Organization of the Legislature," *African Repository* 42, no. 4 (1866): 104; "Letter from Liberia," *African Repository* 43, no. 6 (1867): 172.

65. "Inauguration Day at Monrovia," *African Repository* 48, no. 9 (1872): 269.

66. "Affairs in Liberia," *African Repository* 49, no. 8 (1873): 248.

67. "Late from Liberia," *African Repository* 51, no. 10 (1875): 117.

68. Frederick Douglass, "Editorial Correspondence," *North Star*, February 11, 1848, 2.

69. Washington, "Liberia as It Is," 3.

70. Washington, "Liberia as It Is," 3.

CHAPTER 6

1. Coffin, *Reminiscences of Levi Coffin*, 606–8.

2. For more on the changing visual representations of contraband slaves in illustrated newsmagazines, see Gonzalez, "Stolen Looks, People Unbound."

3. The sesquicentennial of the Civil War reignited an interest in the photography of the Civil War and shored up the oeuvres of well-known photographers. See Wilson, *Mathew*

Brady; Rosenheim, *Photography and the American Civil War*; Trachtenberg, *Reading American Photographs*; Trachtenberg, "Albums of War"; and Panzer, *Mathew Brady and the Image of History*.

4. On the mythical elements of historical events and personage that Brady wished to document, see Panzer, *Mathew Brady and the Image of History*.

5. For more information on the rapidly increasing number of newspapers before the Civil War, see Casper, "Introduction."

6. Nerone, "Newspapers and the Public Sphere."

7. "Publisher's Notice," *Harper's Weekly*, June 15, 1861, 369; "Our Success," *Harper's Weekly*, April 26, 1862, 258; "Our Success," *Harper's Weekly*, May 3, 1862, 274; "Our Success," *Harper's Weekly*, May 10, 1862, 290; "To Advertisers," *Harper's Weekly*, April 16, 1864, 242. See also *Frank Leslie's Illustrated Newspaper*, February 4, 1860, 383, as quoted in Gambee, "*Frank Leslie's Illustrated Newspaper*"; and Brown, *Beyond the Lines*, 35–40.

8. For truth claims, see "Harper's Pictorial History of the Great Rebellion in the United States," *Harper's Weekly*, August 23, 1862, 543; "Progress of Victory," *Harper's Weekly*, March 29, 1862, 194; "Domestic Intelligence," *Harper's Weekly*, February 25, 1865, 115; "The Stars and Stripes in South Carolina," *Harper's Weekly*, November 23, 1861, 738; "Flight of the President to Washington," *Harper's Weekly*, March 9, 1861, 151; "The Armada," *Harper's Weekly*, November 16, 1861, 722; "Domestic Intelligence," *Harper's Weekly*, January 30, 1864, 67; "Giuseppe Garibaldi," *Harper's Weekly*, November 17, 1860, 722; "Our War Illustrations," *Frank Leslie's Illustrated Newspaper*, July 6, 1861, 113; "The Only Reliable War Illustrations," *Frank Leslie's Illustrated Newspaper*, April 27, 1861, 353–54; "Our Illustrations," *Frank Leslie's Illustrated Newspaper*, November 16, 1861, 403; and "The Conclusion of Vol. XVII.," *Frank Leslie's Illustrated Newspaper*, March 12, 1864, 386.

9. See Gonzalez, "Stolen Looks, People Unbound"; Fahs, *Imagined Civil War*; and Masur, "'Rare Phenomenon of Philological Vegetation.'"

10. For claims of authenticity and accuracy, see the articles cited in note 8, above.

11. Manning, "Working for Citizenship"; and Taylor, *Embattled Freedom*.

12. "A Typical Negro," *Harper's Weekly*, July 4, 1863, 429.

13. "The Scourged Slave's Back," *Liberator* (Boston), September 4, 1863, 4.

14. "The Scourged Back," *Independent* (New York), May 28, 1863, 4.

15. [*Escaped Slave Gordon, also Known as "Whipped Peter," Showing His Scarred Back at a Medical Examination, Baton Rouge, Louisiana*], LOT 14043-2, no. 606 [P&P], Library of Congress.

16. *The Branded Hand* is one such example. See Wood, *Blind Memory*, 246–49.

17. Cutter, *Illustrated Slave*; Goddu, "Anti-Slavery's Panoramic Perspective"; Wood, *Blind Memory*; Abruzzo, *Polemical Pain*; Wood, *Black Milk*. Though sometimes implicit, unphotographed are the forms of violence that enslaved women suffered during slavery and even after their escape to Union lines. See Glymph, *Women's Fight*, 109–10.

18. "Typical Negro." 429.

19. Abruzzo, *Polemical Pain*, 203.

20. Silkenat, "'Typical Negro,'" 174.

21. Mitchell, "'Rosebloom and Pure White.'" Several years before these Civil War images circulated as cartes de visite, Senator Charles Sumner toured with Mary Mildred Williams, a young formerly enslaved girl who appeared white to many viewers. Images of her circulated and visually persuaded audiences of the sexual assault of enslaved women. For more on Williams and Sumner, see Morgan-Owens, *Girl in Black and White*.

22. For more on Wilson Chinn, see Mitchell, *Raising Freedom's Child*, 88; and Wood, *Black Milk*, 321–25.

23. Rosenheim, *Photography and the American Civil War*, 158.

24. Gonzalez, "Stolen Looks, People Unbound"; McPherson, *For Cause and Comrades*; Friend and Glover, *Southern Manhood*. For ways that free African Americans claimed and argued for different rights of citizenship, see Jones, *Birthright Citizens*; Manning, "Working for Citizenship"; and Glymph, *Women's Fight*, 91.

25. Another triple portrait dating from 1853 by James Presley Ball featured the abolitionists Levi Coffin, Edward Harwood, and William Brisbane and is not known to have been reproduced for wide audiences after its creation. As Matthew Fox-Amato has argued, northern white abolitionists often commissioned photographs of themselves to build networks among one another. See Wallace, "J. P. Ball's 1853 Daguerreotype"; and Amato, *Exposing Slavery*, 103–59.

26. Hundreds of these images can be seen at the Library of Congress in the Civil War Glass Negatives and Related Prints Collection, the Gladstone Collection, the Liljenquist Family Collection, the Anthony-Taylor-Rand-Ordway-Eaton Collection, the Selected Civil War Photograph Collection, and the Stereograph Cards Collection.

27. This image also appears in Willis and Krauthamer, *Envisioning Emancipation*, 91.

28. Coffin, *Reminiscences*, 606–8.

29. In the thousands of photographs currently in the Civil War Photographs Collection at the Library of Congress, fewer than five feature soldiers with a revolver drawn across their chest.

30. Coffin, *Reminiscences*, 607.

31. Coffin, *Reminiscences*, 607.

32. Jacobs, *Incidents in the Life of a Slave Girl*, 242.

33. Simpson, *Horrors of the Virginian Slave Trade*, 57.

34. Troy, *Hair-Breadth Escapes from Slavery to Freedom*, 70–71.

35. Green, *Narrative*, 34.

36. Coffin, *Reminiscences*, 607.

37. Coffin, *Reminiscences*, 607.

38. Coffin, *Reminiscences*, 609.

39. The silences surrounding African American women attempting to gain freedom during, and immediately after, the Civil War are being filled by scholars. See Glymph, "Rose's War"; Rosen, *Terror in the Heart of Freedom*; McCurry, *Women's War*; Manning, *Troubled Refuge*; Taylor, *Embattled Freedom*; and Glymph, *Women's Fight*.

40. Panzer, *Mathew Brady and the Image of History*, 15.

41. Panzer, *Mathew Brady and the Image of History*, 18.

42. See Manning, *Troubled Refuge*; and Taylor, *Embattled Freedom*.

43. Panzer, *Mathew Brady and the Image of History*, 1, 116.

44. Panzer, *Mathew Brady and the Image of History*, 2.

45. Bannister's barbershop in Malden, Massachusetts, was one of three shops broken into during the night of May 7, 1852. See "Storebreaking," *Boston Daily Atlas*, May 11, 1852, 1.

46. Nell, *Colored Patriots of the American Revolution*, 318.

47. William Cooper Nell, "Colored Genius," *Liberator* (Boston), August 11, 1854, 127.

48. "Barber's Shop for Sale," *Boston Herald*, May 21, 1857, 4.

49. Scholars have long documented the activist, and sometimes radical, strategies implemented by the African American population of Boston. See Horton and Horton, *In*

Hope of Liberty; McDaniel, "The Fourth and the First"; and Kachun, "Antebellum African Americans."

50. Regarding the "historical amnesia" surrounding Crispus Attucks and the methods of commemoration that began in the late 1850s in Boston, see Kachun, "From Forgotten Founder to Indispensable Icon."

51. "Commemorative Meeting in Faneuil Hall," *Liberator* (Boston), February 26, 1858, 35.

52. "New England Colored Citizens' Convention," *Liberator* (Boston), August 19, 1859, 132.

53. "Oberlin Rescuers," *Liberator* (Boston), June 10, 1859, 90.

54. "Meeting of Colored Citizens," *Traveler* (Boston), May 25, 1859, 4.

55. For more on Leonard Grimes, see Sinha, *Slave's Cause*, 506–19.

56. "Association for the Relief of Destitute Contrabands," *Liberator* (Boston), October 10, 1862, 163.

57. "Affairs about Home," *Boston Herald*, December 24, 1862, 2.

58. "Emancipation Day," *Liberator* (Boston), December 26, 1862, 207.

59. "The Combination Effort," *Liberator* (Boston), January 20, 1860, 11.

60. Lancaster, "'I Would Have Made Out Very Poorly,'" 109. Lewis Hayden had recruited several African American men to join John Brown at Harpers Ferry. See Geffert, "John Brown and His Black Allies," 600, n. 46.

61. "'An Appeal to the Public,'" *Boston Evening Transcript*, May 10, 1864, 2.

62. "Letter from Mrs. Child," *Liberator* (Boston), November 18, 1864, 185.

63. "Local Matters," *Boston Daily Advertiser*, October 19, 1864, 1; Bearden and Henderson, *History of African American Artists*, 43.

64. Holland, "To Be Free, Gifted, and Black," 11.

65. "Commemorative Meeting in Faneuil Hall," 35.

66. "A Colored Physician," *Frederick Douglass' Paper* (Rochester, N.Y.), September 22, 1854, 2.

67. "The Colored Citizens of New York and the African Civilization Society," *Liberator* (Boston), May 4, 1860, 72; "Affairs about Boston," *Pacific Appeal* (San Francisco), November 1, 1862, 3.

68. For more on the debates about and reactions to the enlistment of black Union soldiers, see Berlin, Reidy, and Rowland, *Freedom*.

69. Ramold, *Slaves, Sailors, Citizens*.

70. Taylor, "Spatial Organization and the Residential Experience," 56.

71. Taylor, *Frontiers of Freedom*, 212.

72. Taylor, *Frontiers of Freedom*, 152.

73. Gould, *Diary of a Contraband*.

74. "The Original Ball Ahead Again," *Cincinnati Daily Press*, March 16, 1861, 2.

75. "Home Interest," *Cincinnati Daily Press*, April 23, 1861, 2.

76. "Home Interest," *Cincinnati Daily Press*, May 22, 1861, 2.

77. "The War Has Begun," *Cincinnati Daily Enquirer*, May 26, 1861, 2.

78. "Our Military Correspondence," *Cincinnati Daily Press*, June 20, 1861, 3.

79. "Our Military Correspondence," 3.

80. Edward M. Thomas, "A Picture by a Colored Artist," *Weekly Anglo-African* (New York), April 2, 1862, 2.

81. Thomas, "Picture by a Colored Artist," 2.

82. Quadroon, "Anglo-African Exhibition of Industry and Art," *Weekly Anglo-African* (New York), February 22, 1862, 4.

83. "Colored Inventors, Artists, Mechanics, Etc.," *Weekly Anglo-African* (New York), April 19, 1862, 2.

84. "Our Friends at the East," *Pacific Appeal* (San Francisco), June 21, 1862, 2.

85. "Eastern Items, Selected and Condensed from the Anglo-African," *Pacific Appeal* (San Francisco), July 2, 1862, 3; "The National Exhibition," *Pacific Appeal* (San Francisco), August 30, 1862, 2.

86. "Exhibition of Art," *Christian Recorder* (Philadelphia), February 1, 1862, 18.

87. "Exhibition of Art," 18.

88. Den Nottah, "Communications, *Pacific Appeal* (San Francisco), September 6, 1862, 3.

89. Edward M. Thomas, "Anglo-African Exhibition of Industry and Art," *Weekly Anglo-African* (New York), February 2, 1862, 1.

90. Thomas, "Anglo-African Exhibition of Industry and Art," 1.

91. Thomas, "Anglo-African Exhibition of Industry and Art," 1.

92. Thomas, "Anglo-African Exhibition of Industry and Art," 1.

93. Thomas, "Anglo-African Exhibition of Industry and Art," 1.

94. Thomas, "Anglo-African Exhibition of Industry and Art," 1.

95. Thomas, "Anglo-African Exhibition of Industry and Art," 1.

96. Lincoln, *Collected Works*, 375, n. 1, as reproduced from Edward M. Thomas to Abraham Lincoln, August 16, 1862, Abraham Lincoln Papers, Library of Congress.

97. Masur, "African American Delegation to Lincoln."

98. "A Resignation Tendered," *Pacific Appeal* (San Francisco), October 18, 1862, 2.

99. "Affairs about Boston," *Pacific Appeal* (San Francisco), November 1, 1862, 3.

100. "The First Exhibition of the Anglo-African Institute for the Encouragement of Industry and Art," *Anglo-African* (New York), July 4, 1863, 4.

101. For more on the race riots that grew out of the New York City Draft Riots in the middle of July 1863, see Harris, *Shadow of Slavery*, 279–88.

CHAPTER 7

1. Frederick Douglass, "Sources of Danger to the Republic," in Blassingame, *Frederick Douglass Papers*, 4:158.

2. "Fred Douglass in Mozart Hall," *Cincinnati Daily Enquirer*, January 13, 1867, 2. It is no coincidence that Douglass mistrusted President Johnson especially after Johnson's support of black codes in the South and his hostility shown toward the Freedmen's Bureau. See Blight, *Race and Reunion*, 45.

3. "Fred Douglass in Mozart Hall," 2.

4. "Lecture of Fred. Douglass," *Cincinnati Daily Gazette*, January 14, 1867, 1.

5. "City News," *Cincinnati Daily Gazette*, January 15, 1867, 1.

6. During the Civil War, Sojourner Truth raised money from her supporters by selling a series of cartes des visite that corrected misrepresentations of her. See Painter, *Sojourner Truth*, 185–99. See also Mitchell, *Raising Freedom's Child*, 116–21, for abolitionist fundraising using cartes de visite.

7. "Wanted," *Daily Missouri Democrat* (St. Louis), July 1, 1867, 4.

8. "A Tribute for the Negro," *North Star* (Rochester, N.Y.), April 7, 1849, 1.

9. Stauffer, Trodd, and Bernier, *Picturing Frederick Douglass.*

10. Frederick Douglass, "Lecture on Pictures," in Stauffer, Trodd, and Bernier, *Picturing Frederick Douglass,* 129–30.

11. Douglass, "Lectures on Pictures," in Stauffer, Trodd, and Bernier, *Picturing Frederick Douglass,* 130.

12. For information on the Reconstruction efforts to annex Santo Domingo and Frederick Douglass's involvement, see Guyatt, "America's Conservatory"; Polyné, "Expansion Now!"; and Wilkins, "'They Had Heard of Emancipation.'"

13. Scholars have written several biographies of these AME Church leaders who participated vigorously in campaigns to secure social and legal privileges for African Americans while serving their religious needs. See Newman, *Freedom's Prophet*; Seraile, *Fire in His Heart*; Miller, *Elevating the Race*; and Angell, *Bishop Henry McNeal Turner.*

14. Campbell, *Songs of Zion*; Little, *Disciples of Liberty.*

15. Bailey, *Race Patriotism,* xvii.

16. Bailey, *Race Patriotism,* xvii.

17. McHenry, *Forgotten Readers,* 87.

18. Hall, *Faithful Account of the Race*; Ernest, *Liberation Historiography*; Maffly-Kipp, *Setting Down the Sacred Past.*

19. Bailey, *Race Patriotism.*

20. Seraile, *Fire in His Heart.*

21. "Brief Editorials," *Christian Recorder* (Philadelphia), April 16, 1870, 2.

22. "Brief Editorials," 2.

23. "Brief Editorials," 2.

24. Gilpin, *John Brown Still Lives!*

25. U.S. Const. amend. XV, § 1.

26. Nwankwo, *Black Cosmopolitanism,* 30. See Schmidt-Nowara, *Empire and Slavery,* for more about Caribbean and transatlantic political coalitions, including antislavery campaigns.

27. "Douglass' Studio," *Christian Recorder* (Philadelphia), April 2, 1870, 4.

28. Scott, "Gradual Abolition," 450–51.

29. Gannon, "Sites of Memory, Sites of Glory."

30. For more on Memorial Day (previously known as Decoration Day), see Blair, *Cities of the Dead,* 49–76; and Blight, *Race and Reunion,* 64–71.

31. Blight, *Race and Reunion,* 72.

32. Artifex, "Sunday-School Anniversary," *Christian Recorder* (Philadelphia), November 6, 1869, 3.

33. Artifex, "Sunday-School Anniversary," 3.

34. Artifex, "Sunday-School Anniversary," 3.

35. Artifex, "Sunday-School Anniversary," 3.

36. Artifex, "Sunday-School Anniversary," 3. For more about the founders of the Sunday schools, see Power, *Rise and Progress of Sunday Schools.*

37. Artifex, "Sunday-School Anniversary," 3.

38. Gross and Snyder, *Images of America,* 7. Scholars have also highlighted the mistreatment of African American attendees at the 1876 Centennial Exhibition. See Kachun, "Before the Eyes of All Nations"; Clark, *Defining Moments,* 123; Foner, "Black

Participation in the Centennial of 1876"; and Brundage, "Meta Warrick's 1907 'Negro Tableaux,'" 1374.

39. Robert Douglass, "The Centennial Exhibition," *Christian Recorder* (Philadelphia), October 26, 1876, 8.

40. Douglass, "Centennial Exhibition," 8.

41. Douglass, "Centennial Exhibition," 8, emphasis added.

42. *Christian Recorder* (Philadelphia), January 22, March 5, 1874, as quoted in Kachun, "Before the Eyes of All Nations," 311.

43. Foner, "Black Participation in the Centennial of 1876."

44. R. D., "The Centennial Exhibition," *Christian Recorder* (Philadelphia), September 28, 1876, 1.

45. R. D., "Centennial Exhibition," 1.

46. R. D., "Centennial Exhibition," 1.

47. "Local Column," *Christian Recorder* (Philadelphia), February 14, 1878, 3.

48. "Local Column," *Christian Recorder* (Philadelphia), February 21, 1878, 3.

49. "Local Column," *Christian Recorder* (Philadelphia), January 24, 1878, 3.

50. Robert J. Holland, "Local Column," *Christian Recorder* (Philadelphia), June 20, 1878, 2.

51. "The Three-Fold Nature of Man," *Christian Recorder* (Philadelphia), April 25, 1878, 2.

52. Among many African Americans, the prospect of Haiti as a country to flee the proliferating black codes, increased racialized violence, and the slow momentum of federal legal rights remained popular.

53. Polyné, *From Douglass to Duvalier*, 25–55; Pitre, "Frederick Douglass and the Annexation of Santo Domingo"; Brantley, "Black Diplomacy and Frederick Douglass's Caribbean Experiences"; Logan, *Haiti and the Dominican Republic*.

54. Robert Douglass, "Salnave," *Christian Recorder* (Philadelphia), February 19, 1870, 1.

55. "Salnave," 1.

56. Clavin, *Toussaint Louverture*, 78, 81, 86, 94.

57. "Salnave," 1.

58. "To Robert Douglass, Esq.," *Christian Recorder* (Philadelphia), July 18, 1878, 2.

59. "To Robert Douglass, Esq.," 2.

60. "Personal Items," *Christian Recorder* (Philadelphia), July 15, 1875, 4.

61. Bishop Foster, "Methodism," *Christian Recorder* (Philadelphia), January 22, 1874, 6.

62. Southall, *Blind Tom, the Black Pianist-Composer*; Southall, *Blind Tom*. See also O'Connell, *Ballad of Blind Tom*. Scholars of disability studies have also pointed to business managers taking advantage of Tom. See Rowden, *Songs of Blind Folk*; and Krentz, "'Vacant Receptacle?'" Other scholars have concentrated on his contributions to musical performance culture in the late nineteenth century. See Riis, "Experience and Impact of Black Entertainers in England."

63. "'Blind Tom in Court,'" *Cincinnati Daily Enquirer*, July 21, 1865, 3.

64. "'Blind Tom in Court,'" 3.

65. "Local News," *Cincinnati Daily Enquirer*, July 22, 1865, 3.

66. The current historiography does not mention Ball playing any part in Tom's trial, though the historical record proves otherwise.

67. "'Blind Tom in Court,'" 3.

68. "'Blind Tom in Court,'" 3.

69. "Local News," 3.

70. "Local News," 3.

71. "'Blind Tom in Court,'" 3.

72. "'Blind Tom in Court,'" 3.

73. Historians have pointed to the disjointed adherence to the Emancipation Proclamation throughout the South and have repeatedly shown that little to no enforcement of the proclamation existed in many areas of the South, even long after the end of the Civil War. See Masur, *Lincoln's Hundred Days*; and Blair and Younger, *Lincoln's Proclamation*.

74. "'Blind Tom,'" *New-York Evening Post*, July 27, 1865, 4.

75. In 1870, with his father recently deceased and his mother living in Georgia, Tom neared his twenty-first birthday — the end of his term of indenture. Bethune traveled with Tom to a Virginia probate judge who declared Tom mentally incompetent and then named Bethune his legal guardian. Such a decision contrasted with Tom having been deemed competent enough by Judge Woodruff in Cincinnati to select the person he wished to be his legal guardian in 1865. Bethune then resumed promoting and touring Tom. For more, see Southall, *Blind Tom, the Black Pianist-Composer*; O'Connell, *Ballad of Blind Tom*; and "Blind Tom" in Gates and Higginbotham, *African American Lives*, 85.

76. "City News. Law Report," *Cincinnati Daily Enquirer*, January 18, 1866, 3; "Law Report," *Cincinnati Daily Gazette*, January 18, 1866, 1.

77. "Law Report," *Cincinnati Daily Gazette*, January 18, 1866, 1.

78. "Court Affairs," July 3, 1867, *Cincinnati Daily Gazette*, July 3, 1867, 1.

79. "Law Report," *Cincinnati Daily Enquirer*, December 25, 1867, 2; "Died," *Cincinnati Daily Gazette*, September 26, 1866, 2.

80. "Sheriff's Sale," *Cincinnati Daily Gazette*, January 4, 1868, 4.

81. Blassingame, *Slave Testimony*, 611–14. See also Washington, *Story of the Negro*, 267–69.

82. Keckley, *Behind the Scenes*, 367.

83. *Catalogue of Phillips Academy*, 11; *Catalogue of the Boston Public Latin School*, 332.

84. "Anniversary of the Assassination," *Cincinnati Daily Gazette*, April 16, 1867, 2.

85. "Lincoln Memorial Club — Banquet Saturday Evening," *Cincinnati Daily Gazette*, February 14, 1870, 1.

86. "Lincoln Memorial Club — Banquet Saturday Evening," 1.

87. "Lincoln Memorial Club — Banquet Saturday Evening," 1.

88. Gilpin, *John Brown Still Lives!*

89. "The Tendency of Our Age," *Cincinnati Daily Gazette*, July 12, 1870, 2.

90. "Tendency of Our Age," 2.

91. "Newport," *Cincinnati Daily Enquirer*, July 15, 1870, 7.

92. "Home News," *Cincinnati Daily Gazette*, July 21, 1870, 2; "Wants — Miscellaneous," *Cincinnati Commercial Tribune*, July 18, 1870, 3.

93. Theophilus Gould Steward, "Colored Society," *Christian Recorder* (Philadelphia), January 11, 1877, 8, emphasis in original.

94. Steward, "Colored Society," 8.

95. Steward, "Colored Society," 8.

96. Joseph Henry Lee, "Pictures of Our Prominent Men," *Christian Recorder* (Philadelphia), June 13, 1878, 1.

97. Lee, "Pictures of Our Prominent Men," 1.

98. Lee, "Pictures of Our Prominent Men," 1.

99. Lee, "Pictures of Our Prominent Men," 1.

100. For example, a portrait of Senator Hiram R. Revels can be found in *Harper's Weekly*, February 19, 1870, 122.

101. "Picture Gallery," *Cincinnati Daily Gazette*, September 9, 1869, 2.

102. "Wants — Miscellaneous," *Cincinnati Commercial Tribune*, September 12, 1869, 3.

103. "Wants — Miscellaneous," 3.

104. 1850 United State Census (Free Schedule), Pitt Township, Wyandot County, Ohio, p. 233, family 86, dwelling 79, lines 967–77, June 1, 1850, National Archives Microfilm M-19, roll 719.

105. "Home News," *Cincinnati Daily Gazette*, April 2, 1870, 1.

106. "The Colored Voters' Association," *Cincinnati Daily Gazette*, August 9, 1870, 2.

107. *Gopsill's Cincinnati City Directory of 1871*, 74.

108. "J. P. Ball," *Cincinnati Commercial Tribune*, March 11, 1872, 4.

109. "J. P. Ball," 4.

110. Foner, *Reconstruction*, 294–96.

111. Hahn, *Nation under Our Feet*, 178.

112. James D. Lynch, July 9, 1867, in *Hayes Historical Journal* 6 (1986): 30, as cited in Hahn, *Nation under Our Feet*, 178.

113. Lynch was one of the most prominent black AME leaders in Mississippi and founded the *Canton Citizen* in 1870. See Thompson, *Black Life in Mississippi*, 14; and Sewell, *Mississippi Black History Makers*, 38–48, for more about his life.

114. Gaines, *African Methodism in the South*, 1–9; Smith, *History of the African Methodist Episcopal Church*, 45–73; Tanner, *Apology for African Methodism*, 38; Wright Jr., *Centennial Encyclopaedia of the African Methodist Episcopal Church*, 312–19.

115. Litwack, *Been in the Storm So Long*, 511; Foner, *Forever Free*, 88; Sewell, *Mississippi Black History Makers*, 38–48. Lynch also pushed back against the more racially separatist politics advanced by the AME Church. See Montgomery, *Under Their Own Vine and Fig Tree*, 240–41. For a broader discussion of the AME Church's separatist racial politics, see Walker, *Rock in a Weary Land*.

116. Foner, "'Tocsin of Freedom,'" 128.

117. H. J. Young, "Cincinnati Correspondence," *Christian Recorder* (Philadelphia), November 24, 1866, 1.

118. R. G. M., "Word from Toledo," *Christian Recorder* (Philadelphia), October 25, 1877, 1.

119. "Brief Editorials," *Christian Recorder* (Philadelphia), December 17, 1870, 2.

120. "Brief Editorials," 2.

121. A. G. M., "West Texas Annual Conference," *Christian Recorder* (Philadelphia), January 17, 1878, 1.

122. A. G. M., "West Texas Annual Conference," 1.

123. Shalom, "For the Christian Recorder," *Christian Recorder* (Philadelphia), April 2, 1864, 53.

124. Henry Highland Garnet, "The Pioneers of the African Methodist Episcopal Church," *Christian Recorder* (Philadelphia), February 20, 1869, 22.

125. Henry McNeal Turner, "Thoughts and Facts," *Christian Recorder* (Philadelphia), March 23, 1876, 2.

126. "Home News," *Cincinnati Daily Gazette*, February 14, 1871, 2.

127. "Local Matters," *Cincinnati Daily Times*, February 13, 1872, 3.

128. Hahn, *Nation under Our Feet*, 286.

129. "The Grateful Colored Man," *Cincinnati Daily Enquirer*, February 13, 1872, 8.

130. "J. P. Ball Esq," *Weekly Louisianian* (New Orleans), May 25, 1871, 2.

131. "J. P. Ball," *Weekly Louisianian* (New Orleans), April 11, 1872, 2.

132. "J. P. Ball," 2.

133. Scott, *Degrees of Freedom*, 42–44.

134. Scott, *Degrees of Freedom*, 49–60.

135. A. F., "A Sad Mishap to a Cincinnati Colored Man," *Cincinnati Daily Enquirer*, May 24, 1873, 4.

136. Foner, *Reconstruction*, 384–411.

137. 44th Cong., 1st Sess., S. Rep. 527, *Mississippi in 1875: Report of the Select Committee to Inquire into the Mississippi Election of 1875, with the Testimony and Documentary Evidence*, vol. 2 (Washington, D.C.: Government Printing Office, 1876), 1507.

138. A. F., "Sad Mishap to a Cincinnati Colored Man"; 4; McNeily, "War and Reconstruction in Mississippi," 453.

139. "J. P. Ball in the Mississippi Penitentiary," *Cincinnati Commercial Tribune*, May 27, 1873, 5.

140. Rosen, *Terror in the Heart of Freedom*.

141. "J. P. Ball in the Mississippi Penitentiary," 5.

142. "Business Colored Men in Cincinnati," *Cincinnati Commercial Tribune*, February 18, 1877, 5.

143. "Business Notices," *Cincinnati Daily Commercial*, April 13, 1861, 2; "Business Notices," *Cincinnati Daily Commercial*, April 27, 1858, 2; Henry Highland Garnet, "Cincinnati the Queen City of the West," *Anglo-African* (New York), October 14, 1865, 2.

144. "Picture Gallery," *Cincinnati Daily Gazette*, September 9, 1869, 2.

145. Anniversary of the birthday of Abraham Lincoln, H. Rep., 43rd Cong., 1st Sess., Misc. Doc. No. 148.

146. "Commemoration of Lincoln's Birthday by Colored Citizens," *Cincinnati Commercial Tribune*, February 13, 1870, 5; "Death of a Prominent Colored Citizen," *Cincinnati Commercial Tribune*, January 31, 1875, 4.

147. "The Gazette Speaks," *Cincinnati Daily Enquirer*, February 2, 1875, 4.

148. "Celebration of the Sixty-Seventh Anniversary of the Birth of Abraham Lincoln," *Cincinnati Commercial Tribune*, February 13, 1876, 6.

149. 1870 Census, County of Hamilton, City of Cincinnati, 13th Ward, p. 96.

150. Housed at the Cincinnati History Library and Archives, the Ball family album is too fragile to be scanned and reproduced. For more on African American family photograph albums, primarily during the twentieth century, see Hoobler and Hoobler, *African American Family Album*.

151. Motz, "Visual Autobiography," 63.

152. For more on families communicated their histories and stories, see Siegel, *Galleries of Friendship and Fame*.

153. Motz, "Visual Autobiography," 67.

154. Garnet, "Cincinnati the Queen City of the West," 2.

155. "Portraits of Rev. Henry H. Garnet," *Colored Citizen* (Cincinnati), May 19, 1866, 4.

156. For other examples of cartes de visite albums maintained by an African American, see the Arabella Chapman albums, held at the William L. Clements Library at the University of Michigan. Born free in New Jersey before the Civil War, Arabella Chapman maintained several albums later in the nineteenth century. The Arabella Chapman

Project, The Regents of the University of Michigan and the William L. Clements Library. Two cartes de visite albums assembled by Harriet Hayden were recently acquired by the Boston Athenaeum and provide insight into her family's personal and political networks. The albums included images created by Edward Bannister of Leonard Grimes, Jane Howe Watson, and John Van Surly DeGrasse.

EPILOGUE

1. Rusert, *Fugitive Science*, 65.

2. Du Bois, "American Negro at Paris," 577.

3. Kruger, "'White Cities,' 'Diamond Zulus'"; Peavler, "African Americans in Omaha."

4. Smith, "'Baby's Picture Is Always Treasured,'" 202.

5. Graham King, *Say "Cheese"! The Snapshot as Art and Social History*, 9, as cited in Olivier, "George Eastman's Modern Stone-Age Family," 1.

6. For more on the developments and characteristics of the leisure classes and advertising, see Veblen, *Theory of the Leisure Class*; Lears, *Fables of Abundance*; Crary, *Suspensions of Perception*; Ewen and Ewen, *Channels of Desire*; and West, *Kodak and the Lens of Nostalgia*.

7. Smith, *Photography on the Color Line*, 2.

BIBLIOGRAPHY

PRIMARY SOURCES

Archives

American Antiquarian Society,
 Worcester, Mass.
Beinecke Rare Book and Manuscript
 Library, Yale University,
 New Haven, Conn.
Boston Public Library
British Museum, London
Cheyney University of Pennsylvania
 University Archives and Special
 Collections, Cheyney
Cincinnati History Library and Archives
Connecticut Historical Society, Hartford
Emory University, Manuscript and
 Rare Book Library, Atlanta
Haverford College Quaker and Special
 Collections, Haverford, Pa.
Historic New Orleans Collection
Historical Society of Pennsylvania,
 Philadelphia
Library Company of Philadelphia,
 Philadelphia
Library of Congress, Washington, D.C.
Massachusetts Historical Society, Boston

Montana Historical Society, Helena
Moorland-Spingarn Research Center,
 Howard University, Washington, D.C.
New-York Historical Society
New York Public Library, Stephen A.
 Schwarzman Building
New York Public Library, Schomburg
 Center for Research in Black Culture
Presbyterian Historical
 Society, Philadelphia
Smithsonian Institution, National
 Portrait Gallery, Washington, D.C.
Swarthmore College Archives, Friends
 Historical Library, Swarthmore, Pa.
University of Manchester,
 Special Collections
University of Oxford, Bodleian Library
University of Pennsylvania,
 University Archives and Records
 Center, Philadelphia
William L. Clements Library, University
 of Michigan, Ann Arbor

Digital Archives and Databases

Accessible Archives
African American Newspapers, 1827–1998

American National Biography Online
Ancestry.com

Archive of Americana
British Newspapers, 1600–1950
Digital Commonwealth
Early American Imprints, Series I and II
Early American Newspapers (America's
Historical Newspapers), Readex

GenealogyBank.com
HathiTrust
19th Century U.S. Newspapers,
Gale Cengage

Newspapers and Periodicals

African Repository and Colonial Journal
(Washington, D.C.)
Anti-Masonic Intelligencer (Hartford, Conn.)
Baltimore Sun
Blackburn (U.K.) Standard
Boston Daily Advertiser
Boston Daily Advertiser and Patriot
Boston Daily Atlas
Boston Evening Transcript
Boston Herald
Charleston Courier
Christian Recorder (Philadelphia)
Christian Reflector (Worcester, Mass.)
Christian Register (Boston)
Christian Watchman (Boston)
Cincinnati Commercial Tribune
Cincinnati Daily Enquirer
Cincinnati Daily Gazette
Cincinnati Daily Press
Cincinnati Daily Times
Cleveland Leader
Cleveland Plain Dealer
Colored American (New York)
Colored Citizen (Cincinnati)
Columbian Centinel (Boston)
Columbian Register (New Haven, Conn.)
Constitutional Advocate of Universal Liberty
(Philadelphia)
Daily Age (Philadelphia)
Daily Commercial Bulletin (St. Louis, Mo.)
Daily Missouri Democrat (St. Louis)
Daily National Intelligencer
(Washington, D.C.)
Daily News (London)
Eastern-Shore Whig and People's Advocate
(Easton, Md.)
Emancipator (New York)

Essex North Register and Family Monitor
(Newburyport, Mass.)
Frank Leslie's Illustrated Newspaper
(New York)
Frederick Douglass' Paper (Rochester, N.Y.)
Freedom's Journal (New York)
Friend of Man (Utica, N.Y.)
Gazette (New Bedford, Mass.)
Genius of Universal Emancipation
(Baltimore)
*Gleason's Pictorial Drawing-Room
Companion* (Boston)
Guardian (Preston, U.K.)
Harper's Weekly (New York)
Hartford (Conn.) Courant
Hartford (Conn.) Daily Courant
Hartford (Conn.) Times
Haverhill (Mass.) Gazette
Liberator (Boston)
Manchester (U.K.) Guardian
Manchester (U.K.) Times
Massachusetts Spy (Worcester)
Leeds (U.K.) Mercury
Liverpool (U.K.) Mercury
National Anti-Slavery Standard (New York)
National Enquirer (Philadelphia)
Newark (N.J.) Daily Advertiser
Newcastle Courant
(Newcastle-upon-Tyne, U.K.)
New Hampshire Patriot (Concord, N.H.)
New Orleans Times-Picayune
New-York Colonization Journal
New-York Daily Tribune
New-York Evangelist
New-York Evening Post
New York Sun
North American (Philadelphia)

North Star (Rochester, N.Y.)
Pacific Appeal (San Francisco)
Patriot and Democrat (Hartford, Conn.)
Patriot and Eagle (Hartford, Conn.)
Pennsylvania Freeman (Philadelphia)
Philadelphia Inquirer
Philanthropist (New Richmond, Ohio)
Poulson's American Daily Advertiser
 (Philadelphia)
Provincial Freeman (Toronto)
Public Ledger (Philadelphia)

Register (Newburyport, Mass.)
Salem (Mass.) Gazette
Saturday Morning Transcript (Boston)
Slave's Friend (New York)
State Journal (Montpelier, Vt.)
Traveler (Boston)
Union Herald (Cazenovia, N.Y.)
United States Telegraph (Washington, D.C.)
Virginian (Lynchburg, Va.)
Weekly Anglo-African (New York)
Weekly Louisianian (New Orleans)

Published Primary Sources

Andrews, Charles C. *The History of the New-York African Free-Schools.* New York: Mahlon Day, 1830.

Ball, James Presley. *Ball's Splendid Mammoth Pictorial Tour of the United States.* Cincinnati: Achilles Pugh, 1855.

Barnes, Gilbert H., and Dwight L. Dumond, eds. *Letters of Theodore Dwight Weld, Angelina Grimke Weld and Sarah Grimke, 1822–1844.* 2 vols. Gloucester, Mass.: Peter Smith, 1965.

Bibb, Henry. *Narrative of the Life and Adventures of Henry Bibb.* New York: Henry Bibb, 1849.

Blassingame, John, ed. *The Frederick Douglass Papers. Series One: Speeches, Debates, and Interviews.* 5 vols. New Haven, Conn.: Yale University Press, 1985.

Blyden, Edward W. *Liberia as She Is and the Present Duty of Her Citizens.* Monrovia, Liberia: Gaston Killian, 1857.

———, ed. *A Brief Account of Proceedings on the Occasion of the Retirement of J. J. Roberts.* Monrovia, Liberia: Gaston Killian, 1856.

Bronson, C. P. *Elocution; or, Mental and Vocal Philosophy.* Louisville, Ky.: Morton and Griswold, 1845.

Brown, Henry Box. *Narrative of the Life of Henry Box Brown Written by Himself.* New York: Oxford University Press, 2002.

Brown, William Wells. *A Description of William Wells Brown's Original Panoramic Views of the Scenes in the Life of an American Slave.* London: Charles Gilpin, 1849.

Catalogue of Phillips Academy, Andover, Mass., June 1869. Andover, Mass.: Warren F. Draper, 1869.

Catalogue of the Boston Public Latin School, Established in 1635 with an Historical Sketch Prepared by Henry F. Jenks. Boston: Boston Latin School Association, 1886.

Catto, William T. *A Semi-Centenary Discourse.* Philadelphia: Joseph M. Wilson, 1857.

Child, Lydia Maria. *The Fountain for Every Day in the Year.* New York: R. G. Williams, 1836.

Coffin, Levi. *Reminiscences of Levi Coffin, the Reputed President of the Underground Railroad.* 2nd ed. Cincinnati: Robert Clarke, 1880.

Constitution of the Philadelphia Anti-Slavery Society. Philadelphia: Thomas Town, 1834.

De Grasse, Isaiah George. *A Sermon on Education.* New York: James Van Norden, 1839.

Description of Banvard's Panorama of the Mississippi River. Boston: John Putnam, 1847.

Du Bois, W. E. B. "The American Negro at Paris." *American Monthly Review of Reviews* 22, no. 5 (1900): 575–77.

Easton, Hosea. *A Treatise on the Intellectual Character and Civil and Political Condition of the Colored People of the U. States; and the Prejudice Exercised towards Them: with a Sermon on the Duty of the Church to Them.* Boston: Isaac Knapp, 1837.

Fourteenth Annual Report of the Philadelphia Female Anti-Slavery Society. Philadelphia: Merrihew and Thompson, 1848.

Fourth Annual Report of the Massachusetts Anti-Slavery Society, with Some Account of the Annual Meeting, January 20, 1836. Boston: Isaac Knapp, 1836.

Gaines, Wesley J. *African Methodism in the South or Twenty-Five Years of Freedom.* Atlanta: Franklin Publishing House, 1890.

Gopsill's Cincinnati City Directory of 1871. Cincinnati: James Gopsill and Sons, 1871.

Green, Jacob D. *Narrative of the Life of J. D. Green, a Runaway Slave, from Kentucky.* Huddersfield [U.K.]: Henry Fielding, 1864.

Haydon, Benjamin Robert. *The Autobiography and Memoirs of Benjamin Robert Haydon (1786–1846).* Vol. 2, edited by Tom Taylor. New York: Harcourt Brace, 1926.

History of Pennsylvania Hall, Which Was Destroyed by a Mob on the 17th of May, 1838. Philadelphia: Merrihew and Gunn, 1838.

Jacobs, Harriet. *Incidents in the Life of a Slave Girl. Written by Herself.* Edited by Lydia Maria Child. Boston: Published for the Author, 1861.

Keckley, Elizabeth. *Behind the Scenes; or, Thirty Years a Slave and Four Years in the White House.* New York: G. W. Carleton, 1868.

A Lecture delivered before the Female Anti-Slavery Society of Salem. Boston: Anti-Slavery Office, 1847.

Lincoln, Abraham. *The Collected Works of Abraham Lincoln.* Vol. 5. New Brunswick, N.J.: Rutgers University Press, 1953.

Longworth's American Almanac, New-York Register, and City Directory. New York: Thomas Longworth, 1800–1850.

Mayo, Robert. *United States Fiscal Department.* Vol. 1, *A Synopsis of the Commercial and Revenue System of the United States, as Developed by Instructions and Decisions of the Treasury Department for the Administration of the Revenue Laws.* Extra ed. Washington, D.C.: J. and G. S. Gideon, 1847.

Merrill, Walter McIntosh, ed. *The Letters of William Lloyd Garrison.* Vol. 1, *I Will Be Heard!, 1822–1835.* Cambridge, Mass.: Harvard University Press, 1971.

Message of the President of the Republic of Liberia to the Legislature. Monrovia, Liberia: Gaston Killian, 1857.

Mickle, Issac. *A Gentleman of Much Promise: The Diary of Isaac Mickle, 1837–1845.* Vol. 1, edited by Philip English Mackey. Philadelphia: University of Pennsylvania Press, 1977.

Mott, Lucretia. *Slavery and "the Woman Question": Lucretia Mott's Diary of Her Visit to Great Britain to Attend the World's Anti-Slavery Convention of 1840.* Edited by Frederick B. Tolles. Haverford, Pa.: Friends' Historical Association and Friends Historical Society, 1952.

Nell, William Cooper. *The Colored Patriots of the American Revolution.* Boston: Robert F. Wallcut, 1855.

New-York Committee of Vigilance. *Fifth Annual Report of the New-York Committee of Vigilance.* New York: G. Vale, Jr., 1842.

Nineteenth Annual Report, Presented to the Massachusetts Anti-Slavery Society, by Its Board of Managers, January 22, 1851. With an Appendix. Boston: Prentiss and Sawyer, 1851.

Pennsylvania Abolitionist Society. *The Present State and Condition of the Free People of Color in the City of Philadelphia*. Philadelphia: Published by the Society, 1838.

Pennsylvania Academy of the Fine Arts. *Pennsylvania Academy of the Fine Arts, 1805–2005: 200 Years of Excellence*. Philadelphia: Pennsylvania Academy of the Fine Arts, 2005.

Pennsylvania Act for the Gradual Abolition of Slavery, March 1, 1780. Section 4.

Power, John Carroll. *The Rise and Progress of Sunday Schools: A Biography of Robert Raikes and William Fox*. New York: Sheldon, 1863.

The Present State and Condition of the Free People of Color, of the City of Philadelphia and Adjoining Districts, as Exhibited by the Report of a Committee of the Pennsylvania Society for Promoting the Abolition of Slavery. Philadelphia: Pennsylvania Society for Promoting the Abolition of Slavery, 1838.

Proceedings of the Connecticut State Convention of Colored Men. New Haven, Conn.: M. H. Stanley, 1849.

Proceedings of the Third Anti-Slavery Convention of American Women, Held in Philadelphia, May 1st, 2d, and 3d, 1839. Philadelphia: Merrihew and Thompson, 1839.

Register of Trades of the Colored People in the City of Philadelphia. Philadelphia: Merrihew and Gunn, 1838.

Report of the Proceedings of the Colored National Convention, Held at Cleveland, Ohio on Wednesday, September 6, 1848. Rochester, N.Y.: John Dick, 1848.

Sandiford, Ralph. *A Brief Examination of the Practice of the Times*. Philadelphia: [Benjamin Franklin and Hugh Meredith], 1729.

Saunders, Prince. *An Address Delivered at Bethel Church, Philadelphia; on the 30th of September, 1818*. Philadelphia: Joseph Rakestraw, 1818.

Senate Report 527, Part 2. Mississippi in 1875. Report to the Select Committee to Inquire into the Mississippi Election of 1875 with the Testimony and Documentary Evidence. Vol. 2. Washington, D.C.: Government Printing Office, 1876.

Shoberl, Frederic, ed. *Forget Me Not; A Christmas and New Year's Present for MDCCCXXVIII*. London: R. Ackerman, 1828.

Simpson, John Hawkins. *Horrors of the Virginian Slave Trade and of the Slave-Rearing Plantations*. London: A. W. Bennett, 1863.

Sixth Annual Report of the Executive Committee of the American Anti-Slavery Society. New York: William S. Dorr, 1839.

The Slave's Friend, no. 10. New York: American Anti-Slavery Society, 1836.

Smith, Charles Spencer. *A History of the African Methodist Episcopal Church*. Philadelphia: Book Concern of the AME Church, 1922.

Stafford, Cornelius William. *The Philadelphia Directory, for 1800*. Philadelphia: William W. Woodward, 1800.

Stuart, Charles. *A Memoir of Granville Sharp*. New York: American Anti-Slavery Society, 1836.

Tanner, Benjamin Tucker. *An Apology for African Methodism*. Baltimore: N.p., 1867.

Troy, William. *Hair-Breadth Escapes from Slavery to Freedom*. Manchester: W. Bremner, 1861.

Washington, Booker T. *The Story of the Negro: The Rise of the Race from Slavery*. Vol. 2. New York: Association Press, 1909.

Williams, James. *The Narrative of James Williams an American Slave*. Boston: American Anti-Slavery Society, 1838.

Willson, Joseph. *Sketches of the Higher Classes of Colored Society in Philadelphia. By a Southerner.* Philadelphia: Merrihew and Thompson, 1841.

Wheeler, Peter. *The Life and Adventures of Peter Wheeler.* New York: E. S. Arnold, 1839.

Wright, Richard R., Jr., ed. *Centennial Encyclopaedia of the African Methodist Episcopal Church.* Philadelphia: Book Concern of the AME Church, 1916.

SECONDARY SOURCES

Abruzzo, Margaret. *Polemical Pain: Slavery, Cruelty, and the Rise of Humanitarianism.* Baltimore: Johns Hopkins University Press, 2011.

Adams, Virginia Matzke, ed. *On the Altar of Freedom: A Black Soldier's Civil War Letters from the Front.* Boston: University of Massachusetts Press, 1991.

Akers, Charles W. "'Our Modern Egyptians': Phillis Wheatley and the Whig Campaign against Slavery in Revolutionary Boston." *Journal of Negro History* 60, no. 3 (1975): 397–410.

Alexander, Leslie. *African or American? Black Identity and Popular Activism in New York City, 1784–1861.* Urbana: University of Illinois Press, 2008.

———. "The Black Republic: The Influence of the Haitian Revolution on Black Political Consciousness, 1817–1861." In *African Americans and the Haitian Revolution: Selected Essays and Historical Documents*, edited by Maurice Jackson and Jacqueline Bacon, 57–80. New York: Routledge, 2009.

Ali, Omar. *In the Balance of Power: Independent Black Politics and Third-Party Movements in the United States.* Athens: Ohio University Press, 2008.

Angell, Virginia Matzke. *Bishop Henry McNeal Turner and African-American Religion in the South.* Knoxville: University of Tennessee, 1992.

Anthony, Susan B., Elizabeth Cady Stanton, and Matilda Joslyn Gage, eds. *History of Woman Suffrage.* Vol. 1. Rochester, N.Y.: Charles Mann, 1889.

Arrington, Joseph Earl. "Godfrey N. Frankenstein's Moving Panorama of Niagara Falls." *New York History* 49, no. 2 (1968): 169–99.

———. "Henry Lewis' Moving Panorama of the Mississippi River." *Louisiana History* 6, no. 3 (1965): 239–72.

———. "Skirving's Moving Panorama: Colonel Fremont's Western Expeditions Pictorialized." *Oregon Historical Quarterly* 65, no. 2 (1964): 132–72.

———. "The Story of Stockwell's Panorama." *Minnesota History* 33, no. 7 (1953): 284–90.

Augst, Thomas, and Kenneth Carpenter, eds. *Institutes of Reading: The Social Life of Libraries in the United States.* Amherst: University of Massachusetts Press, 2007.

Bacon, Jacqueline, and Glen McClish. "Reinventing the Master's Tools: Nineteenth-Century African-American Literary Societies of Philadelphia and Rhetorical Education." *Rhetoric Society Quarterly* 30, no. 4 (2000): 19–47.

Bailey, James T. *Race Patriotism: Protest and Print Culture in the AME Church.* Knoxville: University of Tennessee Press, 2012.

Bailey, Julius H. *Around the Family Altar: Domesticity in the African Methodist Episcopal Church, 1865–1900.* Gainesville: University Press of Florida, 2005.

Baker, Anne. "Word, Image, and National Geography: Panorama Pamphlets and Manifest Destiny." In *American Literary Geographies: Spatial Practice and Cultural Production, 1500–1900*, edited by Martin Bruckner and Hsuan Hsu, 89–108. Newark: University of Delaware Press, 2004.

Barker, Gordon S. *The Imperfect Revolution: Anthony Burns and the Landscape of Race in Antebellum America*. Kent, Ohio: Kent State University Press, 2010.

Barnes, Gilbert H., and Dwight W. Dumond, eds. *Letters of Theodore Dwight Weld, Angelina Grimké Weld and Sarah Grimké, 1822–1844*. Vol. 1. New York: Da Capo, 1970.

Basker, James, ed. *Amazing Grace: An Anthology of Poems about Slavery, 1660–1810*. New Haven, Conn.: Yale University Press, 2002.

Baumgartner, Kabria. *In Pursuit of Knowledge: Black Women and Educational Activism in Antebellum America*. New York: New York University Press, 2019.

Bearden, Romare, and Harry Henderson, *A History of African American Artists from 1792 to the Present*. New York: Pantheon Books, 1993.

Bell, Howard. *A Survey of the Negro Convention Movement, 1830–1861*. New York: Arno, 1969.

Bell, John. "The Sioux War Panorama and American Mythic History." *Theatre Journal* 48, no. 3 (1996): 279–99.

Berger, Martin A. *Sight Unseen: Whiteness and American Visual Culture*. Berkeley: University of California Press, 2005.

Berlin, Ira, Joseph P. Reidy, and Leslie S. Rowland, eds. *Freedom: A Documentary History of Emancipation*. Series 2, Book 1, *The Black Military Experience*. Cambridge: Cambridge University Press, 1982.

Billington, Ray Allen, ed. *The Journal of Charlotte L. Forten*. New York: Dryden, 1953.

Bindman, David. *Ape to Apollo: Aesthetics and the Idea of Race in the Eighteenth Century*. Ithaca, N.Y.: Cornell University Press, 2002.

Bindman, David, and Henry Louis Gates Jr., eds. *The Image of the Black in Western Art*. Vol. 4, *From the American Revolution to World War I, Part 2: Black Models and White Myths*. New ed. Cambridge, Mass.: Belknap Press of Harvard University Press, 2012.

Blackett, R. J. M. *Beating against the Barriers: Biographical Essays in Nineteenth-Century Afro-American History*. Baton Rouge: Louisiana University Press, 1986.

———. *Building an Antislavery Wall: Black Americans in the Atlantic Abolitionist Movement, 1830–1860*. Baton Rouge: Louisiana University Press, 1983.

Blair, William A. *Cities of the Dead: Contesting the Memory of the Civil War in the South, 1865–1914*. Chapel Hill: University of North Carolina Press, 2004.

Blair, William A., and Karen Fisher Younger, eds. *Lincoln's Proclamation: Emancipation Reconsidered*. Chapel Hill: University of North Carolina Press, 2009.

Blassingame, John, ed. *Slave Testimony: Two Centuries of Letters, Speeches, Interviews, and Autobiographies*. Baton Rouge: Louisiana State University Press, 1977.

Blight, David W. *Race and Reunion: The Civil War in American Memory*. Cambridge, Mass.: Belknap Press of Harvard University Press, 2001.

Bloom, Lisa. *With Other Eyes: Looking at Race and Gender in Visual Culture*. Minneapolis: University of Minneapolis Press, 1999.

Boyd, Melba J. *Discarded Legacy: Politics and Poetics in the Life of Frances E. W. Harper, 1825–1911*. Detroit, Mich.: Wayne State University Press, 1994.

Brantley, Daniel. "Black Diplomacy and Frederick Douglass' Caribbean Experiences, 1871 and 1889–1891: The Untold Story." *Phylon* 45, no. 3 (1984): 197–209.

Brewer, John. "Sensibility and the Urban Panorama." *Huntington Library Quarterly* 70, no. 2 (2007): 229–49.

Brooks, Daphne A. *Bodies in Dissent: Spectacular Performance of Race and Freedom, 1850–1910*. Durham, N.C.: Duke University Press, 2006.

Brown, Ira V. "Cradle of Feminism: The Philadelphia Female Anti-Slavery Society, 1833–1840." *Pennsylvania Magazine of History and Biography* 102, no. 2 (1978): 143–66.

———. "Racism and Sexism: The Case of Pennsylvania Hall." *Phylon* 37, no. 2 (1976): 126–36.

Brown, Joshua. *Beyond the Lines: Pictorial Reporting, Everyday Life, and the Crisis of Gilded Age America*. Berkeley: University of California, 2002.

Brundage, W. Fitzhugh. "Meta Warrick's 1907 'Negro Tableaux' and (Re)Presenting African American Historical Memory." *Journal of American History* 89, no. 4 (2003): 1368–400.

Bulthuis, Kyle T. *Four Steeples over the City Streets: Religion and Society in New York's Early Republic Congregations*. New York: New York University Press, 2014.

Burin, Eric. *Slavery and the Peculiar Solution: A History of the American Colonization Society*. Gainesville: University of Florida Press, 2005.

Campbell, James T. *Songs of Zion: The African Methodist Episcopal Church in the United States and South Africa*. Chapel Hill: University of North Carolina Press, 1998.

Campbell, Penelope. *Maryland in Africa: The Maryland State Colonization Society, 1831–1857*. Urbana: University of Illinois Press, 1971.

Capers, Corey. "Black Voices, White Print: Racial Practice, Print Publicity, and Order in the Early American Republic." In *Early African American Print Culture*, edited by Lara Langer Cohen and Jordan Alexander Stein, 107–26. Philadelphia: University of Pennsylvania Press, 2012.

Casper, Scott E. "Introduction." In *A History of the Book in America*. Vol. 3, *The Industrial Book, 1840–1880*, edited by Scott E. Casper, Jeffrey D. Grovers, Stephen W. Nissenbaum, and Michael Winship, 1–39. Chapel Hill: Published in association with the American Antiquarian Society by the University of North Carolina Press, 2007.

Chagnon-Burke, Véronique. "'A Career True to Woman's Nature': Constructing the Woman Artist in France's Midcentury Feminine Press." In *Women Art Critics in Nineteenth-Century France: Vanishing Acts*, edited by Wendelin Guentner, 117–34. Newark: University of Delaware, 2013.

Chaney, Michael A. *Fugitive Vision: Slave Image and Black Identity in Antebellum Narrative*. Bloomington: Indiana University Press, 2008.

Charpie, Stephen K. "Francis (Frank) Johnson." In *International Dictionary of Black Composers*. Vol. 2, *Johnson-Work*, edited by Samuel A. Floyd Jr., 15–20. Chicago: Fitzroy Dearborn, 1999.

Clark, Kathleen Ann. *Defining Moments: African American Commemoration and Political Culture in the South, 1863–1913*. Chapel Hill: University of North Carolina Press, 2005.

Clavin, Matthew. *Toussaint Louverture and the American Civil War: The Promise and Peril of a Second Haitian Revolution*. Philadelphia: University of Pennsylvania Press, 2010.

Clegg, Claude Andrew. *The Price of Liberty: African Americans and the Making of Liberia*. Chapel Hill: University of North Carolina Press, 2004.

Clytus, Radiclani. "'Keep It before the People': The Pictorialization of American Abolitionism." In *Early African American Print Culture*, edited by Jordan Alexander Stein and Lara Langer Cohen, 290–317. Philadelphia: University of Pennsylvania Press, 2012.

Cobb, Jasmine Nichole. *Picture Freedom: Remaking Black Visuality in the Early Nineteenth Century*. New York: New York University Press, 2015.

Cohen, Lara. *The Fabrication of American Literature: Fraudulence and Antebellum Print Culture.* Philadelphia: University of Pennsylvania Press, 2011.

Cook, James W. *The Arts of Deception: Playing with Fraud in the Age of Barnum.* Cambridge, Mass.: Harvard University Press, 2001.

———. "Seeing the Visual in U.S. History." *Journal of American History* 95, no. 2 (2008): 432–41.

Crary, Jonathan. *Suspensions of Perception: Attention, Spectacle, and Modern Culture.* Cambridge, Mass.: MIT Press, 2000.

Curtin, Philip D. *The Image of Africa: British Ideas and Action, 1780–1850.* London: Macmillan, 1965.

Cutter, Martha J. *The Illustrated Slave: Empathy, Graphic Narrative, and the Visual Culture of the Transatlantic Abolition Movement, 1800–1852.* Athens: University of Georgia Press, 2017.

Davies, John. "Saint-Dominguan Refugees of African Descent and the Forging of Ethnic Identity in Early National Philadelphia." *Pennsylvania Magazine of History and Biography* 134, no. 2 (2010): 109–26.

Davis, David Brion. *The Problem of Slavery in the Age of Revolution.* Ithaca, N.Y.: Cornell University Press, 1975.

Davis, Thomas J. "Emancipation Rhetoric, Natural Rights, and Revolutionary New England: A Note on Four Black Petitions in Massachusetts, 1773–1777." *New England Quarterly* 62, no. 2 (1989): 253.

Davison, Nancy Reynolds. "E. W. Clay: American Political Caricaturist of the Jacksonian Era." Ph.D. diss., University of Michigan, 1980.

DeCaro, Louis A., Jr. "Black People's Ally, White People's Bogeyman: A John Brown Story." In *The Afterlife of John Brown*, edited by Eldrid Herrington and Andrew Taylor, 11–26. New York: Palgrave Macmillan, 2005.

Deloria, Philip. *Indians in Unexpected Places.* Lawrence: University of Kansas Press, 2004.

Desrochers, Robert, Jr. "Slave-for-Sale Advertisements and Slavery in Massachusetts, 1704–1781." *William and Mary Quarterly*, 3rd ser., 59, no. 3 (2002): 623–64.

Dinius, Marcy. *The Camera and the Press: American Visual and Print Culture in the Age of the Daguerreotype.* Philadelphia: University of Pennsylvania Press, 2012.

Dojtowicz, Richard, and Billy Smith. "Advertisements for Runaway Slaves, Indentured Servants, and Apprentices in the Pennsylvania Gazette, 1795–1796." *Pennsylvania History* 54, no.1 (1987): 34–71.

Dondore, Dorothy. "Panorama and the Flowering of New England." *New England Quarterly* 11, no. 4 (1938): 817–26.

Dorsey, Bruce. "A Gendered History of African Colonization in the Antebellum United States." *Journal of Social History* 34, no. 1 (2000): 77–103.

———. *Reforming Men and Women: Gender in the Antebellum City.* Ithaca, N.Y.: Cornell University Press, 2006.

Drescher, Seymour. "Women's Mobilization in the Era of Slave Emancipation: Some Anglo-French Comparisons." In *Women's Rights and Transatlantic Antislavery in the Era of Emancipation*, edited by Kathryn Kish Sklar and James Brewer Stewart, 98–121. New Haven, Conn.: Yale University Press, 2007.

Dunbar, Erica Armstrong. *A Fragile Freedom: African American Women and Emancipation in the Antebellum City.* New Haven, Conn.: Yale University Press, 2008.

Duro, Paul. "The Lure of Rome: The Academic Copy and the *Académie de France* in the Nineteenth Century." In *Art and the Academy in the Nineteenth Century*, edited by Rafael Cardoso Denis and Colin Trodd, 133–49. New Brunswick, N.J.: Rutgers University Press, 2000.

Ernest, John. *Liberation Historiography: African American Writers and the Challenge of History, 1794–1861*. Chapel Hill: University of North Carolina Press, 2004.

Ewen, Elizabeth Stuart, and Elizabeth Ewen. *Channels of Desire: Mass Images and the Shaping of American Consciousness*. Minneapolis: University of Minnesota Press, 1992.

Fabian, Ann. *The Skull Collectors: Race, Science, and America's Unburied Dead*. Chicago: University of Chicago Press, 2010.

———. *The Unvarnished Truth: Personal Narratives in Nineteenth-Century America*. Berkeley: University of California Press, 2002.

Fahs, Alice. *The Imagined Civil War: Popular Literature of the North and South, 1861–1865*. Chapel Hill: University of North Carolina Press, 2003.

Faulkner, Carol. "The Root of the Evil: Free Produce and Radical Antislavery, 1820–1860." *Journal of the Early Republic* 27, no. 3 (2007): 377–405.

Finlay, Nancy. "Introduction: Taking a Fresh Look at Nineteenth-Century Lithography." In *Picturing Victorian America: Prints by the Kellogg Brothers of Hartford, Connecticut, 1830–1880*, edited by Nancy Finlay, 1–10. Middletown, Conn.: Wesleyan University Press, 2010.

Finley, James. "'The Land of Liberty': Henry Bibb's Free Soil Geographies." *ESQ: A Journal of the American Renaissance* 59, no. 2 (2013): 231–61.

Foner, Eric. *Forever Free: The Story of Emancipation and Reconstruction*. New York: Knopf, 2005.

———. "Politics and Prejudice: The Free Soil Party and the Negro, 1849–1852." *Journal of Negro History* 50, no. 4 (1965): 239–56.

———. *Reconstruction: America's Unfinished Revolution, 1863–1877*. New York: Harper and Row, 1988.

———. "'The Tocsin of Freedom': The Black Leadership of Reconstruction." In *Slavery, Resistance, and Freedom*, edited by Gabor Boritt and Scott Hancock, 118–40. Oxford: Oxford University Press, 2009.

Foner, Philip S. "Black Participation in the Centennial of 1876." *Phylon* 39, no. 4 (1978): 283–96.

Foner, Philip S., and George E. Walker, eds. *Proceedings of the Black State Conventions, 1840–1865*. Vols. 1 and 2. Philadelphia: Temple University Press, 1979.

Foner, Philip S., and Robert J. Branham, eds. *Lift Every Voice: African American Oratory, 1787–1900*. Tuscaloosa: University of Alabama Press, 1998.

Foote, Thelma Wills. *Black and White Manhattan: The History of Racial Formation in Colonial New York City*. Oxford: Oxford University Press, 2004.

Forbes, Ella. "African-American Resistance to Colonization." *Journal of Black Studies* 21, no. 2 (1990): 210–23.

Fox, Early Lee. *The American Colonization Society, 1817–1840*. New York: AMS, 1971.

Friend, Craig Thompson, and Lorri Glover, eds. *Southern Manhood: Perspectives on Masculinity in the Old South*. Athens: University of Georgia Press, 2004.

Gaines, Kevin. *Uplifting the Race: Black Leadership, Politics, and Culture in the Twentieth Century*. Chapel Hill: University of North Carolina Press, 1996.

Gambee, Budd Leslie, Jr. "*Frank Leslie's Illustrated Newspaper*, 1855–1860: Artistic and

Technical Operations of a Pioneer New Weekly in America." Ph.D. diss., University of Michigan, 1963.

Gannon, Barbara A. "Sites of Memory, Sites of Glory: African-American Grand Army of the Republic Posts in Pennsylvania." In *Making and Remaking Pennsylvania's Civil War*, edited by William Blair and William Pencak, 165–88. State College: Penn State University Press, 2012.

Gara, Larry. "The Professional Fugitive in the Abolition Movement." *Wisconsin Magazine of History* 48, no. 3 (1965): 196–204.

Gates, Henry Louis, and Evelyn Brooks Higginbotham, eds. *African American Lives*. Oxford: Oxford University Press, 2004.

Geffert, Hannah N. "John Brown and His Black Allies: An Ignored Alliance." *Pennsylvania Magazine of History and Biography* 126, no. 4 (2002): 591–610.

Gellman, David N., and David Quigley, eds. *Jim Crow New York: A Documentary History of Race and Citizenship, 1777–1877*. New York: New York University Press, 2003.

Gilpin, R. Blakeslee. *John Brown Still Lives! America's Long Reckoning with Violence, Equality, and Change*. Chapel Hill: University of North Carolina Press, 2011.

Glickman, Lawrence. "'Buy for Sake of the Slave': Abolitionism and the Origins of American Consumer Activism." *American Quarterly* 56, no. 4 (2004): 889–912.

Glymph, Thavolia. "Rose's War and the Gendered Politics of a Slave Insurgency in the Civil War." *Journal of the Civil War Era* 3, no. 4 (2013): 501–32.

———. *The Women's Fight: The Civil War's Battles for Home, Freedom, and Nation*. Chapel Hill: University of North Carolina Press, 2020.

Goddu, Teresa A. "Anti-Slavery's Panoramic Perspective." *MELUS: Multi-Ethnic Literature of the U.S.* 39, no. 2 (2014): 12–41.

Gonzalez, Aston. "The Art of Racial Politics: The Work of Robert Douglass Jr., 1833–46." *Pennsylvania Magazine of History and Biography* 138, no. 1 (January 2014): 5–37.

———. "Claiming Space, Bearing Witness: The Portraits of Early African American Ministers." In *African American Literature in Transition, 1750–2015*. Vol. 2, *1800–1830*, edited by Jocelyn K. Moody. Cambridge: Cambridge University Press, forthcoming.

———. "Stealing Freedom: Robert Smalls and Modeling Citizenship." In *Visions of Glory: The Civil War in Word and Image*, edited by Kathleen Diffley and Benjamin Fagan, 65–74. Athens: University of Georgia Press, 2019.

———. "Stolen Looks, People Unbound: Picturing Contraband People during the Civil War." *Slavery and Abolition* 40, no. 1 (2019): 28–60.

Gordon, Sarah Barringer. "The African Supplement: Religion, Race, and Corporate Laws in Early National America." *William and Mary Quarterly*, 3rd ser., 72, no. 3 (2015): 385–422.

Gosse, Van. "'As a Nation, the English Are Our Friends': The Emergence of African American Politics in the British Atlantic World, 1772–1862." *American Historical Review* 113, no. 4 (2008): 1003–28.

Gould, William Benjamin, IV. *Diary of a Contraband: The Civil War Passage of a Black Sailor*. Stanford, Calif.: Stanford University Press, 2002.

Greenspan, Ezra. *William Wells Brown: An African American Life*. New York: W. W. Norton, 2014.

———, ed. *William Wells Brown: A Reader*. Athens: University of Georgia Press, 2008.

Greenwald, Eric, ed. *In Search of Julien Hudson: Free Artist of Color in Pre–Civil War New Orleans*. New Orleans, La.: Historic New Orleans Collection, 2010.

Grigsby, Darcy Grimaldo. *Enduring Truths: Sojourner's Shadows and Substance*. Chicago: University of Chicago Press, 2015.

Gross, Linda P., and Theresa R. Snyder. *Images of America: Philadelphia's 1876 Centennial Exhibition*. Chicago: Arcadia, 2005.

Gundaker, Grey. "Give Me a Sign: African Americans, Print, and Practice." In *An Extensive Republic: Print, Culture, and Society, 1790–1840*, edited by Robert Gross and Mary Kelley, 483–94. Chapel Hill: University of North Carolina Press, 2010.

Guyatt, Nicholas. "America's Conservatory: Race, Reconstruction, and the Santo Domingo Debate." *Journal of American History* 97, no. 4 (2011): 974–1000.

———. "'The Outskirts of Our Happiness': Race and the Lure of Colonization in the Early Republic." *Journal of American History* 95, no. 4 (2009): 986–1011.

Hahn, Steven. *A Nation under Our Feet: Black Political Struggles in the Rural South from Slavery to the Great Migration*. Cambridge, Mass.: Belknap Press of Harvard University Press, 2003.

Hall, Catherine. *Civilising Subjects: Metropole and Colony in the English Imagination, 1830–1867*. Chicago: University of Chicago Press, 2002.

Hall, Stephen H. *A Faithful Account of the Race: African American Historical Writing in Nineteenth-Century America*. Chapel Hill: University of North Carolina Press, 2009.

Hall, Stuart. "The Spectacle of the 'Other.'" In *Representation: Cultural Representations and Signifying Practices*, edited by Stuart Hall, 5–17. London: SAGE, 1997.

Halttunen, Karen. *Confidence Men and Painted Women: A Study of Middle-Class Culture in America, 1830–1870*. New Haven, Conn.: Yale University Press, 1982.

Hamilton, Cynthia S. "'Am I Not a Man and a Brother?' Phrenology and Anti-Slavery." *Slavery and Abolition* 29, no. 2 (2008): 173–87.

———. "Hercules Subdued: The Visual Rhetoric of the Kneeling Slave." *Slavery and Abolition* 34, no. 4 (2013): 631–52.

Hanners, John. "The Adventures of an Artist: John Banvard (1815–1891) and His Mississippi Panorama." Ph.D. diss., Michigan State University, 1979.

———. "John Banvard's Mississippi Panorama." *American History Illustrated* 17, no. 4 (July 1982): 30–39.

———. "A Tale of Two Artists: Anna Mary Howitt's Portrait of John Banvard." *Minnesota History* 50, no. 5 (1987): 204–8.

Harris, Katharine J. "'No Taxation without Representation': Black Voting in Connecticut." In *African American Connecticut Explored*, edited by Elizabeth J. Normen, 3–12. Middletown, Conn.: Wesleyan University Press, 2014.

Harris, Leslie M. *In the Shadow of Slavery: African Americans in New York City, 1826–1863*. Chicago: University of Chicago Press, 2003.

Heilbron, Bertha L. "Documentary Panorama." *Minnesota History* 30, no. 1 (1949): 14–23.

———. *Making a Motion Picture in 1848: Henry Lewis' Journal of a Canoe Voyage from the Falls of St. Anthony to St. Louis*. St. Paul: Minnesota Historical Society, 1936.

Hewitt, John H. "Peter Williams, Jr.: New York's First African-American Episcopal Priest." *New York History* 79, no. 2 (1998): 101–29.

Hodges, Graham Russell Gao. *David Ruggles: A Radical Black Abolitionist and the Underground Railroad in New York City*. Chapel Hill: University of North Carolina Press, 2010.

———. *Root and Branch: African Americans in New York and East Jersey, 1613–1863*. Chapel Hill: University of North Carolina Press, 1999.

Holcomb, Julie L. *Moral Commerce: Quakers and the Transatlantic Boycott of the Slave Labor Economy.* New York: Columbia University Press, 2016.

Holland, Juanita Marie. "To Be Free, Gifted, and Black: African American Artist Edward Mitchell Bannister." *International Review of African American Art* 12, no. 1 (1995): 4–25.

Holt, Thomas. "Marking: Race, Race-Making, and the Writing of History." *American Historical Review* 100, no. 1 (1995): 1–20.

Hoobler, Dorothy, and Thomas Hoobler. *The African American Family Album.* Oxford: Oxford University Press, 1995.

Horton, James O., and Lois Horton. *In Hope of Liberty: Culture, Community and Protest among Northern Free Blacks, 1700–1860.* New York: Oxford University Press, 1998.

Hunt, Alfred N. *Haiti's Influence on Antebellum America: Slumbering Volcano in the Caribbean.* Baton Rouge: Louisiana State University Press, 2006.

Hutton, Frankie. "Economic Considerations in the American Colonization Society's Early Effort to Emigrate Free Blacks to Liberia, 1816–36." *Journal of Negro History* 68, no. 4 (1983): 376–89.

Jablow, Alta. *The Africa That Never Was: Four Centuries of British Writing about Africa.* New York: Twayne, 1970.

James, Jennifer C. *A Freedom Bought with Blood: African American War Literature from the Civil War to World War II.* Chapel Hill: University of North Carolina Press, 2007.

Jarenski, Shelly. "'Delighted and Instructed': African American Challenges to Panoramic Aesthetics in J. P. Ball, Kara Walker, and Frederick Douglass." *American Quarterly* 65, no. 1 (2013): 119–55.

Johnson, Carol. "Faces of Freedom: Portraits from the American Colonization Society Collection." *Daguerrian Annual* (1996): 265–78.

Johnston, Patricia. *Real Fantasies: Edward Steichen's Advertising Photography.* Berkeley: University of California Press, 1997.

———, ed. *Seeing High and Low: Representing Social Conflict in American Visual Culture.* Berkeley: University of California Press, 2005.

Jones, Charles K. *Francis Johnson (1792–1844): Chronicle of a Black Musician in Early Nineteenth-Century Philadelphia.* Bethlehem, Pa.: Lehigh University Press, 2006.

Jones, Martha S. *All Bound Up Together: The Woman Question in African American Public Culture.* Chapel Hill: University of North Carolina Press, 2007.

———. *Birthright Citizens: A History of Race and Rights in Antebellum America.* Cambridge: Cambridge University Press, 2018.

———. "Edward Clay's Life in Philadelphia." In *An Americana Sampler: Essays on Selections from the William L. Clements Library,* edited by Brian Leigh Dunnigan and J. Kevin Graffagnino. Ann Arbor: University of Michigan Press, 2011.

———. "Reframing the Color Line." In *Reframing the Color Line: Race and the Visual Culture of the Atlantic World,* edited by Martha S. Jones and Clayton Lewis. Ann Arbor: University of Michigan Press, 2009.

Jones, Steven. "A Keen Sense of the Artistic: African American Material Culture in 19th Century Philadelphia." *International Review of African American Art* 12, no. 2 (1995): 11.

Juster, Susan. *Doomsayers: Anglo-American Prophecy in the Age of Revolution.* Philadelphia: University of Pennsylvania Press, 2003.

Kachun, Mitch. "Antebellum African Americans, Public Commemoration, and the Haitian Revolution: A Problem of Historical Mythmaking." *Journal of the Early Republic* 26, no. 2 (2006): 249–73.

————. "Before the Eyes of All Nations: African-American Identity and Historical Memory at the Centennial Exposition of 1876." *Pennsylvania History* 65, no. 3 (1998): 300–323.

————. "From Forgotten Founder to Indispensable Icon: Crispus Attucks, Black Citizenship, and Collective Memory, 1770–1865." *Journal of the Early Republic* 29, no. 2 (2009): 249–86.

Kahrl, Andrew W. "The Political Work of Leisure: Class, Recreation and African American Commemoration at Harper's Ferry, West Virginia, 1881–1931." *Journal of Social History* 42, no. 1 (2008): 57–77.

Kazanjian, David. "The Speculative Freedom of Colonial Liberia." *American Quarterly* 63, no. 4 (2011): 863–93.

Kelly, Catherine E. *In the New England Fashion*. Ithaca, N.Y.: Cornell University Press, 1999.

Kellow, Margaret M. R. "Conflicting Imperatives: Black and White American Abolitionists Debate Slave Redemption." In *Buying Freedom: The Ethics and Economics of Slave Redemption*, edited by Kwame Anthony Appiah and Martin Bunzl, 200–212. Princeton, N.J.: Princeton University Press, 2007.

Kendi, Ibram X. *Stamped from the Beginning: The Definitive History of Racist Ideas in America*. New York: Nation Books, 2016.

Ketner, Joseph D. *The Emergence of the African-American Artist*. Columbia: University of Missouri Press, 2004.

————. "'Struggles Many and Great': James P. Ball, Robert Duncanson, and Other Artists of Color in Antebellum Cincinnati." *Antiques* 178, no. 6 (2011): 108–15.

Koivunen, Leila. *Visualizing Africa in Nineteenth-Century British Accounts*. New York: Routledge, 2008.

Kremer, Gary R. *James Milton Turner and the Promise of America: The Public Life of a Post–Civil War Black Leader*. Columbia: University of Missouri Press, 1991.

Krentz, Christopher. "A 'Vacant Receptacle'? Blind Tom, Cognitive Difference, and Pedagogy." *PMLA* 120, no. 2 (2005): 552–57.

Kruger, Loren. "'White Cities,' 'Diamond Zulus,' and the 'African Contribution to Human Advancement': African Modernities and the World's Fairs." *TDR: The Drama Review* 51, no. 3 (2007): 19–45.

Lancaster, Jane. "'I Would Have Made Out Very Poorly Had It Not Been for Her': The Life and Work of Christianna Bannister, Hair Doctress and Philanthropist." *Rhode Island History* 59, no. 4 (2001): 103–22.

Landon, Fred. "Henry Bibb, a Colonizer." *Journal of Negro History* 5, no. 4 (1920): 437–47.

Lapsansky, Emma. "'Since They Got Those Separate Churches': Afro-Americans and Racism in Jacksonian Philadelphia." *American Quarterly* 32, no. 1 (1980): 54–78.

Lapsansky, Phillip. "Afro-Americana: Meet the Dickersons." In *The Library Company of Philadelphia, 1993 Annual Report*, 17–24. Philadelphia: Library Company of Philadelphia, 1994.

————. "Graphic Discord: Abolitionist and Antiabolitionist Images." In *Abolitionist Sisterhood: Women's Political Culture in Antebellum America*, edited by Jean Fagan Yellin and John C. Van Horne, 201–30. Ithaca, N.Y.: Cornell University Press, 1994.

Lapsansky-Werner, Emma, and Margaret Hope Bacon, eds. *Back to Africa: Benjamin Coates and the Colonization Movement in America, 1848–1880*. University Park: Pennsylvania State University Press, 2006.

Lasser, Carol. "Voyeuristic Abolitionism: Sex, Gender, and the Transformation of Antislavery Rhetoric." *Journal of the Early Republic* 28 no. 1 (2008): 83–114.

Lears, Jackson. *Fables of Abundance: A Cultural History of Advertising in America*. New York: Basic Books, 1994.

Ledell, Eric. "The End of Black Voting Rights in Pennsylvania: African Americans and the Constitutional Convention of 1837–1838." *Pennsylvania History: A Journal of Mid-Atlantic Studies* 65, no. 3 (1998): 279–99.

Lee, Anthony. *Picturing Chinatown: Art and Orientalism in San Francisco*. Berkeley: University of California Press, 2001.

Lemire, Elise. *"Miscegenation": Making Race in America*. Philadelphia: University of Pennsylvania Press, 2002.

Lerner, Gerda. *The Grimké Sisters from South Carolina: Pioneers for Women's Rights and Abolition*. Chapel Hill: University of North Carolina Press, 2004.

Levesque, George A. "Black Abolitionists in the Age of Jackson: Catalysts in the Radicalization of American Abolitionism." *Journal of Black Studies* 1, no. 2 (1970): 187–201.

Levine, Bruce. *Confederate Emancipation: Southern Plans to Free and Arm Slaves during the Civil War*. Oxford: Oxford University Press, 2005.

Lhamon, W. T. *Jump Jim Crow: Lost Plays, Lyrics, and Street Prose of the First Atlantic Popular Culture*. Cambridge, Mass.: Harvard University Press, 2003.

———. *Raising Cain: Blackface Performance from Jim Crow to Hip Hop*. Cambridge, Mass.: Harvard University Press, 2000.

Little, Lawrence. *Disciples of Liberty: The African Methodist Episcopal Church in the Age of Imperialism, 1884–1916*. Knoxville: University of Tennessee Press, 2000.

Litwack, Leon F. *Been in the Storm So Long: The Aftermath of Slavery*. New York: Vintage Books, 1980.

Logan, Rayford W. *Haiti and the Dominican Republic*. New York: Oxford University Press, 1968.

Lott, Eric. *Love and Theft: Blackface Minstrelsy and the American Working Class*. Oxford: Oxford University Press, 1993.

Lubet, Steven. *Fugitive Justice: Runaways, Rescuers, and Slavery on Trial*. Cambridge, Mass.: Harvard University Press, 2010.

Lynch, Hollis R. "Edward W. Blyden: Pioneer West African Nationalist." *Journal of African History* 6, no. 3 (1965): 374.

———. *Edward Wilmot Blyden: Pan-Negro Patriot, 1832–1912*. Oxford: Oxford University Press, 1970.

Maffly-Kipp, Laurie. *Setting Down the Sacred Past: African American Race Histories*. Cambridge, Mass.: Belknap Press of Harvard University Press, 2010.

Mahar, William J. *Behind the Burnt Cork Mask: Early Blackface Minstrelsy and Antebellum American Popular Culture*. Urbana: University of Illinois Press, 1999.

Maidment, Brian. *Reading Political Prints, 1790–1870*. Manchester, U.K.: Manchester University Press, 2001.

Malamud, Margaret. *Ancient Rome and Modern America*. Chichester, U.K.: Wiley-Blackwell, 2009.

Malone, Christopher. *Between Freedom and Bondage: Race, Party, and Voting Rights in the Antebellum North*. New York: Routledge, 2008.

Manning, Chandra. *Troubled Refuge: Struggling for Freedom in the Civil War*. New York: Vintage Books, 2017.

———. "Working for Citizenship in Civil War Contraband Camps." *Journal of the Civil War Era* 4, no. 2 (2014): 172–204.

Manring, M. M. *Slave in a Box: The Strange Career of Aunt Jemima*. Charlottesville: University of Virginia Press, 1998.

Marchand, Roland. *Advertising the American Dream: Making Way for Modernity*. Berkeley: University of California Press, 1985.

Martin, Jane. "Krumen 'Down the Coast': Liberian Migrants on the West African Coast in the 19th and Early 20th Centuries." *International Journal of African Historical Studies* 18, no. 3 (1985): 401–23.

Martin, Theodore, ed. *The Works of Horace: Translated into English Verse, with a Life and Notes*. Vol. 2. London: William Blackwood and Sons, 1881.

Masten, April F. *Art Work: Women Artists and Democracy in Mid-Nineteenth Century New York*. Philadelphia: University of Philadelphia Press, 2008.

Masur, Kate. "The African American Delegation to Lincoln: A Reappraisal." *Civil War History* 56, no. 2 (2010): 117–44.

———. "'A Rare Phenomenon of Philological Vegetation': The Word 'Contraband' and the Meaning of Emancipation in the United States." *Journal of American History* 93, no. 4 (2007): 1050–84.

Masur, Louis P. *Lincoln's Hundred Days: The Emancipation Proclamation and the War for Union*. Cambridge, Mass.: Harvard University Press, 2012.

May, Nicholas. "Holy Rebellion: Religious Assembly Laws in Antebellum South Carolina and Virginia." *American Journal of Legal History* 49, no. 3 (2007): 237–56.

McBride, David. "Black Protest against Racial Politics: Gardner, Hinton, and Their Memorial of 1838." *Pennsylvania History: A Journal of Mid-Atlantic Studies* 46, no. 2 (1979): 149–62.

McCarthy, Timothy Patrick, and John Stauffer, eds. *Prophets of Protest: Reconsidering the History of the American Abolitionism*. New York: New Press, 2006.

McCurry, Stephanie. *Women's War: Fighting and Surviving the American Civil War*. Cambridge, Mass.: Belknap Press of Harvard University Press, 2019.

McDaniel, W. Caleb. "The Fourth and the First: Abolitionist Holidays, Respectability, and Radical Interracial Reform." *American Quarterly* 57, no. 1 (2005): 129–51.

———. *The Problem of Democracy in the Age of Slavery: Garrisonian Abolitionists and Transatlantic Reform*. Baton Rouge: Louisiana State University Press, 2013.

McElya, Micki. *Clinging to Mammy: The Faithful Slave in Twentieth-Century America*. Cambridge, Mass.: Harvard University Press, 2007.

McHenry, Elizabeth. *Forgotten Readers: Recovering the Lost History of African American Literary Societies*. Durham, N.C.: Duke University Press, 2002.

McInnis, Maurie D. *Slaves Waiting for Sale: Abolitionist Art and the American Slave Trade*. Chicago: University of Chicago Press, 2011.

McManus, Edgar J. *A History of Negro Slavery in New York*. Syracuse, N.Y.: Syracuse University Press, 2001.

McNeily, J. S. "War and Reconstruction in Mississippi, 1863–1890." In *Publications of the Mississippi Historical Society, Centenary Series*. Vol. 2, edited by Dunbar Rowland, 165–535. Jackson: Mississippi Historical Society, 1918.

McPherson, James M. *Crossroads of Freedom: Antietam*. Oxford: Oxford University Press, 2002.

———. *For Cause and Comrades: Why Men Fought in the Civil War*. Oxford: Oxford University Press, 1998.

Meaders, Daniel. *Advertisements for Runaway Slaves in Virginia, 1801–1820*. New York: Routledge, 1997.

Melish, Joanne Pope. *Disowning Slavery: Gradual Emancipation and Race in New England, 1780–1860*. Ithaca, N.Y.: Cornell University Press, 2000.

Midgley, Claire. *Feminism and Empire: Women Activists in Imperial Britain, 1790–1865*. New York: Routledge, 2007.

Miller, Albert G. *Elevating the Race: Theophilus G. Steward, Black Theology, and the Making of an African American Civil Society, 1865–1924*. Knoxville: University of Tennessee Press, 2003.

Miller, Angela. "The Mechanisms of the Market and the Invention of Western Regionalism: The Example of George Caleb Bingham." *Oxford Art Journal* 15, no. 1 (1992): 3–20.

———. "The Panorama, the Cinema, and the Emergence of the Spectacular." *Wide Angle* 18, no. 2 (1996): 34–59.

Miller, Edward. *Gullah Statesman: Robert Smalls from Slavery to Congress, 1839–1915*. Columbia: University of South Carolina Press, 1995.

Miller, Floyd. *The Search for a Black Nationality: Black Emigration and Colonization, 1787–1863*. Urbana: University of Illinois Press, 1975.

Mills, Brandon. "'The United States of Africa': Liberian Independence and the Contested Meaning of a Black Republic." *Journal of the Early Republic* 34, no. 1 (2014): 79–107.

Mitchell, Mary Niall. *Raising Freedom's Child: Black Children and Visions of the Future after Slavery*. New York: New York University Press, 2008.

———. "'Rosebloom and Pure White,' or So It Seemed." *American Quarterly* 54, no. 3 (2002): 369–410.

Montgomery, William E. *Under Their Own Vine and Fig Tree: The African-American Church in the South*. Baton Rouge: Louisiana State University Press, 1994.

Morgan-Owens, Jessie. *Girl in Black and White: The Story of Mary Mildred Williams and the Abolition Movement*. New York: W.W. Norton, 2019.

Moses, Wilson J. "Civilizing Missionary: A Study of Alexander Crummell." *Journal of Negro History* 60, no. 2 (1975): 229–51.

———. *Creative Conflict in African American Thought*. Cambridge: Cambridge University Press, 2004.

Motz, Marilyn F. "Visual Autobiography: Photograph Albums of Turn-of-the-Century Midwestern Women." *American Quarterly* 41, no. 1 (1989): 63–92.

Nash, Gary. *Forging Freedom: The Formation of Philadelphia's Black Community, 1720–1840*. Cambridge, Mass.: Harvard University Press, 1988.

Nelson, Danielle. *Edward J. Roye: From Newark, Ohio, to Liberia*. Columbus: Ohio State University Press, 2004.

Nerone, John. "Newspapers and the Public Sphere." In *A History of the Book in America*. Vol. 3, *The Industrial Book, 1840–1880*, edited by Scott E. Casper, Jeffrey D. Grovers, Stephen W. Nissenbaum, and Michael Winship, 230–47. Chapel Hill: Published in association with the American Antiquarian Society by the University of North Carolina Press, 2007.

Newman, Richard S. *Freedom's Prophet: Bishop Richard Allen, the AME Church, and the Black Founding Fathers*. New York: New York University Press, 2008.

———. *The Transformation of American Abolitionism: Fighting Slavery in the Early Republic*. Chapel Hill: University of North Carolina Press, 2002.

Newman, Richard S., Patrick Rael, and Phil Lapsansky, eds. *Pamphlets of Protest: An Anthology of Early African-American Protest Literature, 1790–1860*. New York: Routledge, 2000.

Normen, Elizabeth J., ed. *African American Connecticut Explored*. Middletown, Conn.: Wesleyan University Press, 2014.

Nwankwo, James T. *Black Cosmopolitanism, Racial Consciousness and Transnational Identity in the Nineteenth-Century Americas*. Philadelphia: University of Pennsylvania Press, 2005.

O'Connell, Deirdre. *The Ballad of Blind Tom, Slave Pianist*. New York: Overlook, 2009.

Oettermann, Stephan. *The Panorama: History of a Mass Medium*. Translated by Deborah Lucas Schneider. New York: Zone Books.

Oldfield, J. R. "Anti-Slavery Sentiment in Children's Literature, 1750–1850." *Slavery and Abolition* 10, no. 1 (1989): 44–59.

———. *Transatlantic Abolitionism in the Age of Revolution*. Cambridge: Cambridge University Press, 2013.

Olivier, Marc. "George Eastman's Modern Stone-Age Family: Snapshot Photography and the Brownie." *Technology and Culture* 48, no. 1 (2007): 1–19.

Painter, Nell Irvin. *Sojourner Truth: A Life, A Symbol*. New York: W. W. Norton, 1996.

Panzer, Mary. *Mathew Brady and the Image of History*. Washington, D.C.: Smithsonian Institution Press, 1997.

Pease, Jane H., and William H. Pease. "Ends, Means, and Attitudes: Black-White Conflict in the Antislavery Movement." *Civil War History* 18, no. 2 (1972): 117–28.

———. *They Who Would Be Free: Blacks' Search for Freedom, 1830–1861*. New York: Atheneum, 1974.

Peavler, David J. "African Americans in Omaha and the 1898 Trans-Mississippi and International Exposition." *Journal of African American History* 93, no. 3 (2008): 337–61.

Peterson, Carla. *Black Gotham: A Family History of African Americans in Nineteenth-Century New York*. New Haven, Conn.: Yale University Press, 2011.

———. *Doers of the Word: African-American Women Speakers and Writers in the North, 1830–1880*. New Brunswick, N.J.: Rutgers University Press, 1998.

Pilgrim, Danya. "Masters of a Craft: Philadelphia's Black Public Waiters, 1820–1850." *Pennsylvania Magazine of History and Biography* 142, no. 3 (2018): 269–93.

Pitre, Merline. "Frederick Douglass and the Annexation of Santo Domingo." *Journal of Negro History* 62, no. 4 (1977): 390–400.

Polyné, Millery. "Expansion Now! Haiti, 'Santo Domingo,' and Frederick Douglass at the Intersection of U.S. and Caribbean Pan-Americanism." *Caribbean Studies* 34, no. 2 (2006): 3–45.

———. *From Douglass to Duvalier: U.S. African Americans, Haiti, and Pan Americanism, 1870–1964*. Gainesville: University of Florida Press, 2010.

Portnoy, Alisse. *Their Right to Speak: Women's Activism in the Indian and Slave Debates*. Cambridge, Mass.: Harvard University Press, 2005.

Power-Greene, Ousmane K. *Against Wind and Tide: The African American Struggle against the Colonization Movement*. New York: New York University Press, 2014.

Quarles, Benjamin. *Allies for Freedom: Blacks and John Brown*. New York: De Capo, 1974.
———. *Black Abolitionists*. New York: Da Capo, 1991.
Rael, Patrick. *Black Identity and Black Protest in the Antebellum North*. Chapel Hill: University of North Carolina Press, 2002.
Ramold, Steven J. *Slaves, Sailors, Citizens: African Americans in the Union Navy*. DeKalb: Northern Illinois University Press, 2002.
Richard, Carl J. *The Founders and the Classics: Greece, Rome, and the American Enlightenment*. Cambridge, Mass.: Harvard University Press, 1995.
———. *The Golden Age of the Classics in America: Greece, Rome, and the Antebellum United State*. Cambridge, Mass.: Harvard University Press, 2009.
Riis, Thomas L. "The Experience and Impact of Black Entertainers in England, 1895–1920." *American Music* 4, no. 1 (1986): 50–58.
Roberts, Rita. "Patriotism and Political Criticism: The Evolution of Political Consciousness in the Mind of a Black Revolutionary Soldier." *Eighteenth-Century Studies* 27, no. 4 (1994): 587.
Rohrbach, Augusta. "'Truth Stronger and Stranger than Fiction': Reexamining William Lloyd Garrison's Liberator." *American Literature* 73, no. 4 (2001): 727–55.
Rosen, Hannah. *Terror in the Heart of Freedom: Citizenship, Sexual Violence and the Meaning of Race in the Postemancipation South*. Chapel Hill: University of North Carolina Press, 2008.
Rosenheim, Jeff L. *Photography and the American Civil War*. New York: Metropolitan Museum of Art, 2013.
Rowden, Terry. *The Songs of Blind Folk: African American Musicians and the Culture of Blindness*. Ann Arbor: University of Michigan Press, 2009.
Ruggles, Jeffrey. *The Unboxing of Henry Brown*. Richmond, Va.: Library of Virginia, 2003.
Rury, John L. "The New York African Free School, 1827–1836: Conflict over Community Control of Black Education." *Phylon* 44, no. 3 (1983): 187–97.
Rusert, Britt. *Fugitive Science: Empiricism and Freedom in Early African American Culture*. New York: New York University Press, 2017.
Rutledge, Anna Wells, ed. *The Pennsylvania Academy of the Fine Arts, 1807–1870: Cumulative Record and Exhibition Catalogue*. Philadelphia: American Philosophical Society, 1955.
Saha, Santosh. "Agriculture in Liberia during the Nineteenth Century: Americo-Liberians' Contribution." *Canadian Journal of African Studies* 22, no. 2 (1988): 224–39.
Sandweiss, Martha A. *Print the Legend: Photography and the American West*. New Haven, Conn.: Yale University Press, 2002.
Schafer, Judith Kelleher. "New Orleans Slavery in 1850 as Seen in Advertisements." *Journal of Southern History* 47, no. 1 (1981): 33–56.
Schiebinger, Londa. *Nature's Body: Gender in the Making of Modern Science*. New Brunswick, N.J.: Rutgers University Press, 1993.
Schmidt-Nowara, Christopher. *Empire and Slavery: Spain, Cuba, and Puerto Rico, 1833–1874*. Pittsburgh: Pittsburgh University Press, 1999.
Scott, Julius. *The Common Wind: Afro-American Currents in the Age of the Haitian Revolution*. New York: Verso, 2018.
Scott, Rebecca J. *Degrees of Freedom: Louisiana and Cuba after Slavery*. Cambridge, Mass.: Belknap Press of Harvard University Press, 2005.
———. "Gradual Abolition and the Dynamics of Slave Emancipation in Cuba, 1868–86." *Hispanic American Historical Review* 63, no. 3 (1983): 449–77.

Scruggs, Dalila. "'The Love of Liberty Has Brought Us Here': The American Colonization Society and the Imaging of African-American Settlers in Liberia." Ph.D. diss., Harvard University, 2010.

Scruggs, Otey M. "Two Black Patriarchs: Frederick Douglass and Alexander Crummell." *Afro-Americans in New York Life and History* 6, no. 1 (1982): 17–50.

Seraile, William. *Fire in His Heart: Bishop Benjamin Tucker Tanner and the A.M.E. Church.* Knoxville: University of Tennessee Press, 1999.

Sewell, George Alexander. *Mississippi Black History Makers.* Jackson: University Press of Mississippi, 1977.

Shalev, Eran. *Rome Reborn on Western Shores: Historical Imagination and the Creation of the American Republic.* Charlottesville: University of Virginia Press, 2009.

Sharpless, Rebecca. *Cooking in Other Women's Kitchens: Domestic Workers in the South, 1865–1960.* Chapel Hill: University of North Carolina Press, 2010.

Shaw, Gwendolyn DuBois. *Portraits of a People: Picturing African Americans in the Nineteenth Century.* Andover, Mass.: Addison Gallery of American Art, 2006.

Shumard, Ann M. *A Durable Memento: Augustus Washington, African American Daguerreotypist.* Washington, D.C.: National Portrait Gallery, 1999.

Siegel, Elizabeth. *Galleries of Friendship and Fame: A History of Nineteenth-Century American Photograph Albums.* New Haven, Conn.: Yale University Press, 2010.

Silkenat, David. "'A Typical Negro': Gordon, Peter, Vincent Colyer, and the Story behind Slavery's Most Famous Photograph." *American Nineteenth Century History* 15, no. 2 (2014): 169–86.

Singerman, Howard. *Art Subjects: Making Artists in the American University.* Berkeley: University of California Press, 1999.

Sinha, Manisha. "An Alternative Tradition of Radicalism: African American Abolitionists and the Metaphor of Revolution." In *Contested Democracy: Freedom, Race, and Power in American History,* edited by Manisha Sinha and Penny Von Eschen, 9–30. New York: Columbia University Press, 2007.

———. *The Slave's Cause: A History of Abolition.* New Haven, Conn.: Yale University Press, 2016.

———. "To 'Cast Just Obliquy' on Oppressors: Black Radicalism in the Age of Revolution." *William and Mary Quarterly,* 3rd ser., 64, no. 1 (2007): 149–60.

Sklar, Kathryn Kish. "'Women Who Speak for an Entire Nation': American and British Women Compared at the World Anti-Slavery Convention, London, 1840." *Pacific Historical Review* 59, no. 4 (1990): 453–99.

Smith, Anna Bustill. "The Bustill Family." *Journal of Negro History* 10, no. 4 (1925): 638–44.

Smith, Shawn Michelle. *American Archives: Gender, Race, and Class in Visual Culture.* Princeton, N.J.: Princeton University Press, 1999.

———. *At the Edge of Sight: Photography and the Unseen.* Durham, N.C.: Duke University Press, 2013.

———. "'Baby's Picture Is Always Treasured': Eugenics and Reproduction of Whiteness in the Family Photograph Album." *Yale Journal of Criticism* 11, no. 1 (1998): 197–220.

———. *Photography on the Color Line: W. E. B. DuBois, Race, and Visual Culture.* Durham, N.C.: Duke University Press, 2004.

Smith, Shawn Michelle, and Maurice O. Wallace, eds. *Pictures and Progress: Early*

Photography and the Making of African American Identity. Durham, N.C.: Duke
 University Press, 2012.
Soderlund, Jean R. *Quakers and Slavery: A Divided Spirit.* Princeton, N.J.: Princeton
 University Press, 1985.
Southall, Geneva Handy. *Blind Tom, the Black Pianist-Composer, 1849–1908, Continually
 Enslaved.* Lanham, Md.: Scarecrow, 2002.
———. *Blind Tom: The Post–Civil War Enslavement of a Black Musical Genius.*
 Minneapolis: Challenge Productions, 1978.
Southern, Eileen. "Frank Johnson of Philadelphia and His Promenade Concerts." *Black
 Perspective in Music* 5, no. 1 (1977): 3–29.
———. "Musical Practices in Black Churches of Philadelphia and New York, ca. 1800–
 1844." *Journal of the American Musicological Society* 30, no. 2 (1977): 296–312.
Stango, Marie. "Vine and Palm Tree: African American Families in Liberia, 1820–1860."
 Ph.D. Dissertation, University of Michigan, 2016.
Stanton, William. *The Leopard's Spots: Scientific Attitudes toward Race in America, 1815–59.*
 Chicago: University of Chicago Press, 1960.
Staudenraus, Philip John. *The African Colonization Movement, 1816–1865.* New York:
 Columbia University Press, 1961.
Stauffer, John, Zoe Trodd, and Celeste-Marie Bernier. *Picturing Frederick Douglass: An
 Illustrated Biography of the Nineteenth Century's Most Photographed American.* New York:
 Liveright, 2015.
Sweet, John Wood. *Bodies Politic: Negotiating Race in the American North, 1730–1830.*
 Philadelphia: University of Pennsylvania Press, 2003.
Swift, David. *Black Prophets of Justice: Activist Clergy before the Civil War.* Baton Rouge:
 Louisiana State University Press, 1989.
Syfert, Dwight N. "The Liberian Coasting Trade, 1822–1900." *Journal of African History* 18,
 no. 2 (1977): 217–35.
Taylor, Amy Murrell. *Embattled Freedom: Journeys through the Civil War's Slave Refugee
 Camps.* Chapel Hill: University of North Carolina Press, 2018.
Taylor, Henry L. "Spatial Organization and the Residential Experience: Black Cincinnati
 in 1850." *Social Science History* 10, no. 1 (1986): 45–69.
Taylor, Nikki. *Frontiers of Freedom: Cincinnati's Black Community, 1802–1868.* Athens: Ohio
 University Press, 2005.
Thompson, Julius Eric. *Black Life in Mississippi: Essays on Political, Social, and Cultural
 Studies in a Deep South State.* Lanham, Md.: University Press of America, 2001.
Timberlake, Richard H. *Monetary Policy in the United States: An Intellectual and
 Institutional History.* Chicago: University of Chicago Press, 1993.
Tomek, Beverly C. *Pennsylvania Hall: A "Legal Lynching" in the Shadow of the Liberty Bell.*
 Oxford: Oxford University Press, 2014.
Townsend, Craig D. *Faith in Their Own Color: Black Episcopalians in Antebellum New York
 City.* New York: Columbia University Press, 2005.
Trachtenberg, Allan. "Albums of War: On Reading Civil War Photographs." Special issue,
 Representations no. 9 (1985): 1–32.
———. *Reading American Photographs: Images as History, Mathew Brady to Walker Evans.*
 New York: Hill and Wang, 1989.
Turley, David. *The Culture of English Anti-Slavery, 1780–1860.* New York: Routledge, 2004.

Tyler-McGraw, Marie. *An African Republic: Black and White Virginians in the Making of Liberia*. Chapel Hill: University of North Carolina Press, 2007.

Veblen, Thorstein. *The Theory of the Leisure Class: An Economic Study of Institutions*. New York: Macmillan, 1899.

Waldstreicher, David. "Reading the Runaways: Self-Fashioning, Print Culture, and Confidence in Slavery in the Eighteenth-Century Mid-Atlantic." *William and Mary Quarterly*, 3rd ser., 56, no. 2 (1999): 243–72.

Walker, Clarence E. *A Rock in a Weary Land: The African Methodist Episcopal Church during the Civil War and Reconstruction*. Baton Rouge: Louisiana State University Press, 1982.

Walker, Juliet E. K. *The History of Black Business in America: Capitalism, Race, Entrepreneurship*. Vol. 1. Chapel Hill: University of North Carolina Press, 2009.

Wallace, Robert K. "J. P. Ball's 1853 Daguerreotype of Cincinnati Abolitionists Harwood, Brisbane, and Coffin." *Daguerreian Society Quarterly* 26, no. 3 (July 2014): 16–17.

Wallace-Sanders, Kimberly Gisele. *Mammy: A Century of Race, Gender, and Southern Memory*. Ann Arbor: University of Michigan Press, 2009.

Werner, John M. *"Reaping the Bloody Harvest": Race Riots in the United States during the Age of Jackson, 1824–1849*. New York: Garland, 1986.

West, Patricia. *Kodak and the Lens of Nostalgia*. Charlottesville: University of Virginia, 2000.

Weyler, Karen. *Empowering Words: Outsiders and Authorship in Early America*. Athens: University of Georgia Press, 2013.

White, Ashli. *Encountering Revolution: Haiti and the Making of the Early Republic*. Baltimore: Johns Hopkins University Press, 2010.

White, Shane. "'It Was a Proud Day': African Americans, Festivals, and Parades in the North, 1741–1834." *Journal of American History* 81, no. 1 (1994): 13–50.

White, Shane, and Graham White. *Somewhat More Independent: The End of Slavery in New York City, 1770–1810*. Athens: University of Georgia Press, 1991.

———. *Stylin': African American Expressive Culture from Its Beginnings to the Zoot Suit*. Ithaca, N.Y.: Cornell University Press, 1998.

Wilder, Craig Steven. *In the Company of Black Men: The African Influence on African American Culture in New York* City. New York: New York University Press, 2005.

Wilkins, Christopher. "'They Had Heard of Emancipation and the Enfranchisement of Their Race': The African American Colonists of Samaná, Reconstruction, and the State of Santo Domingo." In *The Civil War as Global Conflict Book: Transnational Meanings of the American Civil War*, edited by David T. Gleeson and Simon Lewis, 211–34. Columbia: University of South Carolina Press, 2014.

Willis, Deborah. *Black Photographers: An Illustrated Bio-Bibliography*. New York: Garland, 1985.

———. *J. P. Ball: Daguerrean and Studio Photographer*. New York: Routledge, 1993.

———. *Posing Beauty: African American Images from the 1890s to the Present*. New York: W. W. Norton, 2009.

———. *Reflections in Black: A History of Black Photographers, 1840 to the Present*. New York: W. W. Norton, 2000.

Willis, Deborah, and Barbara Krauthamer. *Envisioning Emancipation: Black Americans and the End of Slavery*. Philadelphia: Temple University Press, 2012.

Willis, Deborah, and Carla Williams, eds. *The Black Female Body: A Photographic History*. Philadelphia: Temple University Press, 2002.

Wilson, Robert. *Mathew Brady: Portraits of a Nation*. New York: Bloomsbury USA, 2013.

Winch, Julie. *The Elite of Our People: Joseph Willson's Sketches of Black Upper-Class Life in Antebellum Philadelphia*. State College, PA: Penn State University Press, 2000.

———. *A Gentleman of Color: The Life of James Forten*. Oxford: Oxford University Press, 2002.

———. *Philadelphia's Black Elite: Activism, Accommodation, and the Struggle for Autonomy, 1787–1848*. Philadelphia: Temple University Press, 1988.

Winterer, Caroline. *The Mirror of Antiquity: American Women and the Classical Tradition, 1750–1900*. Ithaca, N.Y.: Cornell University Press, 2007.

Wood, Marcus. *Black Milk: Imagining Slavery in the Visual Cultures of Brazil and America*. Oxford: Oxford University Press, 2013.

———. *Blind Memory: Visual Representations of Slavery in England and America, 1780–1865*. Manchester: Manchester University Press, 2000.

———. "Seeing Is Believing, or Finding 'Truth' in Slave Narrative: The Narrative of Henry Bibb as Perfect Misrepresentation." *Slavery and Abolition* 18, no. 3 (2008): 174–211.

Wood, Nicholas. "'A Sacrifice on the Altar of Slavery': Doughface Politics and Black Disenfranchisement in Pennsylvania, 1837–1838." *Journal of the Early Republic* 31, no. 1 (2011): 75–106.

Wright, Michelle. *Becoming Black: Creating Identity in the African Diaspora*. Durham, N.C.: Duke University Press, 2004.

Yee, Shirley. *Black Women Abolitionists: A Study in Activism*. Knoxville: University of Tennessee Press, 1992.

Yellin, Jean Fagan. *Women and Sisters: The Antislavery Feminists in American Culture*. New Haven, Conn.: Yale University Press, 1989.

Yellin, Jean Fagan, and John C. Van Horne, eds. *The Abolitionist Sisterhood: Women's Political Culture in Antebellum America*. Ithaca, N.Y.: Cornell University Press, 1994.

Younger, Virginia Fisher. "Africa Stretches Forth Her Hands unto You: Female Colonization Supporters in the Antebellum United States." Ph.D. diss., Pennsylvania State University, 2006.

INDEX

abolition, gradual, 18–19, 26–27, 39–42, 66, 71
abolitionists, British, 5, 28–29, 47, 85–87, 100, 104, 123
Act for the Gradual Abolition of Slavery (N.Y.), 40–41
Act for the Gradual Abolition of Slavery (Pa.), 19, 26–27
African Episcopal Church of St. Thomas, 19–21, 79–85, 89–91
African Free Schools, 4, 40, 42–44, 66–67, 231, 246n26, 250n38
African Methodist Episcopal (AME) Church, 36, 202, 210, 219; goals of, 7, 11, 200–201, 205–7, 209, 215–16; leaders of, 19, 70, 194, 201, 215, 219–221, 231; and legal processes, 20; as community space, 73–74, 205–6; and politics, 200–201, 215, 223, 231; spread of, 210, 219–20; and images, 219–21, 223
African Methodist Episcopal Zion Church (New York, N.Y.), 40, 66
Allen, Bishop Richard, 19–20, 70, 83, 201, 208, 216, 221, 249n17
Allen, Mattie, 228–29
American Anti-Slavery Society (AASS), 9, 24, 26–27, 46, 49–50, 53, 60, 63–66, 87, 94, 107, 132, 147
American Colonization Society (ACS), 10, 33, 145–48, 156–60
American Revolution, 39, 46, 74, 84, 105, 141, 148–50, 183
Amistad, 71–72

Anti-Slavery Convention of American Women, 22, 88
Arch Street Daguerrian Gallery, 101–2
Arch Street Meeting House, 21, 88
Asbury African Methodist Episcopal Church (Chester, Pa.), 205–6
Asbury African Methodist Episcopal Church (New York, N.Y.), 73–74
Askew, Thomas E., 233–35
Association for the Relief of the Destitute Contrabands, 184
Atlanta University, 235
Attucks, Crispus, 184–85, 217
Augustine Education Society of Pennsylvania, 21

Bailey, John B., 134
Ball, James Presley, Jr., 211, 214, 217–18, 222–24
Ball, James Presley, Sr.: and slavery, 108, 110, 138, 140–42, 176–81; tour of moving panorama, 110, 135–42; early life, 134; reception, 134–35, 138–40, 198; photographic business, 134–35, 168, 182–83, 187–89, 198–200, 214–31; and Anglo-African Exhibition, 190, 194–95; civic involvement, 190, 194–95, 214–18, 221; legal issues, 211–14, 222–23; and African Methodist Episcopal Church, 216, 219–23; political career, 218–23
Ball, Robert, 224
Ball, Thomas, 223–24, 228, 230

70, 79, 81, 89, 184, 187, 194, 208, 219–20,
233–34; and education, 20–21, 117,
147, 205–7, 209, 211, 214; as targets of
violence, 36, 65; and slavery, 39, 66, 180,
184; and discrimination, 39–40, 66; as
political spaces, 70, 72–74, 149, 184, 194,
209, 219, 223, 231; in Liberia, 152; after
Reconstruction, 194, 200–202, 205–10,
219–31

Cincinnati, 4, 92, 108, 134–35, 140, 168, 176–
82, 187–89, 195, 197–99, 211–31, 270n75

citizenship, 6, 16, 41, 72; rooted in military
service, 84, 175–76, 196; conferred by
states, 86; Liberian, 146, 151, 161, 164; in
contraband camps, 176, 182; and voting,
203; and education, 246n35

citizen-soldier, 175

Civil War, 6, 10–11, 169; images produced
during, 168–90, 195–96; and white
photographers, 169, 181; and black
photographers, 169, 182–90; news reports
of, 169–75; racial stereotypes during, 170,
195; in periodicals, 170–75; and visualized
trauma, 170–75; legislation during, 171,
176, 179, 184, 212; and black military
service, 171–88 passim

Clark, Peter H., 215

Clarkson, Thomas, 87, 100, 104

Clay, Edward Williams, 14–15, 57–58, 75, 91,
96–99, 233, 235, 237

clothing: as negative marker, 13–14,
171; occupations in, 22; as marker of
respectability, 26, 34, 53–56, 58, 76, 79,
96–98, 161–64, 177, 225–30; and slavery,
51, 168, 171–73, 177, 179–81, 184, 195

Coffin, Levi, 168, 176–77, 179–81, 265n25

colonization, 33, 73, 194; resistance to,
33–34, 73, 83, 147–48, 194; support
for, 33–34, 74, 146, 148, 151–67, 194; of
Caribbean, 33–34, 83; of Africa, 33, 146,
148, 152–67, 184–85; of Canada, 75

colored conventions, 71–73, 75, 111, 148, 184,
193, 250n25

Colored Orphan Asylum (Cincinnati), 224

Colored Republican Rallying Committee,
217–18

commemoration: in images, 1, 6, 66–68,

81, 204, 221; of end of international
slave trade, 13–14, 66; of birth of
George Washington, 23; of Haitian
Independence, 34, 89–91; of Francis
Johnson, 81; of Crispus Attucks and
the Boston Massacre, 183–85; of
Emancipation Proclamation, 184–
85; of John Brown, 203, 215, 222; of
Union military casualties, 204; of
Abraham Lincoln, 215, 222; of Toussaint
Louverture, 222

Compromise of 1850, 148

Connor, Aaron J. R., 81

Constable, John, 207

contraband, 169–70, 173, 175–76, 182, 184,
195

Cornish, James, 27

Cornish, Samuel, 41, 72

Correggio, 86, 90

cotton, 47, 114, 122, 125–26, 140, 159

Craft, Ellen, 111, 114, 149

Craft, William, 149

Crouch, Thomas, 94

Crummell, Alexander, 43, 73, 147, 250n38

Cuba, 11, 72, 200, 204

Cuffee, Paul, 148

daguerreotypes: of activists, 1, 102–4, 147,
261n3, 263n55; limitations of, 24, 80–81,
86–87, 152, 158, 173; of black people, 79,
81, 85, 134, 146, 151, 161–64; technology
of, 80–81, 146, 152, 158, 160; business in,
86–87, 101–2, 104, 134–35, 145, 147, 151–52,
158, 160, 165; of landscapes, 152

DeGrasse, Cordelia Howard, 183

DeGrasse, John Van Surly, 183, 185–87,
273n156

Demosthenian Institute, 94

Dickerson, Mary Anne, 29–32

Dinah (fugitive slave), 180

Dorsey, William, 190, 194, 243n76

Douglass, Frederick, 58, 60, 75, 111, 147, 166,
173, 194, 197–99, 209–10

Douglass, Grace Bustill, 20–21, 27

Douglass, Robert, Jr.: antislavery work, 1, 13,
24–27, 36, 102–5; and visual production,
8, 23–24, 32, 35, 79, 86–91, 94–96, 100–

105, 202–6; and Haiti, 9, 33–35, 209–10; and discrimination, 12, 36, 86; and family members, 20–24, 102; early work of, 23–24, 29–33; training of, 23–24, 33–35, 85–86; civic activities of, 26–28, 81–85, 89–91, 104–5, 204, 206, 209; and black Philadelphians, 29–33, 79–85, 89–91, 94–96, 204; in England, 86–88; legal issues of, 94–96; business difficulties of, 99–100; in Jamaica, 105–6, 246n26; and African Methodist Episcopal Church, 200–211; and voting rights, 202–3

Douglass, Robert, Sr., 20–21, 32, 79, 242n61, 255n155

Douglass, Sarah Mapps, 21–22, 24, 31–33, 85–86, 88, 201, 255n155

Downing, George, 43

Dred Scott v. Sandford, 184

Du Bois, W. E. B., 233–35, 237

Duncanson, Robert, 190, 260n138

Dyck, Anthony van, 86

Eastman, George, 235

Easton, Rev. Hosea, 13–14

education, formal, 19–22, 28, 31–32, 41–43, 67

Emancipation Proclamation, 171, 184, 212–13, 270n73

emigration, 4, 33–34, 41, 66

emotions, 51, 68

England, 4, 9, 47, 53, 78, 108, 134; activists in, 5, 28–29, 47, 85–87, 100, 104, 123; Robert Douglass in, 85–87; Henry "Box" Brown in, 107–20; William Wells Brown in, 120, 123–33; Augustus Washington trade with, 158

Federalist Party, 71

femininity, 97, 168, 176–81

Fifteenth Amendment, 202–3, 215, 219

Fisk University, 214

Five Points neighborhood, 67

Forsyth, John, 86

Forten, Charlotte, 31, 139

Forten, James, 12, 21, 240n2

Forten, Margaretta, 104

Forten, Sarah, 79

Foster, Abby Kelley, 1, 75, 102–3

Fourteenth Amendment, 203

Fox, George, 18

Fox, William, 206

Frank Leslie's Illustrated Newspaper, 170, 173

Franklin, Benjamin, 19, 28, 47

Free African Society, 19–20

free black people: in Philadelphia, 3, 8, 18–24, 27–37, 70, 72, 78–85, 87–91, 94–96, 102, 104; in New York City, 4, 9, 39–43, 65–70; and law, 20, 27, 40, 66, 71, 94–96, 141, 211–14, 217; and violence, 27, 31, 34–36, 63, 65, 140, 167, 195, 219, 223, 235, 249n11; and respectability, 54–55, 57–58, 77, 224–31; images of, 54, 59, 69, 76, 80, 162–63, 186, 198, 215–17, 224–31, 264n21, 267n6, 272n156; in Boston, 111, 128, 132, 135, 138, 182–87, 195; in Cincinnati, 134–36, 187–89, 197–200, 211–20, 224–31

Free Soil Party, 149–50

friendship albums, 3, 29–32

Fugitive Slave Act of 1850, 10–11, 75, 108, 131, 141, 143, 148–49, 165, 176, 184

Gardner, Alexander, 169, 181–82, 196

Garnet, Henry Highland, 43, 147, 194, 221, 230–31

Garnet, Julia, 231

Garrison, William Lloyd, 12, 17, 24–26, 35, 37, 75, 87, 100, 104, 184, 240n2, 255n160, 261n3

Geffrard, Fabre, 209

Germantown Petition of 1688, 18

Gilbert Lyceum, 22

Gilpin, Charles, 123

Gimber, Steven, 43–45

Gliddon, George, 233

Gloucester, James, 194

Gordon (former slave), 171–76

Grand Army of the Republic, 204

Grant, Ulysses, 221

Green, Jacob, 180

Grimes, Leonard, 184, 273n156

Grimké, Angelina, 21, 36, 37–38, 85

Grimké, Sarah, 21, 33, 35

Gross, Tabbs, 212–14

Guizot, François, 100
Gunn, Lewis, 33–36

Haiti, 1, 4, 8–9; Robert Douglass in, 33–35, 85; in paintings, 34, 88–91; emigration from, 42; immigration to, 66, 83, 148, 201; printed representations of, 84–85, 209–10; leaders in, 89, 91, 209–10, 251n67
Haitian Emigration Society of Philadelphia, 83
Haitian Revolution, 17, 34, 42, 84
Hall, Prince, 217
Hamilton Street Baptist Church (Albany, N.Y.), 72
Harper's Weekly, 170–75
Harpers Ferry, 147, 185, 263n55, 266n60
Hayden, Lewis, 185, 187, 266n60
Haydon, Benjamin Robert, 87, 100, 253n101
Hinton, Ada, 31–32, 96, 194
Hinton, Frederick Augustus, 21, 27, 32, 94–99
Hoffy, Alfred, 79–80, 103
Howard, Juanna, 194

images, persuasive, 1, 2, 5, 7, 16, 45, 67, 91–92, 102–4, 115–17, 139
Independence Hall, 23
Independent Order of Odd Fellows, 215
Inginac, Joseph Balthazar, 89, 91

Jacobs, Harriet, 179
Jamaica, 105–6, 246n26
Johnson, Andrew, 197, 267n2
Johnson, Francis (Frank), 78–82, 84–85, 209, 251n67
John Street Church (New York, N.Y.), 66
Jones, Absalom, 19–20
Jones, John Wesley, 109

Keckley, Elizabeth, 214
Ku Klux Klan, 221

labor, 18, 22, 41–42
Lake, Augusta, 194
Lamennais, Hugues Félicité Robert de, 101
Lawrence, Thomas, 90
lawsuits, 71, 94–96, 211–14, 217

Lay, Benjamin, 19
Leutze, Emanuel, 23
Liberator, 24, 34, 49–50, 56, 100, 139, 183
Liberia, 4, 10, 145; immigration to, 11, 148–50; politics in, 145; photography in, 146, 151–58, 160–64; politicians in, 146, 156–57, 160–67; Augustus Washington in, 149–67; work in, 150, 155, 157, 159; and "uplift," 151, 154–55; and black rights, 151, 156, 161, 164–67; and colonization, 151–57; and native peoples, 156–57, 164–65; and economics, 158–60, 165
Liberty Party, 75
Lincoln, Abraham, 194, 215–16, 221–22, 224
Lincoln, Mary Todd, 214
Lincoln Memorial Club, 215, 221–22, 224
literary societies, 28, 46
literature, children's, 94, 104
lithography, 1, 3, 17, 24–26, 28, 43, 45, 49, 79–81, 94–96, 99–104, 173, 216, 242n65
Lochard, M. Colbert, 89
Locust Street Theatre, 31
Logan Anti-Slavery Society, 32
Longfellow, Henry Wadsworth, 142
Louis, Henry, 109
Louverture, Toussaint, 84, 210, 222
Lovejoy, Elijah, 215
Lynch, James D., 219–20, 223, 271n113

Manifest Destiny, 109, 154–56
Martin, J. Sella, 184
Martineau, Harriet, 84–85
Maryland Colonization Society, 73–74, 148
masculinity, 56, 60–61, 142, 157, 196, 216
Massachusetts Anti-Slavery Society, 16, 107, 132, 259n104
material culture, 3, 16; and antislavery, 29–32, 37–39, 47–51, 53–63, 75–78, 102–5, 107–43, 203–4, 206–7; and children, 29–32, 60–63, 107–8, 114, 117–19, 206–7, 225–31; and escaped slave narratives, 53–63, 57–78, 127–31; and commemoration, 67–70, 79–81; and black leadership, 67–70, 204, 215–16, 219–22, 224–31; and Haiti, 88–91; and potential negative effects of, 94–96;

to elected office, 157, 165–66; and public
accommodation, 222
riots. *See* violence
Rockwell, Frank M., 177–78
Rogers, Harriet, 194
Roye, Edward James, 161–62
Rubens, Peter Paul, 86, 221
Ruffin, G. L., 224
Ruggles, David, 74–75
Russwurm, John, 41

Sabbath schools, 21, 117, 205–7
Salem Female Anti-Slavery Society, 123
Salnave, Sylvain, 209–10
Sandiford, Ralph, 19
scientific racism, 9, 58, 60, 198, 233
Scurlock, Addison, 237
Sharp, Granville, 52–53, 247n55
Shaw, Robert Gould, 185
Shenstone, William, 29–31
Shepard, Ella, 214
Simpson, William H., 190, 194
slave, kneeling, 5, 28–30, 37, 47–51
slave, supplicant. *See* slave, kneeling
slave catchers, 127–31, 141, 179, 184–85
slaveholder, 18, 39, 113, 124–25, 138, 174, 275
slave narratives, 53–57, 60–61, 75–78, 112–13,
121, 124, 127–33
slave owner. *See* slaveholder
slaves, escaped, 74, 111, 138, 141, 148, 169,
185, 191; representations of, 9, 38–39, 47,
53–54, 58–60, 64, 75–78, 127–31, 138, 141,
176–81; men, 53–61, 75–78, 107–8, 112,
121, 127–31, 134, 171, 174, 184, 231, 251n54;
narratives of, 53–61, 75–78, 112, 121, 123,
127–31, 259n75; on British soil, 75, 130,
132, 141–42, 148; as activists, 111, 121, 134,
231, 251n54; women, 111, 121, 171, 176–81,
243n92; during Civil War, 169–70, 173,
175–76, 182, 184, 195
The Slave's Friend, 50, 61–63, 94
slave trade, African, 50, 114, 118
slave trade, domestic, 77, 115, 126, 129
slave trade, transatlantic, 18–19, 28, 66, 107,
114–16, 137, 234, 243n88
Smith, Hamilton Sutton, 237
Smith, James Caesar Anthony, 112–13

Smith, James McCune, 43
Smith, John Rowson, 109
Smith, John Skivring, 162–64
Smith, William Benjamin, 118–20
social status, 15, 55–56, 70, 77, 96, 120, 131,
150, 164, 182
Society for Effecting the Abolition of the
Slave Trade, 28
Society of Friends, 14, 18–19, 21–22, 32, 37,
40, 86, 88, 176, 242n62
soldiers. *See* Union army; Union navy
Stanley, Benjamin, 94
Stanton, Elizabeth Cady, 87
State Anti-Slavery Society of Pennsylvania,
26–27
stereotypes: challenges to, 2, 5, 10, 13, 34–35,
46, 58, 77, 98, 192, 195, 233; racial, 2, 58, 60,
76, 98, 119, 128, 133, 137, 171, 235
Steward, Theophilus Gould, 216–17
Stockwell, Samuel, 109
Stowe, Harriet Beecher, 138, 172
St. Paul's River, 155–56, 158, 166
St. Peter's Roman Catholic Church (New
York, N.Y.), 42
St. Philip's Episcopal Church (New York,
N.Y.), 65, 67
St. Thomas African Episcopal Church
(Philadelphia, Pa.), 19, 21, 79, 81–83,
89–90
Stuart, Charles, 52
suffrage. *See* voting
sugar, 47, 114, 122, 125–26, 138, 140, 156,
159–60
Sully, Thomas, 85–86
Sunday schools. *See* Sabbath schools

Talcott Street Congregational Church, 147,
149
Tanner, Benjamin Tucker, 201–3, 206, 208,
210
Tappan, Arthur, 17, 57
Tappan, Lewis, 37, 244n2
Thomas, Alexander, 187–89, 223–27, 229–31,
259n109
Thomas, Alice, 230
Thomas, Edward M., 190–96, 207
Thomas, Elizabeth Ball, 224, 228, 230

Made in the USA
Las Vegas, NV
22 October 2020